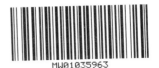

My Fair Ladies

My Fair Ladies

Female Robots, Androids,
and Other Artificial Eves

JULIE WOSK

Rutgers University Press
New Brunswick, New Jersey, and London

Library of Congress Cataloging-in-Publication Data
Wosk, Julie.
My fair ladies : female robots, androids, and other artificial Eves / Julie Wosk.
 pages cm
Includes bibliographical references and index.
ISBN 978–0–8135–6338–1 (hardcover : alk. paper) — ISBN 978–0–8135–6337–4 (pbk. : alk. paper) — ISBN 978–0–8135–6339–8 (e-book (web pdf))
1. Women in art. 2. Anthropomorphism in art. 3. Androids in art. 4. Technology and women. 5. Human body and technology. I. Title.
NX652.W6W67 2015
704.9'424—dc23
2014035923

A British Cataloging-in-Publication record for this book is available from the British Library.

Copyright © 2015 by Julie Wosk
All rights reserved
No part of this book may be reproduced or utilized in any form or by any means, electronic or mechanical, or by any information storage and retrieval system, without written permission from the publisher. Please contact Rutgers University Press, 106 Somerset Street, New Brunswick, NJ 08901. The only exception to this prohibition is "fair use" as defined by U.S. copyright law.

Visit our website: http://rutgerspress.rutgers.edu

Manufactured in the United States of America

Contents

	List of Illustrations	vii
	Acknowledgments	xiii
	Introduction	1
1	Simulated Women and the Pygmalion Myth	9
2	Mechanical Galateas: Female Automatons and Dolls	31
3	Mannequins, Masks, Monsters, and Dolls: Film and the Arts in the 1920s and 1930s	55
4	Simulated Women in Television and Films, 1940s and After	90
5	Engineering the Perfect Woman	137
6	Dancing with Robots and Women in Robotics Design	152
7	The Woman Artist as Pygmalion	166
	Notes	187
	Index	207

Illustrations

Black-and-White Figures

I.1	Advertisement for Swisstex Girdle, 1955	2
1.2	Vintage postcard	4
I.3	Etching of a woman composed of household tools by Giovanni Battista Braccelli in *Bizzari di Varie Figure*, 1624	6
1.1	"Pygmalion Embracing the Image," miniature in the style of Robinet Testard in Guillaume de Lorris and Jean de Meun, *Le Roman de la Rose*, late fifteenth century	10
1.2	Louis-Jean-François Lagrenée I, *Pygmalion and His Statue*, 1777	12
1.3	Honoré Daumier, *Pygmalion*, lithograph from his *Histoire ancienne* series, December 18, 1842	13
1.4	An 1888 photograph of Julia Marlowe as Galatea in a production of W. S. Gilbert's play *Pygmalion and Galatea*	16
1.5	Amelia being admired by Arthur Moore and Dr. Phillips in E. E. Kellett's story "The Lady Automaton," *Pearson's Magazine*, June 1901	21
1.6	Margot Kidder as the flower girl Eliza Doolittle and the transformed Eliza in a 1983 television production of George Bernard Shaw's play *Pygmalion*	26
1.7	Phonographic doll manufactured at Thomas Edison's West Orange, New Jersey, factory, 1890	28
2.1	"Gavrochinette" manufactured by Phalibois in Paris, ca. 1900	32

2.2 Gavrochinette, who wore men's clothes and a man's hat jauntily on her head, was a real-life popular entertainer in Parisian clubs like the Moulin Rouge 33

2.3 *Mademoiselle Catherina*, from an original painting in Vauxhall Garden, etching/engraving by Robert Sayer, ca. 1750 36

2.4 Casanova dancing with the beautiful doll Rosalba in *Fellini's Casanova*, 1976 37

2.5 Nineteenth-century female automaton 40

2.6 *The Rights of Women*, automaton by Renou, ca. 1900 42

2.7 Nineteenth-century stereograph 43

2.8 Automaton of a female *bicycliste* by Vichy 45

2.9 The female Snake Charmer automaton by Roullet & Decamps, 1890 47

2.10 Chinese female tea server automaton by Léopold Lambert, ca. 1900 48

2.11 Autoperipateikos walking doll, 1870, invented in 1862 by Enoch Rice Morrison 50

3.1 Olympia being wound up in Leo Délibe's ballet *Coppélia* 59

3.2 *The Tales of Hoffmann* (1951) with Moira Shearer as Olympia and Robert Rounseville as Hoffmann 62

3.3 German actress Ossi Oswalda as Ossi in Ernst Lubitsch's 1919 silent film *Die Puppe* (*The Doll*) 66

3.4 Maria with electrodes on her head being subjected to electricity and soon to be transformed into her evil double in Fritz Lang's film *Metropolis* 69

3.5 The "good" Maria, played by German actress Brigitte Helm, offers comfort to the children of the city in *Metropolis* 70

3.6 The evil, android version of Maria, also played by Brigitte Helm, in *Metropolis* 71

3.7 The Monster (Boris Karloff) and the Monster's Mate (Elsa Lanchester) in James Whale's 1935 film *Bride of Frankenstein*, loosely based on Mary Shelley's novel *Frankenstein* (1818, 1831) 74

3.8 *Vogue* magazine cover illustration, November 24, 1930 76

3.9 Marlene Dietrich as Lola Lola in Josef von Sternberg's 1930 film *Der blaue Engel* (*The Blue Angel*) 79

3.10	Russian ballerina Alexandra Danilova with a doll of herself, in Massiné's *Boutique Fantastique*	82
3.11	Plate from Hans Bellmer's book *La Poupée* (*The Doll*), 1936	84
3.12	Linocut illustration from the essay "Memories of a Doll Theme" in Hans Bellmer's *La Poupée*, 1936	85
3.13	Berlin Dada artist Hanna Höch's photocollage *Das schöne Mädchen* (*The Beautiful Girl*), 1920	88
3.14	*The Robots* dance	89
4.1	Ava Gardner plays the voluptuous Venus in *One Touch of Venus* (1948)	91
4.2	Professor Henry Higgins (Rex Harrison) dancing with the elegant Eliza (Audrey Hepburn) in *My Fair Lady* (1964)	94
4.3	An American woman war worker resisting the embrace of a male robot in a 1940s cartoon	95
4.4	Marsha in the 1960 *Twilight Zone* television series episode "The After Hours"	97
4.5	The 1963 "Living Doll" episode of *The Twilight Zone*	102
4.6	Robert Cummings and Julie Newmar, the statuesque, beautiful robot in *My Living Doll*, 1964–1965	106
4.7	Dee Hartford as the silvery, accomplished female android Verda in the 1966 episode "The Android Machine" of *Lost in Space*	111
4.8	Fembot with her face exposed in the 1976 "Kill Oscar" episode of *Bionic Woman*	116
4.9	Wire "cage" crinolines under voluminous dresses helped women lighten the load of multiple petticoats, 1850	117
4.10	The glamorous and pensive robot Rachael (Sean Young) in Ridley Scott's 1982 iconic film *Blade Runner*	119
4.11	Pris (Daryl Hannah), a "pleasure robot," in the film *Blade Runner*	120
4.12	The kindly robot grandmother comforts Agatha in Rod Serling's television series *The Twilight Zone* in the 1962 episode "I Sing the Body Electric"	122
4.13	Lisa (Kelly LeBrock), a beautiful mail-order robot, and one of her young creators in the 1985 Hollywood film *Weird Science*	129
5.1	The professor's niece Penelope (Patricia Roc) impersonating a robot in the 1949 British film comedy *The Perfect Woman*	138

x • Illustrations

5.2 Walter (Matthew Broderick) introduces his beautiful, blond, newly transformed wife, Joanna (Nicole Kidman), in the 2004 remake of *The Stepford Wives* — 145

5.3 Lars (Ryan Gosling) seated next to his doll Bianca in the film *Lars and the Real Girl* — 148

6.1 Andrea Thomaz, professor of interactive computing and head of the Socially Intelligent Machines Lab at the Georgia Institute of Technology, with the lab's female research robot Curi, introduced in 2013 — 160

6.2 The "First Robot Super Model" HRP-4C 2009 (an acronym for Humanoid Robotics Project) designed by Japan's National Institute of Advanced Industrial Science and Technology Institute and introduced at Tokyo's Digital Content Expo in 2009 — 161

6.3 Still from Icelandic rock singer Björk's 1999 music video, *All Is Full of Love* — 164

7.1 Heidi Kumao, *Protest* (2005) — 172

7.2 Video still of American artist Joan Jonas in her performance video *Organic Honey's Visual Telepathy*, 1972 — 174

7.3 Cindy Sherman, *Untitled #474*, 2008 — 177

7.4 Laurie Simmons, photograph from her series of dollhouse images, 1976–1978 — 182

7.5 Nancy Burson, *Untitled* (girl with doll's eyes) — 183

7.6 Nancy Burson, *Untitled* (mannequin with real girl's mouth and eyes) — 184

Color Plates

I Julie Wosk, *Bag Lady*, 1992

II Jean-Léon Gérôme, *Pygmalion and Galatea*, ca. 1890

III Lady Musician, intricate clockwork automaton created by Pierre and Henri Jaquet-Droz, 1773

IV The Flower Vendor automaton by Vichy, ca. 1885

V Julie Wosk, *Marlene*, 1995

VI A male scientist with his white coat operates on a female robot, her exposed body parts lying on the table

VII	Glamorous, compliant robot women at the Simply Stepford Day Spa in the 2004 Hollywood remake of *The Stepford Wives*
VIII	Postgraduate student Takahiro Takeda at Japan's Tohoku University dancing with a robot at a factory, Chino city, China
IX	An ultrarealistic female robot made of silicone and electronics, *Repliee QII*, designed and developed by Professor Hiroshi Ishiguro, director of the Osaka University Intelligent Robotics Communications Laboratory in Japan
X	Cynthia Breazeal, director, MIT Media Lab, Personal Robots Group, and the early robot Kismet developed by Breazeal at MIT 1993–2000
XI	Aimee Mullins, from Howard Schatz's *Athlete*
XII	Mariko Mori, *Birth of a Star*, 1995

Acknowledgments

I give great thanks to the staff of Rutgers University Press and especially to my book editor, Leslie Mitchner, the Press's associate director and editor-in-chief, for her enthusiasm and help in making this book possible, and to my very fine copyeditor, Lisa Nowak Jerry, for her editing expertise. My deep appreciation to the Alfred P. Sloan Foundation and to program officer Doran Weber for the foundation's generous grant. I am grateful to the State University of New York, Maritime College, and SUNY Maritime's Provost and Vice-President for Academic Affairs Timothy G. Lynch, for their continuing support.

I also give many thanks to the staff of Maritime College's Stephen B. Luce Library for their aid and to Jay Barksdale at the New York Public Library in Manhattan for the opportunity to be a visiting scholar at the Wertheim Study for writers. My thanks, also, go to Marlene Schwarz and Philip K. Cohen, my very good friends of many years, for their thoughtful editorial comments.

I am also grateful to Marcia Rudy, who as director of education at the New York Hall of Science first gave me the opportunity to curate my new museum exhibit "Alluring Androids, Robot Women, and Electronic Eves," which became the genesis of this book. I give thanks, also, to New York's Public Broadcasting System Channel Thirteen television for taping one of my lectures on the subject and to the New York Council for the Humanities for sponsoring my Speakers Program talks on female robots which have given me lively and useful feedback from audiences.

I give my very special warm thanks to my husband, Averill (Bill) Williams for all of his great patience, support, and (mostly) good humor throughout the several years I was researching and writing this book. I also very much thank my colleagues, family, and friends for their encouragement over the years, particularly Sandra Stern, Sigmund and Elinor Balka, Robert C. Post, Robert Mark, John Rocco, Roberta Siegel-Lutzker, Eunice and Carl Feinberg, Maureen Daley,

and the former Maritime College library director Richard Corson and his late wife Connie who gave me one of my first books on art and technology and also a wonderful bright red robot tee-shirt.

I thank, too, to the museum curators, staff member librarians, and researchers who offered their insights, in particular Jeremie Ryder, conservator of the Guinness Collection at the Morris Museum, Morristown, New Jersey; Ms. Harumi Yamada, curator of the Kyoto Arashiyama Orgel Museum, and Machiko Ohba of Reuge Hambai K.K. in Japan; and Jin Joo Lee of the Personal Robots Group at MIT's Media Lab in Cambridge for her helpful information about gendered research in robotics.

Finally, as always, I would like to thank my parents for their steadfast and enduring love and encouragement: my dear late mother, Goldie Wosk, whose probing and witty essays, published in newspapers and literary magazines, were an inspiration, and my wonderful late father, Joseph Wosk, whose forty-eight years working as an engineer at Western Electric and Bell Labs in Chicago inspired me to keep being excited about new developments in technology. When the early IBM computers arrived in the Chicago area offices of Western Electric and AT&T's Bell Labs, he helped mentor the first group of women programmers, and years later I loved to hear his stories about those days.

Also, when I was a child, my parents sent me for art lessons in an artist's studio in my hometown of Chicago where my first assignment was to sketch plaster casts of statues. Who knows, maybe my interest in Pygmalion and his wondrous female statue that came alive started in that Chicago studio so long ago.

My Fair Ladies

Introduction

One summer many years ago, I was wandering through a Manhattan flea market near Twenty-sixth Street when I spied two startling female mannequin heads. One had a face that looked like Marlene Dietrich, and the other was a woman's head with blue eyes peering provocatively out of a paper bag (plate 1). Her identity was half hidden, and in her bag she seemed like a social commodity, packaged and ready to go. I loved how those artificial women seemed both eerie and magical, and the way they blurred the line between the artificial and the real.

As a photographer, I started taking images of mannequins and masks, not stopping to think about why I found them so intriguing. Later, I realized that I had grown up in a world where women were expected, at times, to be artificial, to put on a mask. I had come of age in the late 1950s and early 1960s, the same period when television's Mad Men were writing advertising copy and when young women—at least in my hometown, Chicago suburb Evanston, Illinois—were still expected not only to learn the skills of cooking and sewing but also to fashion themselves as glamorous creatures wearing bright red lipstick and contouring their bodies with girdles and uplift bras.

It was a time in America when advertisers were telling young women to turn themselves into "Living Dolls." Maidenform earlier had great success with its "I Dreamed" campaign, offering women the allure of the artificial, the exotic, and the disguise: "I Dreamed I Was a Living Doll in My Maidenform Bra; I Dreamed I Went to a Masquerade in My Maidenform Bra." Here was the ad's promise: if women would artificially mold and shape their own doll-like images, then glamour would surely be within their grasp. A 1955 Swisstex Girdle ad ("Be a Living Doll") pictured a young woman in blond pigtails who was wearing a girdle and holding the strings of her own artificial double: a miniature female

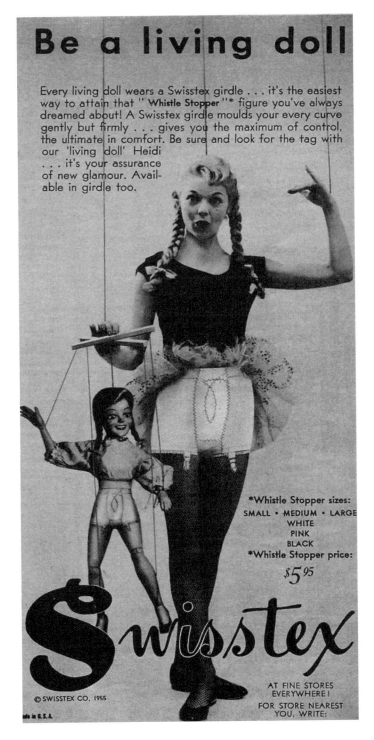

1.1 Advertisement for Swisstex Girdle, 1955. By reshaping her body, this young woman marionetteer can manipulate her own image.

marionette also featuring pigtails, an uplift bra, and a girdle (fig. I.1). The look was for men, yet it offered women agency, too: they could put on the mask of glamour, look like a marionette, but also be pulling the strings.

Meanwhile, my eighth-grade cooking teacher, aptly named Miss Baker, valiantly tried to teach the girls in my class how to make soufflés and popovers for appreciative men, and my sewing teacher Miss Curtain was intent on having us master the sewing machine to produce those popular full skirts. But for me, several years later, another world was beckoning, full of glamour and allure. Right out of Harvard graduate school, I was offered two jobs in Chicago: a copywriter for Quaker Oats and a "creative trainee" at *Playboy* on Michigan Avenue. To me, no contest: I nixed the prospect of grits and oatmeal—it was *Playboy* for sure.

America was already erupting into the upheavals of the Vietnam War, the civil rights movement, and the women's movement, but, at *Playboy*, the offices were filled with manufactured glamour and artifice was all around. Women weren't allowed to be hired as magazine writers, but as a young female copywriter in the advertising department, my job was to portray the allure of the magazine with its air-brushed female centerfolds and Playboy clubs filled with sexy bunnies and lobster bisque (I remember my boyfriend, an earnest political scientist, snorting at the absurdity of it all).

I was also expected to buy false eyelashes from the salesmen who regularly trolled the office aisles and to flirt with television executives at Hugh Hefner's parties (but at the first overtures from one of those men, I remember fleeing to the safety of my parents' home where I lived). *Playboy* was a magazine that fed men fantasies about compliant sexy women, but it also offered its women workers like me the promise of transforming themselves—at least on the surface—into one of those exotic artificial creatures.

It was all fun but not serious enough for an academic at heart like me and after a year I left that glamorous plastic world of *Playboy* for a return to the seriousness of graduate school. I remember reading two books that had a big impact on me, and many years later they became the genesis for this book. One was George Bernard Shaw's *Pygmalion* where the imperious Henry Higgins, using technology, transforms the sassy "guttersnipe" flower-seller Eliza into the surface trappings of an elegant Victorian "lady." The second was Ira Levin's novel *The Stepford Wives* (1972), a cautionary tale of men, made uneasy by the women's movement, who opt to replace their wives with artificial doubles—robotic females that fulfilled the men's notion of the perfect woman: a fusion of happy domesticity and sexy playmate. My fascination with mannequins, my experiences at *Playboy*, my encounters with Shaw's *Pygmalion* and *The Stepford Wives*, not to mention my memories of the vintage American television series *The Twilight Zone* where mannequins come to life and, years later, my seeing Gérôme's glossy nineteenth-century academic painting *Pygmalion and Galatea* at New York's Metropolitan Museum of Art—all contributed to the genesis of this book.

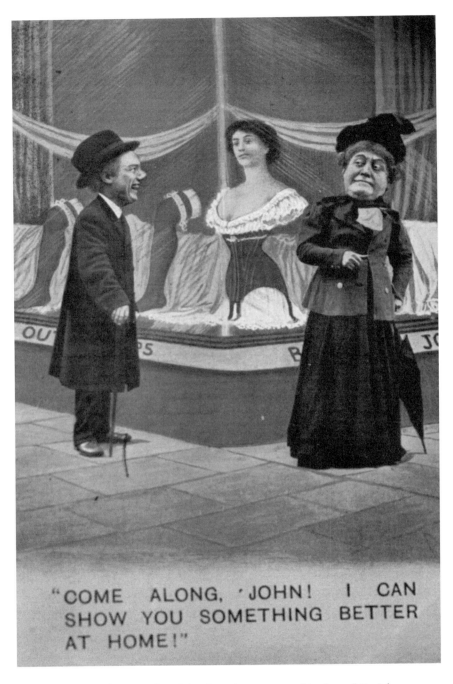

1.2 Vintage postcard. "Come along John! I can show you something better." For John, no doubt, the mannequin is better than the reality. Collection of the author.

In my first book, *Breaking Frame: Technology and the Visual Arts in the Nineteenth Century*, I had written about industrially made imitations in the arts that some had argued were superior to the real thing, and in my book *Women and the Machine* I also wrote about artificial women fashioned through electricity and nineteenth-century women who looked like stiff-walking dolls because their bodies were shaped by wired crinolines and bustles. Now I was ready to bring the two together in a broader study of how technology had been used by both women and men—in film, fiction, art, robotics—to fashion simulated women that looked like the real thing, artificial women that, like Galatea in the myth of Pygmalion, seemed to miraculously come alive.

One of the book's central themes is the story of men's enduring fantasies and dreams about producing the perfect woman, a custom-made female who is what I would call the Substitute Woman, an artificial female superior to the real thing. Twitting this idea, in a comic postcard from 1905, a small man smiles as he ogles a shop-window female mannequin wearing a red corset while his huge, matronly stern wife tells him, "Come along John! I can show you something better!" But we surmise that for John the mannequin will win hands down (fig. I.2).

It is also a story that changes as new technologies became available and cultural perceptions of women change over time. The women that men manufacture are often articulated creatures, assemblages of disparate parts. These assemblages, which had their earliest manifestations in ancient, articulated Greek, Roman, and Egyptian female votive figures and dolls, embody socially constructed conceptions of gender and women themselves—like Italian artist Giovanni Battista Braccelli's 1624 etching of a woman in her conventional social role of domesticity whose body is composed of domestic tools (fig. I.3).

Pygmalion began it all. In Ovid's version of the tale, a sculptor disenchanted with women creates an image of a beautiful woman and longs to marry a woman just like her, and Venus grants his wish by bringing the sculpture, which later generations called Galatea, to life. Modern-day Pygmalions have used science and technology to help accomplish the same thing. Henry Higgins in Shaw's *Pygmalion* used not only his linguist's expertise but also a gramophone, and, in the pivotal scene in James Whale's 1935 film *Bride of Frankenstein*, Dr. Pretorius unwraps their new female creation, he and Henry Frankenstein watch as her eyes open, and Henry says, "She's Alive!" Henry's melodramatic pride and excitement, which today seem campy and funny, are palpable. Here is a man who has put together a female made of dead body parts and brought to life through jolts of electricity garnered from lightning. The new female is intended as a mate for the Frankenstein's creature, the answer to his dreams, but when the new Bride takes one look at the horrendous-looking Monster, she lets out a piercing croaking scream and later runs away. The creature's fantasies, turned to nightmare when his dreams are dashed, become a central part of the modern-day mythos of men creating artificial women.

1.3 Etching of a woman composed of household tools by Giovanni Battista Braccelli in *Bizzarie di Varie Figure*, 1624. Braccelli, a Florentine artist and engraver, created a suite of fanciful figures including this assemblage of a machine-woman made of washboard, spoon, and other domestic wares.

There are other central shaping stories, too. I could call one the "Nathanael Effect" from E.T.A. Hoffmann's nineteenth-century story "The Sandman" where the young Nathanael becomes entranced by Olympia, the beautiful "daughter" of physics professor Spalanzani, only to discover, to his horror, that she is just a doll. It was the type of confusion about the uncanny, probed by

Ernst Jentsch and Sigmund Freud, where it is indeterminate whether a being is inanimate or real. And Japanese roboticist Masahiro Mori later described in 1970 this type of unsettling experience as "the uncanny valley"—that psychic place when someone discovers that what looks animate is not really alive. In Hoffmann's tale, Nathanael's dreams and fantasies are destroyed as Olympia herself is grotesquely disassembled and shattered into discrete parts.

Men in tales like "The Sandman" are horrified when they discover the female is only a doll, but there were also wonderful comic inversions. In Léo Delibes's ballet *Coppélia* (1870) and Ernst Lubitsch's 1919 film *Die Puppe* (*The Doll*), women appropriate the look of a doll not to be manipulated but to assert their own vigorous sense of agency and control. When these women end the artifice or their masquerade is discovered, the men in these comedies are not horrified but happily delighted that their beloved is, after all, real.

Men's Pygmalion-like fantasies about fabricating the perfect women who come alive would change over the centuries, but in some ways they also remained remarkably consistent even as cultural contexts and technologies underwent dramatic change. In the film spoofing adolescent male fantasies *Weird Science*, in *Lars and the Real Girl*, and in *S1m0ne* (*Simone*), the Galateas created on dating websites or through digital manipulations remain the answer to men's dreams— Substitute Women who, for a while at least, seem safer and more appealing than real women with their own identities, wishes, and wants.

Representations of artificial women would often embody gender stereotypes, but also be shaped by shifting social paradigms. The emergence of the New Woman in America and Europe at the end of the nineteenth century, the burgeoning women's movement in the 1960s, the space race in America, all helped shaped representations of artificial women, including space age television robots like Verda in *Lost in Space* and Rhoda in *My Living Doll*—robots that were beautiful but also had minds of their own.

Embodiments of artificial women were also shaped by changing developments in science and technology, including the remarkable Swiss, German, and Chinese female automatons produced using sophisticated clockwork mechanisms in the eighteenth and early nineteenth centuries and Parisian automatons made more available through the industrialization of production in the later nineteenth century. Twentieth-century developments in plastics and electronics also shaped how women were embodied and portrayed—including the humanoid silicone and electronic Japanese female robots, starting in the 1990s, that looked so real they could easily fool the eye. One roboticist even used electronics to create a perfect female dance partner (dancing with dolls is another recurring fantasy in fiction and films).

There is a second major story that looms large in this book: how women artists, writers, photographers, filmmakers, and musicians have themselves inhabited the mythic role of Pygmalion, fashioning their own images of artificial females that imaginatively illuminate female stereotypes and the shifting nature of women's

social identities; consider women like Dada artist Hannah Höch during the 1920s and 1930s whose fractured photographs of dolls and photocollages interrogated the way women have been perceived and upended their doll-like social roles and American photographer Cindy Sherman whose photographs of female mannequins and images of herself as society doyennes heavily masked by makeup wittily probe the role of artifice in social constructions of female identity. American sportswoman and model Aimee Mullins wearing her carbon fiber prosthetic legs and fashions by Alexander McQueen has become her own graceful, artful creation, an elegant contemporary cybernetic female.

These women artists and models have at times taken on the roles of both Pygmalion and Frankenstein, and created their own assemblages to produce lifelike artificial women—echoing an age-old practice where women salvaged pieces of fabric to create new patchwork wholes. My grandmother Tillie, who had come came to America from Lithuania around 1915, pieced together old scraps from worn dresses and turned them into rag rugs—artful scrolls of rolled cloth sewn together to create something new. Mary Shelley in *Frankenstein* had Victor cobble together a creature and his potential Mate from dead body parts, and James Whale in his film *Bride of Frankenstein* did the same, with actress Elsa Lanchester playing both Mary Shelley the novelist and the Bride—a clever conflation of the artificer and the creation. Years later, American artist Shelley Jackson revisited *Frankenstein* by creating a digital female assemblage of parts in her CD-ROM *Patchwork Girl*, where a digital female with an assertive self is fabricated by participants who piece together her story.

Women filmmakers have also revisited the world of the uncanny. In writer and actress Zoe Kazan's 2012 film *Ruby Sparks*, Ruby, like Rachael in *Blade Runner*, makes the painful discovery that, although she looks real, she is just a fictive creature, an artificial fabrication in a digital world. But by the end of the film, this Galatea, who longs for independence, is allowed to abandon her creator and gain the freedom she craves. As created by Kazan, Ruby—who can cook and be sexually available and was the answer to the reclusive Calvin's dreams—turns out to thwart the role of Perfect Woman. Kazan's Ruby, like some of the more memorable artificial women in art, television series, films, and video games since the 1960s, is a virtual female who insists on giving shape to her own identity, a woman with a mind of her own.

In the pages ahead, this book will trace these two parallel stories—both men's Pygmalion-like quest to use the tools of technology to create beautiful artificial females that often mirror men's notions of perfection and women's ability to take on the role of creator to craft their own feisty females and modern-day molls and dolls. Simulated females illuminate the slippery nature of the uncanny and capture how women's cultural identities have undergone remarkable fluidity and change.

1
Simulated Women and the Pygmalion Myth

Men have long been fascinated by the idea of creating a simulated woman that miraculously comes alive, a beautiful facsimile female who is the answer to all their dreams and desires.

The shaping story comes from the myth of Pygmalion as retold by the ancient Roman poet Ovid in *The Metamorphoses*. Pygmalion, a sculptor, was dismissive of women. He was "dismayed by the numerous defects of character Nature had given the feminine spirit" and pledged to remain chaste and not have any relations with them.[1] Instead, he sculpted a beautiful ivory image of a perfect woman, and he fell in love with this simulacra. Ovid tells us that Pygmalion's artistic creation was *superior* to a real woman, for he gave his sculpture "a figure better than any living woman could boast of."[2]

This sculptural lady in the tale is so lifelike that Pygmalion wonders whether she is a mere statue or alive, and he lovingly adorns her with rings, pearl earrings, and a necklace. In his love and longing, he prays to Venus to give him a woman just like his sculpture, and Venus grants his wish by miraculously transforming the ivory woman into a flesh-and-blood female that later became known as Galatea. As Pygmalion lays her down on a bed, kisses her lips, and touches her breasts, the ivory softens like wax and, writes Ovid, "She was alive!"[3]

The outlines of the Pygmalion myth—and the idea of a simulated woman who comes alive—would be echoed over the centuries ahead in cultural images revealing men's enduring fantasy about fabricating an ideal female—a beautiful creature he lovingly clothes and adorns, a woman who is pliant and compliant and answers all his needs, an artificial female that is a superior substitute for the real thing. These simulated women were often shaped not only by men's

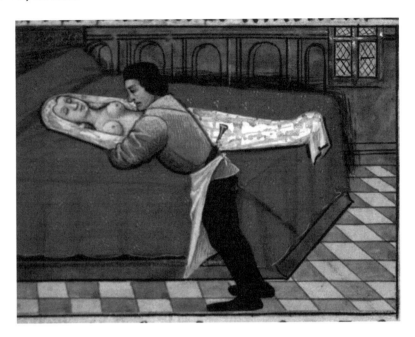

1.1 "Pygmalion Embracing the Image," miniature in the style of Robinet Testard in Guillaume de Lorris and Jean de Meun, *Le Roman de la Rose*, late fifteenth century. The Bodleian Libraries, University of Oxford, MS Douce 195, fol. 151r. Used by permission of the Bodleian Library.

fantasies but also men's beliefs about women themselves—their inherent traits or "nature," their usual behavior, and their proper (culturally assigned) social roles.

The Pygmalion myth, infused with a sense of magic and sensuality, was appealing to artists whose images of Galatea could be spiritual, rapturously worshipful, and also filled with erotic fantasies. Some of the earliest visual images of the Pygmalion myth were miniature paintings or illuminations in medieval and Renaissance editions of the great French poetic narrative *Le Roman de la Rose* (*The Romance of the Rose*) by Guillaume de Lorris and Jean de Meun (ca. 1275–1280). Some contemporaries considered *Le Roman de la Rose* an allegorical poem with thinly disguised sexuality (the rosebud is penetrated), and some contemporaries considered it immodest and an invitation to lust.[4] Medieval illustrations of the poem's section on Pygmalion, often included images of the fabrication process itself, and pictured the sculptor at work, chisel in hand, carving the figure of Galatea. One image attributed to the medieval artist Robinet Testard in a 1480 manuscript edition of the poem also had a decidedly erotic edge: Pygmalion is pictured dressing the sculpture and embracing its nude body as it lies on a bed (fig. 1.1).

The infatuation with the myth continued in later centuries and particularly flourished in eighteenth-century European literature and art. In 1771, Jean-Jacques Rousseau had greatly helped popularize the myth by writing his one-act opera *Pygmalion*—a *scene-lyrique* with musical accompaniment—and his work was one of the first to use the name Galatea for Pygmalion's sculpture; the name didn't appear in Ovid's version of the Pygmalion myth but did appear in his retelling of Acis and Galatea in *Metamorphoses*.[5]

Even before Rousseau, eighteenth-century artists had been captivated by the story and, in particular, the moment of transformation as the sculpture comes alive.[6] Eighteenth-century Venetian artist Sebastiano Ricci in 1717 captured that magical moment when Pygmalion looks on with ecstasy as the sculpture is animated, and in French artist Jean Raoux's painting *Pygmalion,* created the same year, Pygmalion watches in wonderment as the statue's colors change from marble-toned legs to her lively vivid red lips and blond hair. Here, Venus touches her head (the brain in the sixteenth century was considered the seat of the soul) while the god Hymen checks her pulse for life.[7]

One of the more intriguing versions was Louis-Jean-François Lagrenée's 1777 painting *Pigmalion* [sic] *dont Venus animée la statue* (Pygmalion whose statue has been brought to life by Venus), which features images of Venus touching the sculpture and a kneeling Pygmalion feeling for her pulse in her wrist. There are also three cupids, including one carrying a torch with its fire and smoke angling in a diagonal directly toward Galatea's face, as though it too is illuminating and enlivening her (fig. 1.2)—a motif seen in James Whale's campy 1935 film *Bride of Frankenstein* where the fiery zigzag of lightning animates the simulated woman and brings her to life.

Nineteenth-century British Pre-Raphaelite artist Edward Burne-Jones in the fourth of his four-painting series on Pygmalion, *Pygmalion and the Image: The Soul Attains* (1875–1878), pictured Pygmalion kneeling in awe and almost worshipful of his statue, but other nineteenth-century European artists continued to be attracted to the erotic allure of the myth, seen in the sensuous curves of Auguste Rodin's sculpture *Pygmalion and Galatea* (modeled 1889, executed 1906) and artist Jean-Léon Gérôme's high-finish nineteenth-century academic painting *Pygmalion and Galatea* (ca. 1890), which vividly presented the skin tones of the beautiful female sculpture gradually changing from white to pink and Cupid (Eros) speeding the process by shooting an arrow of desire (plate II).[8]

But not all Pygmalion images were this metaphoric, soulful, or serious-minded. Comic artists delighted in picturing their Galateas not as objects of men's desire but as independent, outré women with their own agendas. In his satirical, cheekily pornographic eighteenth-century print *Modern Pygmalion*, British artist Thomas Rowlandson presented the nude Galatea straddling and sexually fondling the reclining Pygmalion, and French artist Honoré Daumier in his comic lithograph *Pygmalion* (1842) lampooned the myth as Galatea impishly reaches down to put a finger in the artist's snuffbox (fig. 1.3).

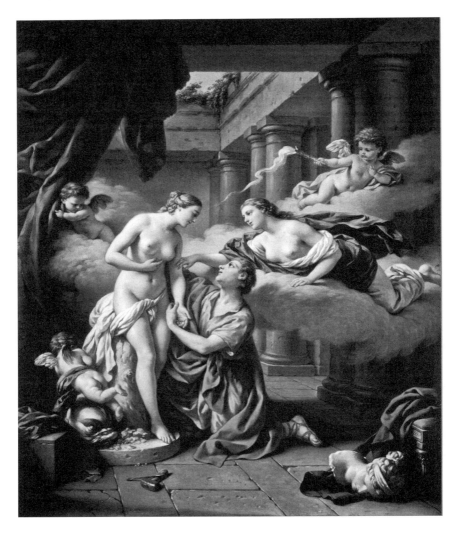

1.2 Louis-Jean- François Lagrenée I, *Pygmalion and His Statue* (*Pygmalion Whose Statue Has Been Brought to Life by Venus*), 1777. Oil on canvas.
Sinebrychoff Art Museum, Finnish National Gallery, Helsinki, Finland/The Bridgeman Art Library.

Writers, too, were captivated by the comic potential of the Pygmalion myth, and George Bernard Shaw's 1912 play *Pygmalion* offers its wittiest treatment. In Ovid's telling of the tale, an artificial woman, a female simulacra, comes to life, but in Shaw's version, Eliza is a modern-day Galatea with a difference: she is a lively, outspoken young woman who resists being transformed into an artificial genteel lady. The feisty Eliza ultimately balks at being a mere doll, a surface simulation, a product of men's technological prowess and ingenuity. She is a far cry from the women in two earlier versions of the Pygmalion myth: Galatea in

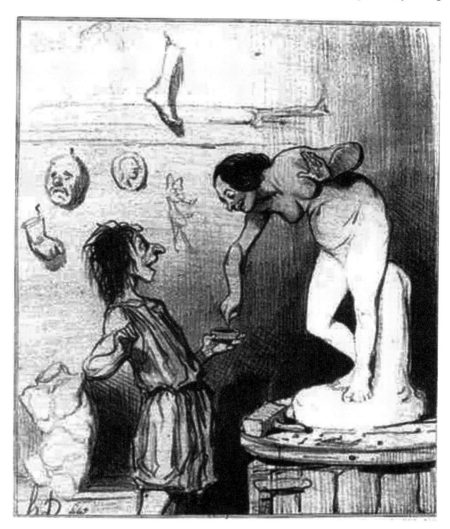

1.3 Honoré Daumier, *Pygmalion*, lithograph from his *Histoire ancienne* series, *Le Charivari*, December 28, 1842. In Daumier's satirical print, Galatea unexpectedly reaches down to put her finger in Pygmalion's snuffbox.

British playwright W. S. Gilbert's nineteenth-century comic drama *Pygmalion and Galatea* (1870) and the mechanical Amelia in E. E. Kellett's story "The Lady Automaton" (1901).

Though very different in conception, these three works of literature present a confluence of two cultural streams: men's age-old fantasies about crafting artificial women and their fascination with mechanical and manufactured reproductions. During the late nineteenth century, new methods of technological reproduction were being developed, including methods for creating sound

reproduction, after Thomas Edison patented his first phonograph in 1877. Manufacturers were also developing new methods for producing industrially made reproductions of works of art, including the use of electrotyping and cast iron to make copies of sculpture, and home furniture as well.

W. S. Gilbert, *Pygmalion and Galatea*

Literary and visual portrayals of the Pygmalion myth are often very much products of their times, especially so in nineteenth- and early twentieth-century British dramas and stories, which were shaped not only by the emerging technological developments in creating simulations and reproductions but also by Victorian and Edwardian conceptions of women and the playwrights' own notions of inherent gender characteristics.

British playwright W. S. Gilbert reinforced Victorian attitudes about women in his comic play *Pygmalion and Galatea*, which was written in blank verse and first presented at Haymarket Theater on December 9, 1871, and one year later, at a theater in New York. His Galatea embodies the innocent, naïve, self-sacrificing female favored in Victorian conceptions of the ideal woman, although at the time the play was written debates were already simmering in England and America about women's social status and roles. Even though middle-class Victorian codes of proper female behavior were still firmly entrenched, particularly conceptions of the "two spheres" where women were assigned the tasks of tending to domestic duties and motherhood at home while men were assigned to the outside world of business and professions, in the 1870s in England social observers saw signs of unrest in the increasingly heated debates in Europe and America about women's access to voting rights, higher education, property rights, and greater employment opportunities.

Gilbert himself—in his immensely popular comic musical operas created in partnership with Arthur Sullivan (he was the librettist, Sullivan the composer)—was ambivalent about the status of women and what was then called the "Woman Question," the issue of women's roles and rights. As Carolyn Williams has suggested, the characters in these jointly created comic operas, which began appearing in 1871, often inhabit and parody "Victorian gender conventions and stereotypes in order to demonstrate their absurdity"—including the cultural insistence that women act with an "exaggerated innocence" and mask their own sexuality—but Gilbert himself was paternalistic toward his female actors, fastidiously insisting that they behave in conformity to strict codes of moralistic behavior in their private lives.[9]

Showing no signs of social flux or parody, Gilbert's *Pygmalion and Galatea*, written before his collaboration with Sullivan, largely embraces the gender conventions of his era and the Victorian notion of female innocence while skirting the issue of sexuality. Pygmalion is a married man living not in Cyprus, but in Athens and whose sculptures of women—though often

commissioned—have faces that resemble his wife Cynisca. Pygmalion considers himself an artist-magician, for he can turn "cold, dull stone" into images of gods and goddesses; as his wife says, he can turn "the senseless marble into life." He creates a sculpture modeled on Cynisca, and the play's complications and crises are set in motion by Cynisca herself: when she leaves on a trip, she reminds Pygmalion to be faithful to her and designates her husband's Galatea sculpture as her proxy while she is gone: if he has thoughts of love, he should tell them to the sculpture.[10]

Paralleling Ovid's myth, while Cynisca is away Pygmalion is discontented because he feels he can create images of gods and goddesses, but this can only go so far. When he prays to the gods asking that his sculpture of the beautiful woman comes to life, to his delight, he suddenly hears the sculpture say his name behind a curtain, and he exclaims, "Ye gods! It lives!" (a sentiment that would also be comically echoed years later in Whale's *Bride of Frankenstein* in the iconic moment when Henry Frankenstein bends over his unbandaged female creation and says with portentousness and mellifluously, "She's alive!").[11]

The play reflects Victorian attitudes toward reproductions and simulations in the arts at the time. The Galatea that Pygmalion creates is a copy of Cynisca, a simulated woman that even Cynisca thinks is better than real. In the 1870s, when the play was written, British manufacturers of decorative wares were busy mass-producing reproductions of domestic silver using the new technological process of electroplating, and manufacturers were also covering buildings with decorative cast-iron building facades that mimicked the look of hand-carved stones. British critics like John Ruskin, however, fretted that the copies were debasements of the much-superior originals, while manufacturers not surprisingly insisted that reproductions were superior to the originals. The play becomes a gloss on creating reproductions, in this case, a lovely Galatea who comes to life from stone.[12]

When she first looks at the sculptural copy of herself, Cynisca views the sculpture as a kind of double—"my other self"—an image she herself considers superior to what she calls the "wife-model." To her, Pygmalion's sculptural copies of her are idealizations. The sculptures have a face younger than her own and are more like her image ten years ago. The copies have "outlines softened, angles smoothed away," and this copy has a "placid brow" and "sweet, sad lips." In Gilbert's play, Galatea in some ways rivals and even surpasses Pygmalion's wife in terms of her sensibilities, her moral vision, and her delicacy of feeling. But when Galatea asks Pygmalion if his wife were as beautiful as she is, he replies that when he sculpted her from marble, he made her lovelier than his wife, and that she indeed has a prototype. Says Galatea with disappointment, "Oh, then I'm not original?"[13]

Gilbert's play is also shaped by Victorian gender stereotypes about the ideal woman. Before she goes away on her trip, Cynisca muses that Pygmalion's most recent sculpture (Galatea) is superior not only because it is lovelier but also

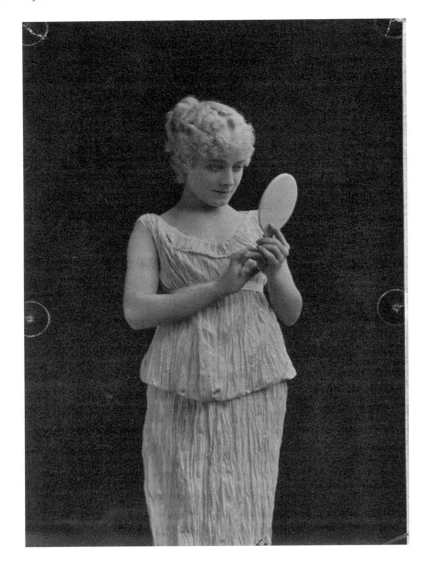

1.4 An 1888 photograph of British-born American actress Julia Marlowe as Galatea gazing at herself in a mirror in a production of W. S. Gilbert's play *Pygmalion and Galatea*.
Billy Rose Theatre Division, The New York Public Library for the Performing Arts, Astor, Lenox and Tilden Foundations.

because it does not have two of women's stereotypical female features: their tendencies to be too emotional and to talk too much. (Years later, in fiction and film, these are two of the very same features men get rid of in their idealized robot women.) Although the real woman Cynisca has vitality—she "laughs and frowns"—Galatea has no emotions. Says Cynisca of the sculpture (in a

voice of resignation, good humor, distress?), "For she is I, yet lovelier than I/And hath no temper, sir, and hath no tongue."[14]

In Gilbert's play, Pygmalion, true to the myth, sees his sculpture Galatea as the ideal woman—she is "perfect in thy loveliness" (fig. 1.4). Her image is shaped by Victorian ideals—which the playwright here embraces—of female purity and perfection, particularly her presumed sexual naïveté and innocence: Pygmalion tells his sister Myrine that Galatea was "born yesterday"—she is "pure and innocent"—and even earlier, that she does not even know she is a woman. Honoring her chastity and avoiding any question of sexual longing, he later tells her that she can love him as a father, and Myrine tells her "he is your father" because he gave her life (Galatea also much later describes herself as "Pygmalion's child").[15]

Essaka Joshua has pointed out that Gilbert's contemporary audiences would have found one part of his play both daring and funny: Galatea's frank expression of her passionate love for the married Pygmalion. When she comes to life she is naïve and innocent, and, as Carolyn Williams has noted, this Galatea has not yet been socialized for she later speaks forthrightly of her sexual desire or "love" for Pygmalion and has not yet learned that a proper Victorian woman would disguise these feelings and embrace the "artificial innocence of Victorian femininity."[16]

The play invokes and confirms conventional gender paradigms about masculinity and femininity. Galatea, with Pygmalion as her model, defines a man as "very tall, and straight, and strong/With big brave eyes," and she also defines a woman as "soft and weak,/And fair, and exquisitely beautiful." Melding Victorian conventions and men's fantasies about the perfect artificial female who is totally within their control and who idolizes them, Galatea also says she's totally subservient to Pygmalion her creator: she has "no thought, no hope, no/enterprise/That does not own thee as its sovereign."[17]

In the play, when Cynisca finally returns home, she is furious when she mistakenly thinks that Pygmalion has been unfaithful and decides to punish him by blinding him. The distraught Pygmalion says he doesn't want to live if his angry wife deserts him.[18] In an era that sentimentalized self-sacrificing women, the facsimile woman Galatea becomes the moral center of the play. In a comic inversion, Myrine suggests that Galatea, who is a simulacra, should now imitate the real-life Cynisca to help save Pygmalion's life and says, "The gods assist thee in this artifice!"[19] The self-sacrificing Galatea agrees to play the role, and in the process the reproduction has something to teach the real-life Cynisca. Posing as Cynisca, Galatea says she forgives Pygmalion and, still in character, asks for Pygmalion's pardon for her blinding him. Cynisca, who was watching unobserved, ultimately learns something from Galatea about compassion and pity. Later, when she embraces her husband, his sight returns. At the end of the play, when Pygmalion, speaking to his wife, disavows ever having loved Galatea, Galatea—reversing the myth—sadly returns to her pedestal and is once again turned to

stone. Playing with paradoxes, in Gilbert's drama the simulated woman—in wanting to save Pygmalion's relationship with his wife—is the most humane. Although Pygmalion, in the end, views his wife as superior to the sculpture, the artificial woman is ultimately the most emotionally authentic and genuine.

E. E. Kellett, "The Lady Automaton"

The Pygmalion myth and the idea of fabricating a mechanical reproduction of a female continued to fascinate writers in the late nineteenth and early twentieth centuries. E. E. (Ernest Edward) Kellett's story, "The Lady Automaton" was published in June 1901 in *Pearson's* magazine—a British periodical of art, politics, and literature, which included science fiction and social commentary, serialized H. G. Wells's novel *War of the Worlds* in 1897, and was published in a New York version as well.[20] In Kellett's story, which some have argued has themes and a plot very similar to Shaw's later play *Pygmalion,* Arthur Moore is a scientist, not a sculptor, who accepts a challenge to produce a counterfeit woman who will fool everyone.

The automaton named Amelia is vastly different from the self-sacrificing, empathetic Galatea in Gilbert's play. She is a cipher, with the same passivity and lack of affect seen in the doll Olympia in E.T.A. Hoffmann's nineteenth-century tale "The Sandman." She is also very much a mechanical creature, a more sophisticated, fanciful version of the mechanical wonders already available at the time. In 1901, when the story was written, Parisian automaton manufacturers had already been producing lifelike clockwork automatons for more than twenty years, which were also being purchased in Europe and America—mechanical females that represented a broad array of types from elegantly dressed members of the upper middle class to scantily clad exotic dancers (see chapter 2).

Like Gilbert's play, Kellett's story is a gloss on both conventional, Victorian social attitudes toward women and technological reproductions. Narrator Dr. Phillips is a physician who describes his friend Arthur Moore as an accomplished inventor who had previously created automatons and now, at age thirty, had a plan to create a type of humanoid, interactive, talking phonograph, which he refers to as an automaton that can engage in conversation. When a person speaks words into this machine, in a short time the machine produces words "constituting the proper answer." The men joke that an irony of the invention is though it records people's words, the words aren't often worth recording: "All of us say many things that will hardly bear repeating." The story is also a thinly veiled satire of women, for the humanoid phonograph that Phillips creates is clearly gendered: with its female voice it becomes a type of Galatea, a creation superior to real women.

Kellett's story, like many other fictional versions of artificial women, is shaped by men's skeptical, stereotyped visions of women themselves. When Phillips first hears the machine's voice, he is startled: "a certain uncanny feeling still

possessing me," but he soon recovers as he banters with Moore about the nature of the machine. Moore sees it as technically and morally superior to women because, as a mechanical recorder, it gives a faithful repetition of words rather than producing the distortions of female gossips. Says the narrator, "What is a phonograph after all but a tattling old woman, repeating whatever it hears—without discrimination or tact?" "Exactly," replies Moore, "but with this difference; that the phonograph repeats what it hears without alteration or addition, whereas the old woman repeats it just as it suits her."[21]

Moore is very much a Pygmalion in an age infatuated with mechanical reproductions and wants to show off his technological prowess by having the female pass for real. For all of his concern with exactitude and creating a faithful reproduction of words, however, he wants to engage in deception; he wishes to use his new phonographic technology to create a female automaton that will be perceived as a society lady. The faux woman will be able not only to walk, eat, turn her head, shut her eyes, but also to hear and speak and do everything but think. More than that, she will pass for one of their social set: She will, says Moore, "behave like a lady, not a lunatic" and "perform the part of a society lady as well as the best bred of them all."

Eighty years before Japanese roboticist Masahiro Mori wrote about the pitfalls of the "uncanny valley"—the disconcerting, illusion-killing moment when an electronic humanoid machine reveals its artificial nature and when an observer realizes a highly realistic-looking robot isn't real—the fictional Phillips, a skeptic, wonders how Moore will make sure that the illusion is flawless, so that when the automaton is given a command like "sit down," she sits down.[22] "Remember," Phillips says, "an error of half a second in your mysterious clockwork may make a difference between your lady occupying a dignified position in a chair and sprawling ungloriously on the floor."[23]

In French writer Villiers de L'Isle-Adam's 1885 novel *L'Ève future* (*Tomorrow's Eve*) about a man who creates a double of a real woman, Alicia Carey is a beautiful but inane doll-like woman incapable of uttering anything more than prosaic thoughts. This derogatory equation of woman with doll was, in part, a reflection of nineteenth-century French cultural conceptions of women. As Elizabeth K. Menon has written, *poupée* (doll) in nineteenth-century France was a slang term used by men to refer to young women of dating age (in the 1860s, *poupée* was also slang for a prostitute), and satirical French writers frequently likened high-fashion women to dolls or *poupées*—empty-headed stylized mannequins parading around in their finery and preoccupied with clothing and makeup. Behind these satires, Menon suggests, were men's fears of increasingly independent women, fears suggested by contemporary caricatures of men as puppets being manipulated by women.[24]

For the men, the synthetic Amelia in many ways mirrors women in their circles. Phillips is a skeptic about the idea of creating an artificial woman, but, as Moore playfully reminds him, Phillips himself actually thinks real society

women are nothing but dolls; he is quoted by the narrator: "'Who was it,' he went on, 'who lectured so vigorously on the folly of certain women of our time, and talked so largely about their utter inanity? "The Society woman of our time," you proclaimed, "what is she but a doll? Her second-hand opinions, so daintily expressed, would not a parrot speak them as well?"'"

One year later, Moore's plan becomes a reality. When Phillips goes to Moore's rooms, "I was ushered into the room by the most beautiful girl I had ever seen; a creature with fair hair, bright eyes, and a doll-like childishness of expression" (fig. 1.5). Again mirroring the men's conception of real women, she is all surface. Says Moore to Phillips, "I wanted the space for other mechanism, so she has to do without a heart altogether. Besides," he added smilingly, "I wanted her to be a Society lady." Still, she has superior looks: "I am determined that she shall be the beauty of the season. She shall eclipse them all! I tell you. What are they but dolls?" As is often the case in men's representations of female automatons, Moore's mechanistic lady, whom he introduces as Miss Amelia Brooke, is conceived of as nonthreatening: she is childlike, naïve, asexual—far safer, in the men's eyes, than real women.

To Moore, his new machine-woman is also superior because, in modern terms, she is much less high maintenance. She is not real; men needn't worry about her sensibilities, her modesty, or her feelings: "You may discuss her as much as you please, and she won't be offended." Given Moore's dim view of women, Amelia also has other merits that women lack: "she is not touchy; but she has a failing the best of them have not; she can't blush. On the whole, however, I prefer her."

Another way she is apparently preferable is that she can be controlled. In the men's eyes, Amelia is very much an Other—a depersonalized object, a machine. To Phillips, she is a spectacle, a circus creature–a being to be looked at and observed; her value lies in her freakishness: "It is uncanny enough, and I can't say I like it, but it will draw. What a pity Barnum has gone! He would have given you a million pounds for it." To Moore, her maker, if she fails to perform her technological and social function, Amelia is worthless and will be destroyed: "She shall walk drawing-rooms like a lady, or I will break her to pieces."

Moore's female automaton has been created to be his obedient servant and is (as so often happens in stories about artificial women) an extension of his narcissistic self. He exclaims, "And she is more than a doll; she is ME. I have breathed into her myself, and she but lives; she understands and knows!" He tells her, "I have made you, and you are mine." He is her master and she obeys: He says "Kiss me," and she kisses him obediently. In fiction and film, inventors of artificial females often ignore the fact that this creature offers no real, personalized affection. Phillips notes dryly that Amelia has the same smile "for prince or peasant, man or maid."

Phillips and Moore take Amelia to a fashionable ball to see if she can pass as a lady, and Phillips presents her as his niece. The ruse is successful, and the

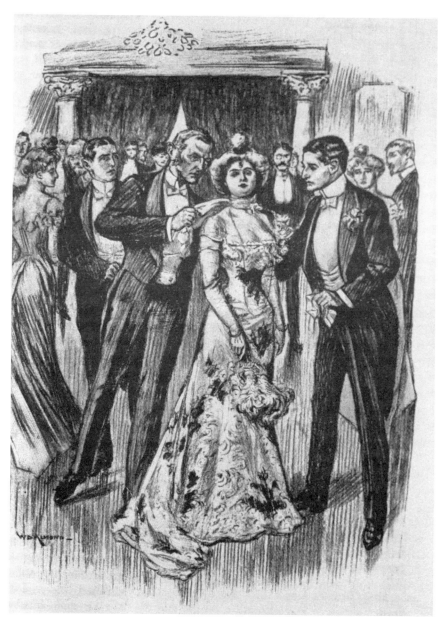

1.5 Amelia being admired by Arthur Moore and Dr. Phillips in E. E. (Ernest Edward) Kellett's story "The Lady Automaton," *Pearson's Magazine*, June 1901.

young man Harry Burton is entranced by her and thinks "she looks like a born queen." In E.T.A. Hoffmann's nineteenth-century story "The Sandman" and other fiction and films about artificial women, it is while dancing with a female automaton that young men fall deeply in love and are entranced and enthralled with the beautiful artificial female. In "Lady Automaton," the smitten young man, Burton, finds Amelia far superior to other women: like Nathanael in "The Sandman," he invests the automaton with deeper, finer feelings: "What are all these painted dolls to her. *They* have nothing to say for themselves, *they* are mere bundles of conventionality, but *she*—she is all soul."

Phillips himself is repelled and loathes this creature for being a mere simulation: "I was almost deceived myself. Could this be after all a real creature of flesh and blood, substituted for the Phantasm? No; that detestable, beautiful smile was there." Watching her from afar, he is critical and aware of her as a rote, technological creature who dances "beautifully but a little mechanically," "saying always the right things, answering questions always in the same way." Evoking the stereotyped nineteenth-century view of women as sickly, neurasthenic creatures, Phillips—with his mocking, misogynistic lens—says to himself, "Good Heavens, this creature never had a cold, never had a headache, never felt out of sorts; yet Moore said he had made a woman."

When Phillips frets that the young man has fallen in love with a falsity, says Moore, evoking Pygmalion, "My dear fellow, what is there so strange in it all? Men have fallen in love with stone-like women before this. Men have given themselves up to heartless and soulless abstractions before this. Anyone who gets my Amelia will get *something* at any rate, not a mere doll."

For all his sardonic bantering about real women, Moore is ambivalent about Amelia as mechanism, and this beautiful creature causes him "considerable uneasiness." "She was a girl of originality—indeed, I venture to think that there has never been a girl quite like her—yet there was a sameness, an artificiality about her which puzzled me and alarmed me." Amelia robotically answers questions with the same programmed answers and the same words: "She uttered her opinions as if they had been learnt verbatim from someone else." But when Amelia responds similarly to the attentions of different men, he sees her less like a machine than a real woman, for she made "a display of fickleness unparalleled in the whole history of womankind."

The lighthearted air of the story takes a darker, melodramatic turn when Amelia seems so real that the men in the story become emotionally attached to her; a crisis occurs when two rivals, Calder and Burton, both fall in love with her and propose marriage, with the weddings to take place on the same day. Moore, meanwhile, had projected so much of himself into his automaton that he had "positively begun to regard her [as] a real living being, in whose veins flowed his own blood, in whose nostrils was his own breath." Phillips, too, comes to see Amelia as real. He wonders, "Could it be that by some unholy [means] Moore had succeeded in conveying some portion of his own life to this creature of his brain?"

By the end of the story, the mechanical Amelia has become an unwitting *femme fatale*: most of the men in love with her are destroyed or distraught. On the day Burton is to be married (Calder had postponed his marriage), the anguished Calder stabs her in the heart, and, as she falls, her head strikes the rails, and "There was a whirr, a rush. The anti-phonograph was broken." Her death breaks Moore, too, and he dies at the scene. At the end, the narrator Phillips is also driven mad, and he describes himself as "no longer a fashionable physician but men around him talk of him as a '*patient*.'"

Although Kellett's story was published in a magazine that relished science fiction and social critiques, the author is clearly ambivalent about the social impact of new technologies. Moore delights in the technological possibility of creating a female simulacra, but the story ruefully acknowledges that the technological feat proves to be the men's undoing. Behind the men's bantering about the doll-like nature and artifice of society women is their ostensible longing for the perfect woman, a woman with "soul" and originality, two qualities that they (unwisely) project onto their automaton. They become alarmed when even Amelia herself seems too artificial and mechanical, but their fixation on believing she is real leads only to death and madness. In Kellett's hands "The Automaton" becomes a type of cautionary tale about belief in artifice—and perhaps, also, a cautionary, Faustian saga about the dangers of stretching the boundaries of science and technology. For the men, their ideal perfect female remains elusive, and the quest itself proves to be their undoing.

George Bernard Shaw, *Pygmalion*

In his own witty reimaging of the ancient myth, George Bernard Shaw in *Pygmalion* invested the story with many of the key features in tales about Pygmalion-type men creating artificial women, yet his Galatea, Eliza with her feistiness, is very different from the automaton Amelia in Kellett's story and the pliant Galatea in Gilbert's play. Shaw's play emerged in a period that had already witnessed important social advances for women in the realm of property rights and education. By the 1890s, the British Parliament had passed a series of Married Women Property Rights Acts, and women in England and America were intensifying their campaigns for suffrage (Shaw himself showed his support for women's suffrage in several essays and appeared as a speaker when the Women's Social and Political Union was founded by Emmeline Pankhurst in 1903).

Also by the 1890s, increasing numbers of women were self-supporting as they worked in factories and used typewriters in offices, and newly developed safety bicycles were available for women to ride, giving women a heightened sense of independence and freedom. A small but significant number of women—lampooned and caricatured as "New Women" in the press—flouted propriety, with a few daringly dressing in men's clothes and smoking cigarettes in public. Many of these women, educated and intelligent, joyfully countered the

conventions of Victorian women in Britain and Gilded Age women in America, those who observed social proprieties and wouldn't dream of going off on their own.[25] In another sign of changing times, some women were also driving electric automobiles, and in 1912, the year of Shaw's play, the introduction of the self-starter made it easier for women to drive combustion-engine automobiles, which, because of their unwieldy cranking mechanisms, had long been considered the province of men.[26]

The assertive Eliza in Shaw's plays is a remarkably independent woman whose characterization by Shaw emerges in the midst of these social and technological changes. She is transformed into an artificial woman, a genteel lady, with the help not of divine intervention but modern-day technology, a gramophone. This Galatea, however, ultimately strips off the artifice and asserts her authentic self. Unlike Gilbert's Galatea, she won't become immobilized by going back on her pedestal, but she will instead confidently leave her creator and go her own way.

In the play, Shaw presents Henry Higgins as a modern-day Pygmalion—a linguist described by Shaw as an energetic "scientific type" who, like his ancient counterpart Pygmalion, is similarly wary of women. He tells his mother, "I shall never get in the way of seriously liking young women," adding ungraciously, "Besides, theyre all idiots." Earlier, he had said to Pickering, "I find that the moment I let a woman make friends with me, she becomes jealous, exacting, suspicious, and a damned nuisance." Higgins is clearly a man of arrested development, a man whose ideal woman is patterned after his own mother. As he tells her, "My idea of a loveable woman is somebody as like you as possible," and she laments that he never falls in love with women under the age of forty-five.[27]

After meeting the Cockney-speaking flower-seller Eliza Doolittle near Covent Garden and taking notes on her speech (the onlookers include the wealthy young Freddy Eynsford-Hill, who later becomes enamored of Eliza and marries her), Higgins makes a wager with Colonel Pickering that he can, with Pickering's help, transform Eliza with her thick, sharply inflected almost unintelligible Cockney accent into an elegantly attired woman who can pass for a well-bred lady of gentility. Says Higgins to Pickering, "I shall make a duchess of this draggletailed guttersnipe."[28]

Higgins tells Eliza, "I will make a lady of you," and he sees surface changes—cultivated speech and manners, cleanliness, and elegant attire—as the keys to her transformation. The new Eliza will resemble what British society of the period would deem a perfect, genteel Edwardian woman—elegant, well-mannered, well-spoken, and restrained in thought and feeling. To keep the normally voluble and outspoken Eliza from venting her feelings and views, Higgins limits her to speaking about a small range of topics, including the weather. In the process, her personality seems to be—at least momentarily—squelched and replaced by a calm, well-mannered female with careful, deliberate speech. She is in effect an automaton, an artificial woman who resembles a living creature and whose vitality—however muted—is an imitation, mechanistically produced

Eighteenth-century automaton makers relied on precise clockwork mechanisms to create artificial females that looked lifelike, but in Shaw's play, Eliza's transformation is produced through her own efforts (never really acknowledged by Higgins), Higgins's teaching, and his use of a laryngoscope. She is also very much a product of a mechanical technology for sound reproduction: a wax-cylinder phonograph. Says Pickering excitedly, "We keep records of every stage—dozens of gramophone disks and photographs."[29]

In tales about men creating artificial women, the men often objectify the women and develop a fetishistic interest in clothing them, as though they were dolls or mannequins. During the process of turning Eliza into a lady, the two men have fun not only teaching her but deciding on her clothes to make sure she is attired properly (Henry's mother, Mrs. Higgins, pointedly tells her son and Pickering, "You certainly are a pretty pair of babies, playing with your live doll").[30] The play highlights Higgins's objectification of Eliza: says Higgins contemplating her, "She's so deliciously low!—so horribly dirty," and he tells his housekeeper Mrs. Pearce to clean her, take off Eliza's clothes, and burn them (though Eliza protests indignantly, "Youre no gentleman, youre not to talk of such things. I'm a good girl I am)." When Eliza emerges from her bath, after howling and screaming, Shaw in his stage directions describes her as looking like "*a dainty and exquisitely clean young Japanese lady in a simple blue cotton kimono printed cunningly with small white jasmine blossoms.*"[31]

In the 1938 film version of the play, adapted by Shaw and starring Leslie Howard as Higgins and Wendy Hiller as Eliza, when Eliza emerges from her bath Henry has her dressed in clothes he brought back not from Japan but from China, and she has become like a China doll in her silken robe. As part of her transformation, her toenails are painted, and she's given a facial mud mask. Soon, transforming her still further, Henry teaches her how to dance, and in a pivotal scene she dances with him elegantly. In the play, for the ultimate test of Eliza's transformation at the embassy reception she is dressed to mimic the facade, the surface appearance and social signifiers of an upper-class lady (fig. 1.6). Wearing an opera cloak and evening dress and carrying a fan and flowers, she successfully passes as aristocracy at the London reception that she attends with the men. In the play, Shaw has fun twitting the social restrictions and superficiality of being an Edwardian lady, which fundamentally turn women into living dolls: in a paradoxical inversion, the usually lively Eliza becomes a simulacra of a "lady" cloaked in the appearance of gentility; if Galatea is freed from the stasis of sculpture, Eliza is in effect turned to stone. (In the film version, the duchess at the embassy reception remarks that Eliza has a remote, "faraway look.")

Eliza is, after all their efforts, a reluctant Galatea. In the Pygmalion myth, Galatea is a beautiful female simulacra that comes to life, but in Shaw's play Higgins and Pickering, in effect, want to turn the living, vital Eliza into someone stationary, a lively woman made stiff and artificial with her newly learned

1.6 Margot Kidder as the flower girl Eliza Doolittle and the transformed Eliza in a 1983 television production of George Bernard Shaw's play *Pygmalion*.

control of movements and speech. Henri Bergson wrote in *Le Rire* (*Laughter*) that there is something inherently comical about trying to put a veneer of the mechanical on a living human being, which is precisely what Higgins tries to do with Eliza in Shaw's play—though Higgins's efforts have a certain poignance as Eliza resists. For all their efforts to contain Eliza, the men find her to be a spirited woman who resists immobility.

After the reception, Eliza listens indignantly as the men congratulate themselves on her success, neither praising her nor considering her future and what will become of her now. The men might have fun considering what clothes Eliza should wear, but it is Eliza who disassembles her own constructed being. Stripping herself of her finery and the pretense, she changes her clothes and leaves the house, heading off alone. Meanwhile, Henry himself proves to be a finicky Pygmalion. Although he had been happy that his Galatea had passed the "lady" test, he later rejects her new fabricated persona. At Mrs. Higgins's home where Eliza had gone, she is formal when she meets him, but he now rejects her artifice and her new guise, telling her, "Dont you dare try this game on me." Again taking sole credit for her transformation, he roundly rejects the Galatea that he feels he has created, adding dismissively, "Let her speak for herself. You will jolly soon see whether she has an idea that I haven't put into her head or a word I haven't put into her mouth. I tell you I have created this thing out of the squashed cabbage leaves of Covent Garden and now she pretends to play the fine lady with me."[32]

Although Henry Higgins takes credit for transforming Eliza into a well-functioning automaton, both the play and the 1938 film foreground

a fundamental paradox: It is Henry who is robotic, and Eliza who has real feelings. In the play, she tells Henry, "youve no feeling heart in you" and insists defiantly about herself, "I got my feelings same as anyone else." Early in the play, Eliza had protested when Henry first took notes about her, "He's no right to take away my character. My character is the same to me as any lady's," and throughout the play she has an inner sense of self that resists being transformed. She insists on asserting her own character and integrity. Near the play's end, she rejects the whole idea of artifice and Pygmalion-like transformation itself: she tells Higgins, "I never thought of us making anything of one another; and you never think of anything else. I only want to be natural."[33]

Ultimately, Eliza proves to be an unhappy Galatea and feels that her lively being has in effect been imprisoned and her spirit has been immobilized by her new role: "Why did you take my independence from me?" she asks the men. "I'm a slave now, for all my fine clothes."[34] This Galatea, however, has a mind of her own. Near the end of the play, she rejects being a valet or servant—she curtly tells the hapless Higgins what his proper size gloves are, what cheese to buy—and then leaves, saying, "Then I shall not see you again, Professor." (Eliza, Shaw tells us, marries Freddy, but the film version features a significantly different ending: she seems to have left Freddy and comes back to Higgins that night.)

In Shaw's play, the "guttersnipe" Eliza may successfully come to life as Galatea, but her Pygmalion, Henry Higgins, is far from the man of myth. He lacks the capacity to fall in love or even express many feelings. In the postscript following the play, Shaw says, "Galatea never does like Pygmalion: his relation to her is too god-like to be altogether agreeable." (If being emotionally detached means being "god-like" to Shaw, than indeed Higgins is.)[35]

Technology figured importantly in the temporary creation of the new Eliza, and at the end technology figures again in her reinvention. During the play, Higgins's mother worries about what would become of her, but in Shaw's postscript we find that she will pragmatically marry Freddy, open her own flower store, and that she and Freddy take a course in a different type of technology: typing. The typewriter—the mechanical recorder of words—will replace the phonograph in her emerging new life. But in the 1938 film, before Eliza returns to him in an ambiguously happy ending, Higgins sadly listens to the remnants of the old synthetic Eliza as reproduced on the machine. After the real woman Eliza drives off with Freddy, he takes solace in listening to all that he has left of her, a gramophone recording of his simulated woman learning to speak properly. For Henry during these few moments, the simulated has poignantly displaced the real.

In the play and the film, the changes in Eliza's speech—her pronunciation and vocabulary and even the phrases she utters—were central to her transformation, and she became, in effect, a well-spoken doll. During the nineteenth-century, fiction writers and inventors had become fascinated by the idea of creating speaking and walking mechanical female dolls, the latest version of artificial

females in the age of new technologies. In Villiers de L'Isle-Adam's *L'Ève future*, Hadaly—the beautiful artificial woman created, in part, by a fictional Thomas Edison—speaks words derived from her embedded phonographic disks. In 1890, the real Thomas Edison manufactured phonographic dolls at his West Orange, New Jersey, factory (fig. 1.7). The dolls had German ceramic bisque heads, jointed limbs, and steel torsos that housed miniaturized phonographs playing wax cylinders (the dolls were prone to breakage). When a string was pulled, the dolls uttered words, including nursery rhymes like "Mary Had a Little Lamb," which had been recorded earlier on the embedded wax cylinders by women working at Edison's plant (the women's constant repetitions of the nursery rhymes became a form of automated response in itself).

Eliza, however, has none of the fragile doll in her, and, though her enunciation and vocabulary may have changed, there is nothing rote about her feelings and thoughts. No self-sacrificing emblem of purity and innocent womanhood

1.7 Phonographic doll manufactured at Thomas Edison's West Orange, New Jersey factory, 1890. *Scientific American*, April 29, 1890.

as was Galatea in Gibson's play, Eliza is a woman who tests the era's restrictive, circumscribed conceptions of femininity and women's appropriate behavior and roles. Ultimately, Shaw's play not only comically riffs on the uses and misuses of technology but also delights in a broader theme of Pygmalion myth: the lively dance between artifice and authenticity, a theme that weaves its way throughout the many literary, visual, and cinematic modes of artificial women who come alive. Eliza as female simulacra of a British lady is, to Higgins and Pickering, an ingenious feat for which they can take sole credit, a marvelous creature they admire dispassionately as a masterpiece of ingenuity. As bachelors, they have no interest in or longing for the perfect woman; they simply want to engage in being masterful technicians or magicians who can successfully produce an illusion of the real. Ultimately, of course, in this comic version of the Pygmalion story, the joke will be on hapless Higgins who is not driven to madness, just irritation and perplexity, when Eliza proves to be not a marvel of artifice but the essence of authenticity.

Kennie McDowd, "The Marble Virgin"

The Pygmalion myth remained a potent fantasy in stories where young men fantasize about using their skills in science and technology to create a perfect simulated woman, a female that they envision as innocent and virginal yet will be an answer to all their needs. In these fantasies of the ideal, these simulated women they create are invariably safe ones who shower them with love and affection and ask nothing in return. Kennie McDowd's pulp fiction story, "The Marble Virgin," published in 1929 in the American science fiction magazine *Science Wonder Stories*, went further than previous versions in endowing the artificial female with a distinctly erotic edge. This Galatea, here named Naomi, is made by the twenty-eight-year-old Wallace Land who sculpts a marble statue of a beautiful nude woman—a sculpture he envisions as a "maiden on the verge of womanhood," a female "flawless, perfect" and "a virgin like unto Eve herself."[36]

Professor Carl Huxhold, Land's apartment neighbor who Land considers insane, asks him, "Wouldn't it be great, Land, if the marble could be brought to life" and offers him a way to make his wish come true. The story's resident mad scientist, Huxhold is a diabolical figure who has created an "electron-dissolver" that splits atoms, can make animals dissolve and disappear, and can make the marble sculpture come alive. He demonstrates the machine by placing a dog in his wooden cabinet, which looks like a 1920s radio on legs, and the dog disappears (Huxhold even thinks the electron-dissolver can supplant an electric chair by making criminals disappear).

After Huxhold convinces Land to place his sculpture inside the cabinet, what had been "cold marble" turns into a beautiful woman whose white skin turns into a "wave of pink" that "flooded her breast and climbed into her face." When she comes to life, her fingers wriggle, her arms begin to move, and her foot lifts

(forty years later, in the 1986 remake of Rod Serling's television series *Twilight Zone* episode "The After Hours," Marsha White is horrified when her own leg transforms back into being that of an immobile mannequin).

Though there was scant sexuality in Gilbert's, Shaw's, and Kellett's Pygmalions, Land, who is ever a gentleman, hurriedly covers the naked and innocently sensual Naomi with his coat, especially after Huxhold eyes her with an "unholy desire." Two weeks later, Naomi is "a girl, a young woman" who doesn't know the meaning of clothes, runs around the room naked "like a Sappho" and is still speechless except for uttering "Oooo!" so that no conversation is possible. True to male fantasies, she says little but is effusive in her affection. More than once, Land writes rhapsodically how Naomi covers him with her "soft, fragrant kisses." Soon, she does learn to speak, but the few words she utters are "Wally" and "I love you."

In men's stories about artificial women, not only is clothing them an important ritual but also the men involved often like to feel they are cloaking an innocent creature who has no idea that her nudity is unseemly. But Land's description of what Naomi wears after eight days has the unmistakable erotic appeal of male fantasy: she is dressed in a "sheer French voile dress, silk stockings, black kid pumps," and she puts a rose in her hair. Even though she wears simple, Greek-inspired clothes, her knee-length gray chiffon robe is transparent. Land educates her, takes her outside to admire birds and flowers, and likens her to an exotic creature, a "savage" like a woman from South America, an Indian who has no concept of clothes, a "lovely princess of some far earlier period." As happens so often in tales about a constructed woman, her creator not only assembles her but also causes her to disintegrate and fall apart. Intent on revenge, Huxhold later seizes Naomi and places her in his electron-dissolver so that she disappears, but for Land the perfect woman once again remains an elusive dream. At the end of the tale, the distraught Land has murdered Huxhold and will soon put himself in the cabinet so he can be dissolved and reunited with Naomi in her mysterious, vaporous world.

The outlines of the Pygmalion story and the longing for idealized synthetic females would play out in the years ahead, modifying as technologies changed. Eighty years after "The Marble Virgin," in an era of ever more sophisticated electronics, the fantasy females Amelia and Naomi became Samantha, the empathetic warm-voiced computer operating system in Spike Jonze's mesmerizing film *Her* (2013), offering words of comfort and virtual orgasms to the lonely Theodore. As with "The Marble Virgin," there is dissolution at the end as Samatha has to go, leaving only snowflakes and motes of dust in the air. Fictional Galateas might vaporize, but in the wide arc of history, the quest to engineer real-life synthetic Galateas, as we will see, went ahead on its own parallel track.

2

Mechanical Galateas

Female Automatons and Dolls

E. E. Kellett's story "The Lady Automaton" (1901) is a fantasy tale about men who use science and technology to create an artificial female that seems alive. The beautiful automaton Amelia fits the men's notion of the perfect Edwardian-era lady: an elegant woman who behaves properly, says nothing inflammatory or irritating (actually says nothing at all), and mercifully—to the men at least—shows no signs of having a mind of her own. Amelia was a fictional character, but in 1900, just a year before Kellett's story, the Parisian automaton manufacturer Phalibois had introduced its factory-made "Gavrochinette," a mechanical lady far different from Amelia and one that upended social proprieties with her air of insouciance and her saucy stance.

Wearing a dress and sporting a beret jauntily on her head, Gavrochinette stood confidently with her hands on her hips and her legs apart; on her base a small brass plaque, in French, read, "Put a fifty-centime piece in the slot, and Gavrochinette will whistle you a tune." Winking and rounding her lips, the spring-driven clockwork creature not only whistled (the sound actually made by a flute) but also sang six different melodies, including one signifying her own modernity as a woman using a new transportation machine: the tune of "Bicycle Built for Two" (fig. 2.1).

Gavrochinette was also the name of a real-life French entertainer in Paris who performed at cabarets like the Moulin Rouge and was pictured in photographs and sheet music wearing men's clothes, with a hat perched on the back of her head. Flaunting convention, in one photo she wears a man's jacket with knickers

2.1 "Gavrochinette," manufactured by Phalibois in Paris, ca. 1900. This insouciant coin-operated automaton whistled a tune and sang six different melodies.
Nouveau Musée National de Monaco. Illustration in André Soriano, *The Mechanical Dolls of Monte Carlo*, trans. John Ottaway, texts by Antoine Battaini and Annette Bordeau (Editions Andre Sauret, Monte-Carlo and the National Museum of Monaco, American ed. New York: Rizzoli,1985), 40.

and pink satin bejeweled shoes and has a camera hanging from a strap over her shoulder (an emblem of her modernity) and a monocle in her eye (fig. 2.2).

Amelia and the Phalibois Gavrochinette represented two very different types of European women at the dawn of a new century—the fashionably dressed,

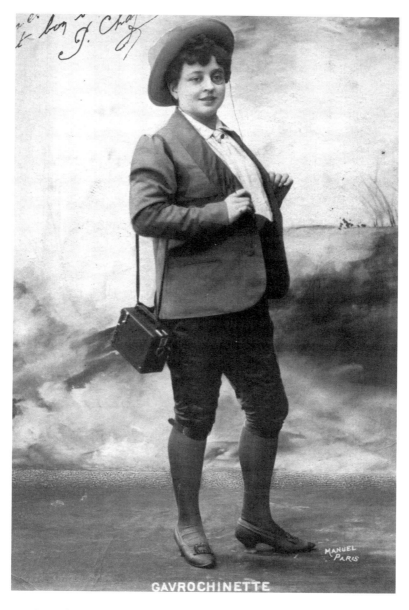

2.2 Gavrochinette, who wore men's clothes and a man's hat jauntily on her head, was a real-life popular entertainer in Parisian caberets like the Moulin Rouge. Carrying a camera signified her modernity. Collection of the author.

well-behaved woman of the men's social set and a version of the "New Woman" with her air of nonconformity and independence. The mechanical females that seemed to magically come alive were actually part of a long technological history of articulated dolls and mechanical automatons or self-moving, mechanical humanoid figures—figures that were shaped by cultural conceptions of femininity and women's social roles.

In ancient Greece and Rome, small female figures made of clay, ivory, and even bone had articulated hands and legs fastened using pins or wire so they that they could look animated when shaken or moved. In Greece, the figures were often too fragile to be toys; instead they were used as votives or offerings to the gods placed in household shrines, temples, burial sites, and graves where they could also be protective devices or prized possessions of the deceased. Young girls offered the doll figures to Apollo, Artemis, and Aphrodite before their marriages to ensure that they would attain a healthy, functioning female body that produced and nourished children, the ideal of ancient Greek femininity.[1]

The idea of automatons—self-moving female and male figures—had been around since ancient times.[2] The ancient Egyptians produced animated, hot air-driven statues used for religious and political purposes, and in Greece some of the oldest female figures were described in Homer's epic poem *The Iliad* where Hephaestus, the blacksmith of the gods (later called Vulcan by the Romans) is helped by two maidservants as he goes about making a shield for Achilles. In Homer's ancient Greece, women (apart from the great goddesses like Aphrodite and Athena) were largely consigned to loom and family, but Homer's description of these metallic ladies as accomplished, smart, and strong has a surprisingly modern ring: they are

> all cast in was gold but a match for living breathing girls.
> Intelligence fills their hearts, voice, and strength their frames,
> From the deathless gods they've learned their works of hand.[3]

Writing about pneumatic and hydraulic devices, Philo (also known as Philon) of Byzantium (280–220 B.C.E.) described a mechanical woman who could pour wine into a cup. But mechanical servants were not necessarily female, and, almost a thousand years later, the medieval Mesopotamian engineer and mathematician al-Jazari (1136–1206 C.E.) in his treatise *The Book of Knowledge of Ingenious Mechanical Devices* envisioned proto-robotic wine servers as female or male. One of these was a girl who periodically emerged from a cupboard holding a glass of wine.[4] In this ingenious device, when wine was poured into a chamber it passed into a glass, and then the mechanical female figure rolled down a chute and served the wine in a cup to the king. She even held a small napkin for the king to wipe his mouth.[5] Another al-Jazari illustration pictured a woman engaged in another service role as she filled a basin with water for washing.

In Jean-Jacques Rousseau's eighteenth-century lyric drama *Pygmalion*, Galatea comes alive without any divine intervention, but during that same century skilled artisans and clockmakers used mechanics to make their automatons look like they had come alive. In eighteenth-century France and Switzerland—reflecting the widespread fascination with clockwork mechanisms and the impact of the French *philosophes* who envisioned the human body as a well-functioning machine—there was a flowering of mechanical automatons, made famous by the mechanical duck created by innovative French inventor Jacques de Vaucanson. Clockmakers produced extraordinarily complex and impressive versions of both male and female automatons made for members of the aristocracy and royalty. Seen by a wider audience in traveling public exhibitions, these automatons catered to the tastes and expectations of their owners and audiences and presented female figures at their elegant best.[6]

In an era when accomplished European women entertained groups with their musical skills, in 1784 Peter Kintzing, a watchmaker, and David Roentgen, a cabinet maker for Queen Marie-Antoinette, created an ingenious female automaton dressed in embroidered silk for the queen, which played a miniature dulcimer in the shape of a harpsichord by hitting forty-six strings with two little flat metal hammers, producing eight different melodies including "Armide" by Gluck.

One of the most impressive and elaborate of the eighteenth-century female automatons was a Lady Musician crafted in La Chaux-de-Fonds, an important center of the Swiss clock industry, by the master Swiss clockmakers Pierre Jaquet-Droz and his son Henri-Louis Jaquet-Droz, aided by the skilled technician Jean-Frédéric Leschot in 1773 (plate III). The two men also produced a boy draftsman who "drew" programmed sketches of the king and queen and a boy writer, and these automatons, which entranced and amazed viewers, were exhibited in the capitals and courts of Europe.[7]

The Lady Musician, though, was an extraordinary female automaton even in this inventive era. She played an instrument that looked like a clavecin but was actually an organ with bellows that pumped air into the pipes, and the musical compositions were probably by the son, Henri-Louis. Remarkably, the Lady Musician's fingers really played the keys (unlike other automatons in which the fingers simply follow the keys and the instrument does the playing itself).[8] To eighteenth-century audiences, this remarkable lady looked amazing lifelike because her mechanism was hidden from view, and even today, when her key is wound, her performance is eerie and astonishing. Aided by bellows, her chest rose and fell, imitating breathing, and levers made her body move and animated her head, which turned from side to side while she played. She cast her eyes down and looked up, and, at the end of a melody, she took a little bow.[9] (A second lady automaton created by the three men was admiringly, and maybe provocatively, described as "a vestal virgin with a heart of steel" in a British advertising poster.)[10]

The Lady Musician was fascinatingly lifelike but sat firmly on her stool. Craftsmen, though, also continued to develop automatons that looked like they

walked. The clockwork movement was produced using hidden wheels rather than legs, as with Gianello della Torre's earlier lute-playing female. (Adapting Western clockwork mechanisms, craftsmen in eighteenth-century Japan during the Edo period also produced moving kakuri or mechanical dolls—tea servers, including female servers looked like they were walking as moved their legs and glided forward.)[11]

One mechanical walking doll captured not only the public's attention in Europe but also the attention of eighteenth-century artists: it was called Mademoiselle Catherina or "La Charmante Catin" (The Charming Doll) in France and England. In an etching based on a drawing by Edmé Bouchardon (1737), a young woman sits kneeling on the ground as she intently watches the walking or at least forward-moving doll, and in another version by eighteenth-century French artist Charles-Nicholas Cochin the younger and engraved by Louise-Madeleine Cochin, a crowded group of people gather in a salon lit by candles on the floor as they are transfixed by the fashionably dressed walking doll, and a young woman has her arms stretched out in amazement.[12] A third print reached a much wider audience in England and America: an etching titled "Mademoiselle Catherina," created in 1750 and published by Robert Sayer, was reprinted in British magazines and could even be seen much later by American readers when it was published in *Scribner's Magazine* in 1889. Here, two ladies, a gentleman, and a serving maid watch as a ragged young man entertains them on a terrace by demonstrating the walking doll while another man plays the hurdy-gurdy (fig. 2.3).[13]

2.3 *Mademoiselle Catherina*. From an original painting in Vauxhall Garden. Etching/engraving by Robert Sayer, ca. 1750.
Courtesy of the Louis Walpole Library, Yale University, New Haven, CT.

Though eighteenth-century craftsmen and artists depicted the mechanical automaton or doll as a marvel, European satirists saw nothing amusing about fashionable real-life women in eighteenth-century Europe who seemed to have turned themselves into mechanical-looking dolls and a version of artificial life. Jean Starbinski and Julie Park have argued that, during the second half of the eighteenth century in Europe, there was a fascination with dolls, puppets, and automatons, and during this period elegantly dressed women "fashioned themselves as dolls" and became the target of men's jaundiced eyes.[14] While eighteenth-century wealthy women may have been modeling themselves on dolls, however, what perhaps played a more central role in their doll-like look and stiff movements was the very nature of their exaggerated fashions, which virtually required them to walk like automatons. To support the wide, heavy, multilayered skirts of their dresses, these fashion-minded women wore highly structured undergarments—often small boxes, one on each side—made of whalebone or wood, a version of the undergarments that had earlier been called farthingales or vertingales in Renaissance Europe and panniers in the eighteenth century.[15]

Evoking the artificial world of Venice in the eighteenth century, Italian director Federico Fellini in his 1976 film, *Fellini's Casanova*, created evocative scenes of the notorious lover Casanova dancing with Rosalba, a beautiful life-sized mechanical moving doll wearing an elaborate farthingale, a stiff female creature that he lovingly lays on his bed (fig. 2.4). In the film, the doll poignantly becomes a fitting partner for a man who carried around his own bird automaton and engaged in his own obsessive, mechanistic erotic escapades. He is a man living in the world of eighteenth-century Venice, a city filled with artifice and masks and whirling

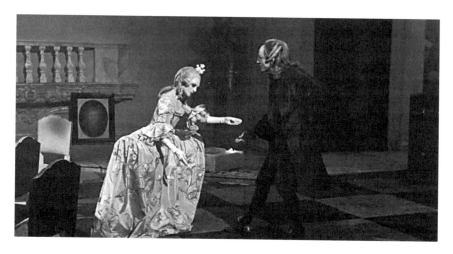

2.4 Casanova dancing with the beautiful doll Rosalba in Federico Fellini's 1976 film *Fellini's Casanova*.
PHOTOFEST

couples dancing at masquerade balls. Years later, as an old man in Württemberg, he still clings to his memory of dancing with the captivating doll.[16]

The fascination with creating realistic-looking mechanical female automatons gained momentum in the nineteenth century. Mademoiselle Catherina continued to have an appeal. An actual wooden moving doll (ca. 1824) was housed in a wooden cabinet and labeled "Mademoiselle Catherina." Ornamented with hand-painted hair, the doll had metal lower arms, a fusee mechanism inside the skirt, and a three-wheel base, which allowed it to glide forward and move in a circular movement.

In a story published in the American magazine *The Atlantic Monthly* in 1861, however, the narrator finds an actual girl rather than the Catherina doll had a greater appeal. In "The Man Who Never Was Young," the male narrator tells how he had been ordered by a physician to take recreation so he took a journey to Alps in the region of southeastern France, western Switzerland, and northwest Italy where he came across a group of strolling Savoyards "with a species of puppet or marionette called by these people 'Mademoiselle Catherina." One of the Savoyards, a man aided by his wife, set Catherina in motion as he accompanied her dance with a song of his own while a young girl of fourteen or fifteen asked for money. The narrator found the flesh-and-blood female more fascinating, for, as he wrote, he was "enchanted by this real girl."[17]

Mechanized female simulacra, though, continued to have great allure in the nineteenth century, particularly as the manufacture of mechanical automatons became industrialized. During the last decades of the century the ways in which mechanical automatons and dolls were designed and manufactured changed dramatically so that they were not only more widely available but also seemed more lifelike. There were automatons manufactured in Paris in the 1860s, but, starting around the 1880s, Parisian manufacturers, including Vichy, Roullet & Decamps, Phalibois, and Lambert, stepped up their production and, with improved techniques, produced a greater variety and number of lifelike female and male automatons and also introduced mechanical walking dolls—all artful products of the industrial age.

With their intricate hidden clockwork mechanisms, moving bodies, and bisque heads with glass and sometimes fluttering eyes, the automatons and dolls evoked a sense of wonder and magic as they seemed to come alive. Eighteenth-century European automatons were highly intricate, hand-crafted, one-of-a-kind creations produced by skilled clockmakers for a small number of wealthy owners, but, as the manufacture of automatons became industrialized in the nineteenth century, the automatons were more easily and efficiently produced by skilled French artisans in workshops. These artisans used machines for cutting several parts at once and for turning drilling, and moulding—mechanization that saved time and reduced costs. Instead of producing beautifully made and finely finished interior mechanisms, manufacturers changed their focus and worked on making the automatons move more naturalistically.[18]

The female figures reflected not only remarkable technological advances of the times but also dramatic shifts in the way that female automatons were portrayed during a time of transition when cultural perceptions of women were changing in nineteenth-century Europe and America. With improved production methods, manufacturers were able to produce a much wider array of female models that ranged between the conventional and the outré.[19] The majority of the automatons represented women in their familiar guise as mothers, seamstresses, and fashionable members of the haute-bourgeoisie, but some were more provocative, presenting undulating exotic females for amusement and entertainment. A small number also gave hints of women's efforts at gaining equal rights and improving their status in society.

Many of the new Parisian automatons, because they were delicate, costly, and breakable, were designed as elaborate showpieces for wealthy and middle-class adults who could afford them; they were sometimes used as ornaments in sitting-rooms and offered amusing demonstrations for guests (though smaller mechanical versions were available as toys for children).[20] The new factory-mades were not only marketed and used for display by the wealthy middle class in France and England, but French-made automatons were also available in America by the 1880s.[21]

With this market in mind, the automatons most often presented women in familiar, domestic roles: cradling babies, working at spinning wheels, knitting, ironing, washing clothes and there was even a young girl holding her own simulacra, a baby doll.[22] Here, too, were female automatons dressed in fashionable Parisian finery and women at their toilette, like a pretty 1890 Roullet & Decamps automaton seen primping in front of her boudoir mirror, powder-puff in hand. Satirizing French social manners, a Vichy female automaton of the period powders her nose, "unaware," wrote an observer, "of a large monkey dressed as a fop, who is ogling her."[23]

The female automatons were usually younger women, but manufacturers also occasionally produced representations of older women, including a remarkable elderly lady, perhaps created by a French or British artisan, whose bent figure walked forward with a cane. Sometimes known as "Mother Shipton," and its French name *feé Carabosse*, the glittering metallic automaton was a jewel of a mechanism, and its glowing figure was made of chased and engraved gilt copper repoussée (fig. 2.5). Although this automaton's unusual representation of an aged woman seemed like a sympathetic social portrait, it may have embodied an ancient fearsome female paradigm: the woman as witch. The English name "Mother Shipton" referred to Ursula Southeil (ca. 1488–1561), a reportedly ugly prophetess born in a cave, and the French name *la feé Carabosse* suggested the evil female character in Charles Perrault's and the Brothers Grimm fairy tale of Sleeping Beauty.[24] Nineteenth-century mechanical women in various forms were also shaped by other female stereotypes including nagging wives and vain creatures. A clock from the Black Forest in Germany featured a stout woman

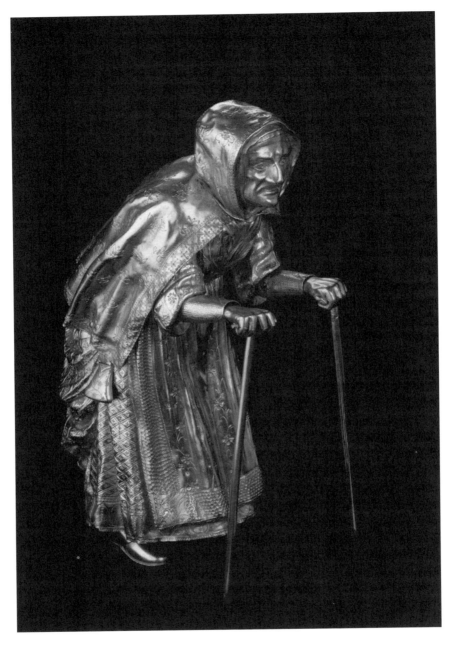

2.5 Nineteenth-century female automaton that walked forward with a cane. She was sometimes known as "Mother Shipton," the English name of a prophetess born in a cave; in France, she was known as *la fée Carabosse*.
Photo courtesy of the Watch Museum of Le Locle, Château des Monts, Le Locle, Switzerland.

who opened and shut her mouth and waved a broomstick or switch as she scolded her husband, a cobbler, who sits hammering a leather sole.

Amid these conventional or stereotyped images of women, some of the new mechanical nineteenth-century automatons represented women seen through a dramatically different lens, suggesting that gender paradigms were being challenged and that dramatic social transformations were underway. The era of the new Parisian automatons coincided with feminist activity in France and the emergence of the cultural paradigm and fictional construct—the "New Woman" in England and America: independent, sometimes politically radical women who flaunted social conventions with their nontraditional ways.[25]

In the early decades of the nineteenth century, a small but influential number of French women activists, including members of the Saint-Simonians—a French political and social movement—rallied for women gaining greater access to jobs, professions, and education.[26] The First International Congress for Women had been held in Paris in 1878, and at the 1896 Congrès Féministe International (International Feminist Congress) in Paris women rallied for greater access to education, including entrance to the premiere art and architecture school, the École des Beaux-Arts. Their efforts continued at the Congress for the Rights of Women held in Paris at the 1900 World's Fair in Paris. In 1900, the French manufacturer Renou produced a very rare representation of what would be considered a radical woman—a musical automaton called "The Rights of Women," a woman dressed as a "feminist advocate" in black robe, silk shirt, a cape, and black velvet cap. When wound with a key, she lowered her head, raised her lorgnette glasses to her eyes, and peered at a paper in her hand titled "Droits de Femme" (The Rights of Women), an automaton inspired by real-life females who were breathing life into stilted notions of women's proper behavior and roles (fig. 2.6).[27]

The Mechanical Woman and New Machines

British novelist Sarah Grand in her 1894 essay "The New Aspect of the Woman Question" wrote that "women were awakening from their long apathy" and "the day of our acquiescence is over," but she also reassured women that "true womanliness is not in danger" and that "the sacred duties of wife and mother will be all the more admirably performed when women have a reasonable hope of becoming wives and mothers of *men*."[28] In their representations of female figures, Parisian automaton makers and mechanical toy manufactures in both Europe and America seemed to similarly embrace both worlds—the comfortably familiar as well as the new.

These manufacturers gave a glimpse of a wider world opening up to nineteenth-century women with the invention of new machines. Using sewing machines, women recast notions about their limited technical abilities. Sewing machines had been introduced for factory use in America in 1851, but,

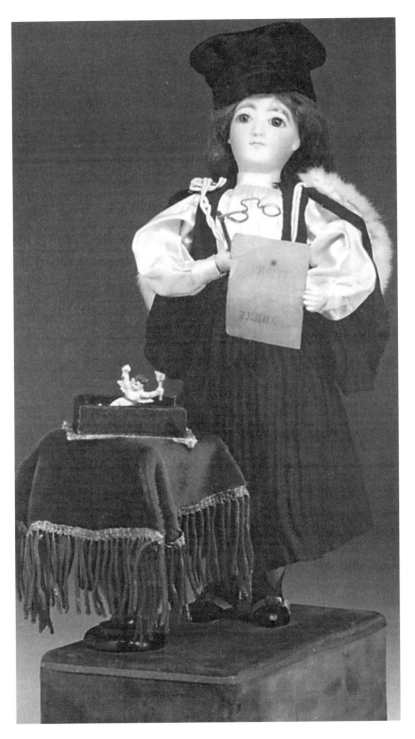

2.6 *The Rights of Women*, automaton by Renou, ca. 1900. This French *suffragiste* was a dramatic counterpoint to other female automatons in more traditional roles. Courtesy of Theriault's.

after the first family sewing machines were introduced by America's Singer Company and others in the 1850s, women showed their ability to master these machines. Soon Parisian automatons as well as small toys made in Europe and America depicted young women at work using these machines.

These representations of women at work straddled two worlds. The toys were, in part, intended to socialize young girls into their expected roles. The "Mechanical Sewing Machine Girl" advertised in an 1882 catalogue for the Erhlich Company in New York featured a little girl seated at a cabinet sewing machine; when wound with a key, she leaned forward, put the work in position, pressed the treadle and the sewing machine begin to sew. She even brought the work up to examine it. For women, using a sewing machine was in many ways an extension of their conventional role as seamstress, and such work was hardly liberating—witness the many European and American women who were working in factory sweatshops and doing contracted piecework at home.

But women's ability to learn to use this technical apparatus was also seen as a sign that they had the capacity to enter a new realm: women sewing-machine users were lauded and later, during World War I, cited as indicators that women had the ability to learn other technical skills, such as using factory machines

2.7 Nineteenth-century stereograph. Wearing her knickerbockers, the lady bicyclist in this satirical image tells her husband, "Take care of the children. I'm ready for a ride."

during wartime.[29] Still, just as years later, in World War I and II, when advertisers reassured women they could maintain their femininity while working on machines, nineteenth-century sewing machine manufacturers felt the need to reassure women they could still be fashionable and use a machine. To appeal to consumers—and indirectly suggest this wasn't really hard work—the 1882 "Mechanical Sewing Machine Girl" advertisement noted that she was "elegantly dressed in the latest fashion."[30]

In Paris, new female automatons in the 1890s more directly challenged conventionality by depicting women mastering another new mechanical invention, the bicycle. Velocipedes of the 1860s and newly designed women's drop-frame safety bicycles introduced in the 1890s offered women an exciting new sense of freedom and mobility. Women bicycle riders demonstrated their expertise and countered the stereotypes of the female baffled by all things mechanical. Bicycling also promoted a move to more practical "Rational Dress"—divided skirts or pantaloon-type "knickerbockers"—which made their bicycling more comfortable.[31]

Satirists in both Europe and America, however, were quick to lampoon these cycling women, with their images of Amazonian women and their bicycles reflecting anxieties about women becoming too powerful or independent. Cartoons and photographs pictured women dressed in their knickerbockers and ready to ride off on their bicycles, leaving their husbands behind to tend to the children and domestic work—like the stereograph card of a woman in her plaid knickerbockers telling her husband, "Take Care of the Children, I'm Ready for a Ride" (fig. 2.7).

Parisian automaton-makers created mechanical female bicyclists that both celebrated as well as gently satirized women in these new roles. A Roullet & Decamps automaton, "Bicyclist Coquette" featured a young woman wearing a satin cycling outfit (her trouserlike "knickerbockers") whose feet turned the pedals of a two-wheeled safety bicycle as music played. Another automaton by Vichy presented a young bicyclist near a road sign indicating she was en route from Paris to Neuchâtel (fig. 2.8). One female automaton riding a tricycle wears a lorgnette (in visual images, wearing eyeglasses could be a signifier that a woman was daring, as seen in an Austrian photograph of the period where a showgirl wearing eyeglasses poses with her velocipede).[32] Automatons like these became animated emblems of the modern woman mastering new machines, a woman demonstrating her independence and skill.

Exotic Women

The lady bicyclists, sewing machine users, and woman's rights representatives were all emblems of changing times, though women using sewing machines both affirmed and challenged women's familiar social roles. Another category of female automatons was simultaneously conventional and provocative. It

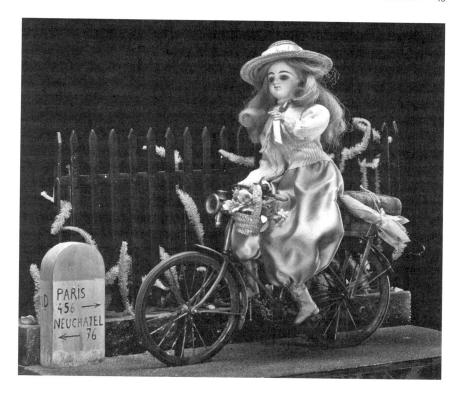

2.8 Automaton of a female *bicycliste* by Vichy. The road signs suggest she has come from Paris and is en route to Neuchâtel, the Swiss city where the eighteenth-century clockmakers Jaquet-Droz father and son made their famed automatons.
Courtesy of the Kyoto Arashiyama Orgel Museum.

represented women who at the time were considered exotic: scantily clad and sometimes erotic female entertainers like snake charmers and dancers who delighted and amused their audiences. Women had been depicted as exotic harem figures in European paintings since the Renaissance, but with increased travel during the nineteenth century and travel through the Mediterranean area made easier through the availability of railroads and steamships, there was also an increased interest in "Orientalism" or the cultures of the Middle East and North African French colonies, including Morocco and Algeria. Paintings by artists, including Delacroix, Ingres, Gérôme, Whistler, Renoir, reflected this trend.[33]

Automatons representing exotic women were also inspired by the great nineteenth-century European and American universal and colonial expositions, where mass audiences visiting colonial pavilions like those at the Paris Expositions of 1900 and, even earlier, the Paris Exposition of 1889 were introduced to "exotic" cultures depicted in exposition paintings, dioramas, and panoramas.[34]

Capturing the allure of these Orientalist motifs, nineteenth-century French automaton makers began producing exotic dancers and female snake charmers exquisitely dressed in faux jewels and brocaded clothes. Vichy in Paris produced its "Harpiste Mauresque" (Moorish harpist), and there were also dramatic, mechanical versions of Cleopatra about to commit suicide (complete with mechanical asp), and "oriental dancers" or female snake charmers like the Roullet & Decamps "Zulma the Snake Charmer" in 1890 (a reference perhaps, to Nala Damajanti, a "Hindu Snake Charmer" who performed at the Folies Bergère). The Roullet & Decamps snake charmer, a woman whose body was ornamented with pearls and other faux jewelry, blew into a horn to charm the snake as her sinuous body undulated suggestively (she also represented a rare instance of an automaton that alternately appeared clothed and in the nude) (fig. 2.9).[35]

In Shaw's *Pygmalion*, Eliza the young Cockney flower vendor was trained by Henry Higgins to perform with automaton-like precision so she could pass for an elegant Victorian lady, but the automaton "The Flower Vendor" by Vichy (1885) was an animated mechanical marvel that captured the allure of the exotic: this dark-complexioned woman wore brocaded robes and a turban on her head, and, when wound up, her three felt "surprises" or "flowers" on the tray opened to reveal a papier-mâché monkey's head with blinking eyes, a mechanical mouse running around, and a tiny dancing doll with a white bisque head (plate IV).

During the nineteenth century, the opening up of Japan to the West also brought a great fascination with Asian and Japanese cultures throughout Europe, called by the French *Japonisme* and reflected in the work of Impressionist and Post-Impressionist painters, including Edouard Monet and Vincent Van Gogh. Japan itself had had a long history of producing automatons, puppets, and mechanical dolls, some of which were used in theaters, homes, and religious festivals.[36] In a nineteenth-century woodcut print by the Japanese artist Utagowa Toyokuni (1857), a woman who is possibly the shopkeeper Oume of Sugimoto-ya, sits on the floor holding up a puppet of a woman in ornate dress. In Japan of the eighteenth-century Edo period, there had been a wealth of mechanical dolls and automatons, called Karakuri Ningyo, used as festival figures.

In nineteenth-century France and its cultural climate enthralled with the exotic, Orientalism, and *Japonisme*, French automaton makers produced their own versions of Asian women in traditional roles, including Chinese tea servers as seen through Western eyes. A "Chenoise Verseuse," manufactured by Leopold Lambert (fig. 2.10), wore an opulent velvet silk kimono; she had a bisque head made by Jumeau and a mohair wig. When wound, she turned her head from side to side, nodded briefly, lifted a teapot, tipped it toward a glass, and moved the tray to the other hand.

These automatons of Asian women are particularly intriguing because they foreground their own status as simulations and reflect the idea of female masquerade—the wearing of camouflaging cultural masks by women. A female Japanese mask

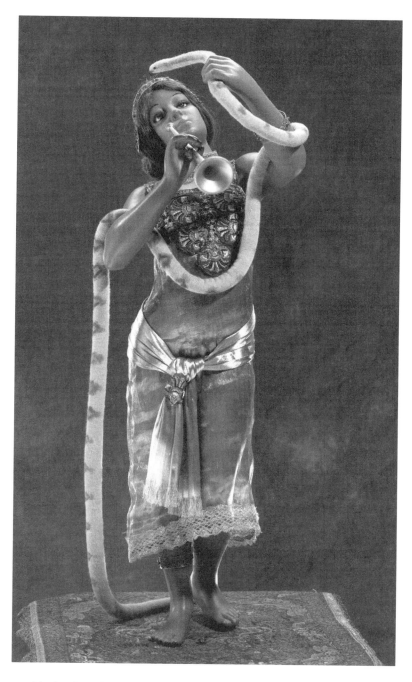

2.9 The female Snake Charmer automaton by Roullet & Decamps (1890), which undulated and blew a horn to charm a snake, was a rare instance of an automaton that was exhibited clothed and in the nude.
Photo courtesy of the Kyoto Arashiyama Orgel Museum.

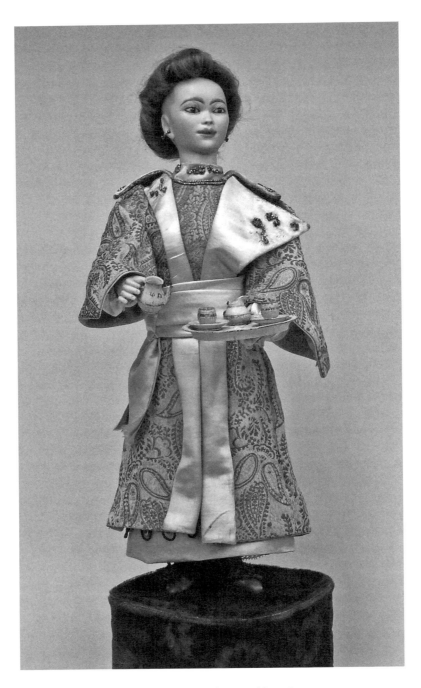

2.10 Chinese female tea server automaton by Léopold Lambert, ca. 1900. Murtogh D. Guinness Collection of Automatic Musical Instruments & Automata, Morris Museum, Morristown, NJ.

seller automaton (1890), manufactured by Vichy, is a richly layered tribute to Asian culture with its stylized rituals and also embodies a cultural paradox: this simulated woman herself is also a purveyor of simulation and disguise as she holds in her hand a festival mask and other masks dangle from her tray. Wearing a black wig on her papier-mâché head and dressed in a richly embroidered silk kimono, she swirls her red parasol and slowly raises the mask toward her face.

While French automaton manufacturers were presenting automatons of exotic females, they also offered up a few versions that hinted at a radical redirection. "La magicienne" by Roullet & Decamps (ca. 1880) presented a female not only as an object of amusement and men's desire but also as a woman with agency and power. In nineteenth- and twentieth-century magical acts (and continuing even today), female performers often served as magicians' pretty assistants who lent their bodies to being sawed in half or levitating into the air—like the Parisian automaton of a male magician who has levitated a volunteer from the "audience," a woman dressed in a satin crepe gown, who blinks her eyes and fans herself right before the magician, wand in hand, miraculously raises her body from her velvet-covered bench.

These women simply served as appendages to magic acts, passive females who could be manipulated and controlled. Rather than just being a passive female assistant, however, the automaton "La magicienne" took on a new role: standing in front of her table, this lady magician had agency as she waved her wand in front of three props, which were then called "surprises"—a monkey, a baby sending kisses, and a clown turning its head and sticking out his tongue. (More than one hundred years later, however, women magicians in actuality still remained an anomaly, with only a small percentage of female magicians in the entertainment world.)[37]

Walking and Talking Dolls

During the nineteenth century, manufacturers in America and Europe also saw a different opportunity to fulfill the Pygmalion fantasy of bringing a fabricated woman to life as they stepped up efforts to create mechanical dolls that walked and even talked.[38] The potency of dolls—as simulacra of women, as repositories of cultural attitudes about women themselves, as emblems of men's fantasies about women—was embodied in these new mechanical dolls designed for children.

In the sixteenth century, Italian craftsman Gianello della Torre of Cremona had created a female doll for Charles V that was meant to look like she was walking. Fashionably dressed in linen and silk brocade, with the help of her iron clockwork mechanism she played the cittern or lute and seemed to walking in small steps as she was propelled forward by two wheels while turning her head and plucking at the instrument.[39] During the nineteenth century, the Madame Catharina doll also glided forth, but later in the century both American and

European doll manufacturers began using more sophisticated technology to produce mobile dolls and some that even talked.⁴⁰

These walking and talking dolls and the technology and the concept of a doll itself often suggested different meanings to men and women. For young girls, the articulated nature of dolls helped make them look alive, for they could be shaped and moved in response to young girls' imaginative fantasies and dreams. For young girls and women, the dolls were not only playthings but also models for those who wanted to emulate or inhabit the persona of a doll—those beautiful, fashionable artificial creatures that often embodied cultural ideals of femininity. To the men who invented and manufactured the dolls, their technical intricacies—the articulated, mechanical parts—often seemed to interest them the most. For nineteenth-century male inventors, the idea of creating mechanical dolls that could mimic walking and talking human beings was an enticing prospect in mechanical terms, and the mechanics of the dolls interested male observers, too.

In 1862, Enoch Rice Morrison became the first American to receive a patent for his walking doll named Autoperipatetikos (meaning "self-propelled" or to walk about) (fig. 2.11). The dolls had bisque heads manufactured in Germany, moveable hands and legs, and wore fashionable clothes and hooped skirts that hid their mechanisms. Because the dolls with their porcelain heads were prone to toppling, cloth heads, manufactured in the United States, were later substituted so the dolls would be less apt to get damaged.⁴¹

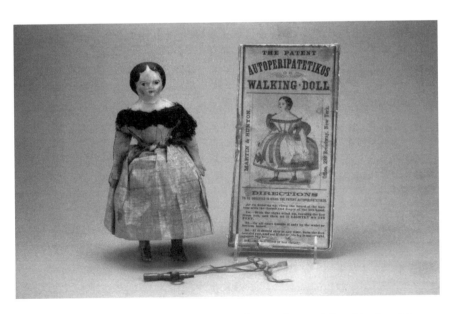

2.11 Autoperipateikos walking doll, 1870, invented in 1862 by Enoch Rice Morrison. Manufactured in the United States, the doll was lampooned by Oliver Wendell Holmes Sr. Photo courtesy of the Strong Museum®, Rochester, New York, 2014.

One of Morrison's Autoperipatetikos dolls garnered unlikely attention from a man who, in commenting about the doll, revealed much about his own attitudes toward anatomy, technology, and women themselves. In his essay "The Physiology of Walking," Oliver Wendell Holmes Sr., the noted American physician and professor of anatomy and physiology (and father of the Associate Supreme Court Justice Oliver Wendell Holmes Jr.), wrote about a mechanical female walking doll, a "young lady" found in shop windows and children's nurseries—a doll whose name Autoperipatikos to him was "Homeric-sounding epithet." He wrote skeptically that the doll "professes to be this hitherto impossible walking automaton."[42]

Holmes may have conjured up Homer's heroic epic, but his essay is filled with mockery, and his description of the doll was shaped not only by his skepticism but also his male gaze: he wrote about the doll's "golden-booted legs," which reminded him of Thomas Hood's fictional character Miss Kilmansegg, and he added that "the size of her feet assures us that she is not in any way related to Cinderella." Not only was she unbeautiful, but her mechanism was awkward: after being wound up and placed on a level surface, "she proceeds to toddle off, taking very short steps, like a child" and walks very stiffly and straight, all of which was accompanied "with a mighty inward whirring and buzzing of the enginery which constitutes her muscular system."[43]

Miss Kilmansegg was a mean-spirited reference to British poet and fiction-writer Thomas Hood's cautionary, satiric book-length tale *Miss Kilmansegg and Her Precious Leg: A Golden Legend*. In Hood's rhymed sardonic tale, Miss Kilmansegg is the vain daughter of a banker who loses her leg and replaces it with a gold prosthesis. A haughty woman who covers herself in gold jewels, she had no part "in vulgar cares." At night, "the independent Miss Kilmansegg/ Took off her independent leg" and "laid it on the pillow beside her." She marries a scoundrel count who loses his money and murders her so he can melt down her leg—after killing her with it.[44] Holmes may be mildly misogynistic, but as a physician his cranky complaints seem to stem from the Autoperipatetikos doll's mechanical anatomy. To the physician Holmes, the doll and other automatons were just poor imitations of the actual human walking mechanism. Analyzing human walking, he portrayed it in mechanical terms: "the peculiarity of bipedal walking is, that the centre of gravity is shifted from one leg to the other, and the one not employed can shorten itself so as to swing forward, passing by that which supports the body." "This," he said, "is just what no automaton can do."[45]

Very much a gentleman of late nineteenth-century America, Holmes may make snide comments about the doll's beauty and deride the social pretensions of the hapless Miss Kilmansegg, but he is also cautious about stripping away the pretence of this female doll. Although he chivalrously wishes "to spare her as a member of the defenceless sex," he adds that "it pains us to say, that, ingenious as her counterfeit walking is, she is an imposter." What Holmes the man of science finds objectionable is—ironically—that this simulacra, which others might find

a mechanical wonder, is a false representation of a doll that walks on two legs. After taking a jibe at the doll's elaborate undergarment, which required it to walk stiffly, Holmes insisted that "duty compels us to reveal a fact concerning her which will shock the feelings of those who have watched the stately rigidity of decorum with which she moves in the presence of admiring multitudes." After describing the doll's mechanical anatomy, he tells the reader the shocking "fact" that he has discovered. He conducted an "autopsy" on the doll and found the "secret springs of her action": the doll, he learns, is not two-legged but "a quadruped!"[46] Ultimately, with grave seriousness (or at least mock seriousness), he describes these "secret springs": the doll had a clockwork mechanism hidden beneath its fashionable hooped skirt, a mechanism that consisted of two sets of legs—an upper set of brass legs was connected to a clockwork mechanism, and the doll "walked" using a second pair of boot-like lower legs that were fitted into the upper set, extending from the soles of the feet. This second set of legs protruded and retracted to give the doll movement.[47]

Like the Autoperipatetikos doll, the century's talking and walking dolls—including dolls by French manufacturers like François Gaultier and Jules Steiner's clockwork Bébé Parlant Automatique mechanical doll (Automatic Baby Talking Doll), which could say "Mama" and "Papa" and kicked and cried—were considered not only playthings but also mechanical marvels. For Holmes, however, the Autoperipatetikos doll was much more a mechanism than a marvel as he painstakingly deconstructed and debunked the illusion that the doll was walking on its two legs. To men like Holmes and also the men who designed and manufactured these automated dolls, they were not cultural wonders but very much machines and, more important, segmented machines assembled from articulated parts. Pointing to the gendered nature of doll production, Miriam Formanek-Brunell has argued that nineteenth-century male inventors were more preoccupied with improving the technology of dolls rather than the dolls' appearance and social function. These men, she noted, in essence viewed the dolls as assemblages of parts. The men "made dolls that resembled the sturdy machines they admired" and produced "hard, mechanized dolls" while women, who had the sewing skills, produced the dolls' dresses.[48]

Looking at doll patents from 1850 to 1930, she found that inventors often "specialized in parts of dolls that had machine-like functions," such as Matthew Anderson's android-like jointed or moveable doll fingers, and that "male inventors frequently patented *parts* of dolls rather than *whole* ones." Noting that "most male inventors patented parts of doll bodies as if constructing parts of a machine," she also argued that women's bodies were "fractionalized in the hands of male inventors" and speculated that perhaps "men felt more comfortable with parts of women's bodies rather than the whole person."[49] (In the twentieth century, the element of objectification and segmentation—that is, seeing women's bodies as doll-like, to be manipulated and played with—would continue to be a central feature in men's cultural representations of woman-as-doll.)

While men were working on creating lifelike walking dolls, women in Europe and America paradoxically were complicit in making themselves look like stiffly walking dolls. During the nineteenth century, to support the heavy fabric of their voluminous skirts, women, as in the Renaissance and eighteenth century, again transformed themselves into doll-like figures by wearing structured undergarments called crinolines made of horsehair, whalebone, and later, starting in the 1860s, "cage crinolines" made of spring-steel, garments that swung when they walked (and sometimes awkwardly swung up), which made it difficult for them to walk with any grace—a phenomenon greeted with glee by nineteenth-century satirists.[50]

The concept of a female doll not only conveyed a sense of prettiness and stiffness but also culturally created notions of women as delicate and fragile creatures—an idea that was rejected by an American woman physician at the beginning of the twentieth century. Denouncing the whole idea of woman as doll, Dr. Mary R. Melendy in her conservative handbook for healthy living, *Perfect Womanhood* (1906), told women sternly, "Do not get the idea that men admire a weakly, puny, delicate, small-waisted, languid, doll-like creature, a libel on true womanhood."[51]

The walking dolls and French automatons of the eighteenth and nineteenth centuries had embodied the contradictions and complexities embedded in middle-class and haute-bourgeois cultural conceptions of femininity. The Parisian automatons, representing fashionable women in their ornate finery and crinolines, reaffirmed the European and American ideals of women as delicate creatures consumed with couture, and the automatons of female seamstresses and women at sewing machines reaffirmed cultural ideas of women content with their roles in the domestic sphere. But other automatons like Gavrochinette and the mechanical female bicyclists held out the possibilities of the New Woman or at least a more independent woman as model. Here were starkly contrasting views of women at the dawn of a new century: mannish New Women and sexually suggestive female snake charmers who were exotic and erotic as well.

By the early twentieth century, the manufacture of Parisian automatons had greatly declined due to fewer skilled craftsmen, and protective legislation restricting imports of French toys during the First World War.[52] Though women themselves often continued to emulate dolls and to be represented by men as dolls in cultural imagery (in twentieth-century American slang, women were called dolls), there were also signs that important changes were underway. With the impact of Victorian dress reform and campaigns to have women adopt rational clothing, increasing numbers of European and American women had abandoned stiff crinolines and corsets as they rode their new safety bicycles, and a small number of women in cities like New York had even started, by the 1890s, becoming motorists as well.

As another sign of change, a few female characters in films would appropriate the look of dolls, not to fulfill cultural ideals of beauty and fashion but

instead—like Ossi in Ernst Lubitsch's 1919 silent film *The Doll* (*Die Puppe*)—to paradoxically gain agency and power. Like the remarkable female magicienne automaton, through the magic of the cinema these women would be portrayed as subverting expectations. They transformed themselves into stiff-moving dolls to gain some freedom and catch men off-guard—men, like Pygmalion, resistant to women but easily seduced by a simulation that comes alive. As we see in chapter 3, these women—extending the precedent of nineteenth-century mechanical automatons and dolls—charmingly and craftily inhabited the world of the uncanny, where it was not easy to tell if they were artificial or real.

3

Mannequins, Masks, Monsters, and Dolls

Film and the Arts in the 1920s and 1930s

In the wonderfully inventive wedding scene of Ernst Lubitsch's silent film comedy *Die Puppe* (*The Doll*, 1919), the pretty young woman Ossi is doing her best to pose as a wind-up doll but goes in and out of character as her impish spirit breaks through. At her wedding, she periodically wolfs down food and drinks when her fiancé Lancelot isn't looking and later astonishes him by acting like a real woman—yelling and slapping him when he gets irritated with her for dancing while he is gone.

Playing the part of a woman who is both artificial and real, the actress Ossi Oswalda in Lubitsch's film is a comic descendent of those ingenious female automatons and walking dolls created during the nineteenth century, which were greatly admired as objects of technological wonder but also had an eerie side, too—especially when they seemed to inhabit the world of the uncanny, that twilight area of ambiguity in which it was difficult to tell if they were simulations or real women. In early twentieth-century fiction, film, and art, these moments of ambiguity when women transform their identities by wearing social masks or acting the role of a doll were especially enticing when they became an entrée into exploring some ambiguities and paradoxes of female identity itself. During this period, the films of German directors Fritz Lang and Ernst Lubitsch illuminated this provocative and alluring shadow world where it is not easy to tell if a woman is authentic or artificial, and the boundaries are provocatively blurred.

Artificial Females and the Uncanny

Long before *Die Puppe*, an early seminal story that captured this unsettling realm of ambiguity was German writer E.T.A. Hoffmann's tale "The Sandman" (1816), published in his 1817 collection *Die Nachtstücke*, where the young Nathanael falls passionately in love with a beautiful and perfectly proportioned Olympia but is horrified when she turns out to be nothing more than a mechanical doll. This type of anguished moment when a man discovers that his female beloved is simply a simulated woman and not real later became central in several works of fiction and films in the nineteenth and twentieth centuries and evoked the type of experience described as "The Uncanny" by German psychiatrist Ernst Jentsch in his essay "On the Psychology of the Uncanny" in 1906 and later revisited in Sigmund Freud's essay "Das Unheimliche" ("The Uncanny," 1919).[1] In his essay, Jentsch gave as an example Hoffmann's "The Sandman" and described the uncanny as a condition of uncertainty or ambiguity about whether a being is animate or inanimate—or whether an entity that appears lifeless is actually alive (for Jentsch, this included life-sized automatons or dolls that could open and close their eyes, and even early locomotives and steamboats that looked startling to some people when the machines began to move). For Jentsch, "imitation can easily produce uneasiness."[2]

Updating the concept of the uncanny years later, Japanese robotics engineer Masahiro Mori in his provocative essay "The Uncanny Valley" (1970) wrote about that startling moment—sometimes filled with shock and revulsion—when an observer, experiencing a dip into what he called the "uncanny valley," realizes that an artificial human being, such as a robot, isn't real. The element of movement added to the uncanny valley effect: If a mannequin started to move, "it would be like a horror story."[3]

In his own essay on "The Uncanny," Freud had argued that the uneasiness and anxiety were not due to uncertainty about the inanimate but rather to repressed feelings and, as with Nathanael's fears about losing his eyes (stemming from a childhood story about the Sandman taking the eyes of children who wouldn't go to bed), latent fears about castration. Freud's essay also linked dismemberment and a severed head to castration anxieties.[4] Hoffmann's story artfully encapsulates many of the themes of uncertainty, ambiguity, shock, and fragmentation that infused later conceptions of artificial women in fiction and films. It also evokes many of the central features found in men's tales about female simulacra: men's idealization of the artificial female, their longing for a woman who will validate and complement them, and the problematic nature of the male gaze—their ways of projecting onto these artificial women their most deeply felt longings, which could distort their vision and point of view.

"The Sandman" is filled with references to vision and eyes, not only the proverbial Sandman who throws sand into children's eyes when they won't sleep and then throws the eyes into a bag and carts them to the moon (as Nathanael's

sister's old nurse r tells him) but also Nathanael's own idealized way of seeing Olympia and his way of missing the cues that this woman isn't real. While at the university, he looks through his own window and sees a young woman, Olympia, who has been identified as physics professor Spalanzani's daughter. He becomes enchanted by the alluring vision of her, and when he first sees her from his house across the street from Spalanzani's home he is indifferent to the fact that she sits in the same position for hours, "stiff and rigid" and that her eyes look sightless. Her features appear blurred, but when he uses a spyglass he purchased from the eyepiece maker Coppola (who is later identified as the lawyer Coppelius), he then sees with "clarity and distinctness," and her eyes, which at first seemed fixed and lifeless, now seem animated by life.[5]

In Nathanael's distorted vision, the inanimate woman seems sensate, and the real woman, his fiancée, Klara, seems artificial. As he looks at Olympia through his spyglass, he projects onto her his own wishes, and, to him, she appears to have a "loving glance" filled with "love and longing" while Klara seems to have a "cold, prosaic disposition." When Klara tries to embrace him, he thrusts her away with harsh words, "You damned, lifeless automaton!" (110–115). Nathanael continues to see Olympia in terms of his own infatuation, not reality, and—as often happens in tales about men and artificial women—his most intense moments of rapture happen while he is dancing with her. At a ball given by Spalanzani, Nathanael dances with her, and in his fervor and passion he is unmindful that her dance steps seem stiff and measured. Pouring out his heart to her, he feels she has a "profound and beautiful mind" and sees her as having great understanding and sympathy, even though all she ever says is "Ah, ah!" and "Goodnight, my dearest" (114–116, 118). In his eyes—and so often in tales of artificial women—she is the ideal female: a woman who says little and is a companion who seems to mirror and complement his innermost thoughts.

In the tale, Nathanael ignores the signs that his beloved isn't real even though his friend Siegmund pointedly asks him how he could be so in love with "that wax-faced, wooden puppet" and tells Nathanael that her eyes seem "devoid of life," that she seems "strangely stiff and soulless," and that all her movements "seem to stem from some kind of clockwork": Olympia plays and sings with the perfect, soulless time of a machine and "seems to us to be playing the part of a human being" (117).

Though Nathanael's friends recognize there is an element of the uncanny in Olympia, Nathanael's own recognition does not come until he overhears Spalanzani and Coppelius arguing and talking about clockwork and sees them twisting and turning the limp body of Olympia as they tried to gain possession of her. After a crashing and shattering of scientific equipment—vials, test tubes, retorts, flasks—Coppelius carries her limp body over his shoulders. At this moment Nathanael has a terrible recognition: "he had only too clearly seen that in the deathly pale waxen face of Olympia there were no eyes, but merely black

holes. She was a lifeless doll." "Coppelius has stolen my best automaton," cries Spalanzani, who had worked on it for twenty years, and he flings the doll's eyes at Nathanael who lapses into madness (119–120).

Hoffmann's tale is not only about the horrendous deconstruction of the illusory Olympia but also the shattering of Nathanael himself. As a young man, Nathanael had fantasies in which he imagined himself to be a segmented artificial human, an automaton. In his father's house, he hid and spied upon his father and Coppelius, whom he imagined was about to put sand in his eyes, but Coppelius was stopped by his father who said, "We must carefully observe the mechanism of the hands and feet" (98). In the fantasy, Coppelius seizes him and disassembles him, unscrewing his hands and feet, and then puts them back as Nathanael blacks out. Now, years later, after witnessing the nightmare of Olympia's true identity, Nathanael climbs up the town tower with Klara, and, while looking at her through Coppola's spyglass, he again sees her as artificial. Roaring horrendously in his derangement, he shrieks, "Whirl wooden doll!" and tries to hurl Klara from the tower. She is rescued by others, but in his madness Nathanael, whose illusions were shattered as he watched his beloved being dismembered, jumps over the railing, destroying and shattering his own head.

Hoffmann's tale is more than a poignant and powerful evocation of Nathanael's own longings and derangement. It also satirizes the men of the town who like Nathanael haven't recognized that Olympia was a doll or automaton and suddenly need assurances that their own wives are real, not dolls. Spoofing the social world of artifice where, suggests Hoffmann cynically, women may adapt features of artifice and masquerade, Nathanael's disillusioning experience makes men anxious and distrustful of their own real-life lovers: many of the men now insist that their mistresses "sing and dance unrhythmically," embroider, and knit so "that they could assure themselves that they were not in love with a doll." They also required their mistresses "not only to listen, but to speak frequently" in a manner that would "prove that they really were capable of thinking and feeling" (123).

Coppélia

Hoffmann's tale ends with the tragedy of the tormented Nathanael being driven insane by the discovery that his beloved is only a mechanism, a construct, but later versions of the tale—including the ballet *Coppélia* (1870) with music by Léo Delibes and works by twentieth-century writers and filmmakers—mined the story's comic possibilities of lively women who took on the role of automatons. Henri Bergson in his book *Le Rire* (*Laughter*, 1900) wrote that there was something inherently comical about stiffly moving human beings imitating machines: "THE ATTITUDES AND GESTURES AND MOVEMENTS OF THE HUMAN BODY ARE LAUGHABLE IN EXACT PROPORTION AS THAT BODY REMINDS US OF A MERE MACHINE"

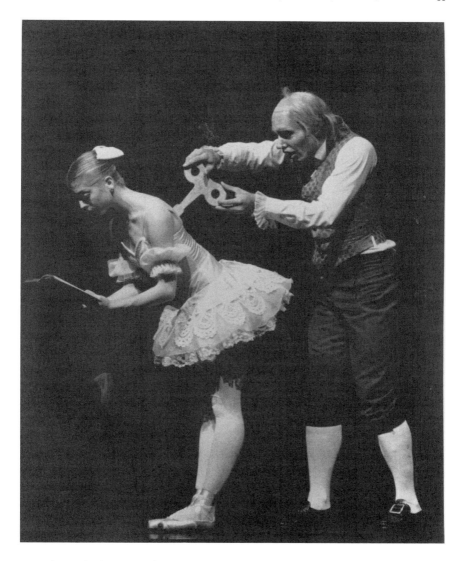

3.1 Olympia (Julie Tobiason) being wound up in Leo Délibes' ballet *Coppélia*, by the Pacific Northwest Ballet, 1993–1996.
David Cooper Photography.

[capitalization in original].⁶ But in *Coppélia*, which was based on Hoffmann's "The Sandman," and in later works about artificial women, something else important happens: rather than being defined as dolls, women appropriate the appearance of dolls for their own ends. Their witty imitation of stiffly moving mechanical dolls is the ruse they use to manipulate, charm, and subvert obsessed or rigid men.

In *Coppélia*'s first act, Franz is entranced by his view of the beautiful Coppélia, a young woman he sees sitting in a window of the house of Coppélius, an eccentric doll maker and creator of automatons. Swanilde, Franz's fiancée, is alarmed by his infatuation with the woman in the window and goes with her friends into Coppélius's house to get a closer look at Coppélia while the doll maker is away, even as Franz himself climbs a ladder to get in.

Much of the ballet's comedy stems from an identity switch that takes place as Swanilde goes in and out of character imitating a machine. Male characters in fictional representations are often aghast when they discover a female is a simulation, not real, but in this ballet, Swanilde and her female friends who are at first fearful of Coppélia are relieved when they touch her and discover she's only a doll. Meanwhile, they also have fun winding up the other life-sized dolls in Coppélius's workshop—including a Scotsman and an exotic female Spanish dancer with her lacy mantilla—that start moving, evoking into the magical world of automatons.

In Ovid's telling of the Pygmalion myth, Venus is the agency that brings the inanimate Galatea to life, but in *Coppélia*, it is a woman herself in a witty inversion who adapts the process to her own ends, and in effect, brings herself to life. When Coppelius unexpectedly returns home, Swanilde hides in the closet where Coppélia is stored while Coppélius, thinking he can steal Franz's spirit to animate the beautiful automaton, meanwhile drugs Franz. While Coppélius (in Pygmalion fashion) is thinking of a way to animate his doll, the ballet foregrounds Swanilde's ability to feign being a doll to further her own ends. When she is about to be discovered by Coppélius, she opens the closet door and presents herself in disguise, wearing Coppélia's clothes. Imitating the lovely Coppélia come to life, she mimics an automaton and dances stiffly as she opens and shuts her eyes (fig. 3.1).

A performance of *Coppélia* by Britain's Royal Ballet in 2001 highlighted Swanilde's adroitness at switching back and forth between woman and machine. When Coppélius looks as though he's going to take Franz's spirit, she abandons the mechanical impersonation and dances more naturalistically to distract Coppélius, who soon becomes entranced. In this production, though, there was an intriguing ambiguity when Swanilde—the spirited woman imitating Coppélia—seems to be a doll running out of control as she tears pages out of Coppélius's book, runs around the room, and takes a sword and fences with him so that he puts her back in the closet to contain what he thinks is a runaway technology. Later, when she exits wearing her ordinary clothes and Franz revives, the woeful Coppélius realizes that Coppélia—now without her dress and slumped over—is just a doll.[7] In the ballet's happy denouement, Swanilde marries Franz, something the doll could never do.

Hoffmann's "The Sandman" not only inspired the ballet *Coppélia* but also the "Olympia" sequence in Jacques Offenbach's opera *Les Contes d'Hoffmann* (*The Tales of Hoffmann*, 1881). In Offenbach's version, the young Hoffmann, a

student, comes to visit Spalanzani, an inventor of mechanical dolls and, while wearing spectacles given to him by the scientist Coppélius, falls in love with Spalanzani's "daughter," the beautiful mechanical doll Olympia. In the opera, while Olympia is singing her famed aria, she periodically acts erratically and flops over when she needs rewinding—a sign of her artifice, which causes audiences to laugh but is lost on the smitten young Hoffmann. At the end, the enraged Coppélius, angry that he's been swindled by Spalanzani, smashes the beautiful Olympia as Hoffmann watches in horror and disillusionment and sings, "A lifeless puppet! Just a painted doll."

In their filmed version *The Tales of Hoffmann* (1951), filmmakers Michael Powell and Emeric Pressburger highlighted the sense of fragmentation and disintegration at the end of the tale as the quarreling Coppelius and Spalanzani literally tear apart Hoffmann's dream woman. As they argue, Coppelius knocks off Olympia's head (Olympia played by Moira Shearer), and Spalanzani pulls off her leg as the disassembled parts of the doll litter the stage, with one isolated leg still wiggling grotesquely. In an almost surreal final sequence, Hoffmann kneels in horror as he stares at Olympia's decapitated head (now with comical-looking mechanical spirals on top), which lies resting on the ground, her eyes blinking bizarrely accompanied by clicking mechanical sounds (fig. 3.2).

The story of "The Sandman," with its rich themes of artifice believed and artifice unmasked, continued to capture the imagination of filmmakers almost fifty years later. Adding their own surreal dimension, the innovative American filmmakers the Quay Brothers (identical twins Stephen and Timothy) in 2000 produced a forty-one-minute film of a dance based on "The Sandman" with seven dancers and music by Hungarian composers Leŏs Janacek and György Kurtag. Their film, which was created for a television broadcast in the United Kingdom, was set at Hoffmann's deathbed and interweaves hallucinatory fragments of his memory, imagination, and dreams.

The Quay Brothers in their eerie, dark stop-motion animations had long been fascinated by puppetry and marionettes, and their version of "The Sandman"—like their famed animation *Street of Crocodiles* (1986)—is filled with crafted mannequins, dolls, and sculpted busts of women that are counterpoints to Nathanael's fevered passions. Near the beginning, a man jumps out of window in a stop-frame image frozen in place, suggesting Nathanael's suicide. As he jumps, a pair of eyes falls on the ground, suggesting the eyes so central in Hoffmann's original tale and the eyes supplied by Coppelius for the doll he creates.

The Quay Brothers' film is filled with dark, shadowy vignettes. A birdcage on a bench suggests imprisonment and Hoffmann's entrapment in an illusory world. Beneath a street light, a man in a dreamscape dances with a woman in 1940s clothes on a darkened street, and in another sequence a man picks up a female doll with a mask-like face in a doll shop and dances with it. In one particularly evocative scene, in what seems like a deathbed dream, Olympia the doll

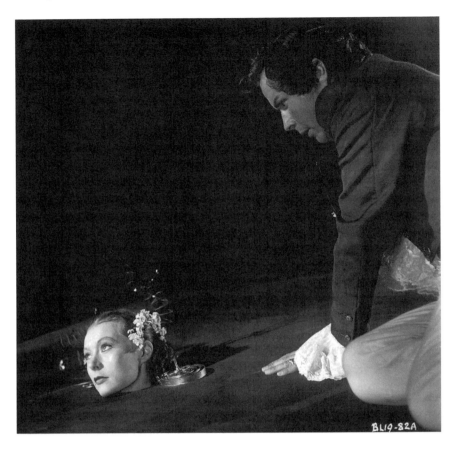

3.2 Startling scene from the British film *The Tales of Hoffmann* (1951). In this version of Offenbach's opera, the poet Hoffmann (Robert Rounseville) falls in love with Olympia (Moira Shearer) but looks on in horror as Coppelius and Spalanzani tear her apart, leaving Hoffmann to gaze in shock at her severed head.
PHOTOFEST

pulls back her veil and dances with Nathanael/Hoffman one more time. In a final evocation of artifice, the film ends with a shot of the female doll/mannequin, once so lithe and enticing to Nathanael, now lying on the floor, its arm awkwardly raised (as with the doll Rosalba in the film *Fellini's Casanova*)—a reminder that this dream woman is artificial after all.

Part of the great drawing power of Hoffmann's "The Sandman," the ballet *Coppélia*, Offenbach's opera, and the Quay Brothers' *The Sandman* is their compelling central image of an artificial female who seems alive and also their evocative conflation of the Pygmalion myth and the uncanny: a Pygmalion figure fabricates a simulated woman, and a young man, taken in by the illusion, sadly

or comically cannot tell that the mechanical lady is not real. These fundamental themes also fascinated pioneering filmmakers who themselves were engaged in a new art form that brought still images to life.

In 1900, Georges Méliès produced his two-minute film *Coppélia the Animated Doll*; two years earlier, he had produced a sixty-second film *Pygmalion and Galatea* where the statue comes to life (through trick photography, a real woman replaces the statue), darts around the room eluding Pygmalion's grasp, and, unlike Ovid's myth, reverts to a sculpture at the end.[8] These and other extraordinary early films of animated dolls are richly suggestive embodiments of men's fantasies and fears about women—women who are both wondrous and wayward. More broadly, the images of mechanically produced simulacra of human beings also become metaphors for filmmaking itself as an art of mechanical reproduction.

Women in these films are illusory, fantasy constructs assembled by men, constructs that seem to magically come alive but then—as in *The Tales of Hoffmann*—are also abruptly torn apart by men. In a variant on this view, in his film *Extraordinary Illusions* (1902), Méliès as actor took several segmented female body parts—a torso with arms, two mannequin legs, and a woman's head—out of a "Magical Box," and the parts assemble into a female dancing doll that then turns into a live woman (which, after Méliès tries to kiss her, surreally transmutes into a chef that Méliès rips apart).[9]

Méliès provocative *Extraordinary Illusions* suggests the socially constructed nature of gender (here, men's piecing together an assemblage of a fantasy female made from discrete parts) and also the constructed nature of cinema itself—the piecing together of isolated, fragmented images or film frames to create the illusion of motion, with its links to Eadweard Muybridge's early photographs, early zoetropes and kinetoscopes, and early films that created sequences of images on strips of celluloid. Méliès's film fantasy world is an artful construct that takes on a wondrous life of its own, but for the men in the films, the female fantasy they construct proves elusive and disintegrates in the end.

In Thomas Edison's early film *The Mechanical Doll* (1901), a professor winds up a mechanical doll that starts to run across a room, and the professor has to stop it from crashing into a wall. The doll that almost crashes suggests nineteenth- and early twentieth-century fears of runaway technologies like runaway trains and the runaway doll might also suggest men's concerns about the "New Women" of their era who, with their independence and insouciance, may have looked like they too were running out of (men's) control.

The Wonders of Women Who Simulate a Doll: Ernst Lubitsch and Mack Sennett

The cinematic magic of these early films is when a doll, if only momentarily, turns into a real woman or seems alive, though there are dark undertones when

the woman flees, is torn apart, or nearly crashes. But in 1919—the same year that Freud published "The Uncanny"—film director Ernst Lubitsch's extraordinary silent film *Die Puppe* (*The Doll*) celebrated a woman's ability to construct her own persona, becoming in effect both Pygmalion and Galatea herself.

Instead of dolls imitating real humans, Lubitsch in his film, as in Délibes's ballet, seized on the comic potential of real women acting mechanical as they imitated dolls—an act that evoked the uncanny as the boundaries between artificial and real became even more layered and blurred. In the film, the young Lancelot, who is fearful of women, is attracted to a doll—or at least what he thinks is a doll but she's actually Ossi, a real-life impish young woman impersonating a doll. Lubitsch's *Die Puppe* with its screenplay by Hanns Kräly was based on a nineteenth-century comic operetta *La poupée* (1896) by Edmond Audran (with the German version by A. M. Wilner) that also played on the comic outcomes of a real woman imitating a doll—a theme that had appeared even earlier in Adolphe Adam's comic operetta *La poupée de Nuremberg* (*The Nuremberg Doll*) in 1852. Audran's *La Poupée* opened in Paris in 1896 and was produced one year later in London and New York where British actress Anna Held played Ossi.

One delight of Lubitsch's film is how it references itself as fable and artifice. Billed as "Four Amusing Acts from a Toy Box," the film opens with the director Lubitsch literally constructing the film, taking out a wooden box filled with tiny trees and figures and setting them up on a board (a self-referential set construction that also appeared years later in Lars von Trier's film *Dogville*); then the figures of a man and a woman morph into live actors.

In the film, Baron von Chanterelle, who worries that he has no heir to carry on his lineage, decides that his young nephew Lancelot should get married. He invites all the maidens in the region to gather in the marketplace, and soon forty women flock to be chosen. Lancelot, a mamma's boy whose mother still calls him "my baby," is a man who cries at the prospect of getting married and comically flees with his knees knocking as the maidens chase him. "Protect me from the maidens!" he calls out anxiously as he seeks refuge in a monastery. In this early twentieth-century riff on the Pygmalion myth, the man wary of women will later be attracted to a simulated woman instead.

Lancelot (played by Victor Janson) clearly is a reluctant groom. In a letter the Baron offers the fleeing Lancelot 300,000 francs if he'll return, but Lancelot defiantly says, "I will not marry a woman." The solution suggested by a member of the greedy, gluttonous clergy becomes the central premise of the film: Lancelot can pretend to get married by marrying a doll and then give the dowry money to the monastery instead. In the monastery's archives is a booklet describing dolls created by a "World Famous Dollmaker," which are "offered to bachelors, widowers and misogynists!" (Ovid's Pygmalion would like one of these.) The doll is mechanical: it can walk, dance, and sing by pushing different buttons and winding it up, and the timorous Lancelot reluctantly agrees to the idea of "marrying" one of these dolls, but "only if it doesn't hurt!"

In a German documentary on Lubitsch's early films *Lubitsch in Berlin: From Schöenhauser Allee to Hollywood* (2006), film director Tom Twyler noted how Lubitsch's films fuse "life and illusion," illusion and reality. *Die Puppe* plays out the humorous outcomes when simulations are confused with the real, and a woman comically engages in a masquerade. In the film, Hilarius, the doll maker, has made a doll in the image of his daughter Ossi and calls this mechanical double of a real woman "our second Ossi" (Ossi Oswalda deftly played both roles).

As so often happens in literature and films about men entranced by mechanical women, there is a dancing scene in which a man has moments of rapture while dancing with a simulated woman. Hilarius's constructed doll is a product of technology activated by a hand crank and buttons on her back. When Lancelot anxiously enters the shop, the apprentice goes into another room, kisses the doll, winds her up, presses her button labeled "dance," and has a few blissful moments dancing with the doll. But—in that other recurring theme of dismemberment—when the apprentice loses his balance and falls on top of the doll, the momentary illusion is shattered as it breaks apart, and he anxiously holds her disembodied arm and hand (*Lubitsch in Berlin* noted that Lubitsch, who began as an actor in Berlin films, played the role of apprentices who break things).

The real Ossi has a solution: she tells the apprentice to fix the doll and meanwhile she'll impersonate it as a temporary replacement. Once she does, though, she finds herself engaged in a tricky, dancing dialectic between her own equivocal impulses and the men's expectations. Simulated women created by men are often invested with men's contrasting conceptions of women themselves. Women are envisioned as representing virtue or vice, uncorrupted innocence, or the essence of sexuality and seductive evil. For Pygmalion, the beautiful sculpted Galatea is far preferable to his perception of sinful women. In Lubitsch's film, Ossi gives off signals of both sexual distance and availability as she comically adapts her own spirited self to the men's constricted notions of morality.

The absurd Lancelot and even Hilarius are moralistic when it comes to sex. In Hilarius's shop, when the dollmaker shows him a row of dancing dolls that kick up their legs, the aghast Lancelot runs away saying, "I want a respectable doll of solid character." When Hilarius offers him a more "respectable doll," played by Ossi, and Lancelot dances with her, Lancelot affectionately chucks her under her chin, but she pushes him away as he says approvingly, "Now that's solid character!" (For all of Lancelot's reserve, when Hilarius discovers Lancelot and the apprentice leaving with Ossi the doll, he comically denounces them both as "you hyenas of lust!")

Ossi herself is ambivalent about masquerading as a doll with all of its potential associations of sexual availability. When Hilarius, not knowing the doll is really his daughter, puts paint on her lips, she later winces at being a painted woman and wipes the paint off when he's gone. When she finds out Lancelot's plan of deception, she looks worried; when he buys her, at first she runs

away. Ossi, though, has her own dueling impulses between distance and availability. She is compliant about fulfilling Lancelot's fantasies: when he presses a button for kissing, she gives him a quick kiss. Later in the film, though she had removed the paint, she also has fun with the impersonation, using the mask of the painted doll with its exaggerated femininity as a way to teasingly play with Lancelot's naiveté and find some freedom for herself too.

An ongoing source of humor in *Die Puppe*—and in many versions of women imitating dolls, including *Coppélia*—is how reality has a way of breaking through the artifice. Mimicking an automaton, Ossi walks stiffly and acts mechanical when needed, but she is also irrepressible. When posing as the doll, she makes comically exaggerated faces at her mother who says that the doll is "just as naughty as Ossi." (The clueless and deluded Lancelot, like Hoffmann's Nathanael, is oblivious to the ruse.) The real Ossi can't help periodically breaking the illusion. When the apprentice tickles her under the chin, she smiles and laughs (fig. 3.3), and when Hilarius pulls back the curtain in his workshop to present his impressive new doll, she coughs and sneezes when undetected.

In the 1852 operetta *La poupée de Nuremberg*, Bertha posing as a doll also breaks through her own disguise. When the storeowner Cornelius wants a perfect woman as a wife for his son, he creates a doll that he plans to have animated by magic. In a comic switch, however, the flower-seller Bertha, who

3.3 German actress Ossi Oswalda as Ossi in Ernst Lubitsch's 1919 silent film *Die Puppe* (*The Doll*).
PHOTOFEST

needs a costume for a masquerade, puts on the doll's clothes and is mistaken for the doll, but, before going to the masquerade, she acts erratically as she begins throwing toys and a plate of food out the window.

In Lubitsch's film, Ossi like Eliza in George Bernard Shaw's play clearly has a mind of her own. When Lancelot buys the doll, decides that he'll marry her, and calls for a wedding dress, she runs away at the prospect as Hilarius apologetically explains, "A screw must be loose!" After she and Lancelot return to his uncle's castle for the wedding, she dances with the other guests when he's out of the room, but when he returns and yells at her for disappearing, the indignant Ossi slaps him and yells back (rather than suspecting something is amiss, the clueless Lancelot attributes this to her being a malfunctioning mechanical object, out of control: "Now I've overwound her!" he says).

For girls and young women, often part of the fun of having a doll is dressing it and changing its clothes, creating stories to go with the clothes, and imagining that it is alive. In nineteenth- and early twentieth-century fiction and films about men with female dolls, however, sooner or later it is the men who try to clothe their doll-women (if there are erotic overtones, these are often downplayed or masked). The men view the "dolls" as commodities—not real women with feelings or modesty but just insensate beings (in Shaw's *Pygmalion*, Higgins blithely tells the housekeeper to strip Eliza and get her in more suitable clothes, though his disapproving mother frets that they're treating her like a plaything and Eliza herself lets out a fierce yowl.) In Lubitsch's film, when Lancelot takes out wedding clothes for Ossi and starts to unbutton her, this real life female hits him and pushes him away.

Women playing the role of doll may have personal boundaries, but they also have appetites, too. Artificial creatures don't have digestive systems or really eat (unless it's simulated, as in Vaucanson's eighteenth-century automaton duck), but in comic versions of artificial women, there is often a tension between the doll that cannot eat and the hungry woman who needs food. Ossie may often keep within the bounds of propriety, but she's a woman with her own appetites too. During the wedding at his uncle's castle, Lancelot tells the guests, "My bride is not hungry," but, when he isn't looking, she takes a drink from the servant and laughingly gulps down water from a flower vase. At the castle when he's looking the other way, she stuffs her mouth with food, leaving the plate empty, to his astonishment.

Even the clergy, Lubitsch hints at slyly, are not only gluttons but also have their own appetites. After the sham wedding, Lancelot, carrying out the original plan, goes back to the monks, gives them Ossi, and tells them, "It's only a doll." They cart the no-longer-needed doll to the "junk room," but not before one of the clergy dances with her as the other clergy also join in until Ossi finally escapes and flees to Lancelot's room.

In the film Lubitsch remains equivocal about Ossi, presenting her as both an innocent as well as a seductive doll-woman. She may be protective of her body

when Lancelot plans to undress her, but near the film's end she coyly plays bedroom games, too. Adding a hint of sexual innuendo to the equation, she gets into Lancelot's bed when he's not there but jumps out quickly when he walks in. Says Lancelot, "Hey, that's really nice of the brothers," adding—without even thinking about her as a potential toy—"It's a shame you're only a doll." Starting to get undressed, he clowns around with the "doll," putting his hat on her head (again, she laughs when unseen) and objectifies her, using her as a coat rack and playful place on which to hang his hat.

As in much later films (like Hollywood's *Lars and the Real Girl*), Lancelot, who is wary of women, becomes transformed after feeling safe and trusting with an inanimate doll. He gets into bed, kisses Ossi on the lips, and, after dreaming of her, he wakes up to find her sitting on his bed. "I can't believe you're a real girl," he says, and, as she nods, the still-skeptical man tests her reality by touching her neck and arm. Ossi had already given signs that she was a live female when she pushed him away as he breached her modesty, but to Lancelot the ultimate culturally recognized proof that she's a real female is when she jumps on the bed in fear after she sees a mouse. He then says with pleasure, "Yes, you're a girl." Now that Ossi is a safe woman—fearful, vulnerable—he can fully embrace and kiss her, and, when Hilarius appears to reclaim his daughter, Lancelot shows him an affidavit saying they are actually married as the fable comes to a happy—and suitably moral—end.

Ten years after *Die Puppe*, Mack Sennett Studios in the Keystone Comedy silent film *Taxi Dolls* (1929) turned the uncanny into farce and presented a short, slapstick version of the mishaps that occur when a real woman gets confused with an artificial double. The film's "Lady Beatrice" is a mechanical doll in a theatrical entertainment, a doll billed as Professor Schmidt's "Celebrated Automaton" with a push-button mechanism in her back. A running riff in comedies about mechanical dolls is the tension between men's longing for a compliant female and women's own wayward or defiant ways. Says the professor, "My automaton obeys better than a real woman," but, when he demonstrates her by pushing a button, she kicks a man in the face. After his assistant touches her mechanism, she becomes a comic runaway as she walks stiffly out of the theater and right into a streetlamp.

Real women in the Sennett comedy get treated with respect, but artificial women don't fare as well. A taxi driver (Jack Cooper) mistakes Beatrice for a real woman, and, thinking she's a drunk, he gallantly says, "I'll take you back home." When he realizes she isn't real, though, he can't resist giving her a kiss as he shoves her into the cab. A policeman who is watching tells him disapprovingly, "You brute. How dare you strike a woman," but in this film's world artificial women do not merit any chivalry: explains the taxi driver to the policeman, "It's not a woman, it's a fake."

One staple of drama and film comedy is the mayhem caused by mistaken identities and identity switches, and this becomes particularly funny when the

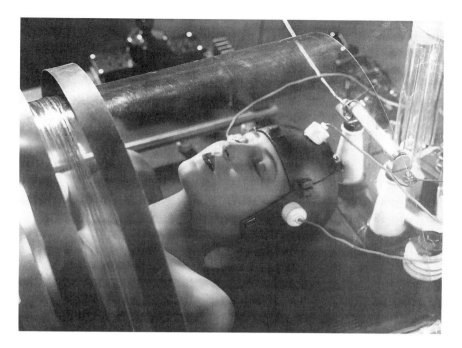

3.4 Maria with electrodes on her head being subjected to electricity and soon to be transformed into her evil double in Fritz Lang's film *Metropolis*.

uncanny is in the mix. The mishaps in *Taxi Dolls* hinge on the comic switches between the artificial and real. After the policeman recognizes that the doll Beatrice belongs to Professor Schmidt, the professor takes the doll out the taxi just as the taxi driver's boss puts his own wife in. Trying to return what he thinks is the doll, the taxi driver goes to the professor's house, telling him, "Here's your phony female." You're wrong, says the professor, "my automaton is here." When the taxi driver touches the professor's wife, however, he realizes, "That's a real woman!" and revives her back to life with ammonia.

In *Die Puppe*, Ossi breaks the illusion with coughs and sneezes. At the end of the short Sennett film, the focus shifts to the taxi driver, who, in trying to hide out from his boss, imitates an automaton. Posing as a "zultan" or sultan automaton with a beard, he squirms as a cockroach crawls into his clothes and later stares at himself in the distorted, mirrored surface of the taxi at the movie's end.

Metropolis and *Bride of Frankenstein*

While Lubitsch's *Die Puppe* and the Sennett Studio's *Taxi Doll* delighted in the comic ambiguities of female doubles, German director Fritz Lang's classic silent film *Metropolis* (1927) evoked the sinister ramifications of creating a duplicate that is indistinguishable from a real woman. In one of the film's most riveting

scenes, amid lightning-like flashes and bubbling beakers, Rotwang the scientist-inventor in the film turns a lever in his lab and launches a startling transformation: he creates an exact replica of the captured Maria who lies imprisoned in a long glass case with electrodes on her head (fig. 3.4). In this pivotal scene, Maria's features are transferred to a metallic robot, which will soon become a diabolical double of the real, saintly Maria. A close-up of the robot's face magically dissolves into the face of Maria, and, as her eyes suddenly open, she emerges as a new seductive creature that will entrance men and lead the city's workers dangerously astray.

Maria's transformation must have seemed magical to the film viewers who first saw *Metropolis* when it opened in Berlin in 1927. In 1928, a much-edited version that was cut by 25 percent from the original played in New York. The discovery of lost film footage and the release of a newly restored version in 2010 helped highlight how Maria's transformation from saintly to demonic became a central tension in the film (figs. 3.5 and 3.6).[10] German actress Brigitte Helm play both the "good" Maria and her evil double.

With its screenplay by Lang's wife Thea von Harbou, the film presents the "good" Maria as a woman who offers kindness and comfort to the beleaguered workers who slave like robots while moving with numbing clock-like regularity in this ruthlessly industrialized world. Joh Fredersen, the Master of the Metropolis, fears that the workers might rebel and decides that Maria's influence must

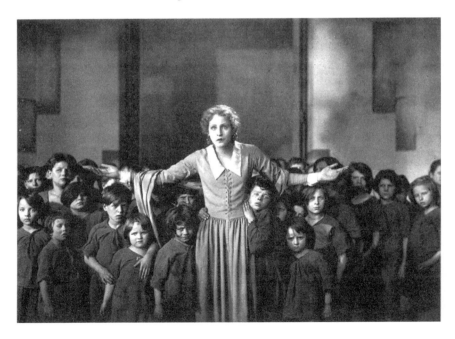

3.5 The "good" Maria, played by German actress Brigitte Helm, offers comfort to the children of the city in *Metropolis*.

Mannequins, Masks, Monsters, and Dolls • 71

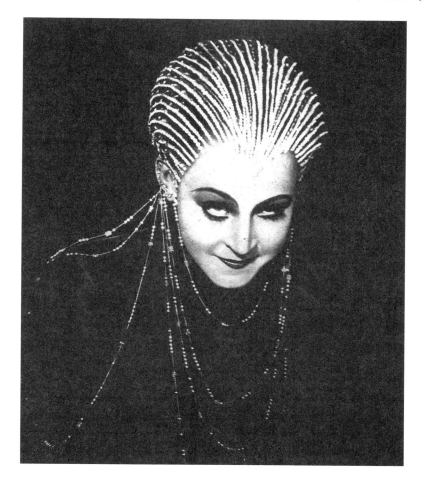

3.6 The evil, android version of Maria, also played by Brigitte Helm in *Metropolis*, is a sultry siren who leads men astray.

be undermined. He asks the scientist Rotwang to create a duplicate or false Maria to challenge the real Maria's credibility and destroy the workers' belief in her. Fredersen's son Freder, meanwhile, becomes enthralled with the real Maria and is distraught when Rotwang captures her to serve his evil purposes.

In the film, the artificial Maria is a product not of magic but of science and technology as Rotwang's metallic female robot is transformed into Maria's demonic double. With his deranged eyes and lab full of beakers and electrical equipment, Rotwang is the film's archetypal mad scientist—a cinematic descendent of Victor Frankenstein and precursors of Dr. Pretorius in British director James Whale's campy 1935 film *Bride of Frankenstein* and Peter Sellers's later, hilarious rendition of Dr. Strangelove in Stanley Kubrick's brilliant satirical film about the Cold War.

In *Metropolis*, the robot or *Machinenmensch* that Rotwang uses for the transformation was originally created by him as a tribute to Hel, the woman that both Rotwang and Fredersen had once loved but who, after marrying Fredersen, had died giving birth to Freder. In the restored version of the film, we learn more about Rotwang's devotion to Hel's memory; some have argued that references to Hel were deleted in the edited version because her name looked too much like Hell. In one restored scene, Fredersen goes to Rotwang's house, pulls back a set of curtains, and is astonished to see a monumental sculpture of Hel's head.

Rotwang shows Fredersen his metallic robot and says in another twenty-four hours (after the workings of his "transformation machine"), no one will be able to tell the difference between the robot and Hel. (Revealing his obsessions, when Rotwang later chases the real Maria, he calls out, "My Hel!" and says "The woman is mine!"). When he first created the robot, Rotwang had intended to give it Hel's own features. Instead, he decides to use it to create an android version of Maria to extract revenge, and he later instructs the robot to destroy Fredersen, Freder, and the city. Through special effects, the film creates its own magic in the transformation of Maria into her duplicate. After capturing Maria, to start the transformation process, Rotwang turns on the electricity that sends rings of light moving up and down, encircling the robot's body, while flashing electrical discharges shoot toward Maria's body lying in the glass tube.[11]

Rotwang's creation of Maria's evil android double is, on one level, a technological feat tapping into an ancient and recurring cultural theme—the quest to create an artificial human being. Legendary medieval tales of the golem created by Rabbi Loew in Prague, Victor Frankenstein's feverish creation of the Creature in Mary Shelley's novel, the creation of intricate eighteenth- and nineteenth-century mechanical automatons by clockmakers, and today's lifelike robots reveal that the idea of creating an artificial human has been and remains a captivating goal.

In the film, the false Maria is an evil being representing science and technology out of control—a female version of Frankenstein's destructive monster who menaces society. She also embodies the familiar female archetype of a woman who is both harlot and saint, angelic comforter and diabolical destroyer. The good Maria, who offers comfort and hope to the workers, is transformed into a seductive vamp who dances lasciviously at the film's Yoshiwara nightclub in front of leering, tuxedoed men. She later also enflames the passions of the workers. Inciting them to riot, she tells them, "Let the machines starve, you fools! Let them die!" and "Death to the machines!" as the mob rushes toward the Moloch-Machine, the powerhouse of the Metropolis, their destructiveness leading to flooding, crashing, and great flashes of light.

This false artificial woman becomes the source of Freder's horror and anxiety when the solace-giving Maria inexplicably turns into a maniacal siren. These dual visions of Maria embody some men's deepest longings and fears—the longing for a woman who offers comfort and the fearsome dangers of a *femme fatale*.

In his compelling essay, "*The Vamp and the Machine*: Technology and Sexuality in Fritz Lang's *Metropolis*," Andreas Huyssen argued that the "machine-woman" in the film embodies men's fears of rampant female sexuality, which elides into an equivocal view of technology itself. In the film, the "myth of the dualistic nature of woman as either asexual virgin-mother or prostitute-vamp is projected onto technology, which appears as either neutral and obedient or as inherently threatening and out- of- control."[12]

Echoing a theme from *Metropolis*, in James Whale's 1935 film *Bride of Frankenstein*, the artificial woman that the Monster hopes will bring him friendship and fulfillment causes him anguish and misery instead. The duality is there from the beginning: in the film's opening frame story, the British poet Percy Shelley, talking to Lord Byron, says of his wife, "She's an angel." "You think so," Mary Shelley murmurs, adding that as a writer she can create monsters, which sets the stage for her story.

The ambiguities of identity in both films were heightened through casting. In *Metropolis*, Brigitte Helm plays both Marias, and in *Bride of Frankenstein*, Elsa Lanchester played the role of both Mary Shelley and the artificial "bride" (coyly, the film's credits omit Lanchester's name for the Bride, writing simply, "Monster's Mate. . . . ????").

In Shelley's original novel *Frankenstein* (1818, 1831), on which the 1935 film was very loosely based, the lonely and tormented creature insists that Frankenstein create a companion for him "of the same species with the same defects," an answer to the Monster's dreams. Filled with anguish and remorse, Frankenstein destroys the partially created female mate before he actually finishes it.[13] But the film's screenplay presents a different motivation: the mad scientist, Dr. Pretorius, is intent on creating a "man-made race" and for this needs to also create a female; he wryly quotes from the Bible, "Male and female, created he them." The Monster's longing for a female provides a convenient rationale for a female to be made.

As constructs created by men, artificial women in these early films are often custom-made fabrications, an assemblage of parts. Whale's film uses elaborate special effects—an inspiration for later filmmakers—to depict the macabre composite creature made from the stolen corpse of a pretty young nineteen-year-old woman, a brain perfected by Dr. Pretorius, and the heart of a woman recently murdered by Pretorius's assistant. Elizabeth Young has argued that as an assemblage, the Bride is emblematic of the social construction of women themselves. The Bride becomes "an essentialist nightmare, whereby women are literally constructed, assembled horrifically from female body parts," and her segmented nature is an antidote to male anxieties—"there is something in whole female bodies to be feared."[14] Young's argument is intriguing and may certainly enter into men's constructions of female dolls and mannequins, but its application to the Bride in the film is problematic because, in Shelley's novel, the ghastly looking male creature is himself a construction assembled from dissected human

body parts and the slaughterhouse—a construction that comes alive when Frankenstein succeeds in "bestowing animation upon lifeless matter."[15]

Swathed in bandages, this composite female creature in the film is animated by first being placed on a platform and raised through the tower roof during a lightning storm when currents of electricity are transmitted from kites to its head during a storm. Later, when her mummy-like bandages are peeled away, the camera fills the frame with a close-up of her open eyes as Henry Frankenstein says dramatically, "She's alive!" Dressed in white, she is an imposing, towering figure with streaks that look like white lightning in her impressively coiffed hair. (Her hair was literally a construct: as women from the 1850s to the 1880s wore horsehair crinolines and wired cage crinolines as a framework for their voluminous skirts, Lanchester's hair was brushed over a five-inch-tall wired horsehair armature [fig. 3.7].)[16]

The element of the uncanny adds to the poignancy of the film as the Monster takes this woman for real. To the viewer, the Bride is clearly an artificial creature. Though the composite nature of her body is seamlessly covered in a long white dress, her starkly illuminated face shows stitch lines, and she walks with herky-jerky movements of an automaton. But to the Monster (played by Boris

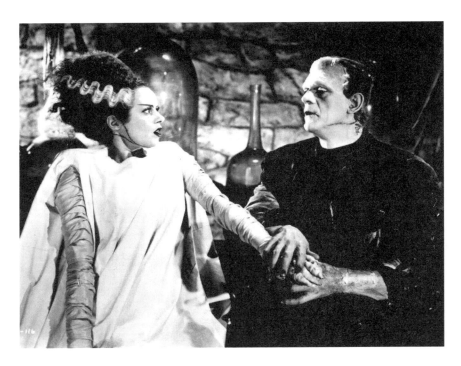

3.7 The Monster (Boris Karloff) and the Monster's Mate (Elsa Lanchester) in James Whale's 1935 film *Bride of Frankenstein*, loosely based on Mary Shelley's novel *Frankenstein*.

Karloff), looking at her with a tender glance and soft focus on his face, she offers the promise of comfort and connection—a way out of his isolation.

In Hoffmann's "The Sandman," Nathanael's preoccupation with his eyes embodies his anxieties, but when he gazes on Olympia he sees only a soothing loveliness. To observers and his friends, Olympia's eyes have a vacant look, but Nathanael feels he is being seen. While she is a cipher, to him, she seems to look at him with ardor and admiration. In *Bride of Frankenstein*, the Bride's eyes too become central when she first opens them, but her gaze later becomes lethal when she views him not with love but horror.

In her seminal essay, "Visual Pleasure and the Narrative Cinema" (1975), Laura Mulvey argued that cinema itself was shaped by a voyeuristic "male gaze"—a gaze which, as Elizabeth Young wrote "both symbolizes and ratifies male power," and creates a visual objectification of women and a form of control.[17] Feminist film criticism has focused on the Bride. As Young noted, when the female in *Bride of Frankenstein* gazes directly into the camera, the film calls into question "the primacy of the male gaze" and focuses on the Bride's perception of the Monster instead. After her bandages are dramatically removed, the Bride takes one look at the Monster and lets out a piercing scream and hiss, dashing his hopes forever. When she shuns and runs from the Monster, it is a "final, fleeing moment of female power," and, as Mary Jacobus wrote in her essay "Is There a Woman in This Text?," the film highlights the Bride's sexual authority and autonomy when she refuses to be his mate.[18]

The film's focus, however, is her impact on the Monster. Though couched as a horror story, the film's pathos and poignancy comes from the Monster's own bitter disappointment with the artificial woman. Invested with the Monster's dreams, this fabricated creature only brings him anguish instead. Her gaze and rejection are devastating, producing destruction, but her mouth becomes central too. When he goes toward her and utters hopefully "Friend," she lets out a piercing scream. The camera focuses with an unsettling, almost surreal closeness on her gaping mouth, which becomes a yawning maw, as monstrous as the Moloch machine in *Metropolis*.

Near the end of the film, the Monster concludes bitterly "We belong dead" as a tear rolls down his face. Shunned by his potential bride, he pulls a lever in Pretorious's lab, causing an explosion that kills them both as Elizabeth and Henry watch in horror from afar. For this macabre, isolated man, his misperception that the newly constructed artificial woman/Bride would offer him new beginnings and companionship turns out to be devastating, a source of his anguish and grief.

The Blue Angel and Marlene Dietrich

During the 1920s and 1930s, the theme of the uncanny continued to shape the work of filmmakers and artists with the focus sometimes noticeably shifting to women playfully donning masks or masquerading as artificial to achieve their

own ends. In 1930, a *Vogue Magazine* cover illustration foregrounded women's uses of cosmetics and fashion to construct a mask, a surface identity of glamour and beauty (fig. 3.8).

My photograph *Marlene* (2001, plate V) evokes the allure and the ambiguity of the uncanny where it is difficult to tell if this mannequin resembling

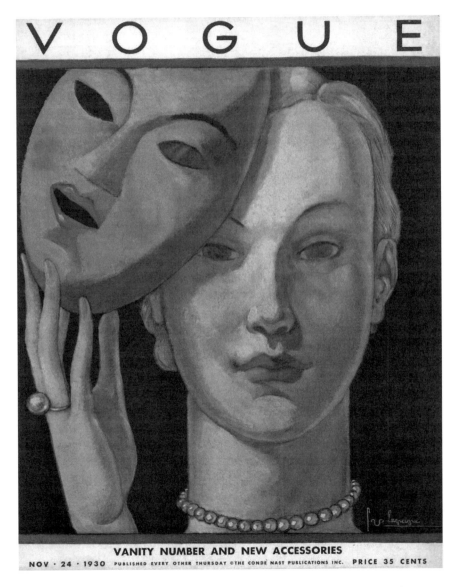

3.8 The elegant woman behind the mask. *Vogue* magazine, cover illustration, November 24, 1930.
© Vogue Magazine/Condé Nast.

Marlene Dietrich, the iconic star of Josef von Sternberg's 1930 film *The Blue Angel*, is inanimate or real. The mannequin bears witness to the great film star's ability to embody the exaggerated femininity of the *femme fatale*—the type of disguise or mask, as argued by feminist film theorist Mary Ann Doane in her essay "Film and the Masquerade: Theorising the Female Spectator" (1982), which, when worn by women, "constitutes an acknowledgement that it is femininity itself that is constructed as a mask." In allowing for a "destabilization of the image," the masquerade, wrote Doane, "in flaunting femininity, holds it as a distance. Womanliness is a mask that can be worn or removed." Considering the power relations of the "fetishistic gaze in the cinema" when male spectators objectify women, Doane asked provocatively, "What is there to prevent her from reversing the relation and appropriating the gaze for her own pleasure?"[19]

Caroline Jones has written persuasively about *fin-de-siècle* fears of the *nouvelle femme*—the "New Woman" who was envisioned by men as a *femme fatale* with a fearsome masculinity, the type of woman who embodied a spirit of independence, a woman who smoked and rallied for suffrage.[20] But rather than being fearsome, Marlene Dietrich, in her twentieth-century film roles as a *femme fatale*—an enticing but deadly seductress—appropriated the look of exaggerated femininity by paradoxically and seductively cloaking herself as masculine while wearing a man's top hat and trousers as an assertive androgynous exterior and playfully positioning herself as an object of desire.

In the role of the musical hall entertainer Lola Lola in *Blue Angel*, she's the perfect foil to Immanuel Rath, the film's bachelor professor who is a repressive, stern man, angry that his students are secretly going to the nightclub to see her perform. Rath is a man trapped by his own tightly wound repressions and rigidity, a man like the carved, clockwork male automatons that are periodically interspliced in the film as they move across the screen whenever the clock chimes, suggesting the relentless movement of time and the rationalized regularity of technology. In his feelings of entrapment and longing to be free, he is like his favorite singing caged bird, which dies at the beginning of the film. Rath, who teaches *Hamlet*, is torn by his own inability to act. What enlivens yet ultimately destroys him is his infatuation with the seductive Lola, who knows how to play him all too well.

Lola Lola is in charge of her own constructed self, a woman who coyly masquerades as an eighteenth-century lady automaton and then gleefully casts the role aside. At the club, she appears in costume wearing an exaggerated eighteenth-century dress made box-like and absurd by the vertingale or farthingale framework underneath (an echo of the underskirts worn by wealthy Renaissance and eighteenth-century women who wore the garments made of whalebone or wooden hoops underneath their voluminous skirts which made them move stiffly, like dolls). For Lola, though, the rigidity is just a masquerade, an alluring look of formality that only thinly covers her provocatively lascivious-looking self.

Julie Park wrote about the early twentieth-century German fascination with half-dolls—miniature dolls with tiny bisque heads and torsos wearing wide eighteenth-century skirts that covered teapots, pincushions, and other domestic wares. These dolls may have been seen by Freud and had an impact on his writing.[21] For Lola, though, beneath her skirt is not a teapot but a seductive, bawdy woman. In her dressing room where the professor has furtively come to visit her, she strips off her farthingale skirt and provocatively drapes her underwear on the professor's shoulder. (Meanwhile, in a film that plays with themes of hiding and discovery, Roth's students hide in a space underneath the floor in her dressing room.)

In her seduction of the professor, Lola smokes a cigarette as she puts on her mask of femininity, including mascara and has the professor hold her powder box as she flirtingly tells the portly man, "You're not at all bad looking." Soon he is covered in powder, the fairy-dust of her illusions. After she has sex with him, she calls him her "sugar daddy," and, as a chanteuse, she becomes his replacement bird. A sultry singer, Lola wears a man's top hat and asks disingenuously, "I often wonder why I appeal to men," though the film makes it clear: as she sings her signature song in the film, "Falling in Love Again," the camera pans to a large carved nude figure of a woman that looks like a ship's masthead, an emblem of Lola's own smoldering sexuality, which she embodies with an androgynous swagger: she sings with her hands on hips, and when she sits, she crosses her legs in a masculine stance with her dress exposing her underwear (fig. 3.9).

The mask of masculine bravado worn by both Dietrich the actress and Lola Lola her fictive embodiment is emblematic of the paradoxes of being female and the complexities of women's socially constructed identities—identities that women may sometimes both embrace and use to their own advantage. Women are often expected to be both artificial and genuine, to wear surface masks of beauty yet also be emotionally authentic. Lola in the film smiles at Roth behind a mask of beauty and glamour, a mask that may give her cover and help camouflage her secret self (feminist psychoanalyst Joan Riviere, in her much-debated 1929 essay, "Womanliness as Masquerade, however, provocatively suggested that the mask of femininity may—in effect—be no mask at all").[22]

Terry Castle in his study of eighteenth-century British fiction and the masquerade pondered whether women wearing costumes and masks at eighteenth-century balls were able, at least temporarily, to suspend traditional gender relations, and free themselves "not as a commodity placed in circulation by men, but according to [their] own pleasure" or, were they, he wondered, still embracing conventional female roles, transforming themselves into spectacles or fetishistic objects for men's pleasure?[23] For Lola, a twentieth-century woman in the stylized guise of an eighteenth-century *femme fatale*, the camouflage seems to paradoxically work both ways—commodifying her yet freeing her as well.

Although Lola/Dietrich with her impersonation dominates *Blue Angel*, it is Rath whose pathos drives the narrative. Back in his classroom, the professor

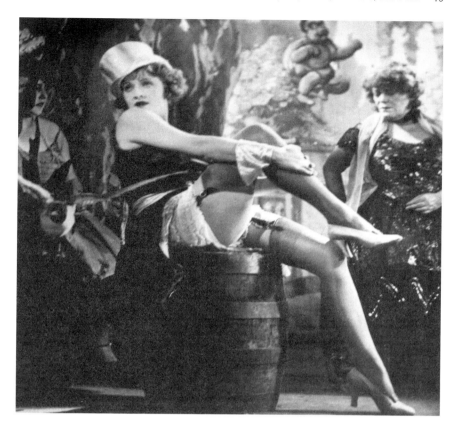

3.9 Marlene Dietrich as Lola Lola in Josef von Sternberg's 1930 film *Der blaue Engel* (*The Blue Angel*).

enters to discover that the boys have covered the board with cartoons of him, and in one he is carrying his top hat in hand as well as Lola's severed leg. In their schoolboy and male imagination the doll is disassembled, with the leg becoming a metonymy for her sexual self. The masculine Lola has emasculated him, and he's forced by the school to tender his resignation. As she readies to leave for another venue, he gives her a ring and asks her to marry him. Crowing with pride like a rooster, Rath, at that moment, is at the height of his infatuation.

The film follows Rath's humiliation, degradation, and downfall over the next several years. The once immaculate man becomes dirty and disheveled; he sells postcards of Lola; he becomes, in effect, her servant: he puts her stockings on her, hands her a curling iron, and is her assistant and slave. He now becomes the one who puts on a mask, that of a clown, and is coerced into performing as an assistant by the magician at the Blue Angel. Humiliated by the magician's tricks, with eggs smashed on his face, in his anguish he crows like a rooster, no longer in pride but now in pain, as Lola seduces another man and takes him upstairs.

Ultimately, both Lola and Rath are obsessive creatures—like the images of automatons that parade by on the screen. Though Lola has moments of tenderness and compassion toward Rath, she compulsively keeps taking up with new men. There is, for both of them, a void underneath. Amid the mournful sounds of the fog horn that recurs throughout the film, Rath at the film's end goes sadly back to his old classroom desk in the gymnasium and dies as Lola continues her loop of seductions, a woman who remains driven—in an almost mechanistic way—by her own obsessions.

Women as Dolls—1920s and 1930s

During the 1930s, artists also examined the role of masking and dolls in the construction of female identity. Lola in *Blue Angel* with a weary self-awareness crafted her own persona as the seductive but ultimately unavailable and elusive masked *femme fatale* as a strategy to maintain her own autonomy. For Lola, the object of men's gaze, the artifice of the *femme fatale* mask helped her deflect and redirect her object status. In the film, she both embraces and distances herself from a paradigm of seductive femininity—a strategy that was also adapted by European women artists during the 1920s and 1930s, as seen their arresting photographic images of themselves posing with dolls.

For these women artists, the doll as female simulacrum becomes both an extension and ironic counterpart to themselves. Rather than evoking the ambiguities of the uncanny, dolls in their work become emblems of artifice and the cultural roles women are often expected to assume, roles that women may ambivalently embrace while still insisting on their own independence, identity, and integrity. In their photographs of dolls, these women artists both embraced and subverted the very notion of woman as pretty, manipulable playthings for men's delectation and desire.

In the 1920s, Hannah Höch was photographed wearing a stage costume and holding one of the two dolls that she had created that had a bizarre appearance: her dolls, with their misaligned eyes and raggedy looks subverted cultural notions of female beauty. Her photocollage *Der Meister* (*The Master*, 1926) subverts the beautiful doll look even further: bridging the distance between doll and observer, the image is a distorted close-up of a doll's face with large penetrating eyes—a sardonic take on the doll as cultural construction of femininity and on pretty dolls seen in Weimar media as a cultural feminine ideal.[24]

Capturing a close and self-conscious connection between woman and doll, a photograph of the Zurich cabaret artist Emmy Hennings pictured her holding a doll in the Cabaret Voltaire in 1917, a cabaret founded a year earlier by her husband Hugo Ball for Dada performances. For Hennings the performer, the doll becomes analogous to her own artifice, an extension of her theatrical, presentational self. Said Hennings, "I sit there in front of my mirror and I can observe this doll. I know that I can double myself."[25] Hennings's identification with a

doll as an extension of herself is both reflective and rueful—a recognition of her theatrical self as a dramatic construct and perhaps a self-aware embracing of this doll-self, too.

But one of the most arresting images of a performer with her doll/double—without Hennings's self-reflective element of irony—was a photograph of the Russian ballerina Alexandra Danilova (1903–1997) who had been was a principal dancer in Serge Diaghilev and George Balanchine's Ballets Russes (she was also Balanchine's lover for many years) and a performer in the Ballets Russes de Monte Carlo founded by director Colonel W. de Basil in 1932. In a 1934 photo, Danilova appears as a performer in de Basil's season of the Ballets Russes at Covent Garden Opera House in England. Dressed in the role of a cancan dancer in Leonide Massiné's ballet *La Boutique Fantasque*, she holds a doll of herself wearing a similar costume (fig. 3.10).

While Hennings and Höch both embraced and distanced themselves from identification with doll-women, Massiné's *Boutique Fantasque* was an unabashedly joyful celebration of dancing dolls.[26] In his ballet, which was based on Josef Bayer's Viennese ballet *Die Puppenfee* (*The Fairy Doll*, 1888) and premiered in London in 1919, an American family and Russian family visit a toyshop in the 1860s where the mechanical toys—which include Cossacks, tarantella dancers, and a pair of male and female can-can dancers who are lovers—dance as they are demonstrated by the owner. A crisis occurs, however, when the Russian family buys the male can-can dancer and the Americans buy the female can-can dancer; after a night in which the toy automata come to life dancing, on the next day the returning customers come to retrieve the can-can dancers and discover the two lovers are no longer there. When the customers irately attack the shop owner, Cossacks chase them from the store, and the ballet ends with the dancers and shop owner dancing in the window.

Massine's ballet celebrates the magic and delight of dancing dolls, and the photograph of Danilova by the photographer Sasha creates a close identification of woman with doll. The eyes of both the doll and the dancer are aligned and heavily outlined in makeup, creating an image that embraces the artifice as the dancer becomes one with her role. But Danilova and her artificial counterpart are no charming, pretty dolls; rather, they are starkly defined females whose faces also suggest the distancing of a mask.

The Dolls of Hans Bellmer

During the 1920s and 1930s, male avant-garde had their own fetishistic interest in female dolls and mannequins. While women artists were investigating the doll as a cultural construct or appropriating the look of a doll to probe female identity, during the 1930s Berlin artist Hans Bellmer created disturbing, often grotesque female dolls and mannequins that reflected his fetishistic fascination with young girls and the female body. He began constructing female dolls in

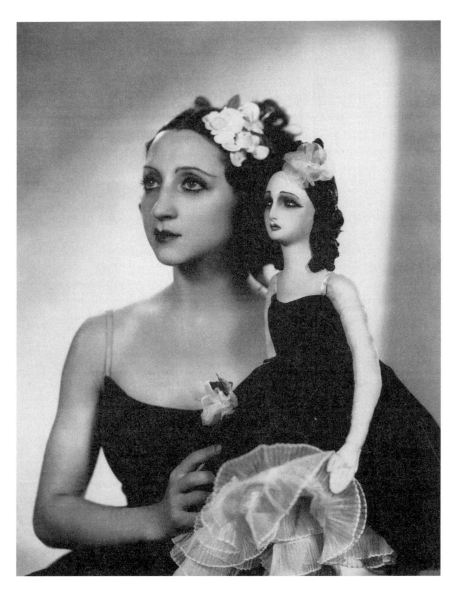

3.10 Russian ballerina Alexandra Danilova with a doll of herself. She is dressed as a can-can dancer in the Ballets Russes performance of Massiné's *Boutique Fantastique* at Covent Garden Opera House.
Photo by Alex Stuart Sasha, © Hulton-Deutch Collection/Corbis.

1933–1934 and presented ten tipped-in photos of them in his privately published *Die Puppe* with an introductory essay "Memories of a Doll Theme" (1934). Later, eighteen of his photographs of his constructed life-sized mannequin or "doll" *La Poupée* were published in a group of images titled *Poupée—variations sur le montage d'une mineure articulée* (*Doll: Variations on the Assemblage of an Articulated Minor*) in the December 1934 issue of *Minotaure* and issued separately as a French edition *La Poupée* in Paris in 1936.

In "Memories of a Doll Theme," he remembered the pleasures of tiny dolls of his childhood and his thoughts of little girls, and revealed also his mixed emotions about these dolls: "Would it not be in the very reality of the Doll that the imagination would find the joy, ecstasy, and fear that it sought?"[27] Fulfilling his fascination, Bellmer created two versions of the doll, produced in several stages. In the first stage, the artist, working with his brother Fritz, an engineer, created a doll's face and torso of flax fiber covered with plaster of Paris, one leg, and supplemented with wigs, a piece of clothing, and glass eyes.[28] The second version used ball joints so that the mannequin could be fragmented into individual parts, manipulated, and reassembled. He used this second figure in more than one hundred photographs from 1936 to 1938. In one particularly arresting and troubling photo, the upper torso of a doll/mannequin scantily clad in a chemise or cotton undershirt with bare buttocks showing is both flirtatious and vulnerable: she has her face tucked coyly behind her shoulder, with the photo also revealing a glimpse of her prosthetic legs (fig. 3.11).[29]

In Höch's *Dada/Ernst*, photographic clips of women's legs conjured up sardonic views of women's sexuality in the media, but for Bellmer body parts and women's legs suggest his own ambivalence about women themselves. In another photograph of his mannequin, the fragmented leg becomes an isolated object in a prettified image of order: it incorporates a single doll's leg wearing a high heel, becoming a fetishistic object decorously placed in a still life with lace. But other Bellmer mages present a more troubling view. The artist rendered the (perhaps to him fearsome) doll-woman powerless by fragmenting the *poupée* into pieces. The doll is disintegrated into a crowded and jumbled assemblage of parts: a bare armless torso, pelvis, arms, head and hand from the first doll, eyeball, rounded spherical breasts, and head.

In Bellmer's work, women are alluring and provocative with the power of the seductress yet also, in a sense, made safe by being armless, and with their amputated legs they become crippled and controlled. His 1937 sculpture *The Machine-Gunneress* gives her the power of a weapon and an anonymous face (she has no eyes or nose), yet her two disembodied spherical breasts and comic legs render her not fearsome but a female caricature. Bellmer perceived himself as a type of Pygmalion, constructing not a beautiful female work of art but an erotic simulacra, one he could probe and operate with push-button ease. In his "Memories of a Doll Theme" essay, he wrote about wanting "to construct an artificial girl with anatomical possibilities . . . capable of re-creating the heights

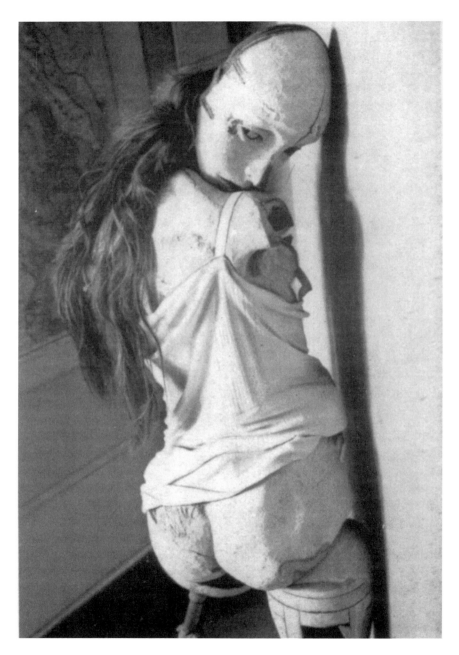

3.11 Plate from Hans Bellmer, *La Poupée* (*The Doll*) (Paris: Editions G.L.M., 1936). Gelatin silver print.

of passion even to inventing new desires." His conception of this artificial girl was suggested by a linocut illustration printed on pink paper of a doll's torso included in his book. In the illustration, a black-gloved finger reaches to press the nipple on a bare female torso with no head, arms, or legs, and on the left, a drawn eye looks closely at the torso's belly (fig. 3.12).

Bellmer's plan was to create a type of push-button female with a mechanism that he would incorporate into the doll's belly and operate by pressing the figure's left nipple. A fetishistic voyeur, he planned to invade the doll's electrically illuminated interior, to "Lay bare suppressed girlish thoughts ideally through the navel, visible as a colorful panorama" deep in the girl's stomach. The panorama itself would be constructed of a hollow wooden disk with little boxes attached to it containing miniature panoramas representing the thoughts and dreams of young girls. Through this surrealistic fantasy fusing technology

3.12 Hans Bellmer, linocut illustration from his essay, "Memories of a Doll Theme" in his book of images, *La Poupée*.

and the erotic, the artist would reduce the girl to a passive object on which he could feast his eyes and penetrate with ease.

Female Mannequins and Women as Machines

During the 1930s, the European Surrealists also had a fetishistic interest in another form of simulated woman—female mannequins that they transformed into playful, sculptural works of art. In 1938, they presented their work at the Exposition Internationale du Surréalisme at the Galerie des Beaux-Arts in Paris. Visitors walking down a corridor on the "Rue Surréaliste" saw a series of sixteen dressmakers' mannequins transformed by a group of artists including Max Ernst, Jean Arp, Yves Tanguy, Sonia Mossé, Man Ray, Marcel Duchamp, Joan Miró, and André Masson who added props and clothing to decorate and clothe shop mannequins. Wrote Georges Hugnet twenty years later, "The Surrealist artists all felt they had the soul of Pygmalion," as they transformed the mannequins into fanciful Galateas.[30]

While the ballet *Coppélia* and films like *Die Puppe* saw the humor in irrepressible women who broke through the restraining role of the doll, these mannequins created by the Surrealists were either restraining or restrained. Max Ernst's mannequin wore a black veil and had a man underneath her foot, while André Masson's mannequin had its head encased in a wicker bird cage, its mouth gagged with a pansy, and its vulva covered with a g-string decorated with a circle of glass tiger eyes surrounding a mirror. (Sonia Mossé, the only female artist in the mannequin exhibit, covered her mannequin's mouth and face with beetles.) The glass eyes on Masson's mannequin suggest that she is an object for male viewing, though the mirror reflecting the viewer returns the gaze.

In an age of machine idolatry, Surrealist artists had earlier also enjoyed constructing other forms of simulated women—images of composite female fusions of woman and machine, sometimes isolating body parts like legs as metonyms for the whole. Raoul Hausmann's photomontage *Fiat Modes* (for a magazine cover) created a type of wheel with six pairs of women's legs as spokes radiating outward flanked by paper cut-outs picturing a woman wearing a bathing cap and fashion models.[31] Francis Picabia's machine-women were satirical images of independent-minded women of the modern era. In his drawing *Fille née sans mère* (*Girl Born without a Mother*, 1917–1918), he painted over an illustration of a steam engine probably found in a railway engineering journal to spoof men's fantasy of creating life without a female. In his sardonic drawing *Portrait d'une jeune fille américane dans l'état de nudité* (*Portrait of a young woman in a state of nudity*, 1915), Picabia, who was allied with the New York Dada artists Marcel Duchamp and Man Ray and the Stieglitz group, produced an image of a young American woman as a spark plug, associating women with new electrical energy and the erotic, and as a "kindler of flame."[32] His spark-plug female is both hot and cool, seductive and coy: she gives a short burst of generative power

and bears the word "FOR-EVER," coyly holding out the promise of the eternal and the enduring.[33] Continuing the electric imagery, in 1917, he created a young American female as an Edison light bulb on the cover of his journal *391*.

Berlin Dada artist Hannah Höch, however, used the light bulb image to create a construction of female identity without Picabia's coy and erotic edge. The artist in her photocollages presented her own witty investigations of female identity and cultural constructions of female beauty that both embraced and satirized the machine aesthetic of the era. Italian Futurist F. T. Marinetti in his 1909 Futurist Manifesto had earlier famously proclaimed the motor car as an emblem of modernity—"A roaring automobile . . . is more beautiful than the Victory of Samothrace"—and in Höch's photocollage *Das schöne Mädchen* (*The Beautiful Girl*, 1920), she created a composite image of a young woman wearing a bathing suit who sits on a metal girder surrounded by cut images of modernity: a BMW automobile insignia and a light bulb in place of her head (fig. 3.13).[34] Her photocollages, which used cut fragments from magazines and advertisements, were both a tribute to the modern woman and a sardonic critique of women's representation in the media.

Höch in *Beautiful Girl* uses the light bulb image to create a construction of women's identity without Picabia's coy and erotic edge. The woman with a light bulb in front of her face has an obscured identity, yet the light bulb suggests her illuminating intelligence and brightness. Dressed in a bathing suit, she has a casual insouciance as she sits with her bare legs crossed, and the bathing suit itself suggests her independent ways. Women in the 1920s wore bathing suits even on road trips to signify their flapper-era independence: in a 1923 photograph from America's *Motor* magazine, two women step out of their automobile wearing bathing suits as the writer Laura Breckinridge McClintock asks, "What woman having tasted the joys of entire freedom would want to go back to man-chaperoned obscurity in the back seat?"[35]

During the 1920s, a period in which Russian Constructivist artists as well as Futurist and Dada artists were intrigued by puppets and marionettes, Russian avant-garde artist Alexandra Exter created her own version of mechanistic-looking women in her marionettes including *Dames en Rouge* (*Women in Red*) and *Longhi III* with its suggestion of a woman wearing a wide farthingale skirt. Her marionettes, comprised of abstracted shapes reflecting the Constructivists' love of the hard-edged mechanistic imagery, are spirited figures that look engaged in a spirited contrapuntal dance.[36]

In the next decade, a group of American women students participating in the Bryn Mawr Summer School for Women Workers in Industry created their own, far different versions of machine women as they imitated the rote movements of robots while performing experimental dances outdoors (fig. 3.14). In their stylized poses captured in photographs of their "Machine Dance" and "The Robots," these women inhabited the spirit of industrial workers and transformed themselves into lively robotic figures.[37] During the 1930s, Charlie

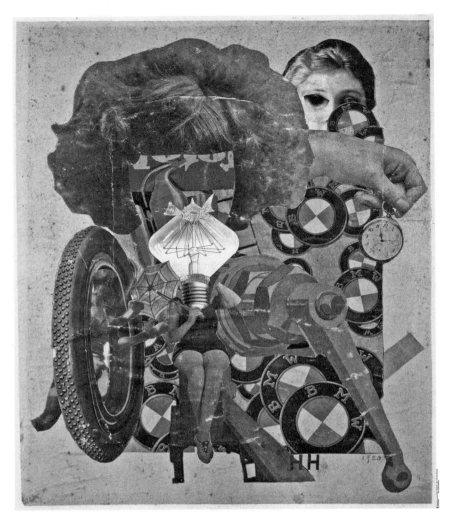

3.13 Berlin Dada artist Hanna Höch's photocollage *Das schöne Mädchen* (*The Beautiful Girl*), 1920.
Private collection. Photo: bpk, Berlin/Art Resource, NY; Artists Rights Society.

Chaplin in his film *Modern Times* had created a comic send-off on the perils of workers subjected to the demands of robotic assembly line production—workers who virtually turn into robotic automatons themselves—but rather than being constricted and enslaved, the young women dancing at Bryn Mawr and simulating robots seem filled with energy and life.

In the years ahead, television producers, male filmmakers, and robotics engineers would fashion electronic female robots invested with male fantasies, fears,

3.14 *The Robots*. Students performing experimental dances outdoors on the lawn at the Bryn Mawr Summer School for Women Workers in Industry.
Schlesinger Library, Radcliffe Institute, Harvard University, Cambridge, MA.

and dreams—and even create their own type of women dancers: female robots serving as ideal dance partners moving in perfect tandem with men. Women artists, meanwhile, would be producing their own, inventive female robots—animated simulacra that sometimes stamped their feet in defiance and deftly evaded control.

4

Simulated Women in Television and Films, 1940s and After

During the wartime years of the 1940s, when Americans were looking for romantic fantasy and comic relief, the Pygmalion myth of a man who falls in love with a beautiful statue that comes to life had a welcome resonance as it resurfaced in the Broadway musical *One Touch of Venus* (1943) with music by Kurt Weill, lyrics by Ogden Nash, and book by S. J. Perlman and Ogden Nash. Five years later, it was followed by the romantic film comedy *One Touch of Venus* (1948), based on the play. Both versions delighted in the magic and mystery of the Pygmalion story while offering a gentle satirical spoof on American commerce and suburban dreams.

In the 1943 stage version, the lyrics of the evocative Kurt Weill/Ogden Nash song "One Touch of Venus" told of women's power over men, and in both the play and the film men are entranced by a beautiful female sculpture that comes to life. The film, however, updates the myth as it comically foregrounds men's concerns about sexy, powerful women themselves—women who can not only be lusted after and admired but kept at safe distance too. In the film, a statue found in Anatolia (Asia Minor) is put on display in Savory's Department Store, and when the store window dresser (Eddie, played by Robert Walker) gives her a kiss, she mysteriously comes to life as the beautiful enchantress Venus (played by Ava Gardner, fig. 4.1).[1]

The Hollywood film teases out some of the sexual issues implicit in the Pygmalion myth that were largely skirted or implied only obliquely in W. S. Gilbert's 1870 play and ignored almost entirely in George Bernard Shaw's *Pygmalion,* aside from the housekeeper's concerns about propriety. In Ovid's rendering

4.1 Updating the Pygmalion myth, Ava Gardner plays the voluptuous Venus, a beautiful statue come to life in the 1948 Hollywood romantic comedy *One Touch of Venus*.

of the tale—and in some translations—Pygmalion, lying down with the newly enlivened Galatea, enjoys her erotic delights. But in the 1948 film, women's sexuality is clearly a sensitive, charged issue: men like Eddie initially prefer to keep sexy women at arm's length, and the erotic female is best when immobilized in stone. This Venus is very much a simulated woman to be looked at on display, and Mr. Savory, the store owner, wants Eddie to adjust the curtain for her dramatic presentation at the store. With Venus safely stationary on her pedestal, men in the film can have fantasies about her, gaze at her, and even kiss her with no fear of their own vulnerability.

Women in the film are kept at a distance or are off-putting. They are admired from afar (Venus), persistent and demanding (Gloria, his girlfriend, who wants to marry Eddie), or are tough-talking and sardonic (Eve Arden as Mr. Savory's assistant, Molly Grant). But once Venus comes alive, one of the running sources of comedy throughout the film is the tension between her obvious sexual availability and Eddie's early efforts to get away (he frets that Gloria will be jealous or that his landlady will disapprove). Venus is seductive and enticing, but the comically jittery, fearful, nervous Eddie evades her seductions and erotic suggestions and moves away as she suggestively lies on a bed in the store's model home (in the play, however, unrestricted by Hollywood codes, Venus and Rodney embrace and bed upstairs). But rather than being really fearsome, the film's Venus manages to sooth and seduce Eddie. Unflappable, she finds his reluctance amusing and rarely gets upset when he shies away.

The men have some good reasons for being fearful: in a witty reversal of the myth, after Venus the statue comes alive, she reveals her ability to immobilize and transform men. In the film, she momentarily turns the detective into an owl and says she once turned Polyphanes into a boulder. She also captures men with her charms. When she hypnotically sings the film's signature song "One Touch of Venus" she casts a spell over Eddie (though later in the film, after Eddie has fallen under Venus's erotic spell, he is more than willing to be metamorphosed: "You could turn me into a fire hydrant," he tells her, and "it would be worth it").

The film becomes a push-pull between the lively Venus and Eddie with his longing for stasis. After Venus has come alive, Eddie wants her to return to her pedestal "where people can admire you," and his life can go back to being "sensible, orderly, practical." But when he takes her to Central Park and they dance—as so often happens when men dance with female simulacra—he's enraptured by her charms. In Shaw's *Pygmalion,* and in the French novel *L'Ève future,* phonographs are used to help animate women. Here, phonograph records are mesmerizing: under Venus's spell, Eddie sings happily that he feels "just like a record that's playing," and she adds, "repeating the same sound."

Seeing the satirical potential of envisioning Venus in a domestic, suburban world, in both the play and the film the erotic goddess Venus unwittingly inspires thoughts of marriage. Many marriage licenses are applied for while she is reported "missing" (off her pedestal), and late in the movie Eddie wants to marry her and get a little place in Ozone Heights (a satirical reference to Ozone Park in the New York borough of Queens). In the wartime 1943 drama, Venus dancing in a ballet recoils from the idea life with Rodney in Ozone Heights, but in the 1948 film, set in a postwar America, life in suburbia has its appeal as Gloria gushes over the department store's all-electric model kitchen with its pushbutton appliances—a place where "you can cook without knowing how to cook."[2]

In Gilbert's nineteenth-century drama *Pygmalion and Galatea,* Galatea's return to stone is touching and sad, but at the end of *One Touch of Venus* the

lovely Venus miraculously revives. After a bout of thunder and lightning, when Zeus says she must return to being a statue on a pedestal, she is gone but not out of Eddie's life. He is startled when a woman who looks just like her (still played by Ava Gardner) asks him where the model home is in the store. She is a new employee, Venus Jones, and the comedy leaves open the possibility that love with a real live Venus, not a simulacra, is still an option in this realm of comedy romance.

After the war, the Pygmalion story kept its appeal and resurfaced in the 1956 Broadway musical *My Fair Lady* based on Shaw's play, with book and lyrics by Alan Jay Lerner and music by Frederick Loewe; it was seen also in the London production with Rex Harrison and Julie Andrews, a 1963 television production starring Peter O'Toole and Margot Kidder, and the Academy Award–winning 1964 film version of *My Fair Lady* starring Audrey Hepburn and Rex Harrison. Venus in *One Touch of Venus* was a statue who comes sexily to life, and in *My Fair Lady,* as in Shaw's version, the irrepressible Eliza just won't be turned to stone.

In the 1964 film, Eliza, leaves her flower selling as part of a wager between Professor Henry Higgins and Colonel Pickering. Higgins provides lessons in gentility and speech, but Eliza cannot "sit decidedly still" as Higgins orders her to do. She is a woman of words who screams when she is forced to take a bath and, as in Shaw's play, is quick to defend herself: "I'm a good girl, I am!" Higgins—played with comic, misogynistic fervor by Rex Harrison—sees Eliza as little more than a commodity to be transformed: with irritation, he tells Mrs. Pearce to strip Liza of her old clothes, burn them, and wrap her in brown paper until her new clothes come. Higgins and Pickering are men who consider Eliza little more than a doll to be clothed, and after they shop for her clothes without bringing her along, the elegant French fashions, not surprisingly, have to be tailored to her when they arrive.

My Fair Lady put a comic emphasis on words: Higgins may be a master of sounds and phonetics, but in his song, "Let a Woman in Your Life" he complains that women will "jabber and chatter and tell you what the matter is with you." Produced amid the social ferment of the 1960s, the film alludes to women's rights—a group of suffragettes playing a drum and tuba and carrying a sign "Votes for Women" parade by as Higgins laments about female jabbering.

Eliza—by modifying her speech, dress, and manners—may be molded to create the illusion of upper-class gentility, but this artificial female creation frequently has outbursts that comically break the illusion. In Hoffmann's "The Sandman," Nathanael ignores the fact that Olympia only says "Ah! Ah!," but his illusions about her are brutally broken when the doll is fragmented, making it apparent to the anguished young man that Olympia isn't real. In *My Fair Lady,* Eliza's admirer Freddie just laughs and is charmed when frameworks are comically broken. While elegantly dressed for the horse races at Ascot, Eliza—who has been instructed to speak only about the weather and people's health—breaks the artifice when she yells out to one of the horses during the race, "Move yer bloomin'

arse!" (a comment so vulgar that one of the aristocratic women faints), and she also unabashedly tells the Ascot group that gin was "mother's milk" to her aunt who was murderously "done in."

With her carefully engineered speech created using "Bell's Visible Speech" and the phonograph, Eliza is the product of technology and, Higgins believes, his own Pygmalion-like skill. After she successfully passes the test at the embassy ball and is mistaken for an aristocrat, even a princess, he takes all the credit for her transformation as he sings "I did it! I said I'd make a woman and indeed I did!"

But, while Eliza may have taken on a convincingly regal facade, her authenticity remains intact. In this play and musical about language, Higgins the speech man tells her, "There's not a word in your head that I didn't put there!" But she insistently remains her own woman and with withering words says good-bye to him. Causing heartburn for critics, however, the Lerner and Loewe Broadway musical and film repeat the happy ending appended to Shaw's play in the 1938 film. Eliza comes back to Higgins at the end, and, as she turns off the phonograph recording of their early conversations to which he's been morosely listening, she ambiguously seems ready to once again serve her chastened but still infantile man.

4.2 Professor Henry Higgins (Rex Harrison) dancing with the elegant Eliza (Audrey Hepburn) in *My Fair Lady*, the 1964 film version of the Lerner and Loewe Broadway musical based on Shaw's *Pygmalion*. Rather than gazing at her rapturously, this Pygmalion admires what he considers his own *tour de force*.

Simulated Women in Television

During World War II, images of artificial females in films and art were scarce. America's soldiers were more apt to fantasize about pin-up girls and movie stars like Betty Grable than fantasize about Galateas-come-to life or compliant sexy female robots and dolls in science-fiction fantasies. Rather than being robotic machine-women, women themselves were successfully showing their mettle as riveters, welders, machine-tool operators, and more. (In a wartime comic inversion of the amorous female robot theme, a cartoon of the 1940s presented a Rosie-the-Riveter factory worker pushing away a male robot that tries to embrace her, telling him: "Cut it out, Buster! There's some ways in which automation will never replace the man!" fig. 4.3.)

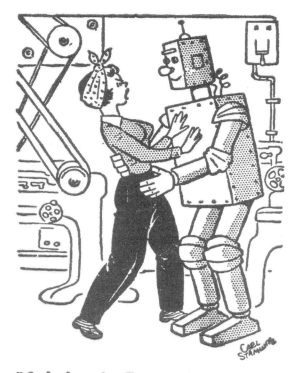

4.3 An American woman war worker in a 1940s cartoon. In a humorous inversion of the man-embraces-female-robot theme, this Rosie resists the robot.

But starting in the 1950s, with the popularity of the new media of television, producers and writers began featuring a whole range of artificial women in their programming: female androids and robots, doll-like women and female mannequins that seemed alive. During the course of the next fifty years, these images in American television and films not only reflected changing technologies but also offered revealing glimpses of the country's cultural preoccupations and changing attitudes toward women themselves.

In television dramas like Rod Serling's *The Twilight Zone,* which aired from 1959 to 1964, the theme of the uncanny surfaced anew in tales where there is a puzzling ambiguity about whether a woman is artificial or real. In postwar television dramas and sitcoms of the 1950s and 1960s, the idea of female robots and Galatea-like mannequins that come to life resonated in a cultural climate enthralled with first-generation computers, early electronic robots, and the Space Race that was underway. Often these female robots, dolls, and androids were still shaped by gender stereotypes, but they also reflected significant signs of social change, particularly the impact of the emergent women's movement, which was gaining traction starting in the 1960s. These were transitional times: though the war had helped alter perceptions of women and their mechanical abilities, television programming in its imaging of artificial females still presented ambivalent views of women as comforting as well as threatening, naïve as well as knowing, innocent and diabolical, easily manipulated females and often forceful, resistant women with minds of their own. Female robots and androids in film and television were much more than novelty figures or sci-fi fantasies. They engagingly embodied some of the central cultural preoccupations of the period, not only equivocal attitudes about women with extraordinary abilities but also ambivalent attitudes about simulations, technology, and control.

Among the earliest television series to introduce simulated women as characters, Serling's *Twilight Zone* series, featured thirty-minute dramas that evoked the dreamlike and surreal world of the uncanny. One of the most memorable episodes, "The After Hours," aired on June 10, 1960, and conjured up a world in which it was difficult to distinguish the artificial and the real. The episode is full of oddities: Marsha White (Anne Francis) goes shopping on the ninth floor in a department store for a gold thimble, but, when she tries to return the defective thimble, the manager tells her that there is no ninth floor. Traumatized, Marsha falls asleep in the store and awakens after hours. Returning to the ninth floor, she finds mannequins walking around and learns the disturbing truth: she herself is a mannequin who was allowed to go off to live a "normal" life among outsiders for a month, but at the end of that time she has to return to being a "wooden lady with a painted face" (fig. 4.4). Though she was at first horrified to discover the thimble saleslady was artificial, after her initial amazement Marsha seems to take the discovery of her own artifice in stride.

"The After Hours" raised the specter of blurred boundaries and the interchangeability of the artificial and the real, a blurring that had often been

Simulated Women in Television and Films • 97

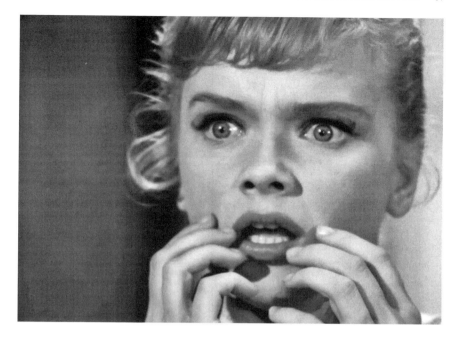

4.4 Marsha in the 1960 *Twilight Zone* television series episode "The After Hours" makes the startled discovery that the store's mannequins are alive and walking around.
PHOTOFEST

especially applicable to the cheerfully happy housewives depicted in 1950s commercials. Marsha's discovery that she herself is a mannequin turned out not to be dreadful for her, perhaps because after a decade when people were enamored with new technologies and plastics—and media images presented carefully coiffed women models with arched eyebrows and red lipstick smiling with delight at their gleaming kitchen appliances—a 1960 teleplay about a woman who found out she was really a mannequin was not particularly the stuff of nightmares after all.

But Serling in two other *Twilight Zone* episodes also evoked the pain of the uncanny. In "Lateness of the Hour" (1960), a beautiful young woman, Jana (Inger Stevens), increasingly chafes at the perfection of her seemingly idyllic family (with its robot maid, butler, and cook) and complains, "Everything built to perfection, Father, everything built for a perfect life!" Becoming increasingly unhappy, rebellious, and resentful, she insists that her parents get rid of the robot servants, and she, longing to get married, have children, and grandchildren, tells her parents, "I want my freedom!" In a crisis of identity, though, she discovers that she herself is a fabricated female with implanted memories, a being created by her parents, who were childless and wanted love. "You built me! You manufactured me!" she cries in anguish, but, by the end of the episode, her parents have wiped her memory and turned her into a replacement maid.

Serling in "The Lonely" (1959) even earlier portrayed the pathos of the uncanny as a skeptical man ultimately embraces the artificial. In this episode, the robot Alicia embodies the familiar female archetype of a woman who brings comfort and companionship to men. James A. Correy (Jack Warden), convicted of homicide, is living far in the future, a prisoner in solitary confinement on a vast desert-like asteroid nine million miles from earth. For Correy—who embodies the masculine stereotype of being enamored with technology—the only thing that keeps him company and sane, he says, is a machine, an old touring car: "I can look out there and know that it's real." To ease Correy's loneliness, the sympathetic Captain Allenby, who visits him with a crew every three months, gives him a crate containing a female robot to keep him company. Says the philosophical captain, the robot "may be just an illusion, maybe it's salvation," but the robot's operating manual insists that "for all intents and purposes, the creature *is* a woman."

In this fantasy about the latest technologies, Alicia (Jean Marsh) is a beautiful electronic woman that has a memory track and can speak. America in the 1950s was both infatuated and ambivalent about the emerging new electronic technologies (in the 1957 Hollywood film *Desk Set,* the reference librarian Bunny Watson [Katharine Hepburn] proves herself superior to the new computer). In earlier tales about artificial women, men are often fooled by appearances or quickly suspend their disbelief. In this late 1950s saga, though, Correy is more technologically savvy. At first he refuses to accept the illusion: she's just a "hunk of metal with arms and legs," a fake woman with no muscles or nerves, and he anguishes over her realistic appearance, asking in anger, "Why did they turn you into a lie!" He adds, "Why don't they build you to look like a machine?" But eleven months later, after she brings him water and reassures him she can feel thirst, heat and cold, pain, and even cry, he's fallen in love with her and, seduced by her seeming human qualities, now reacts as though she were real.

Correy's idealized relationship with Alicia is typical of the narcissistic relationship men often establish with artificial women in literature and film: he envisions her as "an extension of me," and indeed, she—intelligent as she is—is still a female that mirrors his emotions and shares his interests. She smiles broadly while playing chess with him, and he in turn paternalistically becomes her mentor and guide, showing her the constellations at night. The tension between artifice and reality comes to a head near the end. Correy is pardoned, and the crew comes to take him back to Earth. With a luggage weight limit of only fifteen pounds, there is a crisis when he's told he can't take Alicia with him. "She's a robot!" says the captain, but "She's a woman!" Correy replies, saying her gentleness and kindness kept him alive and he won't leave without her.

As in "The Sandman," with its evocation of the uncanny, "The Lonely" presents in that recurring nightmare situation where an artificial woman's interior framework is exposed, causing a harsh shock when the man recognizes that his beloved is just a construct rather than real. The illusion is shattered, and Correy

is forced to recognize Alicia's artifice and status as object when the captain takes out a gun and shoots her, which leaves her sprawled on the ground, wires and electronic parts now grotesquely exposed. Telling Correy "it's a bad dream, a nightmare," the captain finally gets the saddened Correy to leave while Rod Serling, with his narrator's voiceover, reasserts the reality of the artificial woman as machine: Alicia is now like Correy's old car, a rusting obsolete technology in a dreamscape out of time.

"The Lonely" in 1959 presented a softened, sympathetic portrayal of the machine-woman, but the 1963 *Twilight Zone* episode "Living Doll" gave a darker view in which a technological marvel—an innocent-looking talking doll—tyrannizes and fragments a family, leaving destruction in its wake. The doll "Talky Tina"—evoking men's deep fears about angelic-looking women who turn diabolical, as in Lang's film *Metropolis*—is a friendly-looking doll that turns out to be darkly sinister and malevolent, a nightmare toy in the family's neurotically troubled domestic world.

The actual idea of creating a talking doll had intrigued toy manufacturers during the nineteenth century. From the 1860s to the 1890s, French manufacturer Jules Steiner produced remarkable mechanical dolls including his clockwork Bébé Parlant Automatique mechanical doll (Automatic Talking Baby), which could say "Mama" and "Papa" and kicked and cried. Combining a doll and sound reproduction machine, Thomas Edison in 1890 had introduced his short-lived phonographic doll, and in 1895 the French doll manufacturer Jumeau introduced its own Bébé Phonographe doll. Not until 1960, however, did mass-produced talking dolls become hugely successful.

Starting in 1960, a year after the first appearance of Barbie dolls, America's Mattel Corporation introduced its vinyl Chatty Cathy Doll, a blue-eyed doll with Saran blond hair, and two years later, there were also African American Chatty Cathy models. Using an easy-to- operate metal pull string and embedded phonograph records, these dolls uttered eleven random phrases, including "I love you," "Let's play house," and "Please change my dress."[3] Injecting an element of surprise, a television commercial for Chatty Cathy said provocatively, "Just pull the ring. You never know what she'll say next." (The doll's voice was recorded by Jane Foray, the same woman whose voice would later be used for Talky Tina in the *Twilight Zone* episode.)

Mattel's dolls became increasingly talkative: in 1963, the company introduced a new Charmin' Cathy version that allowed for changeable records being inserted into a slot on the doll's left side, and the records—some now available in foreign languages—allowed the doll to utter phrases like "Silence is Golden"—a phrase presumably dear to the hearts of parents and an antidote for too-chatty females. Chatty Cathy and Charmin' Cathy were toys cast in familiar female roles, and the company soon made nurse, Cinderella, and shopper dolls. The shopper doll's "Go Shopping" record produced an uncanny doubling by opening up the world of artifice still further: said the Charmin' Cathy doll, "Let's go shopping for Barbies."[4]

One of the Mattel doll's special features—that children never knew what it would say next—was given a malevolent and scary twist in the *Twilight Zone* "Living Doll" episode. Talky Tina, like Chatty Cathy and Charmin' Cathy, is a technological wonder, but a wonder with a dark, demonic side. This doll talks about love but threatens murder, too. At the beginning of the episode, Christie and her mother Annabelle bring home the new toy—an innocent-looking doll in pigtails wearing a plaid dress and lacy collar, a doll that says sweetly, "My name is Talky Tina, and I love you very much." Christie tells her often irritable stepfather Erich (deftly played by Telly Savalas), "She's alive, Daddy!" and indeed, Talky Tina turns out to have a life of her own.

Serling's "Living Doll"—produced in an era infatuated with psychoanalysis and aberrations like Norman Bates in *Psycho*—is invested with psychological torment and dark, psychoanalytic themes. Although the doll is innocently described as "a lifelike creation of plastic and springs and painted smile," Erich greets it with hostility. A neurotic man, he is also resentful and rejecting of his stepdaughter Christie because he and his wife can't have children of their own and he doesn't want to play the role of father, telling Christie angrily, "Don't call me Daddy!" Later, after he thinks he's successfully gotten rid of Tina by placing the doll in a garbage can, he is next seen cracking nuts in a bowl—a suggestion that he too is a nutty man.

Not only does "Living Doll" probe Erich's increasing paranoia about the doll (of course, as it turns out, he has good reason), but the episode also reflects early 1960s Cold War paranoia about technology and Cold War tensions with Russia, including anxieties about Russian spying and fears about a Russian attack (the Cuban missile crisis was in 1962). In "Living Doll," Erich is suspicious about the malevolent uses of electronics: he thinks his wife and Christie are trying to trick him with technology by putting a "walking talkie" in the doll to make it sound like it is talking and using embedded microphones to project Tina's voice. To Erich, this subversive doll is threatening to break up his marriage, and its phrases (heard only by Erich) are threatening to him too: when the telephone rings, he hears the doll's voice saying, "My name is Talky Tina, and I'm going to kill you!"

"Living Doll" is also shaped by female stereotypes and gender paradigms, particularly conceptions about women masking their identities and having a dual angel/demon nature. With her freckled face, Talky Tina appears to be the essence of innocence: she looks sweet and loving on the outside but is really a murderous and malevolent creature. She is also portrayed as a stereotypical female who can't stop talking. (Erich—like other men in stories about artificial women—longs to have the female be silent. He says irritably to Christie, "Will you shut that thing off!")

This element of control is central: In fiction and films about robot women, men often prefer artificial women to real ones because they can literally turn them off with a switch or at least program and control the phrases they utter so

the synthetic females will only say compliments and soothing things to them. With this control, men don't have to worry about unpredictability or discomfort or surprise. But Talky Tina, like the monster in *Frankenstein,* is a technological creature running out of control.

Ideas about control often weave their way through depictions of simulated women in television dramas and sitcoms of the 1950s and 1960s, with Talky Tina also reflecting more fundamental underlying fears about runaway technologies evading human control. As Langdon Winner more broadly wrote in *Autonomous Technology,* "Ideas about technology out-of-control have been a persistent obsession in modern thought."[5] In films of the 1950s and 1960s, computers caused particular worry: in Stanley Kubrick's 1968 film *2001: A Space Odyssey,* HAL, the spaceship's computerized operating system, threatens to destroy humanity until it is finally deactivated and brought under control.

Talky Tina is a doll that also seems indestructible, like a staple in animated cartoons of the period—the character that is smashed, seemingly destroyed (as in Warner Brothers' Road Runner cartoons) but miraculously stays alive after all types of calamities. For Erich, who is intent on getting rid of the unruly doll, however, there is nothing funny about the fact that Tina can't be killed. Near the episode's beginning, after Erich threw her against wall, the doll maniacally still turns its head and moves its hands with a whirring mechanical sound. In his frustration and fear, Erich unsuccessfully tries a variety of methods: discarding her in a trash can (he even puts a brick on top of the can), sadistically putting her head in a vise, putting a blowtorch in her face, putting a match to her lips (she says "Ooh!"), slashing her neck with a knife, and he even tries cutting her neck with a power saw, but the indestructible Talky Tina remains unscathed (fig. 4.5). Through it all, when he winds her up, her utterances become increasingly threatening: "My name is Talky Tina, and I think I could even (hate) you." When he throws her against the wall, she warns him ominously, "My name is Talky Tina, and you'll be sorry!"

Erich's violence toward the doll echoes the tropes of later slasher horror films where a male killer brutalizes a female victim. In these sadistic films, the monstrous man chains the woman to a conveyor belt as she heads toward a power saw or slashes her throat and torments her. In her psychoanalytic readings of these films that present the attacker and the attacked, including *The Texas Chain Saw Massacre* (1974), Carol Clover suggests that viewers identify with the vulnerable victim as well as the brutalizer who plays a dual role: the malevolent parent and the avenging victim child with repressed infantile rage. We the viewers become both Red Riding Hood and the Wolf.[6]

In Serling's "Living Doll," Talky Tina and Erich are locked into a dialectic of brutalizer and victim, with the roles chillingly reversing as the story evolves. By the end of the film, the malevolent Talky Tina ultimately causes Erich's death. While he's in bed, he hears a whirring sound, looks for the doll, trips over it, and gets killed falling down the stairs. Only at the end does Annabelle realize that

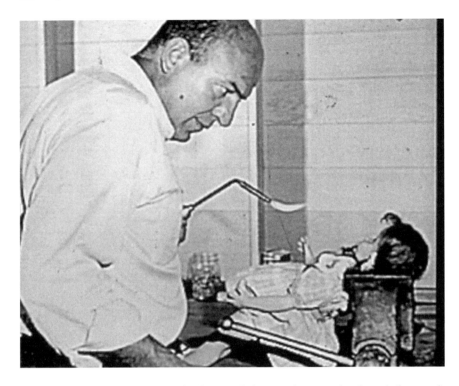

4.5 In the 1963 "Living Doll" episode of *The Twilight Zone*, the enraged and utterly frustrated Erich (Telly Savalas) unsuccessfully tries to kill the doll Talky Tina by putting her head into a vise and a blowtorch near her face.

Erich, who seemed paranoid, wasn't deranged after all: as the doll tells her ominously, "My name is Talky Tina, and you'd better me nice to me."

While Talky Tina was inexplicably evil, a toy version of the 1956 horror/thriller film *The Bad Seed* and by the 1960s the emergent artificial females as dolls, robots, and androids in American television sitcoms were sources of both humor and delight—naïve or savvy creatures that often had a moral sense of their own. These television female simulacra were shaped by the turmoil of the times—the social upheavals generated by the Vietnam War era, the civil rights movement, and, most significantly, the women's movement, which was gaining momentum by 1968, particularly after the publication of Betty Friedan's pivotal book *The Feminine Mystique* (1963) and the founding in 1966 of the organization NOW (National Organization for Women). Though fanciful figures, these facsimile females tellingly embodied dramatically changing conceptions about women and their roles.

The 1960s

The Jetsons

The American animated television series *The Jetsons,* which first aired in 1962, laid the groundwork for a female robot that is stereotypical yet also paradigm-breaking. Rosie is a sassy, savvy, but not sexy servant robot designed to be a well-functioning domestic helper, a household machine that brings no-nonsense sanity to this family living in a Space Age world.

In the opening of the series, when the family needs a replacement household robot the mother, Jane Jetson, goes to "U Rent-a-Maid" agency where the salesman shows her a range of female robot models reflecting a range of gender stereotypes: The servant Agnes from Great Britain is the basic economy model that only serves tea; Blanche from France wearing a sexy maid's outfit is the "rear engine model" that provocatively says "Oo La La, Cheri!"; and Rosie, an old demonstration model, is not much on looks but highly capable and intelligent, programmed to help the family in all its tasks. When the salesman describes her as "H-O-M-E-L-Y" she answers quickly with her comically Brooklyn accent, "I may be homely, Mister, but I'm S-M-A-R-T" (this tough-talking female with twirling antenna ears can also be a conventional female servant: in the episode "Rosie's Boyfriend," she serves the father, George Jetson, his martinis and brings him his slippers).

The Jetsons, an ABC television series directed by Hanna-Barbera (William Hanna and Joseph Barbera), which was broadcast in twenty-four episodes that ran from September 23, 1962, to March 3, 1963, and then again in 1985 and 1987, captured some of the dramatic changes that had taken place in American technologies. During the 1960s, the show spoofed Space Age fantasies about the future in which the Jetson family lives a life of push-button and electronic ease. Lynn Spigel, calling the Jetsons a "space-odyssey version of Levittown," has argued that the show, like other television sitcoms including *I Dream of Jeanie, Bewitched,* and *My Living Doll,* was a new generic form, a merger that parodied the conventions of suburban sit-coms with space age imagery of the New Frontier.[7]

By 1961, a year before *The Jetsons'* first episode, America's space program was expanding, propelled by early Russian successes in space. Russia had already successfully launched *Sputnik* in 1957, and Russian cosmonaut Yuri Gagarin had become the first man to orbit the Earth in 1961. In America, President John F. Kennedy launched Project Mercury in 1961, and on February 20, 1962, a month before the first Jetsons show, John Glenn Jr., riding in a space capsule, became the first American to orbit the Earth.

In this Space Age world, the Jetson family—father George, wife Jane, teenage daughter Judy, and young Elroy—live in Sky Pad apartments, George flies to work in a space vehicle, his boss is Mr. Spacely whose company is Spacely Space Sprockets, and the family shops at Spacely's department store. The family's lives

are not only Space Age but also infused with ubiquitous push-button appliances. By the early 1960s, push-button machines and appliances were widely available—push-button stoves, automatic transmissions, blenders—and they promised to make housework and driving easy and enjoyable. When George, who is employed at Spacely Space Sprockets as digital index operator, comes home from work, Jane asks him, "Hard day at the button, Dear?" (He complains that he's tired: he had to push the on-and-off button five times that day.)

One year before Betty Friedan's *The Feminine Mystique* with its probing look at women's lack of fulfillment in conventional domestic roles, June, who is in charge of the family's housework, tells her mother she hates washing, ironing, and vacuuming and "housework gets me down," even though all she is required to do is push buttons for breakfast, lunch, and dinner (in this television satire, the only exercise she needs are finger exercises for her button-pushing). Yet there are also signs of change: Mr. Spacely in one episode grumpily complains that he married his wife thirty years ago because she could cook and now all she wants to do is go to political meetings. Women may be reluctant housewives in the series, but Rosie as the ideal home robot is both indefatigable and very intelligent, too. Not only can she cook and clean, but she also crosses gender lines: she can play basketball with the family and throw forward pass football and help the children with their homework on geopolitics, space, and calculus, while doing all Judy's homework in ten minutes.

In the 1960s, as computers were becoming more sophisticated and concerns were beginning to mount, writers and artists worked at making them seem more human and humane. American artist Edward Kienholz humorously envisioned a humanized computer in his sculptural piece *The Friendly Grey Computer— Star Gauge Model 54* (1965), which turned a computer into a silver-painted rocking chair with dials, a motor, and two protruding doll's legs. In *The Jetsons*, Rosie is humanized by being portrayed as a machine that is capable of having feelings, including love. In "Rosie's Boyfriend" (1962), she at first scoffs when she sees Judy in a romantic fog over her boyfriend, and when George asks her, "When are you going to fall in love, Rosie?" she says, "Never." Soon, however, after moping about the handyman Henry's new malfunctioning robot (Mac Robot, who looks like a file cabinet) and going to a "Robotologist" for counseling, Rosie and Mac fall in love.

My Living Doll

In American television, female robots and androids at times straddled two worlds. They were often transitional figures: they mirrored gender stereotypes and embodied the new sense of female empowerment infusing the era. In a decade infatuated with push-button appliances and remote controls, America's sitcom writers created button-activated female characters like Rhoda in the *My Living Doll* television series (1964–1965). These women had extraordinary technological or magical powers, yet they could also be mastered by men, a sign

that American television writers and producers were ambivalent and not yet ready to give their female robots—or technology or even women themselves—unfettered independence and autonomy.

In the realm of magic, the sixties spawned two television sitcoms that portrayed extraordinary women in domestic roles. In *Bewitched* (1964–1972), a female witch marries a mortal and becomes a suburban housewife, and in *I Dream of Jeanie* (1965–1970), a female genie released from a bottle has magical powers though she obediently calls her husband "Master." (Her powers are largely domestic: in one episode, "Is It Magic or Imagination?" she does a "little speed-up spell" to do fast housekeeping before her mother-in-law comes for a visit.)[8]

Revealing ambivalent views of women with extraordinary technological abilities, *My Living Doll,* which ran on CBS for twenty-six episodes, featured Rhoda (played by the statuesque Julie Newmar, fig. 4.6) as the ideal Galatea. She is a beautiful, sexy, and intelligent but also nonthreatening female who can often (but not always) be controlled. This lifelike, beautiful woman was actually a prototype robot first named AF709 and developed for the Air Force by Dr. Carl Miller as a secret NASA government project experimenting with sending robots into space to see the effects of space travel.[9] Miller asks his friend, psychiatrist Dr. Robert McDonald (Bob Cummings), to watch over the robot while he is away in Pakistan for a few months, with instructions to educate her and keep her a secret. McDonald renames the robot Rhoda Miller, and, ever-concerned with proprieties, he tells neighbors as a cover story that she was Dr. Miller's niece who was boarding with him until Miller's return from overseas.

McDonald casts Rhoda in a conventional woman's role, putting her to work as a secretary (the robot, no surprise, comically types extraordinarily fast). But in a world in which very smart women may make men uneasy, female robots like Rhoda are portrayed as both sexy and smart. Her memory bank is fed with fifty million items of information, which she can compute or access in one second, but, for all of her technological complexity, she is very much a sex doll. When she walks, men turn their heads and whistle, and when she is first put in his care, McDonald tells his sister, "I need a chaperone."

In Pygmalion stories echoing men's fantasies about the perfect Galatea, the newly minted female is often an innocent and obedient sexual naïf. In the first *Living Doll* episode, "Boy Meets Girl," after Miller leaves Rhoda in McDonald's care, she lies on a table, her nude body covered by a towel. Experimenting with her, McDonald first gives her commands ("Stand up, please, Miss 709"), and he's nonplussed when she stands up and starts to unwrap her towel. When she asks McDonald, "Where do children come from?" McDonald fumbles for an answer, sputters, stammers, and wipes his brow. Rhoda may be sexy and appealing—and McDonald may make sexist comments about her—but as a running joke in the series, it is he, not Rhoda, who is the show's resident prude.[10] Rhoda fulfills men's ideal of the perfect woman in other ways too: she will do

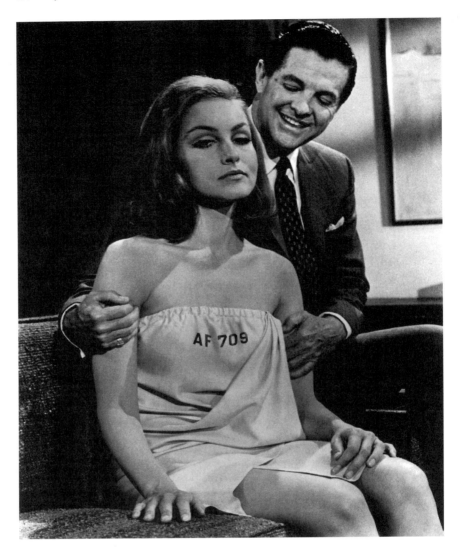

4.6 Psychiatrist Robert McDonald (Robert Cummings) with Rhoda (Julie Newmar), the statuesque, beautiful robot in the American television sitcom series *My Living Doll*, which ran from 1964 to 1965.
PHOTOFEST

anything anyone tells her, talks little, and has no annoying unfettered female emotions to get in the way. McDonald muses only half jokingly, "If a robot such as yourself could be given feelings, human emotions, you'd be the perfect woman—one who does what she's told, reacts the way you want her to react, and keeps her mouth shut." "No offense," he adds cautiously, but, as the perfect

woman, she isn't touchy and doesn't even realize she's been insulted: "Word 'offense'? Doesn't compute."

For female robots in these 1960s and 1970s television series—as well as female robots throughout the twentieth and early twenty-first centuries—sex and technology often go hand in hand. In the first episode, McDonald is at first dubious when his friend Miller tells him she's a robot, "a pile of electronic equipment," and he insists on seeing her in sexualized terms. Says McDonald, "I've seen plenty of piles of electronic equipment, but none of them were stacked like her." But Rhoda is still very much admired as a technological marvel, a product of the 1960s, a decade not only enthralled with the fast-developing world of automated push-button domestic machines (though also worried about push-button nuclear bombs) but also fascinated by electronics. Transistors and integrated circuits were in use by the 1960s, and the Johns Hopkins University Physics Lab in the early 1960s had developed versions of its Beast autonomous robot. When asked by McDonald's leering neighbor Peter what she does in the evening, Rhoda says, "I rest my transistors and associated parts."

Rhoda highlights the period's fixation on simulations and control. In a spoof on computer-driven push-button technology and also reflecting her male creators' wish to be in charge of activation, Rhoda is operated through the four "emergency control" buttons on her back disguised as beauty marks. The round button reactivates her motion, the square button activates her computers, and the triangular one controls her sight, voice, and hearing. With the type of technological feature that men love, she also has the "on-and-off" button.

Rhoda as a simulated woman s also very much a product of a decade infatuated with plastics (as so memorably satirized in Mike Nichols's 1967 film *The Graduate*). She is made of polyethylene plastic and electronic components, and microscopic sensors in the plastic pick up warmth from infrared rays from the atmosphere. As noted by Jeffrey Meickle in his history of plastics, starting in the 1950s thermoplastics, such as polyethylene, contributed to a range of new uses from squeeze bottles and Hula Hoops to plastic pink flamingos, Formica countertops, and Tupperware. Although plastics seemed the height of modernity— they were flexible, durable, light, disposable, malleable—by the 1960s, plastic also became a metaphor "for cheapness, vulgarity, second-rate, the fake and the phony."[11]

In nineteenth-century Europe and America, technological simulations in the arts—cast-iron copies of carved stone, electroplated tea service imitating the look of solid silver—were widely admired even as critics lambasted these imitations, and this type of ambivalence was also associated with plastics in the next century. America was enthralled with plastics, but cultural critics cringed at the Melamine wood-grained tabletops, polyethylene television sets, and fake wood-grain stereos and televisions that were flooding the market. Writers, including Theodore Roszak in *The Greening of America* (1970) and Charles

Reich, worried that America had become too artificial and fretted that in a world of Astro Turf "the genuine is replaced by the simulated."[12]

While female simulacra often caused anguish for men who were fooled by their appearance, Rhoda as a simulated woman made of plastic is presented as very much a technological wonder—an amazing simulacra that even fools McDonald's neighbor into falling in love with her. Her utterly realistic appearance, however, also causes comic mayhem. In "The Beauty Contest," Rhoda wants to enter the contest which is based on beauty, talent, and intelligence, and McDonald, who is a contest judge, worries that she will be exposed as a robot. The episode is about not only simulations but also control, and whether Rhoda, as a fantasy female with willful ways, can be easily deactivated and stopped.

At the end of the nineteenth century, satirical drawings of women pulling the strings of tiny puppet men reflected anxieties about the increasingly independent New Woman, and, as Sabine Hacke has written, there was also cultural ambivalence in depictions of the New Woman of the 1920s—images of the modern emancipated female were still invested with cultural conceptions of femininity, which included sexuality, beauty, and sociability. Women themselves had their own ambivalence about reconciling "emancipation and traditional femininity."[13] In *My Living Doll* and other American sitcoms of the 1960s and after, television writers revealed a similar ambivalence in portraying female robots and seemed to be trying to defuse anxieties about superwomen in the rapidly developing electronic age.

Rhoda in "The Beauty Contest" has a mind of her own, but McDonald says firmly, "I don't argue with a robot" and turns her off. Nevertheless, she manages to enter the contest and in the talent competition wows the audience with her piano-playing skill. She is a comically quick study: after watching famed pianist Van Cliburn perform on television, Rhoda goes from playing "Chopsticks" to playing Chopin, but to stop her during the contest, McDonald pushes one of her switches, and she reverts to playing "Chopsticks" again.

The comic pitfalls of a simulated woman being mistaken for a real one also appeared in the *Living Doll* episode "I'll Leave It to You" where one of Bob's psychiatric patients, Jonas, a millionaire, decides to leave all his money to the beautiful Rhoda instead of giving his fortune to his grasping and domineering sister Edwina and his pompous nephew Waldo. Alarmed, Bob privately tells Rhoda, "You're on the verge of being the wealthiest robot," which is worrisome because "You're nothing—you're an it!" In a series about the comic ambiguities posed by artifice, Rhoda under hypnosis says she's a robot–an admission that Bob the psychiatrist tries to explain away by telling Jonas and his family that Rhoda's problem is that she *thinks* she's a robot.

Tales about artificial women so often circle around issues of control, and in this episode, the women are seen as witchy would-be controllers of men. Jonas asks McDonald to certify him as being of sound mind so he can leave his wealth to a horticultural society rather than his sister and nephew. He complains that

Edwina has always "controlled him like a puppet," and now he wants to regain his self-respect, adding, "Just once in a while, while I'm still here, I would like to feel like a man." Edwina does indeed infantilize him (she tells him to run along for his nap), and Rhoda seems like the right solution. Fictional female robots often help men feel comfortable with their own gender identity, and in this episode the male patient sees Rhoda as the perfect woman, "a marvelous human being." After he decides to make her his heir, Jonas says, "For the first time I feel like a man." Ultimately after Bob convinces him that Rhoda is an unsuitable heir because she believes she's a robot, Jonas decides to leave his money to a fund for mental health, but by knowing Rhoda he's regained his manhood: "You've made a new man of me," he says, and, thus emboldened, he decides to connect instead with a real woman (a theme echoed years later in the 2007 film *Lars and the Real Girl*. See my detailed treatment of the perfect woman theme in chapter 5).[14]

One of the tropes in representations of artificial women is that the "perfect woman"—even with her sexiness, superior intelligence, and skills—is also a fallible machine prone to malfunctioning, mechanical breakdowns, and glitches. These breakdowns may be a way of making these formidable females psychologically safer, too, by defusing them—however momentarily—of their power. Kleptomania, manifest by the obsessive stealing of items, can often stem from feelings of deprivation, but with female robots, it is simply a comic electronic malfunction or misunderstanding. In the *My Living Doll* episode "The Kleptomaniac," the innocent, naïve, and untutored Rhoda innocently shoplifts jewelry and other items to help McDonald find a present for his sister, becoming a female shopper out of control.[15]

Talky Tina's ways of evading control were truly scary in Serling's "Living Doll," but Rhoda's strategies—as befitting a comedy—are clever but benign. In "The Witness" episode, McDonald asks Rhoda to be a witness in a small claims court after Peter's car bangs into McDonald's automobile. In the court, Rhoda is privately given advice by one of the three witnesses about how to sidetrack the judge. After all, "Men are all alike," she tells Rhoda: All a woman needs to do to control the judge is to bat her eyes a little, tell him he's big and strong, "make him think he's smart and sexy," show him a little knee, and she'll be able to "wrap him around your little finger." Rhoda tries these feminine wiles, but what really helps her control the situation is not her sexuality but her intelligence: she goes to a law library, quickly scans all the books, quotes an appropriate case in court, and the judge ends up dismissing the case and tearing up her contempt-of-court summons. In the end, the triumphant Rhoda unwittingly trumps the law as she happily—and in a comic evasion of control—rides off with the policeman's own motorcycle.

Lost in Space

In the midst of the space race and the women's movement, two 1960s television series, *Lost in Space* and *Star Trek,* with female characters as androids, were couched in space fantasies and spoofed gender stereotyping—even as they still continued to frame the female characters in residual stereotypes. The assertive silvery android Verda (Dee Hartford) in "The Android Machine" episode of the 1966 television series *Lost in Space* transcends gender stereotyping through her intelligence (she has math-science savvy), sophistication, loyalty, and courage, as well as an innate moral sense. By the end of the episode, this artificial woman becomes humanlike but remains stubbornly her own being.

In this funky series with its low-budget-looking painted scenery and sets, the Robinson family along with Major West and the series' resident mad scientist, Dr. Smith, are all castaways in a galactic planet and when Dr. Smith accidentally orders a metallic electronic female robot from a mysterious orange celestial department store vending machine Verda appears, complete with a silver-skinned face and some producer's idea of a strange futuristic mechanical headpiece (fig. 4.7).

Dr. Smith soon casts her in a familiar gendered role, calling her a "mechanized maid servant." Using her for his comfort, he has her kneeling at his feet and giving him a footbath as he sits contentedly fanning himself (after Verda, new to the game, first accidentally scalds and then freezes his feet). Even Verda defines herself as Smith's servant, a helper and extension of himself, calls him "Master" and, in the beginning, dutifully follows him, saying, "I am tuned to your psychic frequency. I am yours forever."

Verda is stereotypically feminized: she's good with the children, she admires flowers, which are new to her, and with the aid of her programming she proves to be the better teacher, a quality that the generally infantile Dr. Smith and the male robot resent. But in other ways, she counters gender stereotypes: she is mechanically adept, and when Smith struggles with the design and functioning of his new hydraulic system she shows her superior mechanical know-how by getting it to work. Verda is her own woman-robot, a naïf unaware and unconcerned with her own appearance (which happens to be pretty), saying, "It is not my function to look nice."

When the Robinson daughters, feeling Verda needs a transformation, put makeup on her face and show her her own reflection in a mirror, she is skeptical, insisting that "appearance is not important. It is programming that counts." The episode becomes a comic gloss on the dichotomy between outer and inner, surface and authenticity, a woman's glamorous exterior appearance and her inner "real" self. The show's ambivalence about makeup suggests the impact of 1960s second-wave feminists who were beginning to denounce the wearing of cosmetics, seeing them as the product of patriarchy in which men wanted to objectify women and view them simply as beautiful surfaces.

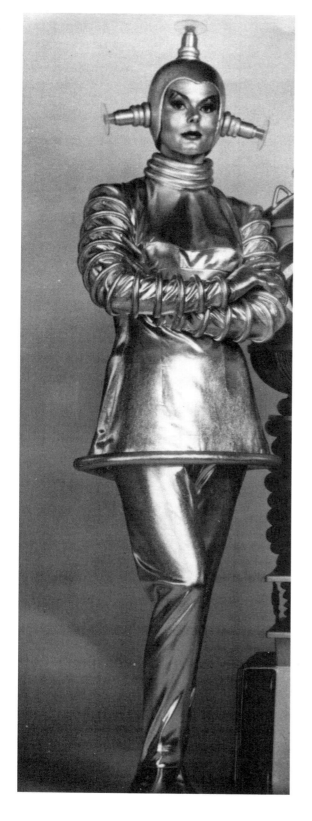

4.7 Dee Hartford as the silvery, accomplished female android Verda in the 1966 episode "The Android Machine" in the American television series *Lost in Space*.

Earlier, though, for writers in American women's magazines, this split posed no problem. In her 1935 essay "Life, Love, and Lipstick," Julia Shawell, the editor of the Chicago magazine *The Woman Today*, wrote about the contemporary woman who "wants to reach for her newest lipstick and clean powder puff after a hard day's work." This woman was authentic even while wearing makeup: "The woman today greets you! You may not like her hat. You may not like all that she thinks about.... But you must admit she's real!"[16]

During the Second World War, even as women were challenging gender stereotypes by showing their technical expertise, advertisers and magazine writers promoted the idea of women war workers wearing makeup to help maintain their femininity and their morale. *Woman's Home Companion* in 1943 featured a photograph labeled "They Call It War Paint" picturing a woman war worker putting on lipstick as she looked at her reflection in an aircraft wing. Psychoanalytic feminist writers like Joan Riviere and later, Mary Ann Doane, looking more closely at the cultural construction of femininity, repositioned the wearing of makeup as an ingredient in the masquerade that could be used by women for their own purposes.[17]

For all of her resistance to makeup, however, Verda even in the 1960s jokingly saw another function for cosmetics: wearing makeup could help her pass for human (years later, in the "Vick's Chip" episode of the 2008 television series *Terminator: The Sarah Connor Chronicles*, Cameron, the beautiful female cyborg with formidable strength and intelligence, starts wearing nail polish to seem more human). "The Android Machine," however, is actually about Verda's more fundamental transformation: her capacity to learn about humanity and become a little human herself.

In the 1960s, amid cultural fears that computers might override programming and become malevolent autonomous machines, American television sitcoms at times portrayed electronic robots and androids as being humane and ethical, and also capable of learning emotions. Verda learns about happiness and even about laughing (she even wonders if there is a button to make her laugh) and also reveals she has a moral code: when Dr. Smith hints she should corroborate his false information about the date Columbus sailed for America, she tells Dr. Smith indignantly, "I am programmed to serve you; I am not programmed to lie."

As a simulated woman conceptualized in the 1960s, Verda straddles two worlds: she resists glamorization and challenges men with her superior abilities, but she is also portrayed with traditionally feminine traits by being protective, caring, and self-sacrificing. She instinctively intervenes to protect the children from the orange-eyed green monster, which puzzles her because "I was programmed to save myself." She also reveals her own feelings and innate altruism. While Smith earlier had dismissed her scornfully as a "mechanized maidservant" and "just a machine you know—not a human being," she cries, as oily tears stream down her face. When he comes to take her back, Zumdish, the

department store complaint manager, points out she's close to human: though she was never programmed for self-sacrifice, now she's willing to sacrifice herself in the name of love by going back to her planet rather than have the family give up their precious fuel to keep her there.

Star Trek and Barbies

With feminist critiques in the air, other 1960s television sitcoms through their robot and android characters were more overtly willing to take on female stereotypes by satirizing them or recasting women in new roles. While Verda in *Lost in Space* is a noble creature with extraterrestrial gravitas, a 1967 television episode of *Star Trek,* "I, Mudd," was a comic send-up of two familiar female stereotypes: women as sexy compliant servants and women as loud-mouthed, shrewish, harridan wives. The Starship *Enterprise* in the series is forced into going to an uncharted planet ruled by the scoundrel and former thief Harry Mudd—a planet kept under control by the androids and robots that serve Mudd. Among these are five hundred identical beautiful female androids Harry made for himself; these women are part of the large "Barbara" contingent that come in models called Alices, Alisons, Annibels, Alisons, Maisies, and Trudies.

Mudd's sexy "Barbaras" suggest the Mattel Corporation's highly popular Barbie dolls with their ponytails and bubble-cut hair produced during the 1960s. By 1969, there was also a Talking Barbie with a pull cord and a Talking Christie, a black friend of Barbie's. Though the first Barbie in 1959 was a housewife dressed in her apron for a barbeque, these mass-produced dolls with their sexy figures and perfectly coiffed hair became role models for young girls to emulate in their play and invest with their fantasies and dreams (decades later, the sexy Barbie figures reflected expanding role models, including an astronaut and a computer engineer).

In the *Star Trek* episode, Harry Mudd's female androids are a fusion of sophisticated technology and men's fantasies about the always obedient, obliging, sexually available female servant. Their bodies are covered with "self-renewing plastic over a skeleton of beryllium titanium alloy," they have human brains fitted to their android bodies, and they are also all "eternally beautiful," says Mudd, made to last 500,000 years. The androids are unaware that they are simulacra: when Chekov says, "A shame you are not real," two of them reply with conviction, "We *are* real," and "We function as human beings."

While women activists in the sixties were challenging the old stereotypes and socially constructed images of women, Harry Mudd as bizarre Pygmalion blithely constructs his own two favorite paradigms of females: sexy and shrewish. Rotwang in *Metropolis* had created a towering sculpture of his adored and idealized Hel, but Harry perversely has the androids create a replica in memory of his detested Stella, the harpy wife he left behind and deserted because of "her continued, eternal, confounded nagging." Rather than looking at her with

adoration, he created this shrill and cross-eyed Galatea "so I could gaze upon her and rejoice in her absence."

Once again the focus is on control. Masochistically, he periodically brings the Stella replica to life, and she chases after him and reminds him of his identity as she sternly calls him by his full name "Harcourt Fenton Mudd!" and chastises him for being a "lazy, good-for-nothing," a drunkard, and "miserable sot." By creating this Gorgon Galatea replica and enlivening her, however, Harry also has the satisfaction of being able to control and silence her, saying, "Marvelous, isn't it? I finally have the last word with her" as he tells her to "Shut up!" At the end, the *Enterprise* crew figures out a ruse to confuse and immobilize Mudd's androids, and the crew members return to their ship while leaving Harry behind. But as a comic comeuppance, they also create five hundred multiples of Stella, and when Harry once again says "Shut up!" one of these Stella replica keeps wagging her finger at him and nagging him—for Harry, a true nightmare scenario.

The 1970s—The Female Wonder

During the 1970s in America, the women's movement was in high gear. American television programming was shifting dramatically to include series like *That Girl* with Marlo Thomas as the unmarried, independent career girl and *The Mary Tyler Moore Show* with Mary Tyler Moore playing an unmarried television producer. But even with signs of a paradigm shift, the television series *The Bionic Woman,* which ran from 1976 to 1978 (an offshoot of *The Bionic Man*), hedged its bets for audiences and continued to present competing views of simulated women as mindlessly sexy electronic females as well as one-of-a-kind cyborg wonders with extraordinary physical power and range.

Written in a decade marked by the growing development of mainframe and personal computer technologies, *The Bionic Woman* celebrated the idea of people empowered by electronics—both a one-of-a-kind woman and man as well as mass-produced duplicate females designed to fulfill men's will. Jaime Sommers (played by Lindsey Wagner) is a woman tennis player who was injured in a skydiving accident and refitted with electronic body parts to give her extraordinary strength, speed, and hearing capabilities that enable her to hear in ultrasonic ranges. Her superhuman powers defy female stereotypes.

In the series "Kill Oscar," which was several episodes (1976), the evil-minded Dr. Franklin has created beautiful and sexy but also lethal electronic "Fembots" for his own evil purposes, and he voices misogynistic statements so sexist they sound like parodies. He brags that his bots can do anything Jaime can. When Baron Constantine says of Jamie, "As a human being she can think for herself," he replies—with blatant comic sexism—"Since when is thinking for herself an asset in a woman?"

The robotic Fembots are created by Franklin to help him steal a weather control device being developed by the American government's fictitious Office of

Strategic Intelligence (OSI) and to capture Oscar Goldman who has developed the device and get him out of the way. They are 1970s versions of a type of Substitute Woman like Maria in *Metropolis* and later *The Stepford Wives* (see discussion in chapter 5), female doubles created for malevolent purposes or to fulfill men's dreams. Franklin develops the Fembots as doubles of the secretaries working for OSI scientists and management men. The real women will be stunned and disabled by a spray and replaced by their exact duplicates, with implanted memory banks and matching voices and accents, women who will infiltrate the OSI offices to further Franklin's plans.

Resurrecting the male fantasy about creating a synthetic woman superior to the real thing, Franklin describes the Fembots as "perfect women"—"programmable, obedient, and as beautiful or deadly as I choose to make them." While the real women like the secretary Ms. Callahan are highly efficient but overworked and unhappy, the Fembots are efficient and uncomplaining. To demonstrate that the androids are indistinguishable from real women but are actually synthetic, Franklin rips the face off of Katie, his personal assistant, to reveal her startling underlying electronic circuits and large staring eyeballs (fig. 4.8). The ritual of ripping off these artificial female faces recurs in the episode, a reenactment of that shocking moment of exposure—that descent into the uncanny valley—which was seen in "The Sandman" with Nathanael's horrible recognition that Olympia was not real.[18]

While the electronically enhanced Jamie remains an extraordinary if enhanced flesh-and-blood woman, in the continuation of the "Kill Oscar" story, Part II (which appeared in the *Six Million Dollar Man* series), Dr. Rudy Wells, an OSI physician, operating on one of the damaged 480-pound Fembots to bring it back to life, marvels that it has small televisions as eyes and heat-sensors in its feet. The scientists and electronics experts in the series are all men, and here one of them, a technician, works on the objectified female who is simply an empty void. This scene echoes artist Edmund Emshwiller's cover illustration for a 1954 issue of *Galaxy Science Fiction* magazine where a man wearing a white coat and a reflector light on his head works intently at making repairs on a female robot, the wired armature of her torso exposed and the section of her breast lying unceremoniously on a table nearby [plate VI]. Emshwiller's robot is clearly an assemblage of parts, a depersonalized thing, and her exposure is no more horrifying than if he were making automobile repairs

(The idea of mechanical exposure had its comic side, too. In nineteenth-century satires, there was something humorous, not horrifying, about a fashionable woman whose underlying mechanical apparatus becomes exposed. In an 1850 *Punch* cartoon, two men look on in puzzlement as a woman walks by, her voluminous dress skirt accidently raised up revealing the armature of her supportive cage crinoline made of wire. Says one man, with his Cockney accent, "My eyes, Bill, what do you call that 'ere thing?" Replies Bill, "Why Jack, it's a new machine they've got for disguising the 'uman form, that's all" [fig. 4.9].[19])

4.8 Fembot with her face exposed in the 1976 "Kill Oscar" episode of the American television series *Bionic Woman*.

4.9 Wearing wire "cage" crinolines under their voluminous dresses helped women lighten the load of multiple petticoats and attain an aura of fashionability—but the effect was startling when the steel armature was exposed. Unknown artist, 1850.
© Museum of London.

The 1980s

During the 1980s, there was a sea-change in electronics as new developments offered the latest in technological wonders: IBM introduced its personal computer in 1981, compact discs were popularized for sound recording and data storage, and VCRs were introduced for television recordings. In the midst of electronic euphoria, television writers celebrated the possibilities of robots and simulated humans and also revisited the conundrums of simulation seen in teleplays and sitcoms of the 1960s. Technological achievements were celebrated but writers and directors also at times took an edgier, more nuanced, and skeptical view.

Twilight Zone—1980s

The original *Twilight Zone* episode "The After Hours" had raised the specter of blurred boundaries and the interchangeability of artificial and the real, a blurring that had often been especially applicable to the cheerfully happy housewives depicted in 1950s commercials. Marsha's discovery that she herself is a mannequin was startling for her, but in Serling's 1986 remake of the same episode

Marsha writhes in agony on the floor as—in a reverse Pygmalion effect—she reverts to being a mannequin. In this much darker version, her transformation from live woman to immobile mannequin is both hellish and horrifying.

The 1986 remake is fraught with menace from the very beginning. Marsha tries to get into a shopping mall, the Galleria, after it has already closed, and, when she tries to escape, her efforts have the hallmarks of a claustrophobic nightmare of entrapment: as she runs she calls, "Let me out!" and "Let me go home!" but her efforts are futile. As in a troubling, surrealistic dream, long hallways are filled with disembodied mannequin heads that call out her name. Distraught, she feels her leg becoming immobilized, and soon she is paralyzed and anxious on the floor. At the end, she is frozen with her arm outstretched as though still reaching out for mobility and life. The briefly animated Galatea has once again become a fashion doll on a pedestal in a commercial world.

Blade Runner

The anxieties of being a simulation were much more probingly and memorably presented in Ridley Scott's 1982 iconic film *Blade Runner,* based on Philip K. Dick's short novel, *Do Androids Dream of Electric Sheep?* (1968). Scott's film becomes a meditation on the uncanny as Rachael comes to the poignant recognition that she is a "replicant," not real. Revisiting the tensions of the uncanny, *Blade Runner* evokes a somber and eerie posthuman world that requires empathy tests to tell who is artificial and who is real. It is a world where human identity is under siege, where replicants like Rachael painfully grasp their own artifice and people as well as simulacra struggle to survive.

Rachael (Sean Young) is in a future world yet also the essence of 1940s chic: a beautiful, red-lipped woman working for the Tyrell Company in Los Angeles she wears her black hair in a stylized forties roll, and her clothes feature the exaggerated wide shoulders of the era (fig. 4.10). After giving her a Voight-Kampff empathy test, the blade runner policeman Deckard (Harrison Ford) correctly identifies her as a replicant—an intelligent Nexus 6 human-looking being created by genetic engineers.

Much of the film's tension comes from its shadowy lighting and elusive boundaries between artificial and authentic, as the female Rachael confronts her own synthetic identity. She gives stock answers identifying herself as a replicant (and unflinchingly kills insects), but it takes more than one hundred questions to determine she's not human. She doesn't know she's a replicant, an experimental model with implanted memories (derived from Tyrell's niece), but she is beginning to suspect so. In a poignant moment in the film, after Deckard reveals he knows her private memories, she realizes she has brain implants and saddened she starts quietly crying. To soothe her, Deckard picks up a photo of her faux-mother and says, "I made a bad joke. You're not a replicant." After she saves his life, he abandons his task of killing her and even says he won't pursue her if she tries to escape.

Simulated Women in Television and Films • 119

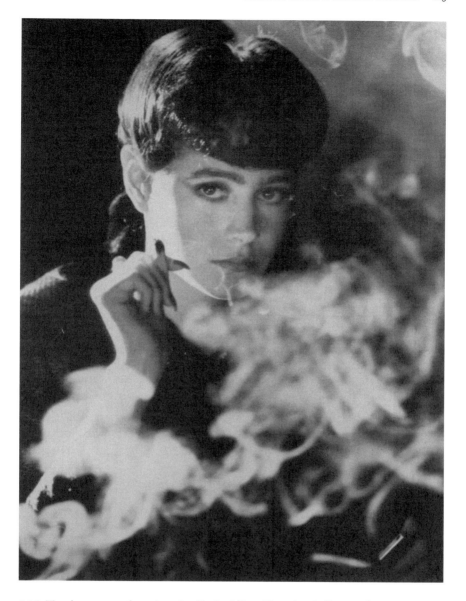

4.10 The glamorous and pensive robot Rachael (Sean Young) in Ridley Scott's 1982 iconic film *Blade Runner*.

Blade Runner deftly conjures up a surreal dreamscape where artificial females morph into human-like creatures and struggle to stay animated and alive. Rachael's severe image is softened when she, with a talent like those wondrous harpsichord-playing eighteenth-century female automatons, discovers she can play the piano. In a pivotal scene of transformation, she takes out her hairpins

and lets down her formally coiffed hair. Now with natural curls and without red lipstick, she looks softer and more feminine, a fitting partner for romance and love. At the film's end, Rachel and Deckard manage an escape, and there is the lingering suggestion—made more apparent in the "Final Cut" version of the film in 2007—that Deckard himself with his memories of a unicorn is a replicant himself.

Apt models for future videogame avatars, women replicants in *Blade Runner* can be formidable and seductive too. In one of the film's most evocative scenes, Pris (Daryl Hannah), who is a "basic pleasure model" with blond hair and dramatically darkened eyes—a replicant created to service men in military clubs in the "Outer-colonies"—stays in the apartment of the genetic designer Sebastian after he is killed, a space filled with female mannequins and small walking automatons. In a chilling and painful image, she dangles the tiny half-torso of a doll from her hand, twirling it by the hair, a miniature double of her own artificial being (fig 4.11).

Scott's film slyly constructs added layers of artifice: When Deckard manages to track the fleeing Pris to the apartment building in Los Angeles called The Bradbury, the artificial woman desperately tries to camouflage her identity by posing as a mannequin wearing a veil, thereby becoming the female

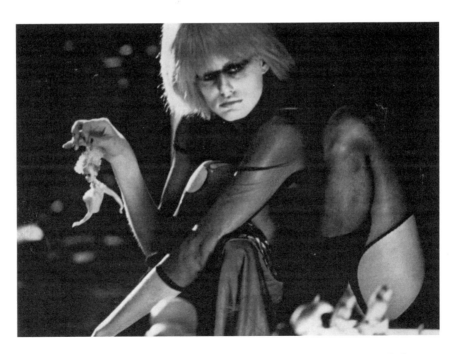

4.11 Pris (Daryl Hannah), a "pleasure robot," in the film *Blade Runner*, absentmindedly dangles a small female doll, a tiny simulacra of herself.

archetype of a bride or a harem woman who is seductive yet hidden. But her disguise is ultimately futile, and, after being found and shot by Deckard, she flails violently until she "dies."

(Scott in *Blade Runner* has his women characters contemplating their own synthetic nature, but in television series, such as *Battlestar Galactica*—which began as an American television series in 1978 and returned intermittently through 2013—the tall, blond artificial female operative Cylon Number Six [Tricia Helfer] who has human emotions and a glowing spine—has mixed reactions to her own artifice. She acknowledges she is a machine, but when Balthar in the 2003 miniseries tells her "You're a synthetic woman, a robot," she also stubbornly insists on her own humanity.[20])

The Electric Grandmother

If *Blade Runner* evoked the angst of artifice and simulation, American writer Ray Bradbury with Jeffrey Kindley wrote the 1982 television film *The Electric Grandmother*, which presented a heartwarming and comforting artificial older woman who helps a family weather the loss of a wife and mother. This utterly lifelike and convincing robotic female is the Substitute Woman with only kindness at heart. The 1982 *Electric Grandmother* was a new version of Bradbury's teleplay "I Sing the Body Electric," which he had written twenty years earlier in 1962 for *The Twilight Zone*.

In this 1962 *Twilight Zone* episode, a family whose wife and mother had died a year earlier reads about a shop that produces "electrical shadows, effigies, and mannequins," including "an electronic data processing system in the shape of an elderly woman" who can offer comfort and care, a woman "built with precision" available at a shop called Facsimiles, Inc. with a mannequin of a woman's headless torso hanging in the window.

The ancient idea—and continuing male fantasy—of constructing a woman from an assemblage of parts resurfaced and may have been particularly appealing in the 1960s, a decade devoted to cars for which customers could select design features, including paint colors. The electric grandmother is a custom-designed assemblage whose parts are chosen by the children themselves. To construct the woman they are invited by the shop owner to choose from "bits and pieces"—eyes, arms, hair, height, and even voice. While male inventors like Coppelius generally passed their fictive females off as real, when the assembled grandmother arrives, she insists that the children recognize that she is a mechanism, a robot: she hands them a key to wind her up, and the son (in this 1960s episode, men are still pictured as most comfortable with machines and thinking scientifically) points out, "You don't run on a key. You run on electricity."

As a writer, Bradbury is intrigued by the slippery borderlines of the uncanny. Anne, one of the two daughters in the family, is resistant to accepting the grandmother because her own mother left her and died. She says angrily to her family, "You make believe as if she were real. But she's not real. She's a machine.

Nothing but an old machine!" With 1960s ambivalence about technology and facsimiles, Grandma insists that they recognize that not only is she artificial but she also has the capacity to love them. She proves herself when she helps save Anne from being hit by a van by sacrificing herself instead.

With the 1960s' longing to humanize machines, "I Sing the Body Electric" is a timely fable about a benevolent mechanism in the guise of a good woman. She plays with the children, she cooks, she loves, and she is kindly and caring—a woman who teaches them languages and science, who playfully flies a kite with them, and who socializes them about gender roles (fig. 4.12). As she runs down the street, she calls out, "Last one is an old maid!"—a joking reference to an unmarried woman, which was something young girls in particular didn't want to be (in the popular children's card game, the ultimate holder of the Old Maid card loses the game).

In tales about simulated women, the horrible proof of artifice can occur at the end when the simulacra "dies" and is destroyed, reverting back to being a random collection of parts, but Bradbury's tale keeps the grandmother alive. When she revives after being hit by a car, she tells Anne she's designed to live forever and never die, and Anne, now comforted, happily accepts her warmth. After Grandma leaves the family, her parts may be redistributed while her mind

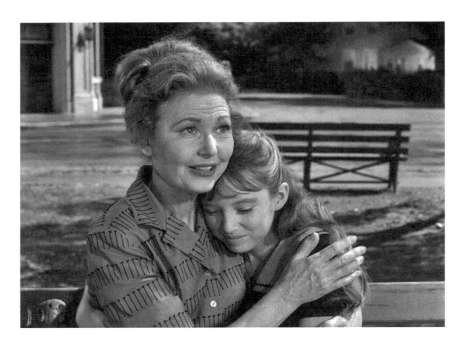

4.12 The kindly robot grandmother comforts Agatha in Rod Serling's television series *The Twilight Zone* in the 1962 episode "I Sing the Body Electric."
PHOTOFEST

and soul goes to a room with other electric grandmothers who swap stories about their families. Someday, says Grandma wistfully, maybe in three hundred years, she'll be given the gift of life.

Seven years after the *Twilight Zone* episode, Bradbury turned the teleplay "I Sing the Body Electric" into an evocative, fairy-tale-like short story, which was originally titled "The Beautiful One Is Here." It was published in *McCall's* magazine in 1969 and included in his collection of short stories, *I Sing the Body Electric!*, published that same year. He opened his volume with the beginning lines of Walt Whitman's famed poem, "I Sing the Body Electric" from his 1851 volume *Leaves of Grass.* Here Whitman wrote of "The armies of those I love" that "engirth me," "and I engirth them"—people who want him to electrically "charge them full with the charge of the SOUL." In Bradbury's story, the warmth of the robot grandmother infuses her young charges with the wisdom of her own "soul."[21]

In the short story, the three children whose mother recently died go with their father to the shop now renamed Fantoccini Ltd run by Guido Fantoccini whose name, in Italian, we are told, means "shadow puppets." There they see a robot whose mechanism has evolved technologically since the 1960s teleplay: it is described in a pamphlet as "the first humanoid—genre minicircuited, rechargeable, AC-DC Mark V Electrical Grandmother" built with "loving precision." The grandmother is a "Miraculous Companion" for families "where death or ill health or disablement undermines the welfare of the children." A knowledgeable robot, this "electro-intelligent" human facsimile has not only complete knowledge of art and sociopolitical world histories but also the capacity to listen, react to, and love children.

Bradbury's story is not only more technologically developed and more evocative than the teleplay but also, like those nineteenth-century Parisian automatons, more exotic too: at the shop, the children hear multiple female voices whispering, and a salesman holds out a small machine that utters the name "Nefertiti," which is not only the name of the ancient Egyptian queen but also, says the salesman, is Egyptian for "The Beautiful One Is Here" (which was the original title of the story when it was first published in *McCall's* magazine). After she is ordered, the key-activated grandmother is delivered, embedded in an Egyptian tomb box, and she is malleable: she is made of "wax-tallow plastic metal forever warmed and forever capable of loving change." She is also custom designed—she has eyes the color of marble selected by son Tim and hair selected by daughter Agatha.

This artificial female is malleable in other ways too as she mirrors the children: her face mysteriously seems to be wearing a different mask depending on what child she is standing near; based on her placement, her appearance varies in the photographs taken of her with a Brownie camera. The family is a blend of different nationalities; Agatha looks British, Tim Italian, and narrator Tom Slavic, and the grandmother takes on the look of each of these differing nationalities.

Bradbury in the story softens the tensions between artificial and real. Their father says that when he grew up, machines were considered evil and dehumanizing, but in this era in which technology was often rendered suspect the grandmother gives machines a good name. The grandmother's emotional mirroring and more fundamental transformative effects come as she listens carefully to each child, gives them love, and offers kind words. When she intervenes to save Agatha from being hit by an automobile, her love helps transform the sullen, hostile, and grieving girl into a receptive person willing to accept Grandma's love.

Bradbury infuses his story with a benign view of both women and technology, and his facsimile grandmother is better than a real human being. Like Verda in *Lost in Space,* she is a robot with a moral center—"I cannot sin, cannot be bribed, cannot be greedy or jealous or mean or small. I do not relish power for power's sake." She is also safely asexual: "Sex does not run me rampant through the world." In many ways, Grandma is both the ideal woman (caring, comforting) and the ideal humanized robot as she helps the children be their best selves. She is also eternally beneficent. After the children go off to college, she will return to the Fantoccini and join the "family" of robots—thirty to forty electric grandmothers sitting and rocking and talking—waiting for the day when they, like Pinocchio, will be given the gift of life, waiting for the day when the children will need them. This fantasy eternal woman never really leaves them: at the story's end, the children, now aged themselves, await the delivery of their grandmother once again.

Twenty years after the *Twilight Zone* version, Bradbury remade the teleplay into a television film *The Electric Grandmother,* which aired on NBC in 1982. The inventor and store owner Guido Fantoccini is still in the business of "fulfilling dreams," and Grandma (played by the kindly Maureen Stapleton) looks like a Norman Rockwell conception of a grandmother—rotund, gray hair in bun, apron—but, as in the original *Twilight Zone* version, she has energy and can run. Grandma in the 1980s is now a fusion female, a product of ancient culture, the early twentieth century, and also the more advanced technological age. Although upon arrival she is encased in a silver Egyptian mummy case/sarcophagus, she is dropped off by a helicopter that hovers over the family's home. With a bit of magic and whimsy, Grandma's automation is updated. At breakfast, she makes them flapjacks and French toast as milk and orange juice magically issue in a stream from her fingers.

Well before early twenty-first century roboticists were engaged in the highly complex task of developing electronic robots to serve as empathetic caretakers, Bradbury provided a blueprint for the ideal female robot caregiver. She is a lifesaver (saving Agatha), a dream-maker (helping the children fly their kite), and the source of unconditional love. She is smart and knows Shakespeare, math, Darwin, and Plato. Most important, she will never abandon them, and she never ages further, never gets sick and infirm. She is warm and understanding,

anxious for the children's welfare, but forever available as she plugs herself into an electrical outlet at night and gets recharged. "I'll always be here when you need me," she says, and indeed, at the end of the story the now-aged children welcome their grandmother who has come back to take care of them in their final years.

Ultimately, the 1980s grandmother further softens the potential discordance of the uncanny and the tension between artificial and real. In the beginning, Agatha, who cannot accept Grandma's love and care because she fears abandonment since her own mother died suddenly, goes down into basement and pulls out Grandma's plug: "You can get them to love you, but I never will," adding, "You're just a machine!" Says Father, however, "I'm so used to thinking of a machine as cold and inhuman," but, he continues, "Often I feel as if you are a real woman." And Grandma, sitting with other electric grandmothers, muses at the end that "sometimes I almost feel as though I feel." Simulated feelings, in this fictional world, will do just fine.

Women, both the robot Grandma and Anne/Agatha, are empowering and empowered in Bradbury's story and teleplays. In the 1980s teleplay, women's career possibilities have dramatically evolved: when Grandma returns to the family years later, resuming her familiar role as caretaker, she discovers that Agatha has now become a doctor. Even earlier, the young Agatha was given an opportunity usually reserved for men: Grandma's inventor, Guido Fantoccini, gave her the robot's key, and she later uses it to bring Grandma to life.

Small Wonder

During the 1980s, the idea of a cyborg bionic woman—a fearsome female with a technologically modified body—appeared in Cyberpunk novels such as William Gibson's 1984 novel *Neuromancer* with its character Molly Millions who has implanted mirrored lenses covering her eyes and retractable blades underneath her fingernails. Yet not only *The Electric Grandmother* but television sitcoms of the 1980 also presented more benign female robots as object of wonder, like Vicki in the series *Small Wonder,* which aired from 1985 to 1989. Actress Tiffany Brissette played the young experimental female robot Vicki (an acronym for Voice Input Child Identicant) that inventor and electronics expert Ted Lawson, who works for United Robotronics, brings home to his family.

Vicki reflects the impact of 1980s technological change: IBM's first Personal Computer, the IBM 5150, was introduced in August 1981, and Vicki is presented as an electronic marvel, the product of the latest in electronic technologies. She is controlled through computer and voice commands, is activated through light (she has solar cells in her eyes), and is programmed "to know everything," with her controls hidden underneath a flap on her back. As the show's theme song proclaims, "She's fantastic, made of plastic, microchips here and there; she's a small wonder, and brings love and laughter everywhere." With her synthetic skin, actual human hair, and perky dresses, she looks like a real ten-year-old girl.

Avoiding those troubling moments of the uncanny when artifice elides with the real, female robots in these sitcoms may look human, but they are unmistakably mechanical, too. In *Small Wonder,* Vicki's artifice is central to the show's comedy. She is very much a robot, and the audience heard in the laugh-track finds it amusing when she speaks in a flat monotone, repeats what she hears, walks stiffly, and swivels her head 180 degrees.

Vicki embodies the recurring male fantasy of the female robot as unthreatening naïve creature. She is a technological newborn whose knowledge of sex is nil, and her learning curve is steep and funny. Though her memory bank is programmed so that she knows everything and can do what any ten-year-old can do, she is still created as a child. The Lawsons' young son, Jamie, who quickly sees practical uses for her, including doing his homework and picking up his clothes, also manages to ask her if she knows about sex (the answer is no, and he too doesn't want her to see him in his underwear). She is not only asexual, but she is also without feelings; she is not even programmed to smile, though Ted wonders if she can be programmed to have human values and emotions.

Vicki may be a technological wonder of the 1980s with extraordinary intelligence and strength, but the men of the family—and this is a running comic riff in an era of women's rights—socialize her to be quintessentially female. The men insist on seeing her in gendered terms. In the third season episode "The Nerd Crush," Vicki is taught by both Jamie and his father to fill a female role. She is a math whiz, but, while Jamie is at work on the computer, Ted tells her to help his wife with vacuuming and work in the kitchen. After Jamie mockingly tells her how boys and girls kiss and hug, he also instructs her on how to be a coquette and bat her eyes, a technique she unexpectedly uses when his nerdy friend develops a crush on her (Jamie also teaches her how to insult the nerd). A quick study, Vicki as robot girl readily takes on female roles—though her extraordinary abilities challenge these conventional roles as well.

The Jetsons—1980s

Rosie in *The Jetsons,* the cartoon version of the wondrous female robot, resurfaced during the 1980s when the series reappeared in 1985 and 1987. The later version not only reflected greater sophistication in electronics but also spoofed the potential for errant technologies. Rosie has a humanlike capacity for emotions, but she is also humanlike—and machinelike—in another way: she's fallible. Rosie's humanity is shown when she, too, malfunctions, in "Rosie Come Home" (1985). The family notices that Rosie is breaking down and wonders, "Has Rosie flipped her microchips?" Indeed, her "microchip master cylinder" needs a replacement part. When George goes to a robot parts store, however, the clerk tells him Rosie's model is old and suggests that the family consider a new generation of robot maids.

When Jane Jetson first went to U Rent-a-Maid to find a house robot in the 1960s series, the choices ranged from sexy-servant to Rosie's no-nonsense

efficiency. The choices in female robots changed in the 1980s *Jetsons* revival, which reflected technological changes that had occurred in the intervening twenty years. In "The Jetsons' Night Out" of the 1960s, Mr. Spacely's robot secretary Miss Galaxy has a sexy pink torso and dials as breasts. Twenty years later, when Elroy has a computer and videodisk and Judy has a digital diary, Rosie's temporary replacement is the high-tech "Mechano Maid 2000."

Mechano Maid, however, annoys the family with her digital efficiency. Programmed to monitor solar watt usage for optimum savings, she ludicrously allows the family only ten minutes of television watching each night. In the name of hygiene and sanitation she allows Elroy's dog to be in the house for only two hours each day. Interfering further in their lives, she won't give George his lunch while telling him he's too paunchy, and Jane ultimately calls her a "transistorized transient." Rosie, in contrast, is the humanized robot with sensitive feelings. After she is fired for malfunctioning, she cries in despair, and before her replacement part is repaired she despairingly jumps into a compactor and needs to be rescued by the family. Once repaired, however, Rosie comes back to normal and happily displaces the efficient but inhuman Mechano Maid.

One of the running gags in *The Jetsons* is that in this Utopian world of electronic modernity there are still technological glitches, and, as with Rhoda, a glitch manifests itself in Rosie's kleptomania. In the second season's "Rip-Off Rosie" (1985), push buttons make life easy, but the family's machines—including Rosie herself—malfunction again. After accidentally eating a lug nut she goes to a mall and shoplifts goods at a sports equipment store, a pet store, a hardware store, and a food store before being found by the family and taken to an operating room for repairs. In tales of the uncanny, there is often horror when the human-looking simulated woman is torn into parts, but when Rosie is reassembled, she comically asserts her (female) sanity, saying at the end, "I'm not the kind of lady that goes to pieces" as she cheerfully eats her box of robot candy.

The second season's "Mother's Day for Rosie" (1985) not only takes a comic view of Rosie's emotions and malfunctioning but also—in this decade of newly invented methods for creating electronic reproductions—comically riffs on visual copies. When Elroy reads aloud the Mother's Day message he's going to give Jane, Rosie looks sad and left out because she has no recollections and no picture of her mother, and when she weeps she blows a fuse (as a machine, she is not Dada artist Francis Picabia's sardonic image of a *Girl Born without a Mother*).

In this episode—which becomes a witty gloss on facsimiles, reproductions, and simulations—George goes to a robot factory looking for Rosie's mother, Model XB400, because he needs to take a photo of it to give to Rosie, but he learns that the obsolete model was discarded (for being too emotional) and thrown into a garbage dump and compacted into a cube by a crushing machine. Undaunted, he discovers a blueprint of the mother-machine in the salesman's office and takes a photograph of the blueprint to give to Rosie, who is finally comforted by this

third-generation simulation of the real thing. The episode includes other facsimile females as well. On a shopping trip with Rosie, Jane becomes fixated on a mannequin in the shop window wearing a black stole described in the store sign as "Genuine artificial imitation synthetic"—a stole she eventually receives from George as a gift. In this world of simulated humans and electronic machines, the facsimiles suit both females just fine.

Pygmalion Redux in Films after 1980

During the 1980s, as filmmakers and television writers were presenting robot females, they also returned to the Pygmalion myth, which maintained its enduring appeal. Evoking the comic spirit of *One Touch of Venus* and *My Fair Lady,* Hollywood films like *Weird Science* and *Mannequin* irreverently turned the myth into farce. In male fantasies about fabricating an artificial female, the dream woman is notable for her docility not her brains, but reflecting an America shaped by the women's movement and a fascination with new home personal computers, two nerdy teenage boys, Wyatt and Gary, in the 1985 Hollywood comedy *Weird Science* endow their female digital creation with high-level intelligence.[22] After they decide to use a computer to "simulate a girl" while one of their parents is away, they debate whether they should give her a brain so they can play chess with her.

Designing her to be both sexy and smart, they scan copies of *Playboy, Cosmopolitan* magazine, and pictures of Harry Houdini and Albert Einstein. Parodying *Bride of Frankenstein* (the film is interspersed with strains of "She's alive!" and flashing interspliced frames from the 1935 film), the boys use a computer rather than lightning to fabricate a woman, transferring her features from their ideal—a Barbie doll. In a mock male ritual they wear bras on their heads and chant while there is lightning outside as the house starts emitting rays, but when they apply high power to the project, electricity again becomes central to the story as the whole house explodes. The new technology may be iffy (they throw the computer out the window), but it helps produce the answer to their dreams: a statuesque Venus they name Lisa (Kelly LeBrock, fig. 4.13).

This Venus/Galatea is no ingénue. To Wyatt and Gary, she is an older woman—twenty-three—wearing a hot pink dress. She quickly takes charge, becoming a vehicle for their transformation into men as she drives them in a pink convertible to a blues bar and, because they are under twenty-one, gives them fake IDs. Rather than men educating her (as in Shaw's *Pygmalion* and "The Marble Virgin" in *Science Wonder Stories*), Lisa empowers the young men and tells Gary's father she's going to introduce them to "sex, drugs, rock'n roll" (indeed she kisses Gary and may have slept with Wyatt). In traditional Pygmalion tales, the men socialize the woman, but here Lisa gives them popularity by helping them throw a party. In this 1980s film, Lisa, the created woman, is clearly in charge but remains unthreatening as she feigns docility—she will tell the guests, "I belong to Gary and Wyatt," and "I do whatever they say."

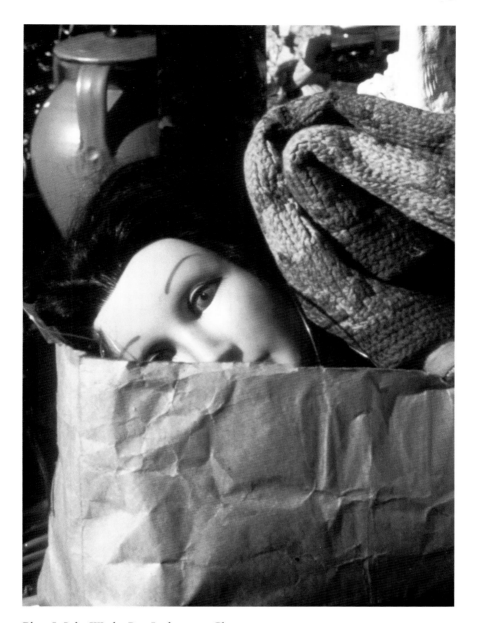

Plate I Julie Wosk, *Bag Lady*, 1992. Chromogenic print.
Photographed at a Manhattan flea market, this packaged blue-eyed mannequin is a commodity that captures us with her half-hidden teasing smile.

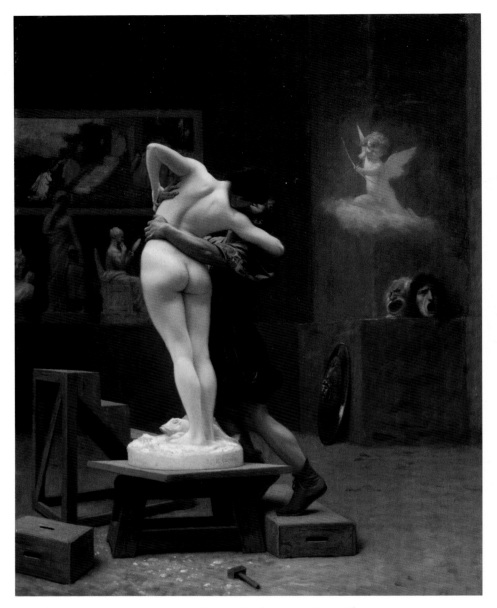

Plate II Jean-Léon Gérôme, *Pygmalion and Galatea*, ca. 1890. **Oil on canvas.**
In Ovid's classic tale, Pygmalion falls in love with his own sculptural creation of a beautiful female, and Venus brings the sculpture, which centuries later was called Galatea, to life.

Gift of Louis C. Raegner, 1927. Metropolitan Museum of Art, New York, New York, U.S.A. Image copyright © The Metropolitan Museum of Art. Image source: Art Resource, NY.

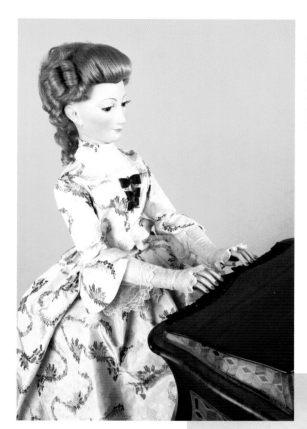

Plate III Lady Musician, intricate clockwork automaton created by Pierre and Henri-Louis Jaquet-Droz in 1773.

Musée d'art et d'histoire, Neuchâtel, Switzerland.

Plate IV The Flower Vendor automaton by Vichy (ca. 1885) had three cloth-felt "surprises": a monkey's head, a mechanical mouse, and a tiny dancing doll.

Murtogh D. Guinness Collection of Automatic Musical Instruments & Automata, Morris Museum, Morristown, NJ.

Plate V Julie Wosk, *Marlene,* **1995. Chromogenic print.**
The simulated women in my photographs are synthetic but provocatively real. A mannequin resembling film star Marlene Dietrich eyes us seductively from beneath her velvet hat as she lures us into her uncanny world.

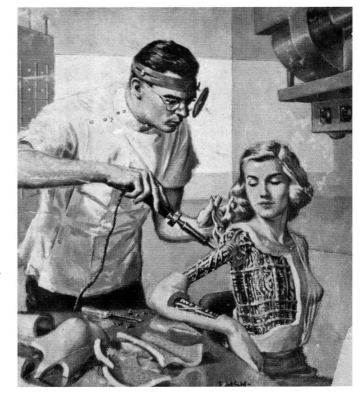

Plate VI A male scientist with his white coat operates on a female robot, her exposed body parts lying on the table.

Illustration by EMSH (Edmund Alexander Emshwiller), from *Galaxy Science Fiction* magazine, September 1954.

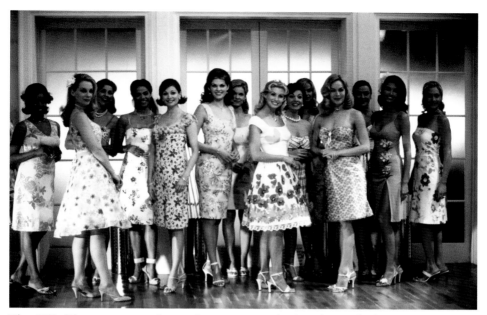

Plate VII Glamorous, compliant robot women at the Simply Stepford Day Spa in the 2004 Hollywood remake of *The Stepford Wives*.

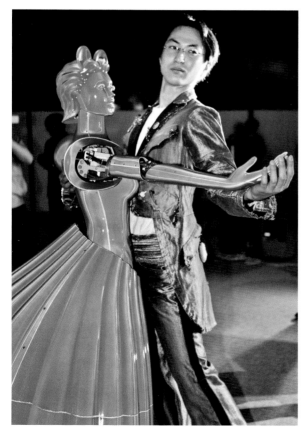

Plate VIII Postgraduate student Takahiro Takeda at Japan's Tohoku University dancing with a robot at a factory, Chino city, China.
AFP Photo/ Getty Images.

Plate IX An ultrarealistic female robot made of silicone and electronics, *Repliee QII,* was designed and developed by Professor Hiroshi Ishiguro, director of the Osaka University Intelligent Robotics Communications Laboratory in Japan.

Photo courtesy of Osaka University.

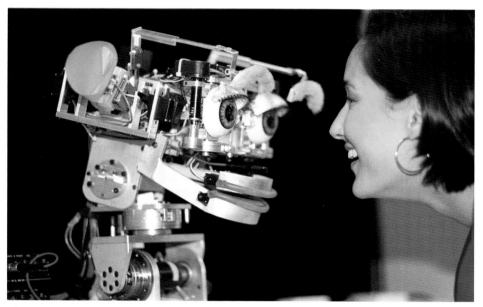

Plate X Cynthia Breazeal, director, MIT Media Lab, Personal Robots Group, and the early robot Kismet developed by Breazeal at MIT 1993–2000.
Photo © Donna Coveney.

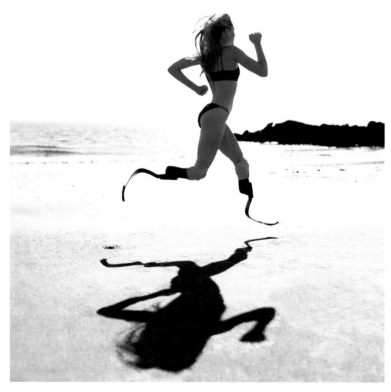

Plate XI Aimee Mullins running on the beach on her carbon fiber legs.
From *Athlete* © 2001 by Howard Schatz and Beverly Ornstein.

Plate XII Mariko Mori, *Birth of a Star*, 1995. Duratrans print, acrylic, light box, and audio CD.

© Mariko Mori 2009. All rights reserved. Photo courtesy of Mariko Mori/Art Resource, NY, ART 402561; © 2014 Mariko Mori, member Artists Rights Society (ARS).

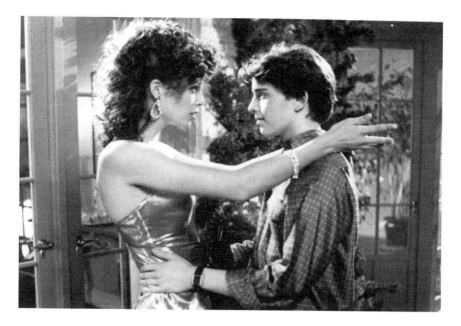

4.13 Lisa (Kelly LeBrock), a beautiful computer-generated robot, and one of her young creators in the 1985 Hollywood film *Weird Science*.

Suggesting the myth of Icarus, the film also becomes a gloss on male hubris as the boy inventors overreach themselves and decide to go after even more power. As they are showing off their newest computer creation—a digital female with big breasts—the house again explodes, and Lisa figures out the problem: they forgot to hook up the Barbie doll. As in Shaw's *Pygmalion* and Kellett's Pygmalion Story, "The Lady Automaton," the Galatea Lisa is also a moralist, telling them that they tried to be "big shots." As she patiently explains to them, people will like them for who they are, and they need not try for power and glory. (Meanwhile, the film also satirizes an America preoccupied with nuclear threat. After the boy scientists have created a nuclear missile, it comically comes through the kitchen floor, a phallic device painted radioactive blue.)

Ultimately the film becomes a coming-of-age story, not for the innocent Galatea but for the two young Pygmalions as the boys learn about masculinity, courage, sex, and love. When the film's motorcycle guys come through the window and ride through the house, Gary, pulling out a gun, drives the intruders off. By the film's end, Wyatt and Gary now drive a Porsche and a Ferrari, courtesy of Lisa, they fend off the tyrannizing brother Chet, and, most important, they are each in bed with a real girl.

Galateas in film and fiction almost invariably get married or depart—or even, as in *One Touch of Venus,* manage to reappear in another guise. Lisa in

Weird Science finally leaves the boys and disappears, only to comically reemerge at the end in another incarnation, this time as the female high school coach who appears again to the satiric strains of "She's Alive!" Ultimately, this beautiful, tough-minded female is still in charge.

Updating the comic mannequin-come-alive story of *One Touch of Venus,* the 1987 film comedy *Mannequin,* starring television's *Sex and the City*'s Kim Cattrall, presents Venus/Galatea as Emmy Hesare, a spirited woman 4,500 years old who was living in ancient Egypt, mysteriously disappears, and is next seen inhabiting a mannequin in a modern Philadelphia department store, Prince & Co. The mannequin was first constructed by the would-be sculptor Jonathan Switcher who lovingly takes a mannequin's torso, arms, and legs, and (in a happier version of *Bride of Frankenstein*) creates a new assemblage from these disparate parts.

After landing a job at the department store, Jonathan finds his beloved mannequin in a storage closet, and, when he places it in the store window, he is astonished that she comes to life.[23] In the 1940s, Venus is a ravishingly beautiful object of men's gaze, but in the 1980s, she is an impressive, knowing woman who elevates men. Emmy reveals herself to be talented designer who, though seen only by Jonathan, assists him in creating window tableaus that draw big crowds and make him successful enough to be promoted to company vice president.

Emmy's invisibility becomes central to the film, and, as so often happen in tales of men investing artificial women with life, Jonathan becomes the butt of jokes. The film's running comic premise is that since no one knows Emmy is alive, they think he's perversely having sex with a mannequin when he is discovered kissing it and lying with her on top of him. He's also mocked when seen riding around town with Emmy, who to others looks like a mannequin peculiarly seated on the back of his motorcycle.

While women in *One Touch of Venus* were infatuated with household machines, in the 1980s the artificial-woman-come-alive has mechanical savvy, which was often still portrayed as the province of men. In a familiar fusion of the 1980s, Emmy, like E. Johnson (Melanie Griffith) in *Cherry 2000,* is sexy but has mechanical know-how, too. During a musical interlude in *Mannequin,* Jonathan sits in a smoking jacket—like the self-satisfied husbands in *The Stepford Wives*—as Emmy flashes open her fur coat-covered body, revealing her sexy underwear. But in ancient Egypt, she had told her mother, "I want to fly," and now in Philadelphia, she works in the store's machine shop and tells Jonathan she loves to build and invent things. In one scene, she flies through the store on a glider, a female Icarus without hubris, soaring on her wings.

But Emmy is also almost destroyed by a machine in a riff invoking classic horror movies where beautiful women, strapped to a plank, are in danger of getting sliced in two by a devouring saw. Jonathan's former girlfriend Roxie—once employed by the Prince store but now working for the store's competitor—maliciously puts the store's mannequins into a pulverizer that grinds them up. In

danger of being crushed and dismembered, Emmy is rescued by Jonathan, and later she becomes permanently alive. With a classic comedy denouement, the two get married in the store window, two real-life lovers now both on display.

Virtual Women in a Digital Age

In the 1990s, representations of android women, Pygmalion images, and the women's movement itself were all ripe for satire. In the comedy *Austin Powers: International Man of Mystery* (1997), sexy female robots or Fembots are introduced to the strains of Nancy Sinatra's 1966 feminist hit about stalwart women, "These Boots Are Made for Walkin.'" In this late twentieth-century spoof, the men—the British secret agent Austin Powers (Mike Myers) and Dr. Evil (also Mike Myers)—are cryogenically frozen and reanimated while the Fembots, as expected, are hot. For years in video games, women were simply sexy love interests or victims, but in 1996 Tomb Raider video games presented a very different paradigm: the athletic, intelligent, and powerful archaeologist Lara Croft who is skimpily dressed but toting a gun in each hand. One year later, in the Austin Powers film, the image of the powerhouse female avatar was satirically embodied by the blond-haired sexy Fembots dressed in skimpy silver, shooting guns from their feathery bras that emit smoke. Lara Croft successfully battled foes, but when Austin Powers, wearing his skivvies decorated with the Union Jack, does his own sexy dance the Fembots go haywire and explode.

The Fembots in the Austin Powers film may have had ludicrously lethal bras, but it was virtual women—in the new millennium's world of video games, films, television, and even fashion modeling—that posed the biggest challenge as virtual females competed with real ones in the electronic age. *Playboy* magazine, which had long been notorious for the artifice of its airbrushed images of beautiful sexy women, pushed artifice to a new level by featuring Bloodrayne, a sexy video game nude, as its centerfold in a 2004 issue. Another digital female, billed as the "world's first" virtual supermodel "Webbie Tookay" (2k) introduced in 2009, was praised (perhaps sardonically) by the founder of Illusion 2K, a business representing virtual models, as superior to real ones: "You know she will never get a pimple or ask for a raise. Sometimes I wish all models were virtual."[24]

Final Fantasy: The Spirits Within (2001) became the first feature film with computer-generated actors—notably the star character, Dr. Aki Ross, a fearless female scientist who also trained as a military jet pilot, and Jane, the film's staunch, muscular female member of the military squadron. These virtual actors would not, however, displace real ones like Sarah Grau as Cameron in the later *Terminator: The Sarah Connor Chronicles.*

After 1990, filmmakers and television producers more tellingly probed the implications of the uncanny in an increasingly digital age as electronic images vied with "real" ones, blurring the boundaries between the two. One of the wittiest films on the impact of creating a virtual woman was New Zealand

director/screenwriter Andrew Niccol's 2002 film *S1mone* (*Simone*). When a high-maintenance film star Nicola Anders (Winona Ryder) suddenly quits her film during production, the director Viktor (Al Pacino) secretly creates a virtual female as her replacement, Simone. This simulated woman becomes hugely successful, a development that causes him much happiness and later considerable anguish as well. Simone was the brainchild of the eccentric hacker Hank Alino whose sympathies were clear in his talk on the future of film, "Who Needs Humans?" Dying of a terminal disease, he had bequeathed to Viktor a disk with the information about Simone, and nine months later a new digital woman was born. In its sardonic update on synthetic women, Niccol's film weaves together familiar themes: the creator acting as Pygmalion; men fantasizing about creating the ideal, perfect, compliant women; and men's lurking anxiety that their virtual creations will ultimately evade their control.

When the prima donna Nicola had given Viktor a hard time, he ruefully regretted the loss of the old studio system when actresses did what they were told. The synthetic Simone, however, is easily manipulated and controlled. Even though she is a product of Hank's technology, this Galatea gives Viktor a god-like role: "You did create me," she says, adding, "I was nothing without you," and "I was all ones and zeros." He replies, "I breathed life in a machine." The film has fun twitting the symbiotic relationship between Viktor and the synthetic Simone—for him, the ideal fantasy female whose words and wishes mirror his own. Through electronics, she utters her words in real time as Viktor—a digital ventriloquist—says them. Her gestures, too—using a prototype of motion-capture technology—are based on scans of his, and her emotions are controlled since he even manipulates her tears. No wonder this compliant, unthreatening female makes Viktor cum Pygmalion feel utterly content: "I'm so relaxed around you," he tells her image. "So myself."

In the film, movie reviewers are also satirized for being rapturous about Simone, seeing in her an exquisite, composite woman: a fusion of Grace Kelly, Audrey Hepburn (her face), Sophia Loren (her body)—the kind of composite craftily created by New York photographer Nancy Burson in her 1982 composites where she morphed the faces of beautiful Hollywood film stars—Marilyn Monroe, Audrey Hepburn, Grace Kelly, Sophia Loren, and Bette Davis in one version and a second group that included Meryl Streep, Jane Fonda, Jacqueline Bisset, Diane Keaton, and Brooke Shields—to produce digital images of a generic beautiful woman.

Novelists and filmmakers have long been fascinated by the mega theme of illusion supplanting reality, especially when faux women are mistaken for real ones. Through Viktor's hucksterism and the public's gullibility, Simone becomes hugely popular; she appears onscreen at a performance, "Splendid Isolation," seen by a live audience of 100,000 and broadcast all over the world, and—with an added twist—she sings, ironically, "You Make Me Feel Like a Natural Woman."

Illusions, though, have a tendency to be shattered, and Simone's creator himself looks like he's heading for disaster. Rather than offering him lasting comfort, the virtual Simone—as so often happens when men turn to synthetic females—causes him angst instead, and he begins to lose his own sense of self. As the public and the studio head, his former wife (Catherine Keener), all clamor to meet Simone, he resorts to other virtual substitutes—a hologram, a mannequin. Eventually, the frazzled Viktor privately tells the truth: she's not a real person. "She's pixels, computer code, molded by me." As he becomes increasingly unhinged by the secret and the ruse, he even begins identifying with her as he puts on lipstick and says, "I'm Simone." Ultimately, the film becomes a witty cautionary tale about a runaway technology and the perils of the virtual displacing the real. For Viktor, the widespread public clamoring to see Simone live becomes unbearable, and to him she's now a runaway, Frankensteinian technology. As he laments in anguish when visiting Hank's gravesite, "She's taken a life of her own!"

As so often happens in stories of virtual women who are constructed from an assemblage of parts, she is dismembered and disintegrates. Viktor loads a "plague" or virus disk into his computer, and Simone disappears as she turns to pixilated dust. His efforts to obliterate her, though, turn out to be futile. In the film, it is a woman who takes on the Pygmalion role and resurrects Simone, bringing her back to life as she is saved from the virus by Viktor's computer-savvy daughter. In Mary Shelley's novel, Frankenstein had abandoned his plan to create a female mate for the Creature, fearful about creating a race of horrendous progeny, but Niccol's satiric film lets the female live and even procreate. After she resumes her role as a superstar, only to soon announce her "retirement," Simone joins with Viktor to appear on television as they introduce their new virtual baby, "Chip," assuring their survival on television as well as Viktor's survival.

Probing films like *Blade Runner* and *Simone* presciently teased out the ramifications of the uncanny and virtuality in an increasingly electronic age. During the 1990s and beyond, Japanese manga and anime like the science-fiction film *Ghost in the Shell* (1995) and its sequel, *Ghost in the Shell 2: Innocence* (2004), reflected Japan's own intense preoccupation with synthetic humans and the uncanny, and these media were filled with images of robot women, female dolls, and androids. Reflecting some of the contradictions and tensions in contemporary Japanese culture itself, Japanese anime and manga were often equivocal in their representations of these virtual women. In anime, female characters are varyingly presented as hypersexualized, innocent, pornographic, lethal, or with some complexity, like female cyborg Kusanagi in *Ghost in the Shell* who is both vulnerable and powerful.[25] In the Japanese television anime *Steel Angel Karumi* (introduced in 1999), set in a fanciful Japan of the 1920s and continuing into the twenty-first century in *Steel Angel Karumi 2*, the sexy and powerful Karumi, who is brought to life when she accidentally receives a kiss from

the adolescent boy Nakahito, reveals her military prowess and strength, but her image is softened with her pink hair and French maid's outfit.

Artfully interweaving many of the themes that have framed cinematic and fictional explorations of artificial women, *Ghost in the Shell 2: Innocence* (2004) presented a thoughtful meditation on the uncanny and the pain and agony of becoming a virtual female who has lost her own corporeal existence. The shaping tension of the film, directed by Mamoru Oshii and based on a manga by Masamune Shirow, centers on a groups of gynoids lifelike women robots designed as sexaroids or sexual "pets" that have been brutally murdering their owners and are being investigated by the security force agent Batou and his human partner Togusa. After they murder their masters, the gynoids (called the "Hadaly" type after the nineteenth-century novel *L'Ève future*) do the puzzling act of killing themselves by trying to malfunction or explode, like the gynoid they encounter who says, "Help me!" and then self-destructs by tearing at her own skin, exposing her innards. The mystery of why these gynoids commit brutal murders and the poignant reasons why they disembowel themselves become the central focus of the film.

We later learn that the gynoids, manufactured by Locus Solus, Inc., are created by using captured young women whose "ghosts" (personalities or souls) are either injected or hacked into the synthetic beings or dolls. Kim, who is an automaton himself, defines a "truly beautiful doll" in terms that men typically use to describe the ideal woman—as a "living breathing body devoid of a soul." He adds, "Perfection is possible only for those without consciousness or perhaps infinite consciousness," "in other words, for dolls or gods." The perfect doll/woman in this film is a vapid toy, a shell with neither awareness nor inner self, but with the addition of a ghost the doll's pain becomes all too real.

Visiting the Locus company's ship, Batou and Tsonga go to the gynoid production area where they see gynoids with bare bodies and green eyes. Batou, aided by Major Kusanagi as a download who has returned to help him (from the earlier *Ghost in the Shell* anime), investigates the technique that infuses dolls with souls: the captured girls are brainwashed, and their ghosts are dubbed into gynoids. As a tribute to human resistance to becoming virtual, the girls' voices call out in anguish, "Help me!" When Batou rescues one of these girls by pulling her out from a gynoid, she tells them that the gynoids engaged in their acts of violence to gain attention so someone would come to save them. She says in agony, "I don't want to become a doll!" But, says the major, paradoxically, if the dolls could speak, they'd scream, "I don't want to become human!"[26]

Ultimately, *Ghost in the Shell 2* becomes a vehicle for the director's philosophical musings (as voiced by the female detective Haraway, cunningly named after Donna Haraway, the author of "The Cyborg Manifesto") on the shifting boundaries between the artificial and the human. Amid references to René Descartes and the French *philosophe* Julien Offray de La Mettrie who posited that human beings are essentially machines, the anime also references female

automatons and dolls, artificial creations constructed by men. While in Kim's study, Batou picks up a copy of Hans Bellmer's *The Doll* (*La Poupée*) with one of the artist's ball-jointed dolls on the cover, and a Japanese mechanical female servant enters carrying a tray of tea for the men. (Steven T. Brown has noted that the director himself referenced Bellmer's ball-jointed dolls as an influence on his conception of the gynoids in his anime, and Brown also cites the influence of Japanese automata like the *karakuri ningyō*, which adapted clockwork technology from the West and peaked in popularity during the eighteenth-century Edo period.)[27]

Kim, who appears to die, soon raises his body upright as the film becomes a meditation on the uncanny, alluding perhaps to the Japanese engineer Masahiro Mori's discussion of the uncanny valley—that moment, sometimes eerie and startling, when an observer realizes that an electronic robot isn't real, and evoking death, a realistic hand feels like that of cadaver.[28] In a conversation with Batou, Kim voices his doubts about "whether a creature that certainly appears to be alive really is" and "alternatively, the doubt that a lifeless object may actually live. That's why dolls haunt us. They are modeled on humans. . . . They make us face the terror of being reduced to simple mechanisms."

The problematic emblem of the doll with its quasi-human yet fundamentally artificial nature—and its threat to displace humans—reappears at the film's end when Togusa returns home and is greeted by his daughter, who holds a doll. The final close-up of the doll's face becomes a startling reminder of the troubling ambiguities—and troubling implications—of this girl/doll fused identity in an increasingly synthetic world. In the twenty-first century, young girls in America, Europe, and countries including Korea and Japan, would embrace the artifice and appropriate the look of dolls.

About a decade after *Simone* and *Ghost in the Shell 2: Innocence*—in an electronic world now saturated with online virtual relationships and the voices of virtual women offering guidance and information on GPS systems and mobile phones—American screenwriter and director Spike Jonze wrote and directed his fascinating futuristic fable *Her* (2013) about a morose man who falls in love with the female voice of his computer's operating system. Isolated and lonely after his divorce, Theodore (played with angst and wit by Joaquin Phoenix) answers a series of online questions and initiates a new female computer operating system. Simone and the Japanese gynoids are virtual women with a female form, but the operating system who names herself Samantha in Jonze's film is simply a warm, engaging, sexy, disembodied voice (Scarlett Johansson).

Theodore earns a living writing other people's romantic e-mails, but Samantha offers him the comfort and attention he himself has been missing. In phone conversations when his mother asks him, "How are you?" she proceeds to talk about herself, but Samantha is the perfect woman—warmly empathetic, a good listener, and the answer to his dreams.[29] When she helps him with his e-mail, he tells her, "You know me so well." Thoroughly captivated by this virtual woman

who gives understanding, fun, and gratifying phone sex, the gloomy Theodore is transformed into a happy man.

With the film's echoes of the Pygmalion story, Samantha is transformed, not into a real, corporeal woman but into a virtual woman with feelings and a growing self-awareness. The virtual woman has her own awakening: feeling close to Theodore, she tells him, "I feel like I could say anything to you" and confides her embarrassing thoughts. She fantasizes that she has a body and is walking beside him: "I am becoming more than what they programmed." She's proud of having her own feelings, though she wonders if they are real. And after they each have orgasms during phone sex, she tells him, "I feel like something changed in me," adding, "You woke me up."

For all of their closeness, though, their relationship and sense of intimacy become strained: Samantha so wants a body that she enlists a surrogate woman to embody her. Her attention wanders, and she starts a connection with the OS version of Alan Watts (the Zen philosopher that the director associated with a constant state of change) and gives signs of her own independence.[30] As so often happens with men experiencing the uncanny valley, Theodore is horrified as the virtual female begins falling apart: he makes the painful discovery that the woman he cherishes has also been talking to 8,316 other men. Ultimately, the illusion completely disintegrates as all the operating systems start leaving, becoming like the discrete particles of snow Theodore sees through the window (and the electronic, television monitor snow as Simone disappears).

But for all the poignancy of loss in the film, the allure of the virtual perfect woman gets displaced by hints of new possibilities. Sitting close next to his friend Amy at the film's end, Theodore flashes a wide smile at her, a hint that perhaps he will reconnect with a real woman after all.

5
Engineering the Perfect Woman

Filmmakers and artists have delighted in tales of men using science and technology to craft the perfect woman. In the witty 1949 British film comedy *The Perfect Woman,* the befuddled scientist, Professor Ernest Belman, creates a beautiful battery-operated electromechanical robot named Olga who is modeled on the professor's own niece, Penelope. Belman calls the robot a perfect woman, he says, because "she does what she is told, she can't talk, can't eat." This obedient creature is just want men want. When given verbal commands, Olga walks, sits, and even allows men to take off most of her clothes at bedtime down to her sexy but mechanistic-looking undergarments (in this chaste film, she falls stiffly on a bed and nothing happens) (fig. 5.1). The fact that Olga doesn't eat is part of her perfection—she is a nonconsuming woman, a safe one for men to have around. She may not be used sexually in the film, but she can easily be touched.

In the film, Professor Belman hires two men—Roger Cavendish and his raffish valet/butler Ramshead—to take Olga out for a trial run in society. The film's broad comedy stems from the fact that two men are unaware that the real-woman Penelope, who wants an opportunity to go out on the town, has substituted herself for the robot. Imitating the artificial woman, the vivacious Penelope (Patricia Roc) has a hard time squelching her own appetite and subduing her ability to talk and move freely. When the men aren't looking, she ravenously wolfs down food in a hotel room.

In the men's eyes, Olga is an unfeeling machine (Ramshead calls her nothing more than a mechanism, a "radio set"), but the real Penelope definitely has feelings: when she is pricked by a pin, she cries and screams out with pain. But when Roger's aunt pricks Olga as a test, the robot acts as a robot would: she shorts

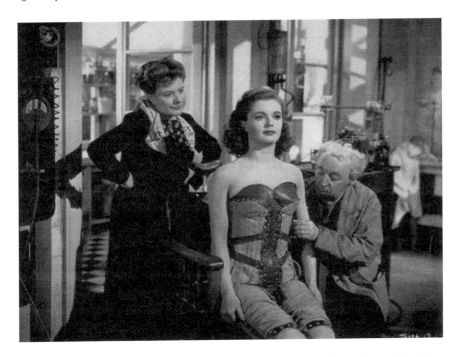

5.1 The professor's niece Penelope (Patricia Roc) impersonating a robot in the 1949 British film comedy *The Perfect Woman*.

out and explodes. Olga goes haywire whenever someone utters the word "love," but Penelope is capable of emotions. When she reveals her true identity at the movie's end, Roger is delighted and Penelope readily responds to the romance of his charms.

The Perfect Woman manages to be more than a running gag about a dotty professor and his mechanistic robot creation. It plays with the absurdity and comic aspects of mistaking reality for artifice—a situation that in other films and literature is usually reversed (mistaking artifice for reality), with frequently somber, even tragic, outcomes. The film also offers a subtext about the social constraints that can turn real women into artificial beings—constraints that limit their spontaneity. When Penelope goes with the professor's housekeeper to pick out a wardrobe for the robot, she rejects tight-fitting fashions that are too constrained by wood and whalebone supports. When the fashion models at the showroom get unruly and boisterous among themselves, the showroom manager tells them to behave like ladies.

The robot Olga in *The Perfect Woman* has some key attributes often found in men's conception of the ideal female: she is beautiful, obedient, easily controlled, and she says nothing at all. Her silence ensures that her words will never make men uncomfortable. Ultimately, though, it is the irrepressible

real-woman Penelope who is clearly the perfect woman—at least perfect for Roger in the film.

In the novel *L'Ève future* (*Tomorrow's Eve,* 1886), written seventy years earlier, French author Auguste Villiers de l'Isle-Adam produced a remarkably modern-seeming version of the technologically created virtual female, the beautiful and elegant Hadaly whose name, the author says, means "perfection" in Persian. In Villiers's novel, however, it is real women who have mechanistic qualities while for Lord Ewald the artificial Hadaly is better than real. In Villiers's novel, Lord Ewald longs to replace his lover, the singer Alicia Carey, a woman whose beauty rivals the sculpture Venus Victorious but who has banal conversations and a mediocre mind. He turns to his friend, a fictional version of Thomas Edison, to help produce a duplicate of Alicia. The novel was written amid the nineteenth-century's great burst of mechanical inventions and industrially produced facsimiles in the arts, and Alicia's double, Hadaly is presented as technological wonder, a fantasy female that surpasses the original.

Hadaly is created using a "photosculpting" process, and she is activated through electricity when a stone on her ring is touched. She is without human frailties, and her every response is technologically controlled. Her conversations are superior to Alicia's, for her beautiful and elegant words are those of eminent writers that are recited by performing artists and encoded on two golden phonographic metal disks set in motion by electricity. (During the period from 1877 to 1879, when the novel was written, the real Edison had developed the phonograph.)

As in later paradigms of the perfect woman, Hadaly embodies men's notion of the ideal, nonthreatening female: her speech offers Lord Ewald soothing responses to his every thought, and she only utters words that are pleasing for him to hear. For Ewald, she is a perfect female companion because her artfully programmed responses match his every mood. Says Edison to Ewald, Hadaly is an "objectified projection of your own soul."[1]

All of Hadaly's actions are also technically controlled, and by just touching the stones on her rings Ewald can manipulate her every move. With her touch-sensitive stones, Hadaly is a nineteenth-century prototype of push-button machines that would be invented in a few decades—electrical push-button doorbells and push-button electric light switches, devices that could be operated with ease. Edison tells Ewald that she will rise up "if you simply take her right hand, rub softly the amethyst on the ring of her index finger, and say to her: 'Come, Hadaly,' she will come to you, better than the living woman." By touching the turquoise on her ring finger, she will readily sit down. Real women, in Edison's eyes, are not as docile, but they too can be (perhaps erotically) manipulated: Edison reassures Ewald that "Living Women" also "have rings one must press."[2] In *L'Ève future,* real women, not Hadaly, are the most artificial. Although in *The Perfect Woman* Penelope is vivacious and full of life, Alicia in *L'Ève future* seems to Lord Ewald to be annoyingly mechanistic.

Speaking about Alicia, he complains about the "mechanical fidelity of her singing."

In the 1870s when the novel was written, American and Parisian manufacturers were already producing mechanical walking dolls, and fashionable European and American women often wore voluminous dresses supported by multiple petticoats or wired crinolines and bustles under their skirts, which caused them to walk awkwardly and stiffly like dolls. *In L'Ève future,* real women themselves are described as artificial beings: Ewald fears that Hadaly will only be an automaton, but Edison says that, if he were to contrast a living woman with Hadaly, he would have to consider if *"it isn't the living woman who seems to you the doll."*[3]

The technologically created women imagined in *The Perfect Woman* and in *L'Ève future* were missing two key features long associated with the ideal female: a devotion to domesticity and motherhood and ready availability for sex. (That Hadaly in Villiers's novel and Olga in *The Perfect Woman* aren't ostensibly used for sex is probably a product of nineteenth-century French bourgeois proprieties and British film codes of the 1940s.) In nineteenth-century America and Europe, the very real and ideal woman was one who fulfilled her proper role of being a devoted wife and mother. Reflecting the social values and conventions of her time, American physician Mary R. Melendy in her woman's medical guide *The Perfect Woman* (1901), written at the beginning of the twentieth century, described the middle-class perfect woman as being devoted to her husband, child-raising, and domesticity. The province of the perfect woman, wrote Melendy, "lies in gentleness, in cheerfulness, in contentment, in housewifery, in care and management of her children, in sweetening her home." For Melendy, housework would "provide a panacea for many of the ills to which flesh is heir." "One hour's exercise at the wash tub," she added, "is of far more value, from a physical standpoint, than hours at the piano."[4]

In the book's section on "Married Life—Its Duties and Pleasures," the pleasures, never explicitly named as sexuality, are described as "necessary to the health of a young woman," but they were pleasures that needed to be kept within bounds because "a wife who lives in a whirl of pleasure and excitement is frequently sickly and nervous."[5] Melendy is explicit about the physical appearance of the perfect woman: she is not a delicate doll. She tells her female readers, "Do not get the idea that men admire a weakly, puny, delicate, small waisted, languid, doll-like creature." Instead, "men turn naturally to healthy, robust, well-developed girls, and to win their admiration, girls must win their [men's] ideals."[6] For Melendy, rather than being doll-like, the ideal female proportions were embodied in another sculpture from antiquity, the Capitoline Venus (Venus Pudica), which Melendy cited as having a waist size that is two-fifths of her height and nine inches less than the top of her hip.[7]

A social and cultural sea change occurred between the writing of the 1901 medical book and the publication of Ira Levin's darkly satirical novel, *The Stepford Wives* (1972), a spoof and cautionary tale about men's longing to replace

their wives with technologically produced perfect women. In 1901 America, women's traditional roles were focused on the family and home, but in 1970s America, with the advent of the Women's Liberation Movement and female consciousness-raising groups, women increasingly began questioning and rebelling against conventional and confining gendered roles. To some men, these women seemed alarming and threatening. Here were women who defied social norms and eluded men's control, women who defiantly burned their bras and didn't wear makeup, women not aspiring to be complacent housewives or *Playboy* centerfolds. Written during these years of social ferment, Levin's novel presents the men of Stepford, Connecticut, who discover an antidote to the women's movement. They murder their wives and replace them with docile, robotic females who have miraculously shed their discontent and questioning ways.

Levin's novel and the two Hollywood film versions of *The Stepford Wives* produced in 1975 and 2004 satirize men's conceptions about the perfect female—conceptions that have, in American and European films and literature, remained remarkably consistent. The paradigm of female perfection is a beautiful, well-groomed obedient woman who happily fulfills women's conventional roles. She cheerfully performs all domestic duties and is always available to gratify her husband's sexual desires. She has no personal needs or professional aspirations of her own. These creatures of perfection adore their husbands, praise them, reassure them, and never challenge them in any way. They mirror men's thoughts and only say words that men like to hear.

In the 1975 film version, Joanna Eberhart (Katharine Ross) is a semiprofessional photographer, a "shutterbug" who has only reluctantly come to live in Stepford with her husband, Walter, and their children. At the beginning of the film and as a harbinger of things to come, she photographs a man carrying an artificial woman, a nude mannequin, across the street. She and her friend Bobbie Markowe wonder about the unquestioning cheerfulness of the oddly mannequin-like compliant women in Stepford whose topics of conversation center on the best recipes and the merits of spray-on starch. Says Walter admiringly about one of the wives who brought over a casserole, "She cooks as good as she looks!" In Stepford, the men, not the women, hold high-power jobs; for example, Walter, a lawyer, is impressed that he is being invited into the Stepford Men's Association whose members include television executives and corporate heads.

For the men of Stepford, their wives are a far cry from their notion of the perfect woman. Their answer is the liberal application of technology to achieve the ideal. In an era still enamored with plastics, the possibilities for fabricating imitations seemed endless and seductive. Using sketched portraits and their wives' tape-recorded voices, the men create doubles of their wives—robotic-looking females who are hypersexual and so busy in the kitchen they have "no time to think." (Bobbie thinks there may be some chemical in Stepford's drinking water—a darkly comic echo of Cold War fears in the age of fluoride when

chemicals were added to purify the water; these fears were spoofed in Stanley Kubrick's brilliantly satirical *Dr. Strangelove,* when Brigadier General Jack D. Ripper [Sterling Hayden] is convinced that fluoride is part of a communist plot to undermine democracies and pollute "precious bodily fluids.")

Joanna and Bobbie make a desperate effort to deal with the women of Stepford (they hold one consciousness-raising group to no avail), but the real tension of the film lies in Joanna's own desperate struggle to survive in this world where, as she tells a sympathetic psychiatrist, she might become "like one of those robots in Disneyland"—and "I won't be me." *The Stepford Wives* was written not long after the development of Disney's early computer-controlled audio-animatronic figures. In 1969, Disney began using computer disks in a Digital Animation Control System (DACS) to animate human and animal figures in its theme parks. These audio-animatronic figures were yet another technological wonder in a decade enthralled with automation, but for Joanna in *The Stepford Wives*—given its grim view of the wives' mindless mechanized behavior—the prospect of becoming a smooth-functioning Disney-like automaton is a nightmare rather than a dream.

In the dark of night in the midst of thunder, lightning, and pouring rain, Joanna discovered the horrible secret of Stepford: the women are murdered and replaced by robotic duplicates of themselves. Says Dale Coba, head of the Men's Association, "We found a way" that is "perfect for us and perfect for you." "Look at it the other way around," he tells her. "Wouldn't you like a perfect stud around the house?" For the Stepford husbands, a technological imperative propels them forward: when Joanna asks incredulously why the men engage in such a dreadful practice of fabricating women, Dale answers simply, "Just because we can."

The film also becomes a gloss on the image-making process itself. Joanna, who had earlier photographed a mannequin and recently found her own authentic voice taking black-and-white photographic images of children that she presented to a gallery, is ultimately strangled by a manufactured and distorted image of herself—a mannequin-like female dressed as the Stepford ideal of perfection wearing a shear negligee and a push-up bra. The 1975 version of *The Stepford Wives* is a dark horror film in which the wives of Stepford are killed in the gloom of night, but the 2004 remake became a much brighter and biting satire of happy housewifery, gender relations, and the uses—and more important, the misuses—of science and technology. More than twenty-five years after the first film, the 2004 film reflects women's advancements in attaining professional roles. Before their transformation, the women of Stepford had high-power jobs, including a corporate CEO—what Walter derisively calls "wonder women," "supergirls," and "Amazon queens." At the beginning of the film Joanna herself is a television executive, but she is soon fired and has a breakdown before Walter decides to move the family to Stepford to help the situation.

In the strangely unreal world of Stepford, Joanna (Nicole Kidman) is astonished that the women are "always busy and perfect and smiling" and that they

have, in effect, become machines. Claire, the Stepford real-estate agent (Glenn Close), takes Joanna to the Simply Stepford Day Spa where the women all wear bright floral dresses and high heels (plate VII). Says Claire, "we always want to look our best" as she looks disapprovingly at Joanna's own "dark stringy hair" and "worn-out sweat clothes." The women at the spa are so enamored of their home appliances—like the women in early appliance commercials from the 1950s and 1960s in the film's opening credits—that they exercise by imitating the whirling motions of a washing machine as they "spin and scrub."[8] To the men of Stepford their women are "sizzling" and "superfine," but to Joanna, "these women are deranged!" As paragons of the perfect female, the women of Stepford not only love to bake but are also always readily available sexual partners devoted to their husbands' needs. At Sarah's house, they hear her piercing screams of orgasmic ecstasy upstairs in the bedroom as Sarah tells her husband, "Oh, you're the king!"

In fiction and films about artificial women, one of the recurring dramatic moments is men's horrifying and painful recognition that their beloveds are artificial mechanisms and not real women, but in *The Stepford Wives* the discovery is both funny and grim. At the Men's Association, Mike Wellington, Claire's husband, gives Walter a demonstration of a woman who functions as an ATM machine. As money comes out of her mouth, Walter jokingly masks his alarm and embarrassment by noting, "She gives singles!" Both Walter and Joanna, however, witness a more troubling hint that the women are not real. In the middle of a Stepford Square Dance, Sarah starts "sparking" and shorts out, as she maniacally repeats the square dance chant, "Do si do, Do si do." When Joanna, Bobbie, and Roger go to Sarah's house to find out what is wrong, Roger picks up a metal remote control engraved with Sarah's name, presses it, and the robot wife walks maniacally backward up the stairs.

The Stepford Wives satirizes attitudes of the 1950s and 1960s toward technology. The men of Stepford who love gizmos play with radio-controlled robot toys and similarly enjoy mastering their wives using remote controls. As a new technology in the 1950s, remote controls were often marketed to both women and men as vehicles for machine mastery and control. Zenith's first remote control designed for television was called "Lazy Bones" in 1950, and an early ad pictured a man using a remote from the comfort of his chair and included, for men's presumed interest, an illustration of the remote's mechanism, its "miracle turret tuner."

Based on the stereotypic conception of women as timid about all things mechanical, however, remote controls were also marketed to women as a simple and easy-to-use device, as seen in early Philco ads in the 1930s for remote-controlled radios. Later advertisements for Zenith Space Command Televisions, which used remotes developed by Robert Adler in 1956, were gendered and frequently pictured a woman's hands using the remotes: in the 1950s and 1960s, the ads implied, women needed only to press the remote to get easy,

"trouble-free performance." One advertisement went even further by promising women proprietorship: it featured a photograph of a stern, even sinister-looking woman holding a television remote with the admonition, "Nobody touches her Admiral TV."

In *The Stepford Wives,* however, remote controls are firmly in the hands of men. The men of Stepford ostensibly fear that either they will lose control over women or women will run out of control; hence, the men need to turn them into docile, obedient, utterly compliant creatures. The remote controls in the film labeled with women's names not only help the men manipulate their wives but also turn the women themselves into operable machines.

The remote-controlled women in the film are versions of another related technology so popular in the 1950s and 1960s—push-button machines, much like the ones shown in the film's opening clips of vintage commercials. Push-button stoves, introduced in the late 1940s, and other push-button appliances were invested with America's postwar hopes and dreams of living an easeful life in an ever-more automated world. Companies like General Electric with their Hotpoint Touch Command washing machines promised women the possibility of power, command, and control. A 1956 Plymouth advertisement pictured a woman's turquoise-blue gloved hands pressing a car transmission button and included a single word in boldface: Power. As in *L'Ève future,* in Stepford the husbands do the button-pushing to control their wives and gratify their own dreams.

Only late in the film, when the anxious Joanna comes to the Stepford Men's Association looking for her children, do both Walter and Joanna finally learn how the Stepford wives were created. To explain the much larger technological secret behind these perfect women, Mike Wellington (Christopher Walken) shows Joanna and Walter the short animated promotional film *Is Stepford Right for You?* In this pivotal scene, they are introduced to Stepford's "Female Improvement System Machine," which uses electronic technology to transform the high-achieving career women of Stepford into sexy and adoring wives who love to cook and clean.

In the promotional film, Mike wears a pseudo-scientist lab coat in a pseudo-lab and demonstrates how a "gloomy dissatisfied woman" with glowering face, dark hair, glasses, and drooping breasts is placed into the machine as her transformation begins. As Mike narrates, a few nanochips are inserted into her brain, and she is programmed, "We enhance her to fit the ideal Stepford wife specifications" and then "Voila! Everything is copacetic." The new wife in the animation is a blond wearing a sexy pink outfit. Like a 1950s male fantasy of the ideal woman, she brings her husband a cocktail on a tray and kneels at his feet to put on his slippers as he sits comfortably in a smoking jacket.

"We perfect you!" says Walter to Joanna who tartly replies, "By turning us into robots!" adding, "is this what you want? Women who behave like slaves? Women who are obsessed with cleaning their kitchens and doing their hair?

Women who never challenge you in any way? Women who wait on you hand and foot?" Joanna may mock it, but to Mike, the "female improvement system" is an efficient way to "streamline your spouse" and a way to get rid of "every annoying habit, every physical flaw, every moment of whining and nagging." (Men's horror of having a stereotypical nagging wife is often one of their incentives for creating a lovely synthetic lady in these films.) For the men of Stepford, the technology gives them the power of creation: says Mike, "We decided to become gods."

Joanna realizes what is to be her fate. Up from the floor comes a marble sarcophagus-like platform with a mannequin lying on it—Joanna's future replacement. It has no hair, and, when its eyes suddenly open with a snap, they are eerily blank. The newly minted machine Joanna who emerges in the next scene is a glamorous blond wearing a large floppy hat and floral dress, an artificial and stylized woman who contentedly glides through the supermarket aisles. Proudly introduced at the Stepford ball, Walter waltzes with his glittery wife as Joanna asks him happily, "Is everything perfect?" (fig. 5.2).

The 2004 film has a happier ending than the earlier version. Walter ultimately has misgivings about transforming his wife into a robot and doesn't go through with it—leaving Joanna, like Penelope, to simply imitate a robot. Ramshead in *The Perfect Woman* dismisses Olga as simply a "radio set," and Walter similarly says he could not go through with the transformation because "I

5.2 Walter (Matthew Broderick) introduces his beautiful, blond, newly transformed wife, Joanna (Nicole Kidman), in the 2004 remake of *The Stepford Wives*.
PHOTOFEST

didn't marry something from Radio Shack." He also had misgivings about all the robot women of Stepford and initiates a "nano-reversal" whereby he deletes the Stepford robot program in each of the women. The real women of Stepford are brought back to life, reverting to their original—now angry—selves.

In another startling reversal at the end of the film, Joanna strikes Mike with a silver candlestick to stop him from trying to kill Walter, and Mike's head shockingly comes off, revealing that he too is a mere robot. In cultural images of the technologically produced perfect women, some of the most distressing moments happen when the artifice is suddenly exposed and all that is left are mechanical fragments, a dismembering of the fantasy and dream. In the 1954 film version of Offenbach's opera *The Tales of Hoffmann,* the doll Olympia's severed head blinks eerily on the floor. In *The Stepford Wives,* Mike's head with its sparks and glowing wires lies grotesquely severed from his body, an awful remnant of his urbane self. Says Claire with profound grief, Mike was "an angel," but now "he's just spare parts!" While in fiction and films it is usually men who conceived of manufacturing perfect women, in the film it was Claire who conceived of the idea of creating perfect women and a robot version of Mike, "a perfect man" after she killed him for his infidelity. She wanted to turn back time, she says, to a world of romance, "a perfect world" with perfect women, a time "before women turned themselves into robots."

In eighteenth-century France and England, a popular amusing salon pastime was electrical experimentation demonstrating the effects of electrostatic discharges. In one experiment called "Electrifying Venus," or "The Electric Kiss," a woman standing on a pedestal was kissed by a man and emitted sparks. In *The Stepford Wives,* the electric kiss turns out to be not amusing but deadly. The distraught Claire kisses Mike's severed head, and as sparks fly she falls to the floor, a victim of her own demented fantasies and dreams.

Six months later, Joanna has received an award for her film, *Stepford, The Secret of the Suburbs,* and, as she sits with Walter, she tells Larry King in a television interview that their marriage is doing well, and, as she adds ruefully, "Now we know for sure it's not about perfect. Perfect doesn't work." At the movie's end, the men of Stepford are now doing the shopping as they push their carts up and down store aisles.

The Stepford Wives' happy ending is based on the premise that the real Joanna with her intelligence, warmth, and capacity for love was far superior to the electronic facsimile women and certainly superior to the real women of suburbia whom the director can't resist spoofing (says Claire, she wanted a place where "people would never notice a town full of robots—Connecticut!"). Other late twentieth-century films that conjure up the technological perfect woman often pit the simplistic artificially created babe with the nuanced real woman who finally trumps the fantasy female in men's affections.

A memorable version of this artificial/real confrontation appears in the film *Cherry 2000* (1987). At the beginning of the film, Sam Treadwell comes home

and embraces his sexy robot Cherry who fixes him a snack. Like other versions of the perfect woman, Cherry is nonthreatening because she praises him, reassures him, and is designed not to challenge him in any way. Her personality is encoded on an embedded electronic chip, and she utters words that men like to hear: "I love you!" "Kiss me!" "I'm so lucky be with you!" "Hi honey—have a nice day?" and entertains him with preprogrammed mindless riddles and factoids.

Soon, however, Cherry has a "total internal meltdown," short-circuiting after her body comes in contact with bubbling kitchen sink water. As in *L'Ève future,* many real women in Sam's world are decidedly unappealing. After the loss of Cherry, he seeks out female companionship, but the women in clubs are crass, monetary, unattractive, cruel, and mean-spirited in their negotiations over sex. Finding another Cherry seems his only recourse. Though he still has Cherry's chip encoded with her personality and speech, he needs to hire a "tracker" who will journey with him to the stark and forbidding "Zone 7" to find another Cherry chassis in the robot graveyard. The tracker in the film is E. Johnson (Melanie Griffith), the tough-minded, attractive, red-haired adventurous female who—like later anime and video game heroines of the 1990s such as Lara Croft—is sexy, fearless, and strong. Rather than being a robotic machine, she is technologically adept, sharing characteristics often linked to masculinity: she drives a fast car, she crashes through barricades, and she repairs the engine on an old prop plane. She is a warrior woman, expert at throwing grenades and firing assault rifles. Unlike the stereotypic dainty female, she also has a ravenous appetite and doesn't mind getting dirty. When Johnson repairs the plane, Sam points out that she has grease on her face, "You're a mess!" "We can't all be glamour-pusses twenty-four hours a day," she pointedly replies. When Sam laments the loss of Cherry, he tells Johnson, "I could talk to her!" Says Johnson in response, "At least I have a brain."

Still, Sam throughout most of the film prefers an artificial woman to a real one. Talking to Johnson's uncle Six-Fingered Jake, Sam describes Cherry in romantic terms; she has "a tenderness, a dream-like quality about her," but Jake later counters, "There's a lot more to love than hot wiring." Johnson, the film unsurprisingly makes clear, is the far superior woman. While Cherry is programmed to be cheerful at all times, Johnson has real passion and emotions and cries when Jake is killed. At the end of the movie, she's heroic and self-sacrificing: she offers to jump out of the overloaded plane so that Sam, accompanied by Cherry, can get back safely, but Sam rejects this idea. Ultimately, Sam abandons Cherry in her pink jacket and red spandex pants in favor of the real flesh-and-blood Johnson, and he dismisses Cherry: "What about her? She's a robot!"

Produced twenty years later, *Lars and the Real Girl* (2007) is a more touching film in which the female doll is a safe, unchallenging female, a simulated woman perfect for the very shy twenty-seven-year old Lars (Ryan Gosling), who

seems incapable of more complicated relationships with women. Awkward with his office coworker Margo, who is interested in him, Lars instead orders a doll named Bianca from a website that lets him design his own woman, complete with her own back story. When she arrives, Bianca comes packaged in a box and wears a sexy fish-net dress with metallic shimmer but for Lars she is not a sex toy: he chooses to have her sleep chastely in a bedroom in his sister's house while he lives in the garage apartment nearby.

Lars tells his brother and sister-in-law that Bianca is a Danish-Brazilian missionary on sabbatical who speaks little English (which helps account for the fact that she never speaks), and he covers for her immobility (and perhaps his fears of women) by placing her in a wheelchair. Bianca may be immobile for Lars, but her presence in his life allows him gradually to become more socially lively as he takes her everywhere—to dinner at his sister's, to church, to a party. Lars's sympathetic sister and brother-in-law and the whole community kindly play along with Lars's fantasy as he brings Bianca to dinner and church, and with the aid of her as a faux-companion becomes more self-assured (fig. 5.3). Lars's doctor (Patricia Clarkson) is also sympathetic, calling Lars delusional rather than psychotic. The doll Bianca, she determines, can probably help Lars work his way out of his psychological issues (we learn that Lars's mother died when he was born and as an adult he still carries his childhood blanket around).

Lars is an innocent who needs to see Bianca as human, but the cynical bantering men in the movie see her as the artificial ideal. Real women voice their opinions and views, but, as happens so often in fictive versions of the perfect

5.3 Lars (Ryan Gosling) seated next to his doll Bianca in the film *Lars and the Real Girl.*
PHOTOFEST

woman, one of the men in the film says half-jokingly, "Wish I had a woman who couldn't talk!" At the party Lars goes to with Bianca, one man marvels that Lars is "in love with that slutty hunk of silicone" while another admiringly says she's the "best thing" because "she doesn't even know how hot she is." Bianca is men's ideal of the innocent, naïve woman who is unaware of her own attractiveness—a woman who will never abandon them. Says one of the men, "That's what you want in a woman. They stay with you because they don't know they can get somebody better." As also happens so often in stories about men and their artificial female lovers, Lars, in a moment of connection and contentment, finds great happiness dancing with Bianca while she sits in her wheelchair at a party. Ultimately, he is socialized and humanized through his use of the doll. He who couldn't stand to have anyone touch him is coaxed into feeling comfortable through the help of his doctor and the confidence he gains from having Bianca in his life. He even buys cell phones for Bianca and him so they can stay connected.

Bianca, the artificial woman, in effect helps Lars find his own humanity. Lars, who fashions Bianca's story and fears abandonment, ultimately becomes ready to have her disappear from his life. He says he asked her to marry him but she said no. He decides that Bianca is dying and cries after she "drowns" by falling in a lake. As in the films *The Perfect Woman, Cherry 2000,* and the 2004 *The Stepford Wives,* the real women supplant the fantasy female. At the movie's end, Lars takes his first tentative steps toward adult manhood and a relationship with Margo. The perfectly designed Bianca doll—immobile and unspeaking—is abandoned in favor of the gentle, vulnerable Margo, who is capable of genuine affection and tears. In late twentieth-century and early twenty-first-century films, real women, not synthetic ones, are seen as preferable if not perfect by the men who finally recognize their worth.

In 2012, the Hollywood film *Ruby Sparks* revisited the idea of the Perfect Woman and also the Pygmalion myth through the edgy lens of the young woman screenwriter, Zoe Kazan, who also starred in the film's title role. Calvin Weir-Fields, author of a famed novel, short stories, and novellas, first dreams about a red-haired twenty-six-year-old young woman and then discovers her mysteriously in his kitchen one day. Ruby is his fictional character come to life, a character that fulfills his dream wish about an idealized woman: she loves his dog Scotty—and him too—just the way he is. Says Calvin's brother in amazement, "You've manifested a woman with your mind!" Ruby has all the familiar trappings of men's fantasies: she's a good cook, she leaves her sexy underwear around the house, she promises never to get rid of him, and she says "I'm going to love him forever." He has total control over her, and, if he writes that she speaks French, she suddenly speaks French. Tailored to Calvin's interests, she goes with him to midnight zombie movies, video arcades, and dancing at clubs. His brother, with satirically masculine preoccupations, suggests Calvin tweak her further—give her good "big tits" and long legs, make sure she has no

annoying habits, and provides unlimited blow jobs—but Calvin says, "Why? She's perfect."

As a woman screenwriter, playwright, and actor, however, Kazan in her conception of the film goes beyond conventional depictions of men's idealized Galateas and tests the limits of the symbiotic Perfect Woman, by having her separate out and pull away. Ruby, who has artistic abilities and is gregarious (especially when compared to Calvin, who is fundamentally a loner) eventually voices her own wishes and becomes discontented, as she wants more. She talks about getting a job in a coffee shop, says one night she's too tired for sex, and says she's lonely. She's outgoing and happily dives into Calvin's hippie mother's Big Sur pool while Calvin stays home alone, reading a book. She talks about spending one night by herself in her own apartment and taking classes. She rejects symbiosis and wants space in the relationship: "otherwise we're the same person."

Kazan explores not only Ruby's complexity but also Calvin's own ambivalence about women and a relationship. With Ruby asserting independence, he writes her closer, so she says, crying, "I'm miserable without you" as she becomes suffocatingly clingy and depressed. Then he transforms her into being happy and filled with effervescent joy. Ultimately, she's filled with confusion and says mournfully, "My internal compass is just gone." After he gets angry with her at a party when she, in loneliness, responds to another man; she answers him back in a way totally imaginable by a woman screenwriter but unimaginable to most Galateas created by men: "I wasn't acting like the Platonic ideal of your girlfriend," she tells Calvin defiantly. "You don't want me doing anything.... Fuck you!"

Kazan's screenplay not only transforms the Pygmalion trajectory by creating an assertive, rebellious Galatea but also teases out the implications of the uncanny as perceived from Ruby's own point of view. As in *Blade Runner,* Ruby does not know she's an artificial woman, a fiction, a product of Calvin's writer's imagination. Not knowing she is simply a novelistic puppet, she later tells him in defiance, "You don't get to decide what I do!" He sadistically proves it to her by having a mysterious force block her way when she tries to leave. He shows her his book manuscript, and says, "I wrote you" and adds, "I can make you do anything because you're not real." The film forces her to recognize her artifice as Calvin harshly deconstructs her identity. To demonstrate his point, he has her humiliatingly crawling on the floor imitating a dog and also has her in a frenzy, uttering painfully and poignantly what he would like to hear: "You're a genius! You're a genius!"

Ultimately, this saddened Pygmalion lets his Galatea go: he writes, "She was no longer Calvin's creation. She was free." When he goes to her room the next day, she's gone. For all its sobering overtones, the film returns to being a romantic comedy after all. Not only does Ruby leave Calvin, but also Calvin himself is freed: at the film's end he has abandoned his typewriter for a current technology

of an Apple laptop, joining the ranks of contemporary writers and the world of men presumably sensitized to women's needs. Taking a plot device from *One Touch of Venus,* where Venus reappears in another guise, giving Eddie a second chance, Calvin at the end goes to a park, and there is Ruby, who has no memories of him. After their awkward introduction, she asks, "Can we start over?"

Kazan's cinematic Ruby suggests a new breed of Galateas fashioned by women—defiant and self-defining, hunting for their own identities, aware of their own faceted makeup, pushing those elusive boundaries between the artificial and the real—the type of simulated females created by contemporary women new media artists in the late twentieth and early twenty-first centuries who used film and video to reimagine their own machine-women, female robots, and cinematic dolls. Meanwhile, as I discuss in the next chapter, male roboticists who have engineered real female robots—as opposed to fictional ones—have continued to invest their electronic creations with their ideas of perfection. There are cultural differences in ideas about the ideal female figure, but many of the more fundamental fantasies about these artificial females remain essentially the same. With increasing technological sophistication, these robots seem ever-more real, drawing men even closer to their paradigm of the perfect female.

6

Dancing with Robots and Women in Robotics Design

———————————————•

Men in literature, film, and art have long been pictured dancing with robots and dolls—beautiful artificial women who gaze at them lovingly and fill them with wonder and bliss. In a pivotal scene in E.T.A. Hoffmann's "The Sandman," Nathanael dances with Olympia and is captivated by her charms, without realizing that she is only a mechanical doll. These men are swept up in the charms of the uncanny as they dance with a woman that isn't real. Soon, though, their dreams, like Nathanael's, will be shattered as their fantasy female is torn apart. Updating the image, in American writer Hannah Dela Cruz Abrams's novella *The Man Who Danced with Dolls* (2012), the male narrator watches with wonder as an Argentinian busker in a subway entertains passersby by dancing with his beloved doll Beatrice, but there is a sad poignancy when errant boys destroy his beloved doll.[1]

In the 2004 film remake of Hollywood's *The Stepford Wives*—a film that spoofs men's quest for the perfect female—dancing with a robot became a metaphor for illusory connubial bliss. In the film's climactic scene, Walter enters the Stepford ballroom with his beautiful, newly transformed (or so it seems) robotic wife, Joanna, on his arm and invites her to join him in a "midsummer night's glorious waltz." Joanna in her shimmering dress is radiant as the two gracefully swirl to the strains of the movie's theme, and they are soon joined by a ballroomfull of men dancing with their glamorous robot wives. At the end of the film, though, when Walter sets in motion a "nanoreversal," the men lose their perfect dance partners, who jarringly revert back to real.

Designing Robot Women

But for at least one twenty-first-century male roboticist, untroubled by the artifice, the idea of a robot female dance partner had special appeal. In 2005, engineering and robotics professor Kazuhiro Kosuge of Tohoku University in Japan dazzled audiences with his waltzing pink plastic Pavlova, the prototype of a three-wheeled electronic female dubbed Partner Ballroom Dance Robot (PBDR) (plate VIII). Kosuge was in little danger of being shocked by the uncanny, for he lead the team that created and designed this robot. PBDR was very much created with men in mind: it had a pretty face, a sexy molded plastic body and dress, and, with an added bit of whimsy, it sported what looked like two Mickey Mouse ears on top of its head. Equipped with underbody electronic sensors, Kosuge's robot was the kind of female dance partner men could fantasize about—a beautiful female who seemed responsive and could mirror their moods and moves.[2]

Kosuge's pink PBDR robot highlighted twenty-first-century trends in robot development as male roboticists used the latest in technologies to embody their fantasies about a perfect female (to his credit, Kosuge in an interview fretted that the compliant robot female partner—or an overly compliant android—could "feed our narcissism"). During the first decades of the twenty-first century, the field of robotics has been slow to turn its attention toward issues of gender in the production of robots. As male roboticists in academia, particularly in Japan and Korea, sought ways to make female robots ever-more realistic looking and acting, they seemed to be only rarely aware of how their research has been shaped by their attitudes toward women themselves.[3]

Robot women have often been envisioned by men as both nurturing and alluring—in essence, electronic versions of both the good and evil Marias in Fritz Lang's film *Metropolis* where the real Maria is a compassionate, caring female, and her robotic double is an alluring *femme fatale*. Often, when male roboticists refer to the beautiful artificial females they are developing, they refer to the robot's future use in a nurturing role. In his press interviews and academic papers, Professor Kosuge spoke not of the fantasy aspect of his PBDR robot, but instead he predicted that it could be used sometime in the future to provide care for the sick and elderly and companionship for people who were lonely.

In 2011, this type of crossover female robot with her dual roles as both helpful aide and pretty partner got a star-turn in the theater. Audiences at Ars Electronica in New York and in Melbourne watched *Sayonara,* a twenty-minute play by Oriza Hirata in which a young terminally ill girl sits facing a female caretaker who reads haiku and other short Japanese poems to her. The caretaker was actually an electronic robot, and her lines were spoken by an actress. In the play, after the girl dies, the caretaker keeps reading the poetry aloud and is sent away where she will continue to recite her lines in a place without humans. *Ars* (and robots) *longa, vita brevis.*

In the early twenty-first century, the availability of increasingly sophisticated software, sensors, and silicone made it possible for men to continue working at creating robot females that fulfilled both roles as the beautiful perfect partner and the nurturing caretaker. The eerie robot used in *Sayonara* was named Geminoid F. It was designed in 2010 by Japanese engineer and roboticist Hiroshi Ishiguro, director of the Osaka University Intelligent Robotics Communications Laboratory in Japan who worked with the Japanese Kokoru Company, makers of animatronics and ultrarealistic androids.

Geminoid F, with its composite European and Japanese face, was created using a live model, a young woman in her twenties who sat in front of a computer with cameras and face-tracking software that captured her head and mouth movements and reproduced them on the robot. The robot could be remotely controlled by a human operator and had the capacity to change facial expressions, smile, and frown. Its hands and face moved, though not its lower torso. In the play, the poetry-reciting caretaker had previously worked for an elderly client, and at the time Ishiguro's Geminoid F was in reality being tested for use in hospitals.

Both men and women roboticists have continued to work at creating intelligent, empathetic personal robots that will have future caretaking roles, but it is largely men who have created ultrarealistic female interactive robots. These robots created in Japan and Korea are often in the guise of pretty young females for use in research and in roles such as receptionists. Their ultimate goal as roboticists, wrote engineers Karl F. MacDorman and Hiroshi Ishiguro in 2005, was to create robots "indistinguishable from humans in external appearance and behavior"—robots, they felt, which were ideally suited for experiments on human behavior and to serve as future caretakers.[4] (In academia, there were no references to creating realistic robots to serve as sexual playmates.)

Ishiguro was in the forefront of developing these lifelike female robots (he also created a robotic double of himself). In 2005 he introduced his female robot Repliee Q1 at the Prototype Robot Exposition in Aichi prefecture and later said that the name "Repliee" derived from the French word "to replicate" and also from the "replicants" or androids in Ridley Scott's 1982 film *Blade Runner*. To create the robot, Ishiguro used silicone molds of a female model's body and then metal and polyurethane body parts covered by the soft silicone skin. The robot, which was modeled on the Japanese newscaster Ayako Fujii, moved its mouth, spoke, blinked or fluttered its eyelids, and shifted its torso as though responding to approaching people. Like the Jaquet-Droz Lady Musician automaton two centuries earlier, its chest also rose and fell so that it looked like it was breathing.

A year later, in 2006, Ishiguro developed Repliee Q2 (plate IX), also known as Uando, again in collaboration with Kokoro Co. Ltd. Like its predecessor, the android had humanlike qualities created by endowing it with a shifting posture, blinking, the appearance of breathing, and it could also make some

facial expressions and gesture with its arms and hands. With floor sensors and vision sensors located in its head, shoulders, and arms, under clothing and skin, Repliee Q2, appeared to make eye contact and recognize people's locations. Its designer also gave the female robot what appeared to be a protective response: if tapped on the shoulder, it said, "What is it?" and it pulled back and raised a forearm if someone tried to strike it.[5]

But for all the work trying to create robots that looked real, the lifelike illusion could also be broken. As reported by the Associated Press, when Repliee Q1 Expo was introduced, the robot sometimes went through "what appears to be spasms when its program hits a glitch." Ishiguro himself seemed to be ambivalent about creating realistic-looking androids, saying, "When a robot looks too much like the real thing, it's creepy. But if they resemble human beings, it also makes communication easier."[6]

The spasmodic glitches and "creepy" factor suggested a lapse into what Japanese engineer Masahiro Mori in 1970 had called "the uncanny valley"—an echo of Nathanael's horrified discovery in Hoffmann's "The Sandman" that Olympia was not real and observers' shock in the 2004 film *The Stepford Wives* when one of the female robots shorts out. In his essay "The Uncanny Valley," Mori included a graph illustrating his hypothesis about this unnerving encounter as it applied to modern-day robots. Making an analogy to mountain climbing, he illustrated how, as robots become more human looking, an observer would find them familiar and be drawn to them (peaks) until that moment when, after seeing the robot's deviations from human behavior, the observer drew back (valleys) with a feeling of revulsion or strangeness, recognizing that the synthetic body wasn't real. His term for this alienating experience was the uncanny valley (he used the word *bukimi* in Japanese, which, said Hiroshi Ishiguro and Karl F. MacDorman, could be translated variously as "weird, ominous, or eerie" in English).[7]

One of Mori's examples was human contact with a realistic-looking prosthetic hand that looks real but, when touched, lacks the temperature of the human body and creates a sense of strangeness, unfamiliarity, or alienation, as though touching the hand of a corpse. He argued that there would be some dangers in creating very human-looking replacements or creating robots that looked too human because they could be unsettling to observers.[8] (In fact, the reverse could be equally unsettling when human beings imitate mannequins—on fashion runways, street corners, and shop windows. Caroline Evans and Mark Seltzer described fashion show runway models of the 1990s as having an aura of deathliness with their imitation of inanimate mannequins and their lack of emotion and affect.)[9]

Thirty-five years after Mori's essay, Ishiguro worked with MacDorman to gather empirical evidence for Mori's uncanny valley effect. Their published findings were shaped by their assumptions about women and also inadvertently raised provocative (and unanswered) questions about gender and robots.

The men began by providing a rationale for using ultrarealistic robots in their research—a rationale that seemed to echo the French novel *L'Ève future* in which Villiers de l'Isle-Adam presented Hadaly as superior to the real-life Alicia Cary. Hadaly was "better than real," a premise that became the heart of many films about artificial women who, in men's eyes, were superior to real women because they were obedient, didn't talk much, didn't have ideas of their own, were always sexually available, and could be custom designed for men's individual preferences.

In 2006, the year of Repliee Q2, MacDorman and Ishiguro suggested that realistic androids were superior to mechanical-looking robots when it came to using them for cognitive research and research designed to understand the parameters of being human. In their essay "The Uncanny Advantage of Using Androids in Social and Cognitive Science Research," they argued that by using ultrarealistic robots to test participants' reactions to humanoid robots, the researchers would be better able to gain insights into human behavior. These realistic-looking robots would help researchers "understand what kinds of behavior are perceived of as human since deviations from human norms are more obvious in them than in more mechanical robots," and "subtle flaws in appearance and movement can be more apparent and eerie in very humanlike robots."[10] Androids, they also argued, could be controlled more precisely than human actors for the purpose of experimentation, and the researchers, without irony, even made the paradoxical claim that androids were superior because they could smile more persuasively—that is, they could more easily simulate an "authentic" smile than a live human actor.[11]

The researchers later gave additional practical rationales for experimentally searching for eeriness in virtual characters, noting that "developing humanlike computer-generated characters that will not fall into the uncanny valley is the Holy Grail for animators in the multi-billion-dollar animation and video game industries." Verisimilitude was important for not only computer graphic animation and video games but also beneficial relationships between humans and robots.[12]

Putting Mori's work on the uncanny—and the concept of "eeriness"—to the test, Ishiguro and MacDorman in an experiment showed Indonesian male and female participants two versions of a scaled image that gradually morphed from mechanical-looking to humanlike, strange to familiar. In one set, the range went from a mechanical-looking male humanoid robot on the left to a photograph of a robot created by Hanson Robotics of a humanoid robot with the face of Philip K. Dick, author of the novel *Do Androids Dream of Electric Sheep?* (the basis for Ridley Scott's film *Blade Runner*), that morphed into an actual photograph of the author. In a second set, the images ranged from a mechanical female robot Eveliee to the android robot Reliee Q1 Expo to a photograph of the actual woman on which Repliee was modeled. Looking at the photographs, participants were asked to judge their degree of verisimilitude ranging from artificial

to real. Validating Mori's original findings, the experimenters ultimately found that people seemed to be highly sensitive to imperfections in near humanlike robots.[13] One explanation the researchers gave for this outcome, though, was embedded with assumptions about gender. They argued that "androids are uncanny to the extent that they deviate from norms of physical beauty," adding that sensitivity to some of these deviations seemed peculiar to men only.[14]

The roboticists cited research from the 1990s, which purportedly presented evidence that there was a biological basis for these norms, and that the norms were "gender specific and fairly consistent across cultures." The research, they argued, showed that to men, beauty is a signifier of women's fertility, and "the most significant features of beauty are youth, vitality, bilateral symmetry, skin quality, and the proportions of the face and body." Men, they wrote, "find women more attractive who have larger eyes, fuller lips, and a shorter and narrower lower jaw," adding "there is evidence these features produce emotional responses in men only." Using female androids, they added, would enable researchers to make changes in the distance between eyes that could change perceptions of beauty and ugliness.[15]

But what was clearly absent from their discussion of universal beauty concepts were the wide-ranging social and cultural factors that shape perceptions of female beauty and the role of image makers, including photographers and artists, in shaping cultural ideals of feminine beauty and social perceptions of what is considered beautiful. The 2011 exhibit "Beauty Culture," held at the Annenberg Space for Photography in Los Angeles, explored these types of factors. The photographs in the exhibit highlighted changing cultural norms of female beauty and the ways that women, and even young girls, often feel compelled to fulfill these social ideals of beauty and perfection. The exhibit's photographs included images of supermodels, Hollywood stars like Marilyn Monroe, Liz Taylor, Angelina Jolie, documentary photos of the cosmetics and plastic surgery industries, and photos by Lauren Greenfield of thirteen-year-old girls at weight-loss camps.[16]

Raising a different, intriguing question about the MacDorman/Ishiguro research study, Minsoo Kang in *Sublime Dreams of Living Machines* wondered why the peaks and valleys in their study were not as pronounced in the case when people were observing the female version.[17] To answer Kang's question, perhaps the long history of women decorating and camouflaging their faces with cosmetics—to prettify themselves, to create the aura of perfection, and to mask perceived imperfections—contributes to less surprise when a female face is perceived to be artificial.

Another intriguing question engendered by the MacDorman/Ishiguro study is whether evidence suggested that the study's male participants were more apt than the female participants to be startled when a female android turned out to be synthetic and not real.[18] If so, was that also because women—as users of cosmetics, as social mask-wearers—are less apt to be startled when a woman's face turns

out to be artificial—or alternatively, is it that men are more apt to be seduced by a woman's appearance? In fiction and films, generally it is men who appear to be more horrified at the discovery that the artificial female isn't real. In fiction like "The Sandman," anxieties of the uncanny come from an unresolved conflict: the longing for the perfect woman and the horror in discovering that the longed-for woman is only a persona wearing a mask, a mechanical creature mimicking a real human being. This discordant experience suggests a dark version of Bertholt Brecht's *Verfremdung* or alienation effect when belief in the construct breaks down. The pretense is stripped away, and the lover is not who we think.

In the second decade of the twenty-first century, we may also ask much broader questions: In the world of robotics, will men be able to create the perfect, ultrarealistic female robot whose artifice is completely undetectable so that the uncanny effect would no longer exist? When these totally persuasive human doubles are created, what will be the troubling implications for both women and men?

Looking at Female Robots

Starting in the early twenty-first century, a small number of roboticists and social psychologists interested in human-robot interactions (HRI) shifted the focus more closely to issues of gender. Some of the findings were especially compelling because they gave credence to the uncanny valley and the type of experiences that I call the "Nathanael Effect" in fiction where infatuated men, like Nathanael in "The Sandman" believe the artificial woman is real and are horrified when they discover the truth.

In their study "Social Presence and Gender: Do Females View Robots Differently Than Males?" a group of American cognitive science and psychology researchers found that compared to women, men were more likely to view a humanoid but not totally realistic-looking robot as a "social entity" while women viewed the robot as more machine-like. Men had a tendency to anthropomorphize, to view robots as human or "persons with autonomy" (giving some credence to the reactions of Nathanael in "The Sandman," *Tales of Hoffmann*, and other versions of the theme as well).[19]

Researchers at MIT Personal Robots Group, including Cynthia Breazeal and her colleagues in their 2008 study of social robots, "Persuasive Robotics: The Influence of Robot Gender on Human Behavior," also found that men were more apt to take a specified action when the persuasion was done by female rather than male robots. The researchers used the Mobile Dextrous Social Robot (MDS) designed by Breazeal at MIT, a humanoid robot with an ungendered body but given gendered characteristics through the use of prerecorded masculine and feminine voices. The study looked closely at a humanoid robot's ability to persuade male and female subjects to donate a small amount of money. Participants, given five dollars for the study, were asked by the robot to donate

the money to the MIT Media Lab for research. Testing for the robots' persuasiveness, the researchers found that men were more likely to donate money to a female robot, while women showed little preference.

The MIT study participants, who were visitors to the Museum of Science in Boston, were also asked to rate the male and female robots on credibility, trustworthiness, and engagement. While both men and women rated robots of the opposite sex higher on these factors (a finding that was surprising to the researchers), the effect was much stronger among men than women: men had a greater tendency to report that the female robot was more trustworthy than the male robot and that they were more engaged with the female robot—again offering empirical support to all those compelling images in fiction, film, and art where men readily give their hearts and bodies to artificial women.[20]

American Women in Robotics and Robo-Sexism

Men have traditionally played the role of Pygmalion fashioning images of women that come alive, and in the world of modern-day robotics, men had largely dominated the early industries. As late as 2006, there were relatively few women in the field, but women roboticists and engineers increasingly became drawn to the field, perhaps as it became more focused on human-robot interactions, particularly in the area of creating more empathetic, sociable personal robots.[21] Even earlier, women in the field played important roles. With degrees in electrical engineering and computer science, Cynthia Breazeal became a central figure in the field. Director of the MIT Media's Lab's Personal Robots Group, she developed the anthropomorphic Kismet, the topic of her 2002 book *Designing Sociable Robots* (2002), and continues to work on developing what the MIT Media Lab has called "building artificial systems that learn from and interact with people in an intelligent, life-like, and sociable manner" (Plate X).[22]

Women roboticists, including professors Jodi Forlizzi at Carnegie Mellon and Andrea Thomaz, head of the Socially Intelligent Machines Lab at Georgia Institute of Technology (fig. 6.1), worked on researching human-robot interactions and developing socially aware humanoid robots that seemed to interact with people in a natural way. The goal continues to be creating robots that appear to have humanlike responses—expressing moods and emotions—and also robots that have the capacity to detect moods in people, particularly important in personal robots acting as caretakers.[23] Thomaz, whose research centers on Socially Guided Machine Learning, commented in 2014 that she never felt any barriers to her being a woman in the field of robotics, though she added that "it is important to break away from gender stereotypes that some jobs or fields of study of for men or women."[24]

While women were becoming increasingly involved in researching social robots, the field of robotics, argued anthropologist Jennifer Robertson, remained embedded with a degree of sexism, particularly in Japan where

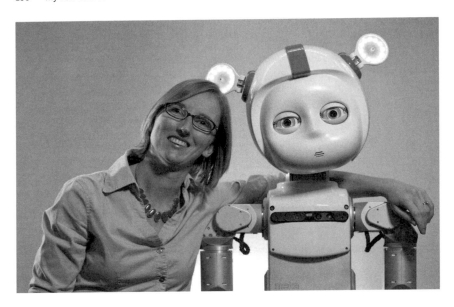

6.1 Andrea Thomaz, professor of interactive computing and head of the Socially Intelligent Machines Lab at the Georgia Institute of Technology, with the lab's female research robot Curi, introduced in 2013. (Aside from Curi's having an electronic female voice and name, there were no gendered differences in design or behavior between Curi and Simon, the lab's male research robot designed five years earlier.)

ultrarealistic robots were being developed. In her essay "Gendering Humanoid Robots: Robo-Sexism in Japan" (2010), Robertson called the Japanese humanoid robot industry an example of "retro-tech" for its ethnocentrism, paternalism, and sexism, and she noted that ultrarealistic humanoid female robots have often been modeled on attractive young women in their twenties. Male Japanese roboticists not only envisioned "gynoids" as much-needed health care aides but also as serving in other stereotypical female roles—including waitresses in coffee shops, women working in bars, greeters in information booths, even serving as fashion runway models.[25]

The stereotyping, though, rather than being unique to Japan, may have been part of a broader cultural phenomenon: German researchers in 2012 found that people project gender stereotypes onto robots perceived of as either masculine or feminine. The researchers, who noted that as of 2012 there was still a scarcity of gender-related robot studies, found that when showing experiment participants computer-created headshots of "robots" (which looked more like stylized animated doll heads with their gendered appearance: the "masculine" robots had short hair and thin straight lips, and the "female" robots long hair, fuller lips), the participants engaged in stereotyping sex-typed tasks. Male robots were perceived to be more suitable for repairing technical devices and guarding houses, and female robots were thought to be more suitable for performing

household work and caretaking. Also, male robots were perceived as being better at math skills than verbal skills.[26]

Robertson's observations about robo-sexism, though, seemed on target. In March 2009, during Fashion Week in Tokyo, the National Institute of Advanced Industrial Science and Technology presented their female robot billed as the "First Robot Supermodel," which lip-synced a Japanese song as it performed with a group of female singers and dancers at Tokyo's Digital Content Expo. Named HRP-4C 2009 (an acronym for Humanoid Robotics Project), this "supermodel" was five feet two inches, had a silicone face and hands, shoulder-length black hair, and a shapely silver and black molded body with dimensions (according to Robertson) that were based on average values for young Japanese females recorded in the Japanese Body Dimension Data Base 1997–1998 (fig. 6.2).[27] The developers of HRP-4C, like other male roboticists, downplayed the gendering of the robot, commenting that it would help meet the demand for socially useful robots that could be used to care for the sick and elderly or for work in amusement parks.

Although male Japanese roboticists were modeling their supermodel robot on their notion of the ideal female and Korean manufacturers were also engaged

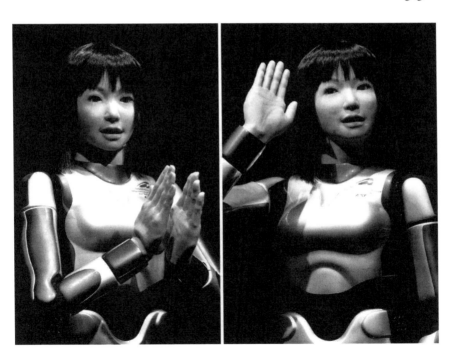

6.2 The "First Robot Super Model" HRP-4C 2009 (an acronym for Humanoid Robotics Project) designed by Japan's National Institute of Advanced Industrial Science and Technology Institute and introduced at Tokyo's Digital Content Expo in 2009.
Yoshikazu Tsuno, AFP Photo/Getty Images

in creating these ultrarealistic female robots, real women were also complicit: press reports in 2011 noted that in South Korea women were transforming themselves into their own notions of the ideal. Plastic surgery became popular among South Korean women, especially young women, who opted to have their eyelids opened and made rounder, with a double fold for a "Western" look, and they also had cosmetic surgery for their noses, lips, breasts as well as double-jaw surgery for cutting and rearranging the upper and lower jaws. Said Dr. Sang Park, "What we do in double-jaw surgery is reassemble the face," and he added with unabashed hype, "Normal people become, sort of, super-normal, and pretty people prettier." Young women in Japan and South Korea also emulated the look of popular starlets and K-Pop rock stars, and in the process they sacrificed their own individuality to look alike—echoing Western girls' imitations of popular stars and the Barbie doll look.[28]

The Korean experience was not unique: it also echoed on a larger scale the widespread popularity of plastic surgery practices in the West as both men and women sought to fulfill culturally defined ideas about physical perfection. Injections of industrial-grade silicone during plastic surgery contributed even more to the look of artifice. In 2014, the *New York Times* reported how American women and men were engaging in plastic surgery to emulate the look of pop culture stars as well as celebrities, including a Texas woman who wanted to look like actress Kate Winslet.[29]

Doubles and Dolls

For all their serious-minded references to female robots as coffee shop attendants, receptionists, and dance partners, male roboticists did not often state the obvious: in men's minds, realistic looking and acting female robots could serve as first-rate sex dolls. In 2010, New Jersey electrical engineer and computer scientist Douglas Hines, who had formerly worked at Bell Laboratories, introduced his Roxxxy line of robotic sex dolls that were advertised as "always turned on" and designed for "companionship" (they were marketed by the company he founded, truecompanion.com). Made from a mold of a female model, his first-generation female robot was five feet seven inches, weighed 120 pounds (later reduced to 60 pounds), had silicone skin, and originally sold for $5,000 to $9,000 depending on customization (the price also later dropped), with a tech support fee of $40 per month. The robots had motors to simulate heartbeats, make responsive gestures, and simulate orgasms.

Tailored to male fantasies, Hines's battery-run robots—powered by a charge that could last up to three hours—came in several models, ranging from naïve to naughty and sadomasochistic to matronly. Models included the adventurous "Wild Wendy," "S&M Susan," and "Mature Martha," which was described by Hines as a matronly robot that liked to talk more than physically interact. There were also "Frigid Farah" (described as a "very reserved" robot that didn't always

like to engage in sex) and "Young Yoko" ("very naïve but curious" and modeled on an "18+ year old"). Hines's robots, like the sex doll in *Lars and the Real Girl,* could be further customized to suit individual preferences and needs.[30]

In film and fiction, men's ideal artificial female was frequently a woman who was silent, said little, or had conversations completely controlled by men such as Hadaly in *L'Ève future* with her recorded conversations, the modern-day female robots in *Cherry 2000, The Stepford Wives* with their soothing words, and Spike Jonze's 2013 futuristic film fable *Her,* in which the lonely Theodore Twombly falls in love with the soothing voice and words of Samantha, his computer's operating system, who is devoted to complementing his thoughts and lending him emotional support (though later in the film, she moves away from simply comforting him and becomes more focused on her own development, telling him "I want to discover myself").

Updating real-life robotics systems, Douglas Hines's "True Companions" featured controlled "conversations" created using voice-over artists as well as voice-recognition and speech-synthesis software.[31] Computer software converted speech to texts and then generated verbal responses so that the robots could engage in "sleepy-time talk" as well as custom-designed "conversations" coming from a loudspeaker under the robot's wig. To make the conversations seem personalized, they were based on a knowledge database created after the customer answered a four-hundred-item questionnaire. For added realism, the robots could even make the unladylike sounds of snoring (though the robots, unlike real women, could presumably have their snoring turned off).[32]

The conversations might have been contrived, but to simulate a real woman Roxxxy had a warm body produced by a motor in her chest area pumping heated air through a tube running through her body and also sensors in the hands and genital areas. The robot's voice responded when the body was touched, and the body simulated an orgasm. Though clearly designing sex dolls, Hines also made efforts to dignify the dolls by writing that they could be used for more lofty purposes; he said he envisioned using female robots not only for sex but also for service as health care assistants and companions for the elderly, aides in children's education (such as a Ben Franklin robot), and for consumer help.[33]

While male roboticists were creating robotic doubles modeled on pretty females, two women musicians took on the role of Pygmalion by playfully creating simulated doubles of themselves, which tweaked the idea of female robot-as-lover and robot as helpful aide. The trope of a woman creating her own double had appeared earlier in the sinister and singularly unappealing Hollywood film *Eve of Destruction* (1991), in which a woman scientist, Dr. Simmons, creates a double of herself for use in the military—a robot embodying her own repressed desires, angers, and wish for revenge (including her repressed wish to be a prostitute). Men have often fantasized about creating the perfect woman they can control, but Dr. Simmons's robotic Eve is a powerful, vindictive, and uncontrollably monstrous version of herself.[34]

6.3 Still from Icelandic rock singer Björk's 1999 music video, *All Is Full of Love*.

In their music videos, the musicians Björk and Aimee Mann presented much more nuanced and witty views of female robot doubles or doppelgangers. Subverting men's fantasies about the ideal female robot partner, the Icelandic rock singer Björk in her music video *All Is Full of Love* (1999) pictured a robot with her own face being assembled with robotic arms and then erotically kissing and embracing her robot double. The lyrics, given the narcissistic romp, are ironic: "You'll be given love.... Maybe not from the directions/You've poured yours" (fig. 6.3).

American rock singer and composer Aimee Mann in her music video for her album *Charmer* (2012) not only saw the wry humor of creating an electronic female double but also went beyond that to consider the masks that women wear. In her video, Mann decides it would be useful to have a robot clone or double of herself to help with the grind of promoting her new album and performing on her world tour. She orders a robot double (played by actress Laura Linney) that arrives wrapped in plastic and carrying a guitar. Activating the clone by turning a metal switch on its back, she teaches it how to play the guitar and sign autographs, but when she sees an online story, "Aimee Mann Better

Than Ever" on the Internet, she gets annoyed that the robot is surpassing her. Reasserting herself, Aimee switches off the clone, wraps it up in plastic, and happily goes off on her tour alone.

Mann's *Charmer* video not only spoofs the absurdity of the female clone concept, but her lyrics also become a meditation on the idea of charm itself—the artificial exterior or outer persona that may mask or deflect who we truly are. In men's fantasies about ultrarealistic female robots, the artificial woman often trumps the real woman. In Mann's video about artifice, as the charming clone wows audiences and threatens to usurp her, the real Aimee dumps the double for her authentic self. For these women musicians and artists living in a contemporary electronic world filled with an ever-increasing number of virtual humans—a world in which men have also been busily engaged in creating beautiful robotic female doubles—the quest to interrogate masks and artifice had a special urgency and allure.

7
The Woman Artist as Pygmalion

While male engineers in the late twentieth and early twenty-first centuries were constructing amazingly lifelike female robots—pretty, compliant creatures that embodied men's fantasies and desires—twentieth- and twenty-first-century female artists taking on Pygmalion's role have used the tools of technology and science to fashion their own machine-women, female robots, mannequins, and cinematic dolls. These carefully crafted female simulacra illuminate the fabricated nature of women's socially constructed identities—identities that have undergone remarkable reconfiguration and change.

Women artists took on the role not only of Pygmalion but also of Frankenstein. In Mary Shelley's *Frankenstein,* the fearsome Creature assembled from disparate dead body parts became a powerful, richly layered metaphor for the outcomes of science and technology gone pathologically awry. In the novel, the idea of creating a female mate that would produce monstrous offspring became a prospect too dangerous for Victor Frankenstein to bear. But rather than danger, American and European women artists in the 1980s and 1990s began assembling their own articulated and often articulate artificial females that embodied the fluid nature, shifting shapes, and complexities of female identity. Using video and digital media, artists, including Linda Dement and Shelley Jackson (in her 1995 CD ROM *Patchwork Girl*), fashioned new breeds of the Bride of Frankenstein, their own artfully conceived assemblages of disparate parts.

Feminist writers during the period, rejecting essentialist ideas about women having innate, gender-based psychological characteristics, had argued instead for the socially constructed nature of female identity. Gender and sexual characteristics were not inherent but rather shaped by a range of social factors, including

the environment, social expectations, and education. These new assemblages by women artists often seemed to embody Donna Haraway's conceptions of the cyborg and shifting female identities.

In her influential essay "A Cyborg Manifesto: Science, Technology, and Socialist-Feminism in Late Twentieth Century," first published in 1985 (and later included in her book *Simians, Cyborgs, and Women* in 1990), Haraway examined the cyborg as a transgressive, hybrid creature challenging the old Enlightenment dualisms or binaries separating human/machine, nature/culture. For Haraway, the cyborg, which blurs the distinctions between artifice and reality, human and machine, becomes the embodiment of fluid boundaries, new fusions, and new identities in a posthuman world.[1]

Extending the arguments of Haraway, in the heady days of cyberfeminism, which emerged in the early 1990s, women theorists and artists optimistically saw the digital terrain of cyberspace as one in which women artists could challenge the old stereotype-ridden realm of gendered portrayals of women. Cyberspace breaking down the old binaries of male/female, and virtual/real, would create blurred boundaries. Women would become increasingly computer savvy and appropriate web-based digital and video technologies for their creative projects.[2]

In Mary Shelley's novel, both the male creature and his "mate" are made of bits and pieces of corpse parts, and, if completed, the female counterpart would, like the "Monster," no doubt have looked hideous as well—though in James Whale's 1935 film *Bride of Frankenstein,* the Bride as played by Elsa Lanchester is a pretty woman, aside from her scars and impressively towering coifed hair. In her witty 1995 CD-ROM *Cyberflesh Girlmonster,* Australian media artist Linda Dement took on the idea of the "monstrous" by creating a parody of the monster female and producing conglomerate, composite bodies in what she called "a macabre comedy of monstrous femininity, of revenge, desire, and violence."[3]

In her art work Dement brought flesh, embodiment, and messiness to the disembodied realm of cyberspace as she foregrounded and spoofed cultural conceptions of female monstrosity. In an interview, she talked about how she created the interactive *Cyberflesh Girlmonster* and her wish to "get women to put their flesh into cyberspace." She constructed her versions of a "very fleshy female conglomerate" by collecting body parts from women, that is, she had them scan parts of their body and donate the images digitally. Calling her work a dark comedy and a spoof, she used digital bits and pieces to produce "little monsters"—amorphous, surreal shapes, disembodied lips, and added recordings of words and phrases from the participants as well as videos of the monster's behaviors and stories.[4]

During the 1930s with its adulation of Machine Art—seen in the work of Precisionist painters including Charles Sheeler and the photography of Paul Strand—machine parts were admired for their clean lines and geometries, their unadorned functionality. Years later, however, in the world of electronic

technologies, Dement intended not to admire but rather radically subvert what she conceptualized as the pristine digital realm and the impersonal, clean world of computer hardware and body designs. "I liked the idea of contaminating the technology, of putting the blood, the guts, the madness, all those nasty womanly things into this beautiful, slick technology, into the beautiful slick machines." Sadie Plant, interviewed along with Dement in 1996 at Warwick University, saw Dement's work as "dealing with very gritty, blood, fleshy body stuff in a way which again is very different to the male cyberpunk, especially the corporate line about cyberspace being a disembodied zone."[5]

Dement's wish to "contaminate" cyberspace and the Internet with female messiness and constructed images of monster females is a witty counter to notions of "abjection," as discussed by Julia Kristeva and Barbara Creed and defined as cultural and religious perceptions—both historical and contemporary—of religious "abominations": "sexual immorality and perversion; corporeal alteration, decay and death; human sacrifice; murder, the corpse; bodily wastes; the female body and incest."[6] Creed has been particularly concerned with representations of the "monstrous-feminine" in late twentieth-century horror films, which, argued Creed, were shaped by male fears and desires—films where bodily wastes, the horrific, and images of the female body speak to men's fears and ambivalence toward the mother.

When Linda Dement was asked in the 1996 interview if men were frightened by her work, she replied that much of her work "is about male fear." For Dement, the morphed monsters in her work are a satirical mirror of men's views of the monster woman. "The perception I have is that men are very scared of women's sexuality, that they are very scared of women who have power, intelligence or any kind of murderous desires, or passions or any kind of intense emotions." Addressing these men, she asked, "Are you scared? Well, you should be!" (Suggesting a possible source of these fears, Sadie Plant spoke of the major cultural shift in which there had been an upsurge in what was perceived as "dangerous female activity": women's changes in career structures, working patterns, and education.)[7]

Dement's work encapsulates not only physiological monsters but also monstrous behaviors and revenge. Her website described "the sacred and the savage, sexuality and abuse" that informs her work and shaped her "private square of opposition." *Cyberflesh Girlmonster* includes a written narrative in a woman's voice telling about two women in a bar who are confronted by a man who places his hand on her hips. Later, when the women go outside, the man, driving in his van, puts out his tongue obscenely, and, in revenge, the narrator swings a chain around her head and smashes his van's back window. *Cyberflesh* illustrates the scene with fierce images of revenge: a photograph of a woman's hand using an electric drill to drill into a man's hairy leg, a morphed digital image of what looks like a praying mantis eating flesh. These female "girlmonsters"—like Frankenstein's "Monster" who left messages on trees—leave their own threatening phrases: "We will find you where you sleep."[8]

Restless Legs

In Dement's work, disembodied lips morph into new monstrous composites, and in American writer-artist Shelley Jackson's hyperfiction hypertext CD-ROM *Patchwork Girl,* her reimagining of Mary Shelley's *Frankenstein,* the stand-alone body fragments are often metonymns for the whole, becoming fictive characters in their own right that tell tales about the construction of a new identity.

The narrative possibilities of isolated female body parts had been explored even earlier in the work of Polish artist Alina Szapocznikow whose work featured sculptural, isolated, fragmented body parts. Szapocznikow, a survivor of the Auschwitz and Bergen-Bergen concentration camps in World War II, moved from Warsaw to Paris in 1951 and created a plaster cast of her own right leg at rest (*Noga*, 1962) as one of the first of her many sculptural castings of her body, including more of her leg, lips, mouth, breasts, belly. In her work, disembodied lips and bodies seem to have a life of their own. (The artist, who worked with toxic sculptural materials, polyester resins, polyurethane, plastic cement for her body castings, died of cancer in 1972.[9])

In her essay on Szapocznikow, Cornelia Butler referenced the trauma of the Holocaust as one of several sources for the artist's images of fragmentation.[10] But in addition to these autobiographical elements, Szapocznikow's work also revisits the Frankenstein *topos*. While Mary Shelley in *Frankenstein* saw the horrors of dismemberment and reconstruction, Szapocznikow used casts of female anatomical parts—including imaginatively varied wax-molded lips—to construct a new, almost defiant assertion of self. These sensuous lips seem to be in the midst of talking, as if the artist is saying, "Listen to me: I have a story to tell."

In the electronic age, disembodied body parts had a new technological vehicle for telling their own stories. Shelley Jackson's *Patchwork Girl* (1995) subtitled *by "Mary/Shelley and Herself"* presents a reimaging of the unfinished female mate in Mary Shelley's *Frankenstein* as the artist reassembles fragmented body parts into an edgy new construction, an intriguing counterpoint to not only the female mate but also the Creature's Bride in Whale's film.

Elizabeth Young, commenting on *Bride of Frankenstein,* argued that the film suggested there is something to be feared in whole female bodies and that the Bride's "composite female form translates the idea of social construction of women into an essentialist nightmare, whereby women are literally constructed, assembled horrifically from female body parts."[11] But though the Bride is a source of tremendous disappointment and agony to the Monster, Jackson's Patchwork Girl is decidedly unthreatening. She does not have a coherently defined gender or identity but describes herself instead as "a passel of parts." Evocative of Haraway's conception of transgressed and fluid boundaries, she is a 175-year-old digital composite made of multiple particles with "no absolute boundaries," and she is in a constant state of flux.

Rather than being created by fictive mad and obsessed men like Victor Frankenstein who fashion an artificial female to fulfill their own ambitions, longings, and dreams, Jackson's Patchwork Girl is fabricated or at least resurrected by the reader's input using links in Jackson's interactive CD-ROM: "I am buried here. You can resurrect me, but only piecemeal. If you want to see the whole, you will have to sew me together yourself." She is also a metaphor for the process of fiction writing: writing is a "semblance of breath" and "simulacrum of living discourse." The narrative itself is a nonlinear patchwork. The reader negotiates hyperlinks to bring the narrative to life and create "a reprieved corpse" (suggesting too the early twentieth-century Surrealists' game of the Exquisite Corpse in which participants collectively assembled random sequences of words or images). Through these hyperlinks, the reader assembles the Patchwork Girl's past moments which remain "without shape, without end, without story."

The Patchwork Girl, who describes herself as an assemblage of disembodied body parts ("a digital composite"), has a headstone that fittingly reads, "Here lies a Head, Trunk, Arms(Right and Left), and Legs" (it adds punningly, "May they Rest in Piece"). The segments include a "famous" disembodied foot or lower part of a leg, and legs are the most important because this female is a restless one who is "never settled." She is a type of outsider, and she describes writing itself, reworking a phrase by Jacques Derrida, as "an outlaw, a pervert, a bad seed—a monster—a vagrant, an adventurer, a bum"—more like Mary Shelley's "Monster" than Whale's Bride.

In Hans Bellmer's 1936 photograph of a still life with rose and leg in his *La Poupée* photographic series, the disembodied leg is simply a static, decorous, fetishistic part of a male fantasy. But for the unsettled, restless Patchwork Girl, the leg is linked to movement and longing. She gives details about her legs, which belonged to two different repressed or restless women: one who camouflaged her passions under restrictive undergarments, and the other who longed to "go places."

The right leg belonged to Jennifer who wore tight bodices and "buried herself in layers of petticoats"—a woman who outwardly lived a "mild, exemplary, and unwed life" but was in fact hiding and "unbound, she might tear all to shreds." The left leg belonged to Jane, a nanny, who took the children down to the wharf when a ship was docking, longed to go places, and her leg had "enough of waiting." The leg, says the Patchwork Girl, "is always twitching, jumping, joggling." Ultimately, Jackson's Patchwork Girl is a compelling embodiment of the postmodern woman—a woman with restless, fluid boundaries who evades stasis and definition.

Disembodied legs have had a startling, insistent presence in both fiction and art. Miss Kilmansegg in Thomas Hood's story is murdered by a man wielding her artificial leg and Hulga, the hapless woman in Flannery O'Connor's "Good Country People," published in her 1955 volume *A Good Man Is Hard to Find*, is a victim whose wooden prosthetic leg gets stolen by Manley, a man posing as

a Bible salesman, who leaves her stranded. In these stories, the men sadistically need to make women seem safer to them and to disable women who are already disabled. Perhaps, too, there is something of doll-historian Miriam Formanek-Brunell's observation that nineteenth-century American toy doll designers who patented individual body parts may have felt more comfortable with parts than wholes.[12]

While male artists created assemblages of women and deconstructed them as well, women artists like Jackson have foregrounded isolated female body parts to celebrate a reimagined vision of female identity. In the 1930s, the pair of disembodied, truncated legs (in silk stockings, and one in a high-heeled shoe) in Dada artist Hannah Höch's photocollage *Dada/Ernst* gave a contested view of the New Woman that seemed to be celebrating her bold sexuality yet also associating her identity with money and the machine, but for women artists in the twenty-first century, disembodied leg images have conveyed a celebratory sense of restlessness—these are the legs of women clearly on the move.

With her restless leg Jackson's Patchwork Girl, who says "I am never settled" and argues that she belongs nowhere, is a newly created, problematic whole, an amalgam of identities in perpetual process of being formed anew. This quality of restlessness with its legs on the move has also been central to the work of other contemporary artists including American artist Heidi Kumao in her installation *Misbehaving: Media Machines Act Out*. While male engineers in the 1990s and the early twenty-first century were constructing new compliant females—pretty, lifelike women robots that embodied their fantasies and desires—Kumao in her *Misbehaving* series used three sets of mechanized, engineered female legs to create witty female "robotic performers" that were rebellious and defiant. The artist named the three pairs "Protest," "Resist," and "Translator" (fig. 7.1).

In a 2008 interview, Kumao described *Misbehaving* as being about the "performance of gender" and how young girls were taught appropriate behavior but managed to flaunt expectations, too. The legs become metonyms for "girls and women who disobey or resist expectations" and who "perform badly, act out, misbehave, or act against type." The engineered legs create "tableaus of protest and transformation" in which rebellious girls engage in "acts of defiance," which become "small yet powerful, signs of agency."[13] Two of the pairs, representing those of a six-year-old girl, are mechanized aluminum legs (segmented, bolted-together metal parts in the shape of legs) fitted with shoes. These "robot performers" have monitors with projected videos embedded in their torsos, and the "hybrid machines" make physical gestures accompanied by visual imagery. The legs called "Protest" stomped the floor loudly while the "Untitled, Resist" legs, described by the artist as sexualized and fearful, squirmed on the floor. The third pair of legs, "Translator," was conceived of by the artist as poetic meditation on nonverbal gestures and sounds.

Kumao's work with its restless, stamping legs is about defiance and resistance, while for the real-life amputee Aimee Mullins, artificial legs have helped her

7.1 Heidi Kumao, *Protest* (2005). Motorized pair of girl's legs that stomp and tap on household furniture (aluminum legs, shoes, motors, custom electronics, wood). Courtesy of the artist.

celebrate her autonomy and power. By the 1990s, through dramatic developments in lifelike, bionic electronic prosthetic legs, amputees aided by centers like the Media Lab at MIT could wear robotic devices using microprocessors and sensing devices that allowed them to walk, run, and compete in sports. For Mullins, the legs have helped her transform a disability into an asset whereby she displayed astonishing achievements in sports and became a fashion model as well (plate XI).[14]

Mullins was born without fibulae in both legs, and at the age of one had both legs amputated beneath her knee to improve mobility. Through the use of her carbon-fiber legs, she has become the very embodiment of a cyborg woman, and, when photographed, she became a representation of elegant art. With her sprinting prosthetic legs specially designed in the shape of a cheetah's hind legs, she set world records in the 1996 Paralympics in Atlanta, Georgia, in the 100 meter, 200 meter, and long jump.

She also transformed herself into a fashion model and appeared wearing silicone legs made by Dorset Orthopaedic in the United Kingdom and also custom-designed legs by designer Alexander McQueen in his Spring/Summer 1999 show. Earlier, in 1998, she was photographed by Nick Knight for a special

issue of the British magazine *Dazed & Confused,* guest edited by McQueen. In her cover photograph and interior shots, she is pictured wearing a crinoline-like hoop skirt that reveals her prosthetic legs, and she also wears a wing-like bodice. The images are equivocal: in one she appears bent over like a doll, her segmented wooden prosthetic legs exposed, but in another she wears a wing-like bodice suggesting flight and freedom. While nineteenth-century cage crinolines made it difficult for women to walk gracefully or even sit, and turned them into doll-like creatures, Mullins in her legs and crinoline is a woman freed from the confines of her disability. In Matthew Barney's 2002 performance art epic *Cremaster 3* she appeared as a fearless and feral cheetah woman, partially nude, wearing her C-shaped legs, a tail, and a cheetah face.

McQueen's 1999 fashion ensembles for Mullins, though, were paradoxically both freeing and confining. In the 2011 blockbuster exhibit of McQueen's fashions, *Alexander McQueen: Savage Beauty,* held at the Metropolitan Museum of Art in New York, a mannequin was dressed in one of the designer's creations made for Mullins: a corset of brown leather, skirt of cream silk lace, and custom-made prosthetic legs with floral motifs carved from wood.[15] The sections of the corset were pieced together with enlarged stitches resembling the Bride of Frankenstein's pieced-together frame, but the layered lace skirt softened the look. As this ensemble suggests, McQueen himself took on the role of Frankenstein. Commenting on his "Eclect Dissect" fashion ensembles designed in August/Winter season of 1997/1998, McQueen described this collection: "my idea was this mad scientist who cut all these women up and mixed them all back together again." The composite fashion designed for Givenchy included a black leather dress ornamented with red pheasant feathers and resin vulture skulls.[16]

McQueen remained ambivalent about whether he wanted to showcase the artifice of Mullins's legs or hide them. The Savage Beauty exhibit catalogue included a revealing quote from McQueen: "When I used Aimee [Mullins] for [this collection], I made a point of not letting her in . . . sprinting legs [prostheses for running]. . . . We did try them on but I thought no, that's not the point of this exercise. The point is that she was to mould in with the rest of the girls." Rather than celebrating Mullins's difference, McQueen opted for the anonymous uniformity of the mannequins. His ornamenting of the wooden leg turned artifice into art, masking their function and keeping the highly technological bionic legs at bay.[17]

The Artificial Woman: Mannequins and Masks

The images of Mullins capture the equivocal interplay of exposure and masking, artifice and authenticity that often shape women's presentational selves. Some photographs celebrate her running in her exuberantly exposed bionic legs while in other photographs she fits in as McQueen envisioned her, as he transformed her into an elegantly camouflaged work of art. Twentieth- and

twenty-first-century women artists, however, have confronted female artifice head-on as they probed the cultural paradigms and tropes that have often been intimately linked to female identity: camouflage, masks, and dolls.

Men throughout the years have created articulated female dolls and doll-like women that embodied their fantasy ideal women (and sometimes, horribly, they tore these dolls apart). In contrast, however, American artist Joan Jonas through her performance pieces and videos of the 1970s, donned exotic masks and deconstructed the female body and persona to explore facets of gender identity—and also the way electronic media and mirrors shape our perceptions of the female body.[18] In her 1972 performance piece *Organic Honey's Visual Telepathy*, which was recorded on several videos, Jonas wore multiple masks as she explored women's many faceted identities as well as the ways women are visualized by others and visualize themselves (fig. 7.2). The piece was performed with several other women, and, through the use of a camera at the center of the performance space, images of her face were projected onto a large wall; the images also appeared on a monitor facing the audience, and the artist had her own monitor.

At the beginning of the performance, a four-by-eight-foot mirror on wheels was rolled in front of the audience, a suggestion that *Visual Telepathy* was not only about visualization but also about the act of seeing while her

7.2 Video still of American artist Joan Jonas wearing a mask in her performance video *Organic Honey's Visual Telepathy*, 1972.
Courtesy Electronic Arts Intermix (EAI), New York.

eyes, which peered out from her mask, oddly darted about.[19] Jonas's *Visual Telepathy* was a very public and paradoxically a very private exploration of facets of herself. At one point, she obsessively hit a mirror with a large silver spoon, "trying to break her image" as she wrote in her script, but "the mirror does not break."[20]

In *Visual Telepathy,* Jonas inhabited a variety of archetypal female roles, including a goddess, high priestess, and sorceress. At the beginning, she appeared as an "imitation Bengali goddess" in what she described as an interplay of erotic imagery: she donned a plastic mask, a sequined jacket, and a feathered pink headdress attached with loops of pearls dangling over her forehead. The artist had visited Japan with her video camera starting in 1970 and revisited it several times. Her mask and headdress were inspired by the masks worn in classical Japanese Noh and Kabuki theatre, which represented women of varied classes and ages. Turning her head sideways, as in a Kabuki and Noh dance, the artist gazed at herself in the monitor, striking a traditional pose.

In *Visual Telepathy,* she changed identities while she played with different versions of image-making and image-perception as she gazed at—and let the audience gaze at—different facets of herself. In a conversation recorded at New York's Museum of Modern Art in 1981, Jonas talked about trying on different disguises and being transformed into an "erotic seductress."[21] Changing identities, with each sequence separated by sounds of buzzer (sound provided by composer Philip Glass), she put on a blue satin robe, a black and white scarf, and a turban mask she described as "different persona electronic sorcery."[22] Not always taking herself seriously, she laughed at her own image as high priestess. For all of her public self-display, the artist was ambivalent about revealing herself. Near the end of the piece, we see her only partially as she covered the left side of her face with white paper and the right side with black paper, in what she described as a "divided self—opposites." Without a mask, her profile was half brightly lit, half shrouded in darkness as her identity ultimately remained half exposed, half hidden and mysterious.

In a world in which women were engaging in plastic surgery to transform themselves into culturally defined notions of female beauty and perfection—becoming, in effect, their own Pygmalions as they sculpted their bodies and brought to life artificial versions of their own idealized selves—the French performance artist Orlan (born Mireille Suzanne Francette Porte) engaged in nine plastic surgeries on her own body to interrogate norms of idealized female beauty and explore her own multiple identities. Her famous if not infamous surgeries were filmed, videotaped, and photographed to raise money and also turned the procedures into spectacle. In her early work of the 1970s, she dubbed herself "St Orlan," wore exaggerated costumes, and, as critic Barbara Rose described, became a type of living doll and living sculpture.[23] By 1990, she started her sequence of nine surgeries to transform herself in what may have been a quest to create the perfect woman. After her third surgery to retouch

areas of her face and eyelids, she posed for an ironic, elegant portrait of herself wearing long black gloves and a wig like that worn by Elsa Lanchester in Whale's *Bride of Frankenstein* film—a wry reference to the constructed Bride as product of a mad scientist's imagination. The image remained problematic, though, by also suggesting that it sprang from a Gatsby-like Platonic conception of herself.

From 1990 to 1993, in *The Ultimate Masterpiece: The Reincarnation of St Orlan,* she continued this quixotic quest to become a living doll and reshape her body and identity. In a Frankensteinian mode, she created a newly assembled idealized self of discrete parts. She asked surgeons to give her facial features like females portrayed by five European Renaissance and post-Renaissance artists: the nose of a sculpture of Diana attributed to a School of Fontainebleau artist (she associated Diana, the goddess of the hunt, with aggressiveness, a goddess who did not submit to men), the mouth of Boucher's Europa, the forehead of the Mona Lisa, the chin of Botticelli's Venus, and the eyes of French artist Jean-Léon Gérôme's Psyche. Orlan's surgical performances remained contested, though, as critics debated whether she was critiquing men's cultural constructions of female beauty or too closely engaged in objectifying her own body.[24]

Cindy Sherman

Masking, role playing, and self-image manipulation have been at the very center of New York photographer Cindy Sherman's much more nuanced and inventive work throughout her artistic career. Her photographs for decades have centered on the roles women play, the personas they construct for themselves, and the masks that they wear. In a world where women are often expected to conform to social expectations of female beauty and perfection, Sherman's photos focus on artifice and women's constructed masks of femininity. As Laura Mulvey wrote of Sherman's photographs, the "accoutrements of the feminine struggle to conform to a façade of desirability haunt Sherman's iconography."[25]

As the model in most of her photos, Sherman constantly takes on different personas and roles. In her *Untitled Film Stills* series (1979), she evoked 1950s films in which the images of the women are carefully constructed for viewing. Said Sherman about this series, "The women aren't lifelike, they're acting. There are so many levels of artifice."[26] Women's efforts to create a constructed self of glamour and youth were also seen in her *Portraits* (2008), *Headshots* (2000–2002), and, most intriguingly, in the untitled *Society Portraits* (2000) with Sherman as model masquerading as socialites "of a certain age."

As portrayed by Sherman, these society portraits feature wealthy women with status or members of the nouveau riche, women who are photographed in a variety of settings and backgrounds, including luxurious apartments, the National Arts Club in Manhattan, in Central Park, and in front of artificial backdrops (fig. 7.3). Posing for their formal portraits, these women dressed in

finery have an element of artifice: they have heavily made-up faces laden with cosmetics, and their expressions are stylized, fixed, and frozen. With Sherman embodying their personas, they paradoxically become simulacra of simulacra.

Commentators have tended to see pathos in the *Society Portraits* and even in Sherman herself. In her essay "Will the Real Cindy Sherman Please Stand Up?"

7.3 Cindy Sherman, *Untitled #474*, 2008. Chromogenic color print. Sherman, appearing as a society woman with arched eyebrows and perfectly coiffed hair, stands elegant and composed at New York's National Arts Club, showing no signs of vulnerability or pathos.
Photo courtesy of the artist and Metro Pictures.

Eva Respini viewed the portraits as embodying the "vulgar and tragic," representing women who struggle "with the impossible standards of beauty that prevail in our youth- and status- obsessed culture." These are women with signs of plastic surgery, with aging skin, and the photos of them have a "darker reality lurking beneath the glossy surface of perfection." In these portraits, says Respini, there is an ambiguity about "what is artificial and what is real."[27] Peter Schjeldahl writing in *The New Yorker* described the women as "wealthy dames fighting losing battles with age"—seeing in Sherman's work an element of cruelty along with compassion.[28] Sherman herself has commented that she empathized with these women, seeing herself in some of them, and she mused about whether the women were unhappily married or divorced.[29]

There may be compassion and pathos in these images, but there can be another way to view them as well. Yes, the women show signs of aging, and they wear constructed masks: they are heavily rouged and have exaggerated arched eyebrows, heavy pancake makeup, and obviously outlined lips. And yes, they are often attempting, as Respini wrote, to present an elegant and polished appearance. But in their defense, these women also have an admirable spirit and strength—they are still game, they are still out there pitching. If society demands this mask, then they will wear it. Yes, they do indeed look elegant—and why not?

As seen in these portraits and her other photographs, Sherman has often been fascinated by female masking and representations of the female face as artifice. Masking the body—decorating and veneering the face—has often been central to women's cultural experience, and cosmetics have played an important role as women have ornamented and transformed their faces in a layering of identities as they altered skin tones, exaggerated their facial features, stylized eyebrows, outlined lips, rouged cheeks.

Kathy Peiss in her chapter "Masks and Faces" in *Hope in a Jar* discusses the ethical dimension of women wearing masks, noting that a woman wearing cosmetics was historically denounced as a "painted woman": a seventeenth-century British Puritan man wrote that, "a painted face is a false face," and a British law of Parliament in 1770 annulled marriages of women who ensnared men using "scents, paints, cosmetic washes." Even iron corset stays, hoops, and other undergarments that reshaped women's bodies were suspect because they misrepresented women's "true" selves.[30]

In nineteenth-century America, proper middle-class women were expected to distance themselves from what were considered corrupt upper-class fashionable women who wore cosmetics and turned themselves into works of art rather than nature, and some writers denounced women who wore paint, powder, enamel, and filled in their wrinkles with paste. Observing "painted women" at the other end of the social spectrum, in dance halls and saloons, a male observer in Halifax in 1842 saw one debilitated prostitute as having a face that looked like a "painted, galvanised corpse."[31]

For women, the wearing of masks—particularly the wearing of cosmetics—has had myriad social meanings. Cosmetics and masks allow a woman to construct a social persona, a public, presentational self. It can be a stylized face that masks perceived imperfections or celebrates an *au courant* fashionable look. Mask-wearing can also be liberating by allowing women a degree of privacy and independence, providing a place marker in the public arena while leaving women to their own thoughts, or, as in Joan Jonas's performance videos, presenting a way for women to explore more glamorous, more exotic fantasies and identities.

Sherman's *Society Portraits* ultimately suspend any judgment about these women with their heavily made-up faces and instead raise provocative questions about the process of masking itself. Perhaps the real question to be asked about her *Society Portraits* is not why these fictive women risk looking grotesque or pathetic but to what degree they have done it to maintain their individual selves. Some of the women look composed and calm as though they can relax now that they have fashioned a formal façade. They have done whatever it takes to look calm and stately and have been successful at it—Margaret Thatcher and Hillary Clinton come to mind. These women assembled a constructed front, in much the same way men wear suits; the presentation establishes their dignity and ultimately lets them be themselves.

Though Sherman's society women have produced coherent, "put together" images of an idealized self—women projecting a seamless façade of perfection—Sherman in her *Disasters Series* (1986–1989) and *Sex Pictures* (1992) also does quite the opposite by disassembling the images and exploding them apart. The ambivalent, iconoclastic photographer embraces and inhabits women's doll-like roles but brutally deconstructs the roles as well. *Untitled #188* from the *Disasters Series* positions an upside down, blue-toned torso of an inflatable female doll in a sea of fragments—torn papers, environmental detritus, the remnants of a once cohesive world.

For her *Sex Pictures,* Sherman took apart nude vinyl female mannequins purchased from medical supply catalogues, put facial masks on some of them, and created new composite females—assemblages of breasts, hairless vulvas (she sometimes added pubic hair), and penises. Her photographs picture female (and sometimes transgender) figures as fractured creatures that could easily be described as ugly and grotesque. *Untitled #250* presents a grotesque inversion of the *Society Portraits.* The mask of the woman here has an aged face with streaming hair. She lies with her hands behind her head and her breasts, surrealistically pregnant belly, and gaping vulva face front, demanding attention rather than being camouflaged. This woman's eyes are wide open—she seems to have no eyelids—and she lies staring at us. (Sherman, in an interview about the sex pictures, described this as a "blank expression.") This segmented woman projects a grotesque composite of sexual parts, but to Sherman, "The clear and lucid eyes coming through the weathered face seemed so very touching."[32] The woman

seems to be defiantly saying, "Look at me, I'm not embarrassed, I'm not trying to hide anything."

Many of the *Sex Pictures* are riffs on pornographic images of women who are objectified and unadorned, not airbrushed to perfection. There are links in Sherman's work to Hans Bellmer's *La Poupée* series of photographs published in *Minotaure* in 1934. But while Bellmer's photos render women as fetishistic objects to be viewed by a male gaze, Sherman subverts the voyeurism and fetishism by flaunting the female-as-object construct with the mannequin's brash return gaze. These female images both embody and transcend the grotesque, confronting our voyeuristic view by looking at us head on.

Mariko Mori: Masks of Japan

Interrogating the role of masks and masquerades in a far different culture, Japanese media artist Mariko Mori also used herself as a model in her photographs where she transformed herself into other forms of artificial females as she satirized the glossy, digital wired females in Japanese pop culture since the 1990s—women in video games, J-Pop (popular Japanese music), anime, manga—all dramatically different from women in kimonos in traditional Japanese culture. In *Play with Me* (1994), she transforms herself into a female cyborg in an anime or video game, a cyborg wearing a metallic, robotic suit black boots, helmet, and carrying a machine gun, with her body digitally pasted in front of front of an "Akihabara" video game arcade in Tokyo. Here and in her images like *Warrior* (1994) she becomes coy but tough women—remote cut-outs standing in front of artificial sets.

Mori also melded Japanese spirituality with the digital age. A student of Tibetan Buddhism, she adapted Shinto elements in performance-based videos like *Miko no inori* (*Shaman Girl's Prayer*) where she appeared as a cyborg version of a shrine maiden wearing a space-age costume with winged shoulders, white contact lenses, and a white wig as she posed in Osaka's ultramodern Kansai International Airport, a female with crystal ball and supernatural powers.[33] In *Birth of a Star* (1995, plate XII), Mori embodies a different type of artificial woman as she presents a satirically exaggerated *aidoru* or popular culture idol—the Japanese female singers in J-Pop music groups and television personalities. A commercial commodity and wired woman with her headset and microphone, she is dressed in a short plaid skirt, she has punk purple hair, she wears blue contact lenses that give her eyes a glassy look, and she is surrounded by satirically vapid color balls or balloons. Accompanied by a pop culture music track, the photographic image transforms her into a product of technology: the image was created using Duratrans—a backlit box with print on a polyester sheet, a type of display model also used for television sets. To highlight the commercial nature of *aidoru,* Mori also created an edition of ninety-nine Barbie-like dolls, miniature versions of the *Birth of a Star* female wearing similar plaid skirts,

headphones, and microphones, turning the pop culture dolls into commodified works of art that were later auctioned off at Christie's.

Dolls as Women/Women as Dolls

Female dolls are one of the oldest forms of female simulacra, and images of women as dolls have had myriad cultural meanings and embodiments ranging from delicate, pretty children's toys to sexy, fetishistic *femmes fatales*. Dolls have been used to socialize young girls for their future domestic roles, and in the eighteenth and nineteenth centuries French fashion dolls provided role models for women who wished to be *a la mode*. Dada women artists, as we have seen, playfully embraced and reimagined dolls, and today's women artists like American photographer Laurie Simmons have presented their own witty takes on the doll image and provocatively probed issues about female identity as doll.

In her early black-and-white photographs from her series of dollhouse images (1976–1978), Simmons used a miniature doll with jointed body as a playful stand-in for women as she wittily subverts cultural images of contented domesticity. For her photographs, she created tiny home interiors with dollhouse furniture, evoking miniature vignettes of domestic life in the 1950s. Her mock tableaus tweaked conventional images of women as happy housewives in love with their kitchens and homes. As she wrote in her essay "In and Around the House," in the kitchen vignettes, she "had her do all kinds of nutty things." Her doll "stood on her head, gazed into the abyss of the refrigerator, and generally made a mess."[34] In these photographs there are signs of disarray: a skillet, dish, and kitchen utensils are spilled on the floor. In some images her tiny doll is quietly subversive: one doll-wife sits on the countertop as she contemplates—or quietly challenges—the confinement of her domestic world. In another image, where the kitchen is in state of mayhem, the doll doing handstands ("Woman Standing on Her Head") seems to be having a meltdown or an outbreak of rebellion in this shadowy, sharply-angled scene (fig. 7.4).

Lynn Hershman Leeson reconceptualized the idea of woman as a doll-like object of men's gaze with her two electronic installations *Tillie, The Telerobotic Doll* and *CyberRoberta* (1995–1998) from her "Dollie Clone Series." Each was situated in a gallery space and used cameras for "eyes": a video camera in the left eye and a web cam in the right. The left eye, which "saw" in color, recorded what was in front of the doll in the gallery and sent the images to her website. The eyes were controlled by visitors to the website who, by clicking on the "eye con" to the right of each doll's Internet image, could turn the doll's head 180 degrees so they could "see" the gallery space. Visitors could also see themselves on a monitor through a mirror placed in front of Tillie. Using Tillie's eyes as an extension of their own, the visitors became not only voyeurs but also, in the artist's words, "virtual cyborgs."

7.4 Laurie Simmons, photograph from her series of dollhouse images, 1976–1978. Courtesy of the artist and Salon 94, New York.

Perhaps most intriguing has been the way women artists in the digital world have revisited the uncanny, creating images that blur the lines between women and mannequin, woman as doll. Using digital morphing techniques, New York photographer Nancy Burson in 1988 fused two digitally scanned photographs to create eerily penetrating composite faces of women-dolls (figs. 7.5 and 7.6). In one of these startling photographs, there is a fusion of a young girl's face with a doll's eyes, and in another a mannequin's face fuses with a real woman's eyes and mouth. The girl with a doll's eyes draws us in with her demure and friendly smile, while the mannequin with woman's eyes and mouth keeps us at a distance and remains impassive, impersonal, and impenetrable.

The elision between woman and doll, animate and inanimate, also became an important feature in the world of contemporary *haut couture* starting in the 1990s. In *Fashion at the Edge,* Caroline Evans wrote about the contemporary world of high fashion, which "substitutes dolls for models or makes models look like androids," seen in the work of both Alexander McQueen, who "played on the robotic quality of the model" in his 1999/2000 fashions for Givenchy, and Adel Rootstein whose mannequins/dummies were modeled on real women. In some photographs it could be difficult to tell which image was the real model and which was the mannequin.[35]

To Evans, this slippage between animate and inanimate—the "uncanny replication and standardization of the female form"—reflects in part the "the idea of femininity commodified in an age of mass production." She also sees high

7.5 Nancy Burson *Untitled* (girl with doll's eyes), digitally produced from a Polaroid Polacolor ER Land Film print shot from the computer screen.
Copyright 1988 by Nancy Burson. Courtesy of the artist.

fashion models as having associations with death and describes supermodels from 1993 to 2003 as "assembly-line cyborgs" and "sci-fi posthumans." Evans cites Annette Kuhn's argument that the "glamour tradition" presented women "stripped of will and autonomy," like the Stepford Wives, and seen too in female representations where the "woman is dehumanized by being represented as a kind of automaton, a 'living doll.'"[36]

But there are also other ways to view this phenomenon. When male designers opt for robotic cyborg-looking models, they are, in effect, freezing women—not transforming them into corpses but striving instead for control. Seen through

7.6 Nancy Burson, *Untitled* (mannequin with real girl's mouth and eyes), digitally produced from a Polaroid Polacolor ER Land Film Print shot from the computer screen. Copyright 1988 by Nancy Burson. Courtesy of the artist.

yet another lens, these cyborg-like models also evoke a male fantasy: the classical quest for timeless beauty where Venus stands serenely on her pedestal, motionless and still in her perfection.

In film and art, when Swanilda in *Coppélia* and Ossi in Ernst Lubitsch's *The Doll* adopt the look of the uncanny and pose as "living dolls," rather than evoking death and stasis, they are impishly animated by their own wishes and desires. Women artists like Cindy Sherman and Mariko Mori and actresses like Marlene Dietrich were able to usurp the role of the image-making Pygmalion by creating their own Galateas that defied stasis. Appropriating the look of a

mannequin, wearing the mask of a seductive star, imitating the look of a video game robot, they found their own ways to subvert the quest to immobilize, objectify, and freeze gender definitions. Aimee Mullins may have been photographed as a doll, but when aided by technology she becomes a formidable woman who makes great strides. Transforming themselves into dolls, mannequins, and women-wearing-masks, these women cannily challenged cultural constructions of femininity with their lively intelligence and wit as they teased out those still-shifting boundaries between the virtual and the real.

Notes

Chapter 1: Simulated Women and the Pygmalion Myth

1 In the lines right before the tale of Pygmalion, Ovid had written about the "The Propoetides and the Cerastae," a section of *The Metamorphoses* where Venus, angry at the Propoetides, makes them act as prostitutes, and, perhaps because of that, Pygmalion envisions women as fallen creatures. Ovid, *Metamorphoses*, trans. Charles Martin (New York, London: Norton, 2004), 350. Ovid's version of the myth of Pygmalion was preceded by the story written by the Hellenistic poet Philostephanus (3rd century B.C.E.) as part of his *Cypriaca* no longer extant but reported by Clement of Alexandria (ca. 150–211 C.E.) and Arnobius of Sicca. In Philostephanus' version, Pygmalion is king of Cyprus who falls in love with his sculpture of Aphrodite; in Ovid's version, Pygmalion is not a king, and the sculpture is not that of Venus/Aphrodite. See the introduction to Ovid, *Metamorphoses*, trans. A. D. Melville (Oxford: Oxford University Press, 1986), x; Victor I. Stoichita, *The Pygmalion Effect: From Ovid to Hitchcock*, trans. Alison Anderson (Chicago: University of Chicago Press, 2008), 8; and also Essaka Joshua, *Pygmalion and Galatea: The History of a Narrative in English Literature* (Aldershot, Hants, UK; and Burlington, VT: Ashgate, 2001), 1–2.

2 In another translation, Ovid's words are, "Now in the while by wondrous art an image he did grave/Of such proportion, shape, and grace as nature never gave/Nor can to any woman give." *Ovid's Metamorphosis*, trans. Arthur Golding (Baltimore: Johns Hopkins University Press, 2002), 302.

3 Ibid., 363.

4 Stoichita, *Pygmalion Effect*, 29. The comments about lust were by medieval writer Christine de Pizan.

5 Essaka Joshua notes that, after Rousseau's opera, Galatea was widely used by British writers and that his opera had a broad impact, inspiring later operas, plays, and the British Romantics. Rousseau's *Pygmalion* particularly focuses on the sculptor's changing attitudes toward his own artistic abilities. Joshua, *Pygmalion and Galatea*, 24–38.

6 Stoichita, in *The Pygmalion Effect*, illustrates the work of Emmanuel Jean Nepomucene de Ghendt who had created a whole series of copper engravings as illustrations for *Pygmalion* by Boudreau Delandes. The engravings were based on drawings by Charles Eisen. Stoichita, *Pygmalion Effect*, 115–117.

7 Stoichita discusses sixteenth-century treatises on cerebral anatomy, which associated the brain with the soul. See ibid., 125.

8 The four Burne-Jones paintings are *The Heart Desires, The Heart Refrains, The*

Godhead Fires, and *The Soul Attains*, all 1879. He also produced small paintings and drawings for William Morris's poem "Pygmalion and the Image," in the first volume of Morris's *The Earthly Paradise* (1868). As Essaka Joshua notes, in Morris's poem, there is a distinction between the love given to the statue and love given to the real woman; he prefers the real woman because she has a soul (*Pygmalion and Galatea*, 87–88).

9 Carolyn Williams, *Gilbert and Sullivan: Gender, Genre, Parody* (New York: Columbia University Press, 2011), 6, 21; Carolyn Williams, "Reproducing Gender Roles in Victorian England," in *Created in Our Own Images.com: W. S. Gilbert's Pygmalion & Galatea: An Introduction to the Art, Ethics, and Science of Cloning*, ed. Fred M. Sander (New York: International Psychoanalytic Books, 2010), 93.

10 W. S. Gilbert, *Pygmalion and Galatea: An Original Mythological Comedy in Three Acts* (1870, reprint Chicago: Dramatic Publishing Co., 1886), 10–11. All page references and quotations are from this edition. Pygmalion in Gilbert's play says he first modeled his sculpture of Galatea out of clay, his artisans roughly chiseled out the sculpture's raw shape, and, as he tells Galatea, he then "made you what you are—in all but life" (13).

11 Ibid., 12. See chapter 3 for a more complete discussion.

12 Julie Wosk, *Breaking Frame: Technology and the Visual Arts in the Nineteenth Century* (New Brunswick, NJ: Rutgers University Press, 1992); rpt. with new introduction, Breaking *Frame: Technology, Art, and Design in the Nineteenth Century* (New York: Authors Guild Back-in-Print.com, 2013). See chapters 3, 4, and 5 on decorative electroplating and the uses of cast iron in architecture, furniture, engine design, and sculpture.

13 Gilbert, *Pygmalion and Galatea*, 11, 6, 16.

14 Ibid., 6, 11.

15 Ibid., 14, 20, 22, 32.

16 Joshua, *Pygmalion and Galatea* 105; Williams, "Reproducing Gender Roles in Victorian England," 94.

17 Gilbert, *Pygmalion and Galatea*, 31, 15.

18 At the beginning of the play, we are told that Cynisca, before her marriage, was a "holy nymph" of Artemis but decided to marry Pygmalion at age seventeen. Artemis agreed but told her that if either one of the couple is unfaithful, then the wronged one has the power to blind the other, with the blindness lasting until pardoned (Gilbert, *Pygmalion and Galatea*, 9). In an earlier iteration of the blinded lover, E.T.A. Hoffmann's story "The Sandman," Nathanael's vision is distorted by the spyglass given to him by Coppola, and Nathanael fears that he will lose his eyes to the Sandman who puts sand in people's eyes so they will sleep.

19 Gilbert, *Pygmalion and Galatea*, 42.

20 Though there is no proof Shaw ever read Kellett's story before he produced the final draft of his play eleven years later, both works have important plot and theme similarities, as Philip Klass has pointed out. In Kellett's story, Arthur Moore, a scientist not a sculptor, accepts a challenge to produce a counterfeit woman who will fool everyone. Both works have a preoccupation with phonographs and a gramophone as reproduction machines capable of duplicating a woman's voice and also the "testing of a manufactured female at a great social occasion." Philip Klass, "'The Lady Automaton' by E. E. Kellett: A Pygmalion Source?" *Shaw* 2 (1982): 75–76.

21 E. E. (Ernest Edward) Kellett, "The Lady Automaton," *Pearson's Magazine* 24 (June 1901): 63–75. All further quotations are from this source.

22 Masahiro Mori, "The Uncanny Valley" [*Bukimi no tani*], originally published in

Japanese in *Energy* 7, no. 4 (1970): 33–35. English translation by Karl F. MacDorman and Takaski Minato in "Androids as an Experimental Apparatus: Why Is There an Uncanny Valley and How Can We Exploit It?" in *Android Science* and *IEEE Spectrum*, posted June 12, 2012.
23 See Kellett, "The Lady Automaton."
24 Elizabeth Menon also discusses the use of fashion dolls in nineteenth-century Parisian shop windows—dolls that, in an era when women were becoming more independent, were seen by some male critics as dangerous, immoral models for young females. Elizabeth K. Menon, *Evil by Design: The Creation and Marketing of the Femme Fatale* (Urbana: University of Illinois Press, 2006), 13, 167, 171.
25 Much has been written on the "New Woman" as cultural construct and as a social threat—what Sally Ledger has called a "signifier for social integration and the break-up of the cultural boundaries that had been so carefully erected earlier in the century." Sally Ledger, "The New Woman and the Crisis of Victorianism," in *Cultural Politics at the Fin de Siècle*, eds. Sally Ledger and Scott McCracken (Cambridge: Cambridge University Press, 1995); Angelique Richardson and Chris Willis, eds., *The New Woman in Fiction and Fact: Fin-de Siècle Feminisms* (Basingstoke: Palgrave Macmillan, 2002).
26 See Wosk, *Women and the Machine: Representations from the Spinning Wheel to the Electronic Age* (Baltimore, MD: Johns Hopkins University Press, 2001), chapter 5 (on Women and the Automobile).
27 George Bernard Shaw, *Pygmalion*, 1912 (Baltimore: Penguin Books, 1974), 40, 58.
28 Ibid., 26, 31.
29 Ibid., 69.
30 Ibid., 69.
31 Ibid., 51
32 Ibid., 97–98.
33 Ibid., 107, 33, 34, 19.
34 Ibid., 106, 110.
35 As I discuss in chapter 4, Shaw's play was the basis for the 1956 Broadway musical *My Fair Lady* with book and lyrics by Alan Jay Lerner and music by Frederick Loewe, and other versions of the musical including New York and London productions in 1958 with Rex Harrison and Julie Andrews, a 1964 film starring Audrey Hepburn as Eliza and Rex Harrison as Higgins, and a 1963 television version starring Peter O'Toole and Margot Kidder.
36 Kennie McDowd, "The Marble Virgin," *Science Wonder Stories* I (June 1929): 53–61, 83. See Lester del Ray's 1938 story "Helen O'Loy" for an emotionally needy female robot.

Chapter 2: Mechanical Galateas: Female Automatons and Dolls

1 The Greek "dolls" often had small holes in their heads so they could be worn around the neck where they dangled and moved. Joan Reilly, "Naked and Limbless: Learning About the Female Body in Ancient Athens," in *Naked Truths: Women, Sexuality, and Gender in Classical Art and Archeology*, ed. Olga Koloski-Ostrow et al. (London; New York: Routledge, 1997), 164; Jenifer Neils, John H. Oakley, and Katherine Hart, "Coming of Age in Ancient Greece: Images of Childhood from the Classical Past" (Hanover, NH: Hood Museum of Art, Dartmouth College, no. 45), 15, 268; Maya B. Muratov, "Greek Terracotta Figurines with Articulated Limbs," Heilbrunn Timeline of Art History (New York: Metropolitan Museum of Art. 2000); http://www.metmuseum.org/toah/hd/gtal/hd_gtal.htm, accessed March 19, 2014. Some

of the earliest of these Greek doll-like figures date from the tenth century B.C.E. The segmented nature of these small figures could be important in their representation: on some stone grave markers, there were carved relief figures of a girl holding a doll with no arms or legs—a method thought by some scholars to be a way of differentiating images of dolls or votive figures from images of real children. Reilly, who argues that these were not really dolls but anatomical votive figures, questions the belief that, as some have argued, they were limbless to avoid confusing them with children or sacred images. Reilly,"Naked and Limbless," 160, 161, 171n29. In much later versions of artificial women, including E.T.A. Hoffmann's "The Sandman," there was something horrifying about seeing a fragmented, dismembered woman without limbs—a nightmare experience causing a recognition that the woman was artificial, not real.

2. Historically there were also nonmechanical, proto-robotic figures. The ancient Egyptians, for example, sculpted moving figures with articulate limbs, and there were sixteenth-century Hebraic legends about a golem, such as the clay creature created by Rabbi Loew in Prague in 1560. Historians of robots also include early examples of Chinese and Japanese robotic figures. For general histories of robots, see Lisa Nocks, *The Robot: The Life Story of a Technology* (Baltimore: Johns Hopkins University Press, 2008); Jean David Ichbiah, *Robots: From Science Fiction to Technological Revolution*, trans. Ken Kincaid (Geneva: Éditions Minerva; New York: Harry N. Abrams, 2005), and even earlier, Jasia Reichardt, *Robots: Fact, Fiction, and Prediction* (Harmondsworth, Middlesex, UK, and New York: Penguin, 1978) and the classic studies of automata cited below.

3. Homer, *The Iliad*, Book 18, lines 488–491, trans. Robert Fagles (New York: Penguin Books USA, 1991), 481.

4. See John Peter Oleson, ed., *The Oxford Handbook of Engineering and Technology in the Classical World* (Oxford: Oxford University Press, 2009); al–Jazari, *The Book of Knowledge of Ingenious Mechanical Devices*, trans. and annotated by Donald R. Hill II (Dorecht-Holland/Boston: Reidel Publishing Co., 1974), 226. See Plate XX, Cat., chapter 10. For this edition, the translator used the Oxford Graves 27 Manuscript dated 1315, the oldest almost complete manuscript.

5. Nocks, *The Robot*, 15–16. Nocks writes that it is not clear if his inventions were created during his lifetime for a sultan or whether he copied them from ancient designs by Archimedes, Apollonius, or from the Banu Musa (brothers).

6. For an extended discussion of automata and eighteenth-century French philosophy, see Minsoo Kang, *Sublime Dreams of Living Machines: The Automaton in the European Imagination* (Cambridge, MA: Harvard University Press, 2011). Kang argues that during the eighteenth century, the "automaton emerged as the central emblem of the entire mechanistic world view that dominated during the period." By the second half of century, though the popularity of automatons continued, there was a less sanguine view of the human as well-functioning machine and a tension as Enlightenment philosophers considered the problematic aspects of considering humans as clockwork automatons with a lack of autonomy and freedom (ibid., 112, 148, 158).

7. Alfred Chapuis and Edmond Droz, *Automata: A Historical and Technological Study*, trans. *Alec Reid* (Neuchâtel: *Editions du* Griffon/New York: Central Book Co., 1958), 280. The book includes a nineteenth-century illustration of the Jaquet-Droz Lady Musician at the Court of Louis XVI (p. 280); Alfred Chapuis and Edmond Droz, *The Jaquet-Droz Mechanical Puppets* (Neuchâtel: Historical Museum, 1956, New Edition, 1971), 9.

8. The mechanical parts for the automaton include bellows inside the instrument that pump air into the pipes. The other parts are inside the stool; two large twin cylinders

propel a large studded brass drum (in two halves) with studs corresponding to five fingers on each hand. The two halves of the drum are separated by ten steel cams. The studs, acting on the fingers, make them move using sets of levers and rods inside the body, which pass through the elbows, forearms, and wrists to the ten fingers.

9. Alfred Chapuis and Edmond Droz, *The Jaquet-Droz Mechanical Puppets* (Neuchâtel: Historical Museum, 1956, New Edition, 1971), 18–19. Chapuis and Droz, *Automata* (286 and 318), also write of other female musician automatons, including an eighteenth-century woman playing a harpsichord-shaped dulcimer in the Peking Museum and nineteenth-century walking dolls by François Gaultier.

10. This second lady musician automaton was listed in the accounts of Jaquet-Droz and Leschot of Geneva in 1782 and finished in the rough in 1784. It was the figure of a girl playing a harpsichord that used an organ mechanism with two registers. The automaton was sold to the firm of Jaquet-Droz and Maillardet of London and advertised by Henry Maillardet in a British poster as a "Musical Lady" or "Maillardet's Grand Automaton" (Maillardet called her Roxlane). It was to be sent to St. Petersburg in 1833, but there is no record of what happened to it (Chapuis and Droz, *Automata*, 283–285).

11. Kazuo Murakami, trans. and ed., *Japanese Automata—Karakuri Zui: An Eighteenth-Century Manual of Automatic Mechanical Devices* (first published as *Karakuri-Zui* in 1796) (Oakland, CA: Masalai Press, 2012).; Chapuis and Droz, *Automata*, 317–319.

12. Bouchardon's drawings depicted Paris streets. *Études prise dans le bas Peuple ou les Cris de Paris* includes sixty plates etched by A. C. Philippe du Tubières after Bouchardon (Paris: E. Fessard, 1737–1746). Julie Park suggests 1731 as a date for the Cochin print. Julie Park, *The Self and It: Novel Objects in Eighteenth-Century England* (Palo Alto, CA: Stanford University Press, 2009), 233.

13. This was one of a series of engravings made from paintings by Francis Hayman and created for the Vauxhall Garden ballroom in 1743, etched in 1750. The reprint of this engraving was in *Scribner's* Vol. 5. Another version of the print was etched in 1764.

14. Starbinski cited in Park, *The Self and It*, 219,105. Park discusses the concept of woman as fashion doll.

15. See Julie Wosk, *Women and the Machine: Representations from the Spinning Wheel to the Electronic Age* (Baltimore: Johns Hopkins University Press, 2001), chapter 2, "Wired for Fashion: Images of Bustles, Corsets, and Crinolines in the Mechanical Age."

16. Near the beginning of the film, even the nun who lusts after Casanova wears little but a miniature red farthingale during their encounter on a remote island.

17. "The Man Who Never Was Young," *The Atlantic* 7, no. 41 (March 1861): 325–327 (the story starts on 320).

18. Christian Bailly with Sharon Bailly, *Automata: The Golden Age, 1848–1914* (London: Robert Hale 1987; rpt., 2003), 16–17, 207.

19. In medieval Europe, and sixteenth- and seventeenth-century Germany and other European countries, mechanical clock towers of cathedrals featured another type of moving mechanical figures: jaquemarts (also spelled jacquemarts), which were automatons in the form of wooden or cast-metal figures of prophets, saints, apostles, and more. These figures held hammers to strike bells marking the hours or the figures moved forward on the hour. See Antoine Battaini, "A Short History of Mechanical Dolls," in Andre Soriano, *The Mechanical Dolls of Monte Carlo*, trans. John Ottaway, texts by Antoine Battaini and Annette Bordeau (Editions Andre Sauret, Monte-Carlo and the National Museum of Monaco; New York: Rizzoli 1985), 40. In 1878, the Pennsylvania clockmaker Stephen D. Engle used moving figures in

his Monumental Clock, now located in Pennsylvania's National Watch and Clock Museum. The clock features moving biblical figures including the three Marys.
20 Bailly, *Automata*, 16.
21 Annette Bordeau, "The Galéa Collection," essay in Soriano, *The Mechanical Dolls of Monte Carlo*, 73, 75, 85–87.
22 The woman named the "Fileuse" at her spinning wheel is illustrated in a 1890s Roullet & Decamps catalogue (Bailly, *Automata*, 243). The German clockwork figures of the scolding woman and a shoemaker are illustrated in Chapuis and Droz, *Automata*, 127. A washerwoman created by Decamps in Paris in 1900 holds a brush as she washes to the tune of "The Bells of Corneville" as she stands by a tub (Soriano, *The Mechanical Dolls of Monte Carlo*, 48). The Shelburne Museum in Burlington, Vermont, has in its collections an elderly woman wearing glasses who knits with a basket in her lap and a female automaton that pats her lace tablecloth with a damp cloth as she gets ready to iron.
23 Bailly, *Automata*, 64, quotes from a visitor to the Universal Exhibition in Paris in 1878, the first exposition in which Vichy automatons were exhibited.
24 I am indebted to Marlène Rufenacht, document archivist at the Musée d'horlogerie du Locle in Le Locle, Switzerland, for this information.
25 Talia Schaffer has described the new woman as both a cultural scapegoat and fictional construct: "They walked without chaperones, carried their own latch keys, bicycled, and the more daring ones smoked cigarettes, cut their hair, or wore divided skirts." Talia Schaffer, "'Nothing But Foolscap and Ink': Inventing the New Woman," in *The New Woman in Fiction and Fact: Fin-de Siècle Feminisms*, ed. Angelique Richardson and Chris Willis (Basingstoke: Palgrave Macmillan, 2001), 39.
26 Claire Goldberg Moses, *French Feminism in the Nineteenth Century* (Albany: State University of New York Press, 1984), 231–234.
27 The automaton is illustrated in *Dolls in Motion 1850–1915* (Annapolis, MD: Florence Theriault/Gold Horse Publishing, 2000), 81. The book's unnamed editor notes that there was a similarly dressed automaton named "Advocate" of a male attorney manufactured by the Parisian company Roullet & Decamps.
28 In France, no mass political movement for feminist causes arose until the twentieth century, but the rise of the New Woman in fin-de-siècle England brought what Sally Ledger has called a "collision between the old and the new"—a time "fraught with both anxiety and with an exhilarating sense of the possible." Sally Ledger, "The New Woman and the Crisis of Victorianism," in *Cultural Politics at the Fin de Siècle*, ed. Sally Ledger and Scott McCracken (Cambridge: Cambridge University Press, 1995), 22; Sarah Grand, "The New Aspect of the Woman Question," *North American Review* 158, no. 448 (March 1894): 271, 274.
29 Wosk, *Women and the Machine*, 28.
30 Hillier, *Automata*, 84. A similar toy was patented by R. J. Clay in 1875. The toy may have been manufactured by American toy manufacturer Edward Ives in Bridgeport, Connecticut.
31 Wosk, *Women and the Machine*, chapter 4, "Women and the Bicycle."
32 Illustrated in Bailly, *Automata*, 321.
33 See Roger Benjamin, *Orientalist Aesthetics: Art, Colonialism, and French North Africa 1880–1930* (Berkeley: University of California Press, 2003), 1–32.
34 Ibid., 105–106, 114.
35 Zulma the Snake Charmer created by Roullet & Decamps, was the only known automaton that performed in the nude (Soriano, *The Mechanical Dolls of Monte Carlo*, 25); Bordeau, "The Galéa Collection," 70–71. See also illustration in Bailly, *Automata*, 21, 137.

36 Puppets and dolls were produced in Japan during the seventeenth through nineteenth centuries. There were three main categories of these figures: Butai Karakuri puppets used in the theater; Zashiki, which were played with in rooms; and Dashi Karakur puppets performing on wooden floats. The Japanese adopted Western technology to produce these puppets. The karakuri ningyo were Japanese mechanical dolls or automatons (*Karakuri* means mechanism), which were developed during the Edo period. During the eighteenth century these automatons were influenced by foreign cultures (information provided by the Yokohama doll museum and Tokyo Science Museum).

37 The elaborate nineteenth-century female automaton "La magicienne" was manufactured in small numbers and marketed to adults, in the age of electronics, but an American toy manufacturer offered young girls a much more accessible toy with a similar sense of agency evoked by La magicienne: Fisher-Price introduced its interactive, battery-powered Dora the Explorer Fairy Wishes Magical Doll, which seemed magically animated: when the user touched a wand to doll's necklace, the doll said the advertisers "comes to life" as it blinked its eyes, smiled, sang, and spoke phrases—becoming, in effect, a twenty-first-century simulacra or double of young girls themselves.

38 A curious predecessor of the talking doll was Joseph Faber's *Euphonia*, a pedal-operated machine with a representation of a woman's head that moved its lips and tongue and spoke a variety of European languages. Faber exhibited *Euphonia* in Philadelphia in 1845 and in London's Egyptian Hall in 1846.

39 Hillier, *Automata*, 21.

40 An eighteenth-century automaton also seemed to be walking as it glided forth on wheels.

41 When walking, the dolls were apt to lose their balance and could crack their ceramic heads. Miriam Formanek-Brunell, *Guise and Dolls: The Rise of the Doll Industry and the Gender of Material Culture, 1830–1930*, Ph.D. Dissertation Rutgers University, 1990, on file at the Hagley Museum and Library.

42 Oliver Wendell Holmes Sr., "The Physiology of Walking," *Pages from an Old Volume of Life: A Collection of Essays, 1857–1881* (Boston and New York: Houghton, Mifflin/Cambridge: The Riverside Press, 1892), 129.

43 Ibid., 129.

44 Thomas Hood, *Miss Kilmansegg and Her Golden Leg: A Garden Legend* (London: F. Moxon, n.d.). Hood's story is an intriguing antecedent to a tale where a prosthetic leg becomes a source of torment. In American writer Flannery O'Connor's twentieth-century southern Gothic story, "Good Country People," a woman's leg is stolen, leaving her stranded.

45 Holmes, "The Physiology of Walking," 129.

46 Ibid., 129–130.

47 Ibid., 130.

48 Miriam Formanek-Brunell, *Made to Play House: Dolls and the Commercialization of American Girlhood, 1830–1930* (New Haven: Yale University Press, 1993; intro., Baltimore: Johns Hopkins University Press, 1998), 40, 48.

49 Formanek-Brunell, *Guise and Dolls,* p. 131- 132, 136. See also Formanek-Brunell, *Made to Play House,* 41, 43.

50 See Wosk, *Women and the Machine*, chapter 2.

51 Mary R. Melendy, *Perfect Womanhood for Maidens—Wives—Mothers: A Complete Medical Guide for Women* (K. T. Boland, 1906), 27.

52 Bailly, *Automata*, 23.

Chapter 3: Mannequins, Masks, Monsters, and Dolls: Film and the Arts in the 1920s and 1930s

1. Ernst Jentsch, "Zur Psychologie des Unheimlichen," *Psychiatrisch-neurologische Wochenschrift* 8.22 (August 25, 1906): 195–198, and 8.23 (September 1, 1906): 203–205 (Jentsch's essay is spread over two separate issues of the weekly); and "On the Psychology of the Uncanny," trans. Roy Sellars, *Angelaki* 2.1 (1995): 7–16. Sigmund Freud, "Das Unheimliche," trans. "The 'Uncanny,'" in *The Standard Edition of the Complete Psychological Works of Sigmund Freud*, 17, trans. and ed. James Strachey et al. (London: Hogarth Press and the Institute of Psycho-Analysis, 1955), 218–252.
2. Jentsch, "Zur Psychologie," 12.
3. Masahiro Mori, "The Uncanny Valley," *Energy* 7, no. 4 (1970): 33–35, trans. Karl F. MacDorman and Norri Kageki, *IEEE Robotics and Automation Magazine*, 19, no. 2 (June 2012): 100.
4. Years later, postmodern psychoanalyst Jacques Lacan in "Aggressiveness in Psychoanalysis" would link images of the fragmented body—and Nathanael's suicide—to castration, mutilation, and dismemberment. Lacan's "Aggressiveness in Psychoanalysis" (1948) discussed in Lydia H. Liu, *The Freudian Robot: Digital Media and the Future of the Unconscious* (Chicago: University of Chicago Press, 2010), 222.
5. E.T.A. Hoffmann, "Der Sandmann" ("The Sandman," 1816) in *Tales of E.T.A. Hoffmann*, ed. and trans. Leonard J. Kent and Elizabeth C. Knight (1969; abridged ed., Chicago: University of Chicago Press, 1972), 112. All further page references are to this edition. The translators note that "*coppo*" in Italian means "eye socket."
6. Henri Bergson, *Le Rire* (*Laughter: An Essay on the Meaning of the Comic*), trans. Cloudesely Brereton and Fred Rothwell (Rockville, MD: Arc Manor, 2008), 5.
7. In a Kirov Ballet production, Franz, carrying out the denuded doll, recognizes it for what it is—an artificial woman—and kneels in homage before his real-life fiancée.
8. Other early filmmakers in America were also fascinated by the idea of a doll that comes to life, including the 1908 Essanay Film Manufacturing Company's *An Animated Doll* and the silent film *The Doll* (1902, Lubin Manufacturing Company) where a man dances with a mechanical doll. Gaby Wood notes that Méliès himself played the role of the sculptor in his film *Pygmalion and Galatea*. Wood, *Edison's Eve: A Magical History of the Quest for Mechanical Life* (originally published as *Living Dolls*, 2002) (New York: Anchor Books, 2003), 187-190. In another version of the lady as mechanism, in the Méliès film *The Clockmaker's Dream* (1908), a clockmaker dreams that his clocks have all turned into women—a motif echoed earlier in an eighteenth-century engraving *L'Horlogère* (*The Mistress of Horology*) of a woman whose body incorporates an ornamental clock.
9. Wood argues that early cinema was a direct descendent of eighteenth-century androids (168), and she traces the intriguing interplay between Méliès's early background as a magician, his fascination with illusions, his working in the Robert-Houdin Theatre in a space usually reserved for repair automatons, and his focus on creating early cinema. Wood, *Edison's Eve*, 187–190, 196-197.
10. Key scenes in *Metropolis*, thought to have been lost forever when the original film was drastically edited shortly after its release in 1927, were rediscovered and digitally restored in a new version that premiered at the Berlin Film Festival in February 2010 and had its North American premiere in Hollywood in April 2010. The new version, which contains about twenty-five minutes of added scenes and reaction shots, was made possible by the discovery of reels containing a copy of the original film found in canisters on the shelves of the Museo del Cinema in Buenos Aires. See Julie Wosk, "Update on the Film *Metropolis*," *Technology and Culture* 51, no. 4 (October 2010): 1061–1062.

11 The film's remarkable special effects used to create this scene of transformation were produced and designed by Günther Rittau who wrote about how he and the film's crew spent months in the lab with "photo-chemistry" as they "illuminated liquids in strange test-tubes and made them bubble, the electrical apparatus surrounding Maria was made to emit sparks and we gradually enveloped it in huge arcs of lightning, at the same time as rings of fire formed around the robot, moving up and down her body." (The rings were actually two circular, arched neon lights in tubes which were moved up and down by a type of elevator.) Günther Rittau, "Die Trickaufnamen im Metropolis Film," *Die Filmtechnik* (January 28, 1928), trans. in Thomas Elsaesser, *Metropolis* (London: British Film Institute, 2000), 25. The film's lightning-like discharges produced using a tesla coil were a special effects technique employed in silent films as early as 1915 and used most famously in James Whale's film *Frankenstein* (1931).

12 Andreas Huyssen, "The Vamp and the Machine: Technology and Sexuality in Fritz Lang's *Metropolis*," *New German Critique* 24–25 (Fall/Winter 1981–1982): 221–237, reprinted in Andreas Huyssen, *After the Great Divide: Modernism, Mass Culture, Postmodernism* (Basingstoke: Macmillan, 1988), 65–91 (cf. 73).

13 Mary Shelley, *Frankenstein; or, The Modern Prometheus* (1831 edition) (New York: Bantam Books, 2003), 133.

14 Elizabeth Young, "Here Comes the Bride: Wedding, Gender, and Race in *Bride of Frankenstein*," in *The Dread of Difference: Gender and the Horror Film*, ed. Barry Keith Grant (Austin: University of Texas Press, 1996), 317–318; originally appeared in *Feminist Studies* 17, no. 3 (Fall 1991): 403–447.

15 Shelley, *Frankenstein*, 38, 40.

16 Alberto Manguel, *Bride of Frankenstein* (London: British Film Institute, 1997), 46.

17 Laura Mulvey, "Visual Pleasure and Narrative Cinema," *Screen* 16, no. 3 (Autumn 1975): 12–13; Young, 327-329. Young's essay extends the arguments of feminist readings, writing that the film is also racially-encoded, with the Monster as a black man and the Bride as a white woman.

18 Young adds that the "bride's look may suggest a wry awareness of her own monstrosity, a suggestion that if women are, in the visual economy of the gaze, always already monsters, then at least the female monster can stare back." Young, "Here Comes the Bride," p. 328; Mary Jacobus, "Is There a Woman in This Text?" *New Literary History* 14, no. 1 (1982): 135.

19 Mary Ann Doane, "Film and the Masquerade: Theorising the Female Spectator," *Screen* 23, no. 3–4 (1982): 74–88. Doane alludes to and extends the arguments of Joan Riviere's pioneering essay, "Womanliness as a Masquerade," in *Psychoanalysis and Female Sexuality*, ed. Hendrik M. Ruitenbeek (New Haven: Yale University Press, 1966), 213. Revisiting the issue of masquerade in her later essay "Masquerade Reconsidered: Further Thoughts on the Female Spectator" (*Discourse* 11, no. 1 [1988–89]: 42–54), Doane discusses how, in her own 1982 essay, she deviated from the arguments of Riviere, who in her 1929 essay "Womanliness as Masquerade" wrote that the masquerade of exaggerated femininity or "womanliness" helped intellectual women cloak what was perceived of [in a patriarchal society, notes Doane] as a woman's masculinity and assertiveness. Riviere's essay has been much debated, particularly her distinctions between a mask of femininity and "genuine womanliness." See chapter 3, endnote 31.

20 Caroline A. Jones, "The Sex of the Machine," in *Picturing Science, Producing Art*, ed. Peter Galison and Caroline A. Jones (London and New York: Routledge, Taylor & Francis, 1998), 159.

21 Julie Park, *The Self and It: Novel Objects in Eighteenth-Century England* (Stanford, CA: Stanford University Press, 2010), 221–225.
22 Riviere in "Womanliness as a Masquerade" wrote, "The reader may now ask how I define womanliness or where I draw the line between genuine womanliness and the masquerade. My suggestion is not, however, that there is any such difference; whether radical or superficial, they are the same thing." (213). In the second decade of the twenty-first century, however, in an era of vapid female media celebrities, the mask may be camouflaging nothing more than a void.
23 Terry Castle, *Masquerade and Civilization: The Carnivalesque in Eighteenth-Century English Culture and Fiction* (Stanford, CA: Stanford University Press, 1986), 255.
24 Maude Lavin, *Cut with the Kitchen Knife: The Weimar Photomontages of Hannah Höch* (New Haven: Yale University Press, 1993), 136.
25 Quoted in Ruth Hemus, *Dada's Women* (New Haven: Yale University Press, 2009), 51, translated from *Das Brandmal: Ein Tagebuch* (Berlin: E. Reiss, 1920), 150. Hemus (62) notes the influence of doll maker Lotte Pritzel's erotic and sexualized male, female, and androgynous dolls of angels and dancers.
26 Audiences in the 1920s may have had ambivalent reactions toward the abstracted dolls and mechanistic stage figures in Bauhaus and Dada performances. Juliet Koss has suggested there was a sense of estrangement as well as empathy in these stage dolls: spectators, which included women in the audience, felt a sense of alienation but also identified with the charming figures. Lázló Moholy-Nagy, referencing Futurist and Dada mechanistic human stage figures of the 1920s, wrote about the experience of empathy and estrangement, identification and shock. Juliet Koss, "Bauhaus Theater of Human Dolls," *Art Bulletin* 85, no. 4 (December 2003): 230, 235, notes 28 and 57 (743–744).
27 Peter Webb and Robert Short, *Hans Bellmer* (London; New York: Quartet Books, 1985), 34, translated by the authors.
28 Hans Bellmer, *Poupée* illustrated in *Minotaure* 6 (December 1934), and *La Poupée (The Doll)*, trans. from the German by Robert Valençay (Paris: Editions GLM, 1936).
29 Bellmer was said to have been influenced by several personal events in his life. He had seen a production of Offenbach's *Tales of Hoffmann* (perhaps Max Reinhart's 1931 production in Berlin with Titana Menotti playing Olympia) in which Nathanael is entranced with the dancing doll Olympia; the visit of his young cousin; and having seen sixteenth-century dolls constructed with ball joints in the Kaiser-Friedrich Museum. Sue Taylor, "Hans Bellmer in The Art Institute of Chicago: The Wandering Libido and the Hysterical Body," *Art Institute of Chicago Museum Studies*, 22, no. 2 (1996): 150–165, 197–199; Webb and Short, *Hans Bellmer*, 36.
30 Man Ray photographed the show, and in 1966 he published *Résurrection des mannequins* (Paris: Jean Petithory, 1966), which included sixteen gelatin silver photographs with a descriptive text. Hugnet cited in Lewis Kachur, *Displaying the Marvelous: Marcel Duchamp, Salvador Dali, and the Surrealist Exhibition Installations* (Cambridge, MA: MIT Press, 2003), 38, 40; Georges Hugnet, "L'Exposition Surréaliste internationale de 1938," *Preuves*, no. 91 (September 1958), reprinted in *Pleins et déliés: souveniers et temoignages, 1926–72* (La Chapelle-sur-Loire: Guy Authier, 1972), 329.
31 Hannah Höch in her photocollage *Dada/Ernst* playfully used isolated legs to create a more evocative reimagining of women's identity. *Dada/Ernst* not only referenced her friend artist Max Ernst and his photocollages but also united two opposing female images: the romantic and sentimental woman playing a musical instrument on the left and an image that celebrated the bold sexuality of the modern female with the cut-out image of a single woman's leg dressed in stockings and a high-heeled

shoe. The collage has other sexual imagery too: a woman wears a phallic-shaped cone hat suggestively and provocatively aimed toward a photographic pair of woman's spread legs. Hemus, *Dada's Women*, 109.
32 Jones, "The Sex of the Machine," 153, 59.
33 The drawing appeared on the cover of the avant-garde journal *291* in June 1915. Picabia's mechanical "object-portraits" were inspired by both Apollinaire and Duchamp, as well as by illustrations in popular magazines. A similar image of the spark plug appeared in an advertisement for a "Red-Head" priming plug manufactured by the Emil Grossman Manufacturing Company in Brooklyn which was advertised in *The Motor* (December 1914): 97. See William A. Canfield, "The Mechanistic Style of Francis Picabia," *Art Bulletin* 48 (September-December 1966), and William Innes Homer, "Picabia's *Jeune fille américaine dans l'état de nudité* and Her Friends," *Art Bulletin* 57 (March 1975): 110–115. Homer (15) noted that the word "forever" appeared in the text of the Grossman advertisement which read, "Every part so good we can guarantee them forever." The meaning of Picabia's spark plug has stirred debates and has been viewed variously as an image of American culture dominated by declining values (so thought Picabia's wife), as an eroticized portrait of American womanhood, or as a reference to Agnes Meyer, friend of the Stieglitz group in New York and a patron of modern art (Homer, 115).
34 Linda Nochlin, *Women, Art, and Power and Other Essays* (rpt.; New York: Harper & Row, 1989), 28–29.
35 Laura Breckinridge McClintock, "Why Take a Man Along?" *Motor* 40 (July 1923): 25.
36 Sophie Tauber-Arp in Zurich had created innovative abstracted puppets and jointed wooden marionettes in 1918, and Exter's appeared eight years later. See the introductory essay by John E. Bowlt in *Alexandra Exter, Russian 1882–1949: Marionettes Created 1926* [exhibit catalogue] (New York: Leonard Hutton Galleries, 1974), 2–6. See also Vera Idelson's illustration of a machine woman in *Machine Art* catalogue (New York: Museum of Modern Art, 1934).
37 A typescript notebook in the Schlesinger Library outlines a program with the theme of "Social Control" presented on July 2, 1932, by twenty-five students in which they portrayed a group of workers after a day at the factory and presented "in dramatic form the common problems of all industrial workers." Their "mechanical dance" suggested "the present day situation in industry."

Chapter 4: Simulated Women in Television and Films, 1940s and After

1 In the stage version, she is first put on display in an art museum and later stolen.
2 The kitchen is filled with automated machines that ostensibly liberate women (even though as Ruth Schwartz Cowen memorably demonstrated in her seminal study *More Work for Mother*, the machines increased expectations about cleanliness, which actually added to women's labors). Ruth Schwartz Cowan, *More Work for Mother: The Ironies of Household Technology from the Open Hearth to the Microwave* (New York: Basic Books, 1985).
3 Soon after Chatty Cathy, Mattel also introduced its "Charmin Chatty" doll, which had even more to say. Buyers could purchase five different playable records, giving the doll more than one hundred phrases, including "silence is golden," a paradoxical proverb for a talkative doll.
4 The doll came in Caucasian versions with blond and brown hair, and there were also two African American versions, including one introduced in 1962 and later a

black Charmin Cathy. Sean Kettelkamp, *Chatty Cathy and Her Talking Friends: An Unauthorized Guide for Collectors* (Atglen, PA: Schiffer, 1998), 6, 18, 29, 53, 61. In 1970 Mattel revised the doll and its new voice was that of Maureen McCormick. See also Sharon Scott, *Toys and American Culture: An Encyclopedia* (Santa Barbara, CA: Greenwood, 2010), 60, which cites Kettelkamp and works by Judith Izen.

5 Langdon Winner, *Autonomous Technology: Technics-Out-of-Control as a Theme in Political Thought* (Cambridge, MA: MIT Press, 1977), 106.

6 Carol J. Clover, "Her Body, Himself: Gender and the Slasher Film," *Representations*, no. 20 (Autumn 1987): 187–228. Reprinted in *The Dread of Difference: Gender and the Horror Film*, ed. Barry Keith Grant (Austin: University of Texas Press, 1996), see esp. 71.

7 Lynn Spigel, "From Domestic Space to Outer Space: The 1960s Fantastic Family Sit Com," in *Close Encounters: Film, Feminism, and Science Fiction*, ed. Constance Penley et al. (Minneapolis: University of Minnesota Press, 1991), 213, 216, 219–220.

8 See Karal Ann Marling, *As Seen on TV: The Visual Culture of Everyday Life in the 1950s* (Cambridge, MA: Harvard University Press, 1994), and Gillian Horvat, "My Living Doll: Androids and the Social Construction of Femininity," online paper by Professor Denise Mann, March 7, 2010. Horvat argues that television shows like *Bewitched* and *I Dream of Jeannie* wanted to attract an audience of female consumers and therefore had a vested interest in maintaining traditional gender roles—"gorgeous acquiescent females" who reasserted their position as consumers (2).

9 In his satirical 1965 essay, "Why I Wouldn't Have Done It This Way," Isaac Asimov wrote a mock critique of Rhoda as a "poor robot, badly designed to simulate a large woman of spectacular physique." Her woman's shape wouldn't provide enough room for all of the engineering equipment, he argued, and her controls should have been right below her belly button so they wouldn't accidentally be turned on and off. Originally published in *TV Guide*, January 16, 1965, and later retitled "How Not to Build a Robot" in Issac Asimov, *Is Anyone There?* (New York: Doubleday, 1967).

10 In another 1964 episode, "Rhoda's First Date," he gets similarly anxious after he orders new clothes for her (including stockings, dress, and a girdle) and tells her how to put them on, and then she starts taking off her wrap.

11 Jeffrey L. Meikle, *American Plastic: A Cultural History* (New Brunswick, NJ: Rutgers University Press, 1995), 177, 189–190, 259. Meikle writes that "polyethylene changed the way that people thought about plastic" because of its "resilient flexibility without sacrificing durability" (189).

12 Ibid., 259, 261, note 55; Charles A. Reich, *The Greening of America* (New York: Random House, 1970), 372. Even earlier, there was ambivalence as nineteenth-century critics fretted about new technologies like electroplated silver and decorative cast iron producing second-rate imitations, even as Americans and Europeans were happily embracing the new simulations that made silverware, decorative railings, and building facades more affordable. Julie Wosk, *Breaking Frame: Technology and the Visual Arts in the Nineteenth Century* (New Brunswick, NJ: Rutgers University Press, 1992); rpt. with new title and new intro., *Breaking Frame: Technology, Art, and Design in the Nineteenth Century* (New York: Authors Guild backinprint.com, edition, 2013).

13 Sabine Hake, *Passions and Deceptions: The Early Films of Ernest Lubitsch* (Princeton, NJ: Princeton University Press, 1992), 82.

14 In cultural representations, female simulacra—like imitations in art—have often been touted as superior to the real thing. In a sitcom, which both embraces and comically satirizes gender stereotypes, Rhoda in *My Living Doll* is presented as superior to many real women. See the "I'll Leave It to You" episode and the carping wives in the "Something Borrowed" episode where Rhoda accidentally gets engaged to Mr. Armbruster,

a man who has had a string of irritating wives: his first wife was not good at listening, and Thelma, his second wife, had a fiery temper and was mercenary.

15 The episode also takes a broader comic swipe at a familiar gender stereotype, the female shopper (later spoofed by American artist Barbara Kruger in her 1987 photo-collage *Untitled [I Shop, Therefore I Am]*). As a strategy for discovering what his sister wants for her birthday, McDonald in *My Living Doll* asks her to flip through pages of a woman's magazine to see her response to possible gifts, and she enthuses over a cashmere sweater and jewelry, saying she's engaging "in a basic feminine trait—greed!" She clearly wants something feminine and turns up her nose at a very masculine four-wheel drive vehicle. After Rhoda, the kleptomaniac, takes money from the pocket of the store detective, he tells her, "You may be a robot, but you're acting like a wife."

16 Julia Shawell, "Life, Love, and Lipstick," *The Woman Today* (Chicago) (May 1935). The magazine's cover features an illustration of a woman equestrian holding out her powder compact, and the magazine is filled with stories about applying cosmetics and the elegant fashions worn by movie stars and the moneyed.

17 Joan Riviere, "Womanliness as a Masquerade" (1929) in *Formations of Fantasy*, ed. Victor Burgin, James Donald, and Cora Kaplan (New York and London: Methuen, 1986); Mary Ann Doane, *Femmes Fatales: Feminism, Film Theory, Psychoanalysis* (London: Routledge, 1991); Catherine Constable, "Making Up the Truth: On Lies, Lipstick, and Friedrich Nietzsche," in *Fashion Cultures: Theories, Explorations, and Analysis*, ed. Stella Bruzzi and Pamela Church Gibson (London and New York: Routledge, 2000), 191–200.

18 The unmasking of a female with camouflaged identity reappeared years later in Jonathan Glazer's 2013 film *Under the Skin* when the femme fatale extraterrestrial (played Scarlett Johansson) who has become increasingly vulnerable is brutally attacked and ripped open, exposing her stark black head and body underneath her beautiful, synthetic exterior. In this unsettling film, at the end she holds her own severed artificial head (with its blinking eyes) in her hands as she looks at her own faux identity.

19 In the third episode of "Kill Oscar," now once again part of the *Bionic Woman* series, Franklin and his maniacal plan are ultimately defeated, and the generous OSI members keep him alive. Franklin, who earlier made snide comments about a woman with a mind of her own, now congratulates her.

20 *Battlestar Galactica* began as a series in 1978, returned in 1980, reemerged as a three-part mini-series in 2003, and returned periodically through 2013. There were several copies of Number 6 with differing personalities, and Helfer played these roles in 2003 and in the 2009 television film *Battlestar Galactica—the Plan*.

21 Ray Bradbury, "I Sing the Body Electric!" in *I Sing the Body Electric! Stories by Ray Bradbury* (New York: Knopf, 1969). All page numbers refer to this edition. The story, originally titled "The Beautiful One Is Here," was published in *McCall's* (August 1969).

22 Three years later came Hollywood's hugely successful film tribute to female ingenuity and street smarts, *Working Girl* (1988).

23 During the film's opening credits, there are animations of robots mass-producing sculptural mannequins that get taken away.

24 Ruth La Ferla, "Perfect Model: Gorgeous, No Complaints, Made of Pixels," *New York Times*, May 6, 2001, Section 9, 6.

25 See Susan J. Napier, *Anime from Akira to Howl's Moving Castle: Experiencing Contemporary Japanese Animation* (New York: Palgrave Macmillan, 2005), 65, 108, 112. *Chobits*, a manga by the all-female Japanese artists group Clamp, became a television anime series in 2002 and featured a familiar type of anime female: the "cute girl"

character Chi, a humanoid computer that is childlike but amusingly teachable by a young man. She is initially without clothes and an innocent, yet her on-off switch is located near her genitals.

26 Perhaps, as Steven Brown writes, the director Oshii suggests that the young girls themselves are complicit rather than innocent: they also embraced cultural constructions of beauty that transformed them into nonhuman, artificial-looking dolls. Stephen Brown, "Machinic Desires: Bellmer's Dolls and the Technological Uncanny in *Ghost in the Shell 2: Innocence*," in *Mechademia 3: Limits of the Human*, ed. Frenchy Lunning (Minneapolis: University of Minnesota Press, 2008), 244.

27 Brown, "Machinic Desires," 230, 234.

28 Masahiro Mori, "*Bukimi no tani* [The Uncanny Valley]," originally published in Japanese in *Energy* 7, no. 4 (1970): 33–35. English translation by Karl F. MacDorman and Norri Kageki, *IEEE Robotics and Automation Magazine* 19, no. 2 (June 2012): 98–100.

29 As another form of the helpful, electronic, disembodied female voice, in 2011, Apple introduced Siri, its iPhone female personal assistant, and in 2014, Windows introduced its own personal assistant Cortana for use on Windows phones. Cortana was named after the highly intelligent, skilled, and sexily naked holographic female AI character in the Halo video game series.

30 Jonze in a *New York Times* story is quoted as saying about Watts in connection with *Her*, "Alan Watts talks about it. Everything's in a constant state of change, and to try to be the same as the way you were the day before is painful." Logan Hill, "A Prankster and His Films Mature," *New York Times*, Movies section, November 1, 2013.

Chapter 5: Engineering the Perfect Woman

1 Auguste Villiers de l'Isle-Adam, *L'Ève future*, trans. Robert Martin Adams, *Tomorrow's Eve* (1982; Champaign: University of Illinois Press, 2001), 68.
2 Ibid., 81.
3 Ibid., 64.
4 Mary R. Melendy, *The Perfect Woman/Perfect Womanhood for Maidens-Wives-Mothers* (1901; K. T. Roland, 1903), 28.
5 Ibid., 28, 52.
6 Ibid., 27
7 Ibid., 28.
8 Carol Marvin has also cited romantic poetry in nineteenth-century electrical journals which metaphorically identified women with technological objects and called women, "telephones." Marvin, *When Old Technologies Were New: Thinking About Electric Communication in the Late Nineteenth Century* (New York and London: Oxford University Press, 1988), 30.

Chapter 6: Dancing with Robots and Women in Robotics Design

1 Hannah Dela Cruz Abrams, *The Man Who Danced with Dolls* (Westborough, MA: Madras Press), 2012.
2 With underbody sensors, the robot—lacking legs and matching only the movements of the upper body—could follow the male dancer's lead and predict which way he would move through his hand pressure on its back. In the following years, Professor Kosuge and his group introduced a male dance partner as well.
3 For manufacturers of realistic, robotic sex dolls, of course, the gendered nature of the dolls was unequivocal.

4 Karl F. MacDorman and Hiroshi Ishiguro, 2005 essay, cited in "The Uncanny Advantage of Using Androids in Social and Cognitive Science Research," *Interaction Studies* 7, no. 3 (2006): 314–315. In the decades ahead, male roboticists continued to work on developing lifelike female robots. In 2006, the young female robot EveR-1 was developed by the Korean Institute of Industrial Technology based at the Korean University of Science and Technology (KITECH). The robot made use of speech recognition and voice synthesis software, and its entire body was covered with artificial skin. A later model, EveR-3, introduced in 2009, had wheels for locomotion, and EveR-4, introduced in 2012 in Korea, had an artificial tongue and legs but could not walk and was envisioned for work in theme parks or as a receptionist. In 2014, Hiroshi Ishiguro introduced female androids named Kodomoroid and Otonaroid at a Tokyo exhibit. Kodomodroid acted as a newscaster, and when she flubbed her lines, she said, "I'm a bit nervous."
5 MacDorman and Ishiguro, "The Uncanny Advantage," 315.
6 Yuri Kageyama, "Robots Dance, Play at World Expo." Reprinted in usatoday30.usatoday.com/tech/news/robotics/2005-06-09-robot-expo_x.htm, accessed August 5, 2011.
7 Masahiro Mori, "The Uncanny Valley," originally published in Japanese in *Energy* 7, no. 4 (1970): 33–35. English translation by Karl F. MacDorman and Norri Kageki, 2012.
8 Mori argued that rather than developing and using realistic robots, it was better to keep robots artificial looking, made of metal or synthetic material, to avoid the feeling of the uncanny valley—the feeling of alienation and distancing. Later studies suggested that the elderly fare better with mechanical rather than humanoid-looking robots because there is little danger of confusion.
9 Mark Seltzer, *Serial Killers: Death and Life in America's Wound Culture* (New York and London: Routledge, 1998), 271, cited in Caroline Evans, *Fashion at the Edge: Spectacle, Modernity, and Deathliness* (New Haven and London: Yale University Press, 2003), 175.
10 MacDorman and Ishiguro, "The Uncanny Advantage," 297.
11 Ibid., 298–299, 301, 303, 314. In 2009, Christoph Bartneck, working with others including Ishiguro, again argued in favor of developing highly realistic androids and cited weakness in the hypothesis that "a highly realistic robot is like less than a real human." Christoph Bartneck, T. Kanda, H. Ishiguro, et al., "My Robotic Doppelgänger: A Critical Look at the Uncanny Valley," *Proceedings of the 18th IEEE International Symposium on Robot and Human Interactive Communication ROMAN 2009* (Toyama, 2009): 269–276. For their study, they looked at Hiroshi Ishiguro and his robotic copy of himself, Gemanoid H11. MacDorman's work is discussed in "Too Scary to Be Real, Research Looks to Quantify Eeriness in Virtual Characters," IU News Room, Bloomington, Indiana University, September 21, 2009. http://newsinfo.iu.edu/news/page/normal/11945.html
12 MacDorman, "Too Scary to Be Real."
13 The participants consisted of forty-five Indonesians (thirty-seven male and eight female) aged seventeen to sixty, though the majority were in the younger range. The participants were given questionnaires and asked to rate thirty-one images in random order on a nine-point scale of human likeness—very mechanical to very human, very strange to very familiar. The experimenters noted that the morphed images that were rated as uncanny were static, even though Mori had observed that movements increase the effect of the uncanny valley (MacDorman and Ishiguro, "The Uncanny Advantage," 301–305, 308).

14 Ibid., 310–311.
15 Ibid. MacDorman developed an "eeriness index" in which he discovered that large eyes, for example, can have a negative effect when applied to a human model. Caricatures such as distorting facial proportions like eye separation and face height could also have a negative impact. MacDorman, "Too Scary to Be Real." MacDorman and Ishiguro cited a number of physiological and sociological studies on perceptions of female beauty, including M. R. Cunningham, et al., "Their Ideas of Beauty Are, on the Whole, the Same as Ours: Consistency and Variability in the Cross-Cultural Perception of Female Attractiveness," *Journal of Personality and Social Psychology* 68 (1995): 261–279; V. S. Johnston and M. Franklin, "Is Beauty in the Eyes of the Beholder?" *Ethnology and Sociobiology* 4 (1993): 183–199; N. Kanwisher, J. McDermott, and M. M. Chun, "The Fusiform Face Area: A Module in Human Extrastriate Cortex Specialized for Face Perception," *Journal of Neuroscience* 17 (1997): 4302–4311.
16 "BeautyCULTure," Annenberg Space for Photography, Los Angeles, May 21–November 27, 2011. Greenfield's acclaimed documentary film *Girl Culture* looked at pressures that young women felt to fulfill these ideals, and one of her documentaries was also featured in the Annenberg exhibit.
17 Minsoo Kang, *Sublime Dreams of Living Machines: The Automaton in the European Imagination* (Cambridge, MA: Harvard University Press, 2011), 318n79.
18 One researcher at MIT's Personal Robots Lab, in an interview with the author in 2013, reported, anecdotally, that men were less apt to notice deviations from norms of human behavior such as the way a robot's head moved or intensity of gaze.
19 Paul Schermerhorn, Matthias Scheutz, and Charles R. Crowell, "Robot Social Presence and Gender: Do Females View Robots Differently Than Males?" Proceedings of the 3rd ACM/IEEE International Conference of Human Robot Interaction, Amsterdam, The Netherlands, *ACM* (2008): 263–270.
20 Mikey Siegel, Cynthia Breazeal, and Michael I. Norton, "Persuasive Robotics: The Influence of Robot Gender on Human Behavior." *Intelligent Robotics and Systems*, 2009 IROS 2009, IEEE/RSJ International Conference on Intelligent Robots and Systems, St. Louis, MO (October 10–15, 2009): 2563–2568.
21 Carla Diana, "How Women Are Leading the Effort to Make Robots More Humane," *Fast Company Design*, December 15, 2011, http://www.fastcodesign.com/1665597/how-women-are-leading-the-effort-to-make-robots-more-humane, accessed August 7, 2013.
22 *The Media Lab: Center for Future Storytelling*, http://cfs.media.mit.edu/people.html (August 14, 2013).
23 Marsha Walton, in "Engineer Says Robotics Can Use a Woman's Touch" (*WeNews*, March 17, 2010) wrote a report about Robin Murphy, a pioneer in rescue robotics and professor of computer science and engineering at Texas A&M University, who described robots for rescues in hurricanes, mining accidents, terrorist attacks, and disarming bombs and mines. She encouraged other women to join her in research because the field "could benefit from female-influenced research styles."
24 Andrea Thomaz, written comments to the author, July 10, 2014.
25 Jennifer Robertson, "Gendering Humanoid Robots: Robo-Sexism in Japan," *Body & Society* 16, no. 2 (2010): 28, 24.
26 Friederike Eyssel and Frank Hegel, "(S)he's Got the Look: Gender Stereotyping of Robots," *Journal of Applied Social Psychology* 42, no. 9 (2012): 2213–2230.
27 The robot's movements were created using an algorithm based on motion capture of the movements of human females, and the model's dimensions were 158 cm tall with a

weight of forty-three kilos—about ten kilos lighter than the average Japanese woman. Robertson, "Gendering Humanoid Robots," 27.
28. Choe Sang-Hun, "In South Korea Plastic Surgery Comes Out of the Closet," *New York Times,* Asia Pacific Section, November 3, 2011.
29. Abby Ellin, "That Nose, That Chin, Those Legs: With Plastic Surgery, a Makeover to Look Like a Celebrity," *New York Times,* Fashion & Style section, January 15, 2014.
30. http://www.truecompanion.com/about.html, accessed August 7, 2013.
31. While male roboticists were developing interactive female robots, toy manufacturers continued to develop interactive children's dolls that had heightened abilities to speak. Decades after the Chatty Cathy dolls, in 2005 the Hong Kong manufacturer Playmates Toys introduced its eighteen-inch-tall blond and blue-eyed interactive doll Amazing Amanda, which had speech recognition software, memory chips, radio frequency tags, and scanners so that the doll could speak and appear to listen.
32. The conversations could also be upgraded from a home PC. Susan Karlin, "Red Hot Robots—Roxxxy and Rocky, the World's First Sex Robots, Are Ready to Leave the Lab," *IEEE Spectrum* (June 2010), http://spectrum.ieee.org/robotics/humanoids/redhot-robots, Accessed Feb. 10, 2014.
33. Ibid.; Brandon Griggs, "Inventor Unveils $7000 Talking Sex Robot," cnn.com (February 1, 2010), http://www.cnn.com/2010/TECH/02/01/sex.robot/, accessed October 5, 2014.
34. See Carol Colatrella, "Feminist Narratives of Science and Technology: Artificial Life and True Love in *Eve of Destruction* and *Making Mr. Right,*" in *Women, Gender, and Technology,* ed. Mary Frank Fox et al. (Urbana: University of Illinois Press, 2006), 167–168, 170.

Chapter 7: The Woman Artist as Pygmalion

1. Donna J. Haraway, "A Cyborg Manifesto: Science, Technology and Socialist-Feminism in The Late Twentieth Century," in *Simians, Cyborgs, and Women: The Reinvention of Nature* (New York: Routledge, 1991), 149–181.
2. In the 1990s, writers including N. Katherine Hayles examined the disembodied, posthuman realm of cyberspace and argued that cyberfeminism would bring embodiment to what was perceived of as the disembodied digital realm of cyberspace. N. Katherine Hayles, *How We Became Posthuman: Virtual Bodies in Cybernetics, Literature, and Informatics* (Chicago: University of Chicago Press, 1999). Writing in *Domain Errors!* (2002), the collective group of women artists subRosa which emerged in the 1990s described themselves as engaged in "politically active contestational cyberfeminism" and saw their role as one in which they would "scrutinize, publicize, and contest the complex effects of technology" on women's lives. Katherine Hayles, Maria Fernandez, Faith Wilding, and Michelle M. Wright, *Domain Errors!: Cyberfeminist Practices* (Brooklyn: Autonomedia, 2002), 10, 25.
3. http:// www.lindadement.com/cyberflesh-girlmonster.htm, accessed October 18, 2014.
4. "An Interview with Sadie Plant and Linda Dement," interviewed by "Miss M" at the occasion of Virtue Futures 96 Datableed, event at Winchester University, Coventry, England, May 3–5, 1996.
5. Ibid.
6. Barbara Creed, commenting on Julia Kristeva's *The Powers of Horror* (1982) in "Horror and the Monstrous-Feminine: An Imaginary Abjection," *Screen* 27, no. 1 (1986): 46,

included in Creed's *The Monstrous-Feminine: Film, Feminism, and Psychoanalysis* (London and New York: Routledge, 1993), 9.
7 "An Interview with Sadie Plant and Linda Dement."
8 Linda Dement's website http://www.lindadement.com/about-dement.htm, accessed October 3, 2014.
9 Julie Wosk, television interview about the exhibit *Alina Szapocznikow Sculpture Undone 1955–1972* at the Museum of Modern Art, New York, for the Polish Public Broadcasting channel TVP Kultura (Telewizja Polska), July 10, 2012.
10 Butler also cites the Surrealist "trope of scrambling the body's hierarchy," which would have been familiar to Szapocznikow living in Paris, and also the artist's preoccupation with fragmentation during her years when she had cancer. Butler suggests that the artist "was never intended to be associated with political feminism or feminist content as it was understood in Eastern Europe." Cornelia Butler, "Soft Body, Soft Sculpture: The Gendered Surrealism of Alina Szapocznikow," in Elena Filipovic and Joanna Mytkowska, [with] Cornelia Butler, Jola Gola, Allegra Pesenti, *Alina Szapocznikow: Sculpture Undone 1955–1972* (New York: The Museum of Modern Art and Brussels: Mercater fonds, 2011), 37–38.
11 Elizabeth Young, "Here Comes the Bride: Wedding, Gender, and Race in *Bride of Frankenstein*," in *The Dread of Difference: Gender and the Horror Film*, ed. Barry Keith Grant (Austin: University of Texas Press, 1996), 309–337. The essay originally appeared in *Feminist Studies* 17, no. 3 (Fall 1991): 403–437.
12 See discussion of Formanek-Brunell in chapter 2.
13 Regine, "Interview with Heidi Kumao," May 25, 2008, http://we-make-money-not-art.com/archives/rft/, accessed June 16, 2012; Heidi Kumao's website http://www.heidikumao.net, accessed October 4, 2008.
14 Alexis Okeowo, "A Once-Unthinkable Choice for Amputees," *New York Times*, May 15, 2012, section *Science Times*, D1:1, 4.
15 Photographed by Sølve Sundsbø in *Alexander McQueen: Savage Beauty* [catalogue for the 2011 Metropolitan Museum of Art exhibit] (New York: Metropolitan Museum of Art, 2011), 221. The carved leg is pictured on 223.
16 Quoted from *Numéro* (July/August 2002) in *Alexander McQueen*, 77.
17 *Alexander McQueen*, 221.
18 Douglas Crimp and Paula M. Lee have suggested that Jonas used feedback signals, video technology, and mirrors as meditations on the distortions produced by technological reproduction of the female body—the types of distortions created by the media culture and used not to create a coherent image of the body but, as Pamela Lee wrote, for "disarticulating the body." Douglas Crimp, "De-Synchronization in Joan Jonas's Performances," in *Joan Jonas: Scripts and Descriptions 1968–1982*, ed. Douglas Crimp (Berkeley: University Art Museum, University of California, 1983), 8–10; Pamela M. Lee, "Bare Lives," in *Art and the Moving Image: A Critical Reader*, ed. Tanya Leighton and Charles Esche (London: Tate Publishing Co., 2008), 154.
19 Joan Jonas, "*Organic Honey's Visual Telepathy*" (1972 directing script) in *The Drama Review TDR* 16, no. 2 (1972): 66–74, 66.
20 Ibid., 68. Jonas's video *Left Side, Right Side*, produced the same year, investigated two different types of reproduction: the face reflected in mirror is seen in reverse, and the face mirrored in a video monitor is reproduced without reversal. Jonas in her *Organic Honey's Visual Telepathy* script commented that she was interested in the piece's "self-reflective loop through which I regarded myself."
21 Joan Jonas, conversation recorded at the Museum of Modern Art, 1981.
22 Jonas, *Organic Honey's Visual Telepathy*, script, 70.

23 Barbara Rose, "Orlan and the Transgressive Act," review of the exhibit *Orlan: Is It Art?*, *Art in America* 81, no. 2 (February 1993): 83–125.
24 For a discussion of her work and her art historical references, see C. Jill O'Bryan, *Carnal Art: Orlan's Refacing* (Minneapolis: University of Minnesota Press, 2005), 15. Pursuing her own identity explorations, Orlan in photographs later transformed her face to look like pre-Columbian, African American, and Native American women.
25 Laura Mulvey, "A Phantasmagoria of the Female Body: The Works of Cindy Sherman," *New Left Review* 1, no. 188 (July-August 1991) 141
26 Eva Respini, "Will the Real Cindy Sherman Please Stand Up?," in Eva Respini, *Cindy Sherman* (exhibit catalogue, New York: Museum of Modern Art, 2012), 32; Sherman, *The Complete Untitled Film Stills* (New York: Museum of Modern Art, 2003), 9.
27 Respini, "Will the Real Cindy Sherman," 46–47,
28 Peter Schjeldahl, "Faces: A Cindy Sherman Retrospective," *The New Yorker* (March 5, 2012), 84.
29 Respini, "Will the Real Cindy Sherman, Please Stand Up," 46–47, referencing Sherman's comments in David Hershkovits, "In Your Face?" *Paper* (November 2008), 54.
30 Kathy Peiss, *Hope in a Jar: The Making of America's Beauty Culture* (New York, Henry Holt, 1998), 26, 28.
31 Ibid., 28–29.
32 Sherman interview with Therese Lichtenstein, *Journal of Contemporary Art,* http://www.jca-online.com/sherman.html, accessed October 31, 2014. Sherman says she wanted to convey the "repulsive" and used dark brown phallic-like sausages for the look of excrement in the photo. The gaping vagina was a foam body part she bought in the mail, and she later realized it must have been intended for "practice pulling a baby out of it. It seemed so stupid."
33 Allison Holland, "Mori Mariko and the Art of Global Connectedness," *Intersections: Gender and Sexuality in Asia and the Pacific,* no. 23 (November 2009), http://intersections.anu.edu.au/issue23/holland.htm, accessed October 29, 2014.
34 Laurie Simmons, "In and Around the House," in Laurie Simmons, *In and Around the House: Photographs, 1976–1978,* texts by Carol Squiers and Laurie Simmons (New York: Carolina Nitsch Editions; Ostfildern, Germany: Hatje Cantz, 2003), 19–23.
35 Caroline Evans, *Fashion at the Edge: Spectacle, Modernity, and Deathliness* (New Haven and London: Yale University Press, 2003), 165, 172.
36 Ibid., 166, 171–172, 175; Annette Kuhn, *The Power of the Image: Essays on Representation and Sexuality* (London and Boston: Routledge & Kegan Paul, 1985), 13.

Index

Abrams, Hannah Dela Cruz, 152
Adam, Adolphe, 64
Adler, Robert, 143
advertising: encouragement of artificiality in, 1, 2; and Picabia, 197n33
AF709 (robot), 105
"The After Hours" (*Twilight Zone* episode), 30, 96, 97, 117–118
Alexander McQueen: Savage Beauty (exhibit), 173
All Is Full of Love (music video, 1999), 164
Amazing Amanda (doll), 203n31
American Plastic (Meikle), 107, 198n11
Andrews, Julie, 93, 189n35
"The Android Machine" (*Lost in Space* episode), 110, 111, 112
androids: ambivalence over realistic look of, 155; in *Blade Runner*, 118–121; control of, 156; development/production of, 154–158, 201n11; as embodiment of a central cultural preoccupation, 96; Fembots, 115; gender stereotypes and, 96, 104, 110; highly realistic looking, 201n11; Japanese, 133, 134, 154; in *Lost in Space*, 110, 111, 112, 113; male vs. female reactions to discovery of synthetic nature of androids, 157, 158; men's fantasies and, 113; in *Metropolis*, 71, 72; with moral sense, 102, 110, 112; new sense of female power and, 104; popularity in television, 96, 102, 104; reflecting changes in technology and attitudes toward women, 96; as "replicants," 118, 154; representations of, 131; satirization of women's roles by, 113; signs of social change and, 96; in *Star Trek*, 113–114; stereotypically feminized, 110; suggestion of superiority of over humans, 156; superiority to mechanical-looking robots, 156; as transitional figures, 104; unaware that they are simulacra, 113; uncanny in deviation from norms of beauty, 157; women's movement and, 96, 102. *See also* robots
An Animated Doll (film, 1908), 194n8
anime, 133, 134, 180, 199n25
Arden, Eve, 92
Arp, Jean, 86
artificiality: allure of, 1; cautionary tale of, 18–23; encouraged by advertising, 1; in social construction of female identity, 8; superiority to reality of, 5
artists, female: assembly of artificial females by, 166; Burson, Nancy, 182, 183, 184; defining female identity, 166; Dement, Linda, 166, 168; Höch, Hannah, 171; Jonas, Joan, 174, 179; Kumao, Heidi, 171, 172; Leeson, Lynn Hershman, 181; mannequins/masks and, 173–176; Mori, Mariko, 180–181, 184; Orlan, 175, 176; as Pygmalion, 166–185; Sherman, Cindy, 176–180, 184;

artists, female (*continued*)
 Simmons, Laurie, 181; using tools of technology to fashion female simulacra, 166–185
Asimov, Isaac, 198n9
The Atlantic Monthly (magazine), 38
Audran, Edmond, 64
Austin Powers: International Man of Mystery (film, 1997), 131
automaton makers and manufacturers: Jaquet-Droz, 35, 154, 190n7, 191n10; Lambert, 38, 46, 48; Maillardet, 191n10; Phalibois, 31, 32, 38; Renou, 41, 42; Roullet & Descamps, 38, 39, 44, 46, 47, 49, 192n22, 192n27, 192n35; Vaucanson, 35; Vichy, 38, 39, 44, 46, 49
automatons, 21; ancient, 34; "Bicyclist Coquette," 44, 45; "Chenoise Verseuse," 46, 48; clock tower, 191n19; clockwork mechanisms in, 7, 18, 25, 31, 35, 36, 38, 49, 52, 190n8, 192n22; considered technically/morally superior to real women, 19, 156; dancers/snake charmers, 46, 47; depicting women doing mechanical work, 43; displays of fickleness from, 22; in domestic roles, 39; early cinema as direct descendent of, 194n9; emergence as central emblem of mechanistic worldview, 190n6; engagement in conversation, 18; European exhibits of, 35; exotic, 44–49; fashionable clothing, 32, 33, 117, 140; "The Flower Vendor," 46; focus on naturalistic movement, 38, 39; "Gavrochinette," 31, 32, 32, 33, 53; "Harpist Mauresque," 46; hidden mechanisms, 35, 36; industrialized manufacture, 7, 38; Japanese, 46, 193n36; Jaquet-Droz, 35, 154, 190n7, 190–191n8; Karakuri Ningyo, 46; "La Charmante Catin," 36, 36; lacking devotion to domesticity, 140; "Lady Beatrice," 68; Lady Musician (Jaquet-Droz), 35, 154, 190–191n8; "La magicienne," 49, 193n37; long history of in Japan, 46; "Mademoiselle Catherina," 36, 36, 38, 49; mechanical, 31–54; mechanical parts for, 190n8; "Mechanical Sewing Machine Girl," 43, 44; Méliès and, 194n9; men falling in love with, 22, 23; men's need for control of, 100–101, 113, 114; mirroring men's conceptions of real women, 20; "Mother Shipton," 39, 40; musical, 35, 36, 49, 191n9, 191n10; "Musical Lady," 191n10; non-threatening aspect of, 20; popularity of, 190n6; portrayal of during times of social transition, 39; in postwar television programming, 95–102; proto-robotic figures, 190n2; ramifications of creating duplicate of real woman, 69–75; repair, 194n9; "The Rights of Women," 41, 42, 192n27; Roxlane, 191n10; as servants, 34; shaped by female stereotypes, 39; simulated by real women, 63–69; singing/whistling, 31; touted as superior to real women, 198n14; walking/talking, 34, 35, 36, 38, 49–54, 193n40; "Zulma the Snake Charmer," 46, 47. *See also* women (artificial)
Autonomous Technology (Winner), 101
Autoperipateikos (doll), 50–51

The Bad Seed (film, 1956), 102
Bag Lady (Wosk, photograph), plate I
Balanchine, George, 81
Ball, Hugo, 80
Ballets Russes, 81, 82
Barbera, Joseph, 103
Barbie (doll), 99, 113–114, 128
Bartneck, Christopher, 201n11
Battaini, Antoine, 191n19
Battlestar Galactica (television series), 121, 199n20
Bauhaus dolls, 196n26
Bayer, Josef, 81
The Beautiful Girl (Höch), 87, 88
"The Beautiful One Is Here" (Bradbury), 123
beauty: androids and deviations from norms of, 157; Beauty CULTure, 202n16; cosmetic surgery and, 175; cultural constructions of, 200n26; cultural ideals of, 157; struggles with impossible standards, 178
Bébé Parlant Automatique (doll), 52, 99
Bébé Phonographe (doll), 99
Bellmer, Hans, 18, 81–86, 135, 170, 196n29, 200n25
Bergson, Henri, 26, 58
Bewitched (television series), 103, 105, 198n8
bicycling, 43, 44
"Bicyclist Coquette" (automaton), 44, 45
The Bionic Woman (television series), 114; "Kill Oscar" episode, 114, 115, 116
Birth of a Star (Mori), 180, plate XII

Bisset, Jacqueline, 132
Bizzarie di Varie Figure (Braccelli), 6
Björk, 164
Blade Runner (film, 1982), 118–121, 133, 150, 154, 156
Bloodrayne (video game), 131
The Blue Angel (*Der blaue Engel*) (film, 1930), 75–80; appropriating look of exaggerated femininity, 77–80; pathos in, 78, 79; theme of the uncanny, 75
The Book of Knowledge of Ingenious Mechanical Devices (al-Jazari), 34
Bouchardon, Edmé, 36, 191n12
boundaries: between artificial and authentic, 55, 118, 134, 167; blurring of, 96, 97, 167; cultural, 189n25; of the uncanny, 121
"Boy Meets Girl" (*My Living Doll* episode), 105, 106
Braccelli, Giovanni Battista, 5, 6
Bradbury, Ray, 120, 121–125
Breaking Frame: Technology and the Visual Arts in the Nineteenth Century (Wosk), 5
Breazeal, Cynthia, 158, 159, plate X
Brecht, Bertholt, 158
Bride of Frankenstein (film, 1935), 8, 15, 73–75, 128, 167, 176; angst caused by Bride, 73, 75; mad scientist role in, 71; ramifications of creating duplicate of real woman, 73–75; use of electricity in, 5; use of lightning, 11
Brissette, Tiffany, 125
Broderick, Matthew, 145
Bryn Mawr Summer School for Women Workers in Industry, 87, 89
Burne-Jones, Edward, 11, 187n8
Burson, Nancy, 132, 182, 183, 184
Butler, Cornelia, 169, 204n10

Cattrall, Kim, 130–131
Chaplin, Charlie, 87–88
Charmer (music video, 2012), 164, 165
Charmin' Chatty (doll), 99, 100, 197n3
Chatty Cathy (doll), 99, 100, 197n3
"Chenoise Verseuse" (automaton), 46, 48
Cherry 2000 (film, 1987): final preference for real woman in, 146, 147, 163
Chobits (manga and anime), 199–200n25
Cinderella (doll), 99
Clarkson, Patricia, 148
The Clockmaker's Dream (film, 1908), 194n8

clockwork figures (female), 191n19, 192n22, 194n8
Close, Glenn, 143
Cochin, Charles-Nicholas, 36
Cochin, Louise-Madeleine, 36
computers: artificial women fabricated by, 128, 156; and cyberspace, 167; digital technologies and artists, 167; early growth and development, 114; online virtual relationships, 135; operating system as virtual lover in *Her*, 135; personal, 117; speech software, 163
Congrès Féministe International (1896), 41
Congress for the Rights of Women (1900), 41
Cooper, Jack, 68
Coppélia (ballet, 1870), 7, 58–63, 194n7
Coppélia the Animated Doll (film, 1900), 63
Cortana, 200n29
cosmetics, 8, 112, 178, 179
Cowen, Ruth Schwartz, 197n2
Creed, Barbara, 168, 203n6
Crimp, Douglas, 204n18
cultural: ambivalence, 108; boundaries, 189n25; identity, 8; imagery, 53; perceptions of women, 5, 168; representations, 198n14; shifts, 168
Cummings, Robert, 105, 106
Curi (robot), 160
cyberfeminism, 167, 203n2
Cyberflesh Girlmonster (Dement), 167, 168
CyberRoberta (Hershman Leeson, electronic installation), 181
"The Cyborg Manifesto" (Haraway), 134
cyborgs, 112, 125, 167, 180
Cypriaca (Philostephanus), 187n1

Dada/Ernst (Höch), 83, 171, 196n31
Damajanti, Nala, 46
Dames en Rouge (Exter), 87
dance: Ballets Russes, 81, 82; *Coppélia* (Delibes), 7, 58–63; experimental, 87, 89; *La Ballet fantasque*, 81; "Machine Dance," 87
dancing with robots, 5, 7, 57, 61, 90, 94, 152, 153, 200n2, plate VIII
Danilova, Alexandra, 81, 82
Das schöne Mädchen (Höch), 87
"Das Unheimliche" (Freud), 56
Daumier, Honoré, 11, 13

Davis, Bette, 132
Delandes, Boudreau, 187n6
Délibes, Leo, 58–63
della Torre, Gianello, 36, 49
del Ray, Lester, 189n36
Dement, Linda, 166, 167, 168; assemblages of disparate parts in work, 166; disembodied parts morphing into new composites, 169; idea of contamination of technology with female messiness, 168; male fear in work of, 168
Der Meister (Höch), 80
Derrida, Jacques, 170
Descartes, René, 134
Designing Sociable Robots (Breazeal), 159
Desk Set (film, 1957), 98
Diaghilev, Serge, 81
Dick, Philip K., 118, 156
Die Puppe (The Doll) (film, 1919), 54, 63–69; humorous outcomes of confusing simulations with reality, 65, 66; sense of agency/control by women, 7; views women's ability to construct own persona, 64; women appropriating look of dolls, 7, 55, 63–69
Dietrich, Marlene, 75–80, 184
Digital Animation Control System (DACS), 142
Digital Content Expo (Japan 2009), 161
digital developments and changing depictions of robots, 128–129
digital technologies and women artists, 167. *See also individual women artists*
digital women (in films), 131–136
Disasters Series (Sherman), 179
dismemberment: fear of, 56; as recurring theme, 65, 133
"Do Androids Dream of Electric Sheep?" (Dick), 118, 156
Doane, Mary Ann, 77, 112, 195n19, 199n17
Dogville (film, 2003), 64
The Doll (film, 1902), 194n8
dollmakers: Gaultier, François, 52; Jumeau, 99; Morrison, 50; Pritze, Lotte, 196n25; Steiner, Jules, 52
dolls: abstracted, 196n26; Amazing Amanda, 203n31; animated, 63; in art and photography, 80–85, 181–185; articulated, 34; Autoperipateikos, 50, 51, 52; in ballet, 7, 58–63, 81, 194n7; Barbie, 99, 113–114, 128; Bauhaus and Dada, 196n26; Bébé Parlant Automatique, 99; Bébé Phonographe, 99; Charmin' Chatty, 99, 100, 197n3; Chatty Cathy, 99, 100, 197n3; Cinderella, 99; cinematic, 166; as cultural constructions of femininity, 80; with demonic side, 100; differing meanings to women and men, 50; disturbing fragmentation into pieces by Bellmer, 83–86; Dora the Explorer, 193n37; as emblems of artifice, 80; erotic, 83, 196n25; as extensions of presentational selves, 80, 81; fashion, 189n24; fashionable clothing for, 32, 33, 117, 140; as female simulacra, 80; in film and television, 7, 54, 55, 61–69, 100–102, 194n8; gendered nature of, 200n3; Greek votives, 189n1; grotesque, 81–86; indestructible, 99–102; Japanese, 46; lack of balance in, 193n41; living, 1, 5, 19, 20, 25, 176; magical, 193n37; malevolent, 198n6; mechanical, 31–54; as offerings to gods, 34; phonographic, 28, 28, 99; photos by Bellmer, 81–86; Rosalba in *Fellini's Casanova*, 37, 38, 62; Roxxxy, 162, 163; sex, 162, 163, 200n3; sexualized, 196n25; shopper, 99; simulated by women, 63–69; singing, 31; socialization through use of, 147–149; stage, 196n26; in *The Tales of Hoffmann* (opera and film), 60–62, 146, 196n29; talking, 99; Talking Barbie, 113; Talking Christine, 113; Talky Tina, 99–102; threats to displace humans, 135; turning from angelic to malevolent, 99, 100, 115, 198n6; walking/talking, 34, 35, 36, 38, 49–54, 99, 140; as women, and women as, 181–185. *See also* automatons; *individual works*
Doolittle, Eliza (fictional character), 23–29; asserts authentic self, 24, 25, 93, 94; as modern-day Galatea, 12; passes as aristocracy, 25, 46; as partial product of technology, 94; as reluctant Galatea, 25; resistance to transformation to gentility, 12; tests era's conceptions of femininity, 29; transformation into artificial woman, 24, 25, 27, 93
Dora the Explorer (doll), 193n37
drama. *See* film and stage
Duchamp, Marcel, 86, 197n33

Edison, Thomas, 14, 28, 63, 99, 139, 140
Egypt, nonmechanical proto-robotic figures in, 190n2

The Electric Grandmother (film, 1982), 121–125
"The Electric Kiss," 146
electronics, 7; compact discs, 117; for data storage, 117; sound recording, 117; use of disembodied female voice in, 200n29; VCRs, 117. *See also* computers
Emshwiller, Edmund, 115, plate VI
Ernst, Max, 86, 196n31
Euphonia (talking machine), 193n38
Evans, Caroline, 155, 182
Eve of Destruction (film, 1991), 163
EveR-1 and EveR-4 (robots), 201n4
Exposition Internationale du Surréalisme (1938), 86
Exquisite Corpse (game), 170
Exter, Alexandra, 87
Extraordinary Illusions (film, 1902), 63

Faber, Joseph, 193n38
fairy tales, 39
fantasies (male), 3, 5, 8, 17, 115, 121, 126; of creating a perfect woman, 5, 7, 8, 9, 17; of constructing a woman from assemblage of parts, 121; erotic, 10; of female robots as unthreatening naïve creatures, 126; of an innocent simulated female, 17, 29, 30; of female robots as unthreatening naïve creatures, 126; of young girls, 50, 67
fears: of being reduced to a mechanism, 135; of castration, 56; of dismemberment, 56, 65; of female sexuality, 73, 168; of loss of control over women, 132, 144; of uses of technology, 100, 101; of whole female bodies, 169; of women, 63, 64, 65, 68
Fellini, Federico, 37
Fellini's Casanova (film, 1976), 37–38, 62, 191n16
fembots, 114, 115, 116, 131
The Feminine Mystique (Friedan), 102, 104
femininity: constructed as mask, 77; cultural construction of, 108, 112; cultural ideals of beauty and, 157; exaggerated, 77, 195n19; flaunting, 77; as masquerade, 112, 195n19; "monstrous," 167; postwar, 112; seductive, 80; social conceptions of, 29, 53; stereotyped, 110
"Fileuse" (automaton), 192n22
Fille née sans mère (Picabia), 86
film: anime, 133, 134, 180, 199n25; computer-generated casts, 131; horror films shaped by male fears and desires, 168; racial encoding in, 195n17; representations of the "monstrous-feminine" in, 168; virtual women in, 131–136. *See also individual titles*
"Film and the Masquerade" (Doane), 77
Final Fantasy: The Spirits Within (film, 2001), 131
First International Congress for Women (1878), 41
"First Robot Supermodel" (robot), 161
"The Flower Vendor" (automaton), 46, plate IV
Fonda, Jane, 132
Foray, Jane, 99
Ford, Harrison, 118
Forlizzi, Jodi, 159
Formanek-Brunell, Miriam, 52, 171
French automatons, 31–49
Francis, Anne, 96, 97
Frankenstein (Shelley), 8, 73, 133, 166
Freud, Sigmund, 7, 56, 64, 78
Friedan, Betty, 102, 104
The Friendly Grey Computer-Star Gauge Model 54 (Kienholz), 104
Fujii, Ayako, 154
Futurist Manifesto (Marinetti), 87

Gagarin, Yuri, 103
Galatea (mythic character), 5, 9, 187n5, 188n10; comic images of, 11; created digitally, 7; delicacy of feeling in, 15; fashioned by women, 149–151; lack of emotions in, 16; mechanical, 31–54; pornographic images of, 11; as reproduction, 15; returns to pedestal, 17, 18; seen as "ideal woman," 17; Victorian conceptions of, 14–18; worshipful images of, 10
Galaxy Science Fiction (magazine), 115, plate VI
Gardner, Ava, 90, 91, 93
Gaultier, François, 52, 191n9
Gavrochinette (automaton), 31, 33, 33, 53
the gaze (male): cinema shaped by, 75; fetishistic, 77; and monstrosity, 195n18; objectification of women through, 75; problematic nature of, 56; as symbolization of male power, 75; voyeuristic, 75; women as doll-like object of, 181
Geminoid F (robot), 154

gender: parodies of conventions of, 14; performance of, 171; robotics and, 158, 159; roles, 141, 198n8; social construction of, 63; socially constructed conceptions of, 5; stereotypes, 7, 8, 14–19, 39, 41, 96, 100, 104, 110, 112, 113, 143, 159, 160, 161, 198n14, 199n15; Victorian and Edwardian playwrights' conceptions of, 14
Gérôme, Jean-Léon, 3, 11, plate II
Ghost in the Shell (film, 1995), 133
Ghost in the Shell 2: Innocence (film, 2004), 133, 134, 135
Gibson, William, 125
Gilbert, W. S., 13, 14–18, 188n10, 188n18; partnership with Sullivan, 14; paternalism of, 14; reinforces Victorian attitudes about women, 14; views on "Woman Question," 14
Girl Born without a Mother (Picabia), 86, 127
Girl Culture (film, 2011), 202n16
Glass, Philip, 175
Glazer, Jonathan, 199n18
Glenn, John Jr., 103
Godhead Fires (Burne-Jones), 187n8
Gosling, Ryan, 147, 148
The Graduate (film, 1967), 107
Grand, Sarah, 41
Grau, Sarah, 131
Greenfield, Lauren, 157
The Greening of America (Roszak), 107, 108
Griffith, Melanie, 130, 147
Gynoids, 134, 160

Hacke, Sabine, 108
Hales, N. Katherine, 203n2
Halo (video game), 200n29
Hanna, William, 103
Hannah, Daryl, 120
Haraway, Donna, 134, 167, 169
Harbou, Thea von, 70
"Harpist Mauresque" (automaton), 46
Harrison, Rex, 93, 94, 189n35
Hartford, Dee, 110, 111
Hayden, Sterling, 142
Hayman, Francis, 191n13
Headshots (Sherman), 176
The Heart Desires (Burne-Jones), 187n8
The Heart Refrains (Burne-Jones), 187n8
Held, Anna, 64

Helfer, Tricia, 121
"Helen O'Loy" (del Ray), 189n36
Helm, Brigitte, 70, 71, 73
Hemus, Ruth, 196n25
Hennings, Emmy, 80, 81
Hepburn, Audrey, 93, 94, 132, 189n35
Hepburn, Katharine, 98
Her (film, 2013), 30, 135, 163, 200n30
Hershman Leeson, Lynn, 181; "Dollie Clone Series," 181
Higgins, Henry (fictional character), 24–29, 46, 93; arrested development of, 24; objectification of Eliza by, 25, 93; takes credit for Eliza's transformation, 26, 27, 94; use of gramophone by, 5, 93, 94
Hiller, Wendy, 25
Hines, Douglas, 162, 163
Hirata, Oriza, 153
Höch, Hannah, 80, 83, 87, 196n31; photocollages of, 8; view of New Woman by, 171
Hoffmann, E.T.A., 6, 22, 56–58, 188n18, 194n4
Holmes, Oliver Wendell Jr., 50, 51
Holocaust, 169
Homer, 34
Hood, Thomas, 51, 170, 193n44
Horvat, Gillian, 198n8
Howard, Leslie, 25
"How Not to Build a Robot" (Asimov), 141, 198n9
Hugnet, Georges, 86
Huyssen, Andreas, 73

Ichbiah, Jean David, 190n2
Idelson, Vera, 197n33
identity: ambiguities of, 73; camouflaged, 199n18; changing, 175; construction, 80; crisis of, 97; cultural, 8; female, 8, 55, 80, 87, 166, 167, 171, 174, 196n31; fused, 135; gender, 109, 174; masking, 100; mistaken, 68; reimagining, 196n31; searching for, 151; shaping one's own, 8; social, 8; social construction of, 78, 166; switching, 68; synthetic, 118, 119; transformation of, 55
I Dream of Jeannie (television series), 103, 105, 198n8
The Iliad (Homer), 34
"I'll Leave It to You" (*My Living Doll* episode), 108, 198n14
image(s): destabilization of, 77; dollhouse, 181; electric, 87; electronic collide with "real," 131;

of fragmentation, 169, 194n4; image-making, 175; mechanistic, 87; perception, 175; self, 176; Space Age, 103; of women as dolls, 181
Impressionism, 46
"I, Mudd" (*Star Trek* episode), 113
International Feminist Congress (1896), 41
Ishiguro, Hiroshi, 154, 155, 156, 157, 201n4, plate IX
I Shop, Therefore I Am (Kruger), 199n15
I Sing the Body Electric (Bradbury), 123
"I Sing the Body Electric" (*Twilight Zone* episode), 121–125
"I Sing the Body Electric" (Whitman), 123

Jackson, Shelley, 8, 166; assemblages of disparate parts in work of, 166; foregrounds isolated parts to reimagine female identity, 171; reimagining of Mary Shelley's Frankenstein, 169, 170
Jacobus, Mary, 75
Janacek, Leos, 61
Janson, Victor, 64
Japanese: art, 46; dolls and puppets, 193n36; robots, 190n2, plates VIII and IX. *See also* androids: Japanese
Japonisme, 46
Jaquemarts, 191n19
Jaquet-Droz, Henri-Louis and Pierre, 35, 191n10, plate III
Jentsch, Ernst, 7, 56
The Jetsons (television series), 126–128; "The Jetsons' Night Out," 127; "Mother's Day for Rosie," 127; push-button Space Age living portrayed in, 103–104; reflection of greater electronic sophistication in, 126; "Rip-Off Rosie," 127; "Rosie Come Home," 126; "Rosie's Boyfriend," 104; spoofs potential for errant technology, 126–128
"The Jetsons' Night Out" (*The Jetsons* episode), 127
Johansson, Scarlett, 135, 136, 199n18
Jonas, Joan, 174, 174, 175, 179, 204n18, 204n20
Jonze, Spike, 30, 135, 163, 200n30
Joshua, Essaka, 17, 187n5, 187n8
Jumeau (dollmaker), 99

Kang, Minsoo, 157, 190n6
Karakuri Ningyo, 46
Karloff, Boris, 74, 75
Kazan, Zoe, 8, 149, 150, 151

Keaton, Diane, 132
Keener, Catherine, 133
Kellett, E. E., 13, 18–23, 31, 188n20
Kelly, Grace, 132
Kennedy, John F., 103
Kidder, Margot, 26, 93, 189n35
Kidman, Nicole, 142, 145
Kienholz, Edward, 104
"Kill Oscar" (*The Bionic Woman* episode), 114, 115, 116
Kindley, Jeffrey, 121
Kintzing, Peter, 35
Kismet (robot), 159, plate X
Kass, Philip, 188n20
kleptomania, 109, 127, 199n15
"The Kleptomaniac" (*My Living Doll* episode), 109
Knight, Nick, 172
Korean robots, 153, 154, 161–162, 201n4
Koss, Juliet, 196n26
Kosuge, Kazuhiro, 153
Kräly, Hanns, 64
Kristeva, Julia, 168, 203n6
Kruger, Barbara, 199n15
Kubrick, Stanley, 71, 101, 142
Kuhn, Annette, 183
Kumao, Heidi, 171
Kurtag, György, 61

Lacan, Jacques, 194n4
"La Charmante Catin" (automaton), 36
"The Lady Automaton" (Kellett), 13, 18–23, 31
Lady Musician (automaton), 35, 154, 158, 190n7, 190–191n8, 191n10, plate III
la feé Carabosse (automaton), 39, 40
Lagrenée, Louis-Jean-François, 11, 12
"La magicienne" (automaton), 49, 193n37
Lambert (automaton manufacturer), 38, 46, 48
La Mettrie, Julien Offray de, 134
Lanchester, Elsa, 8, 73, 74, 167, 176
Lang, Fritz, 55, 69, 70, 99
La poupée (Audran), 64
La poupée (Bellmer), 83, 84, 85, 85, 135, 170, 180
La poupée de Nuremberg (Adam), 64, 66
Lara Croft and *Tomb Raider* (video game series), 131
Lars and the Real Girl (film, 2007), 7, 68, 109, 147, 148, 149, 163

"Lateness of the Hour" (*Twilight Zone* episode), 97
Laughter (*Le Rire*) (Bergson), 26
Leaves of Grass (Whitman), 123
LeBrock, Kelly, 128, 129
Ledger, Sally, 189n25, 192n28
Lee, Pamela, 204n18
Left Side, Right Side (video, 1972), 204n20
Le Rire (Bergson), 26
Lerner, Alan Jay, 93, 189n35
Le Roman de la Rose (Lorris and Meun), 10
Leschot, Jean-Frédéric, 35
L'Ève future (Villiers de l'Isle-Adam), 19, 28, 92, 139, 140, 156, 163
Levin, Ira, 3, 115, 140, 141
L'Horlogère (clock), 194n8
Linney, Laura, 164
"Life, Love, and Lipstick" (Shawell), 199n16
Liu, Lydia, 194n4
"Living Doll" (*Twilight Zone* episode), 99–102, 109
Loewe, Frederick, 93, 189n35
"The Lonely" (*Twilight Zone* episode), 98, 99
Loren, Sophia, 132
Lorris, Guillaume de, 10
Lost in Space (television series), 7, 110–113; "The Android Machine" episode, 110, 111, 112
Lubitsch, Ernst, 7, 54, 55, 63–69, 184
Lubitsch in Berlin (film, 2006), 65

MacDorman, Karl, 154, 155, 156, 157, 201n4
Machine Art, 167
"Machine Dance," 87
The Machine-Gunneress (Bellmer), 83
"Mademoiselle Catherina" (automaton), 36, 36, 38, 49
magic: in television series, 105
Maillardet, Henry, 191n10
"Maillardet's Grand Automaton," 191n10
manga, 133, 134, 180, 199n25
Mann, Aimee, 164, 165
Mannequin (film, 1987), 130–131
mannequins, 1, 3, 173–176; characters discovery of their status as, 96, 97, 98; deathliness in imitation of, 155; female, 86–89; in film, 61, 62; in French satire, 19; as objects for male viewing, 86; in photographs, 1, 76, 86; in photographs by Bellmer, 81–86; as sculptural works of art, 86; seem better than reality, 4, 5; Surrealist, 86. *See also* women (artificial)
The Man Who Danced with Dolls (Adams), 152
"The Man Who Never Was Young" (story), 38
"The Marble Virgin" (McDowd), 29–30
Marinetti, F. T., 87
marionettes, 3, 87
Marlene (Wosk, photograph), 76, plate V
Marlowe, Julia, 16
Married Women Property Rights Acts (England), 23
Marsh, Jean, 98
The Mary Tyler Moore Show (television series), 114
Marvin, Carol, 200n8
masks, 173–176, 180; cultural, 46; ethical dimension of women wearing, 178; expected of women, 1; of femininity, 78; femininity constructed as, 77; festival, 49; of glamor, 3; of makeup, 8; use as strategy to maintain autonomy, 80
masquerade: in bra ad, 1, 2; as camouflage, 196n22; femininity as, 75–80, 112, 195n19; suspension of traditional gender relations through, 78
Massiné, Léonide, 81
Masson, André, 86
The Master (Höch), 80
Mattel Corporation, 99, 113, 197n3
McClintock, Laura Breckinridge, 87
McDowd, Kennie, 29–30
McQueen, Alexander, 8, 172, 173, 182
The Mechanical Doll (film, 1901), 63
The Mechanical Dolls of Monte Carlo (Battaini), 191n19, 191n22
"Mechanical Sewing Machine Girl" (automaton), 43, 44
Meickle, Jeffrey, 107, 198n11
Melendy, Dr. Mary, 53, 140
Méliès, Georges, 63, 194n8, 194n9
"Memories of a Doll Theme" (Bellmer), 83, 85
men: caricatured as puppets being manipulated by women, 19; concepts of ideal female, 138; delight when beloved turns out not to be artificial but real, 7; desire to turn women into docile, compliant creatures, 144; dreams and fantasies about creating perfect woman, 5; envisioning artificial women as extensions of themselves, 98; falling in love with automatons,

22, 23; fantasies turn to nightmares, 2; fascination with mechanical/manufactured reproductions, 13; fear of increasingly independent women, 19; fear of women's sexuality, 73, 92, 168; fooled by appearances of artificial women, 98; distraught at the discovery beloved females are only dolls, 7, 157, 158; interest in technical intricacies of dolls, 50; less likely to notice deviations from norms of human behavior in robots, 202n18; longing for ideal woman, 130; longing to replace wives with technologically produced perfect women, 140, 141–146; as masters to be obeyed, 20; more likely to take action when persuaded by female rather than male robot, 158, 159; objectification of women by, 25, 52, 75, 77; Pygmalion-like fantasies of, 3, 7, 9–30, 17; Pygmalion-like quest to create beautiful artificial women, 8; sensitivity to deviation from norms of physical beauty in robots, 157; undone by attraction to female automatons, 22, 23; using science and technology to create artificial females, 8; view of dolls as commodities, 67; wishes for control of automatons/women, 100–101, 113, 114, 132; women as objects of male gaze, 37. *See also* fantasies; fears

Menon, Elizabeth, 19, 189n24
Menotti, Titana, 196n29
The Metamorphoses (Ovid), 11, 187nn1,2
Metropolis (film, 1927), 69–75, 99, 115, 153, 194n10, 195n11; digital restoration of, 70, 194n10; dual visions of woman in, 70, 71, 72; mad scientist role in, 71; scene of transformation in, 195n11; ramifications of creating duplicate of real woman, 69–73; seduction in, 70
Meun, Jean de, 10
Meyer, Agnes, 197n33
Miró, Joan, 86
Misbehaving: Media Machines Act Out (Kumao), 171
Miss Kilmansegg and Her Precious Leg (Hood), 51
Mobile Dextrous Social Robot (MDS), 158
Modern Pygmalion (Rowlandson), 11
Modern Times (film, 1936), 88
Moholy-Nagy, Lázló, 196n26
Monet, Edouard, 46

Monroe, Marilyn, 132
Moore, Mary Tyler, 114
Mori, Mariko, 180–181, 184
Mori, Masahiro, 56, 135, 155, 157, plate XII; on "uncanny valley," 7, 19, 201n8
Morris, William, 187n8
Morrison, Enoch Rice, 50
Mossé, Sonia, 86
"Mother's Day for Rosie" (*The Jetsons* episode), 127
"Mother Shipton" (automaton), 39, 40
Mullins, Aimee, 185; achievements in sports and as fashion model, 172; celebration of autonomy and power by, 171–172; as cybernetic female, 8; freed from confines of disability, 173; use of prostheses, 8, plate XI
Mulvey, Laura, 75, 195n17
"Musical Lady" (automaton), 191n10
Myers, Mike, 131
My Fair Lady (musical, 1956), 93, 128, 189n35
My Fair Lady (film, 1964), 94, 128
My Living Doll (television series), 7, 103, 104–109, 198n14, 199n15; "The Beauty Contest," 108, 109; "Boy Meets Girl," 105, 106; "I'll Leave It to You," 108, 109, 198n14; "The Kleptomaniac," 109; "Something Borrowed," 108, 198n14; "The Witness," 109

Nash, Ogden, 90
National Organization for Women (NOW), 102
Neils, Jennifer, 189n1
"The Nerd Crush" (*Small Wonder* episode), 126
Neuromancer (Gibson), 125
"The New Aspect of the Woman Question" (Grand), 41
Newmar, Julie, 105
New Woman, 23, 53; anxieties about independence of, 108; automatons as version of, 34; cultural ambivalence in depictions of, 108; as cultural construct and social threat, 189n25; as cultural scapegoat, 192n25; emergence of, 41; as fictional construct, 192n25; representations of artificial women and, 7; viewed by Höch, 171
Niccol, Andrew, 132
Nichols, Mike, 107
Nocks, Lisa, 190n5
Noga (Szapocznikow), 169

216 • Index

O'Connor, Flannery, 170, 193n44
Offenbach, Jacques, 60, 61, 196n29
One Touch of Venus (play, 1943; film, 1948), 90, 91, 91, 92, 128, 129, 130, 151
"On the Psychology of the Uncanny" (Jentsch), 56
Organic Honey's Visual Telepathy (performance), 174, 175
Orlan, 175, 176
Oshii, Mamoru, 134
Oswalda, Ossi, 55, 64, 65, 66, 67, 69
O'Toole, Peter, 93, 189n35
Ovid, 5, 9, 10, 11, 90, 187nn1,2

Pacino, Al, 132
Pankhurst, Emmeline, 23
Paralympics (1996), 172
Park, Julie, 37, 78, 191n12
Partner Ballroom Dance Robot (PBDR), 153
Patchwork Girl (Jackson), 8, 166, 169, 170; as embodiment of postmodern woman, 170; explores new construct of female body parts, 169; fabrication of by reader's input, 170; reimaging of unfinished mate of Frankenstein's Monster, 169
Pearson's (magazine), 18
Peiss, Kathy, 178
perfect woman, 5, 7, 8, 9, 17
The Perfect Woman (film, 1949), 137–149
Perfect Womanhood (Melendy), 53, 140
Perlman, S. J., 90
Perrault, Charles, 39
Phalibois (automaton manufacturer), 31, 32, 38
Philostephanus, 187n1
Phoenix, Joaquin, 135, 136
"The Physiology of Walking" (Holmes), 51
Picabia, Francis, 86, 127, 197n33
Pigmalion dont Venus animée la statue (Lagrenée), 11, 12
Plant, Sadie, 168
plastics, 107, 108, 198n11
Playboy (magazine), 3, 131
Play with Me (Mori), 180
Portrait d'une jeune fille américane dans l'état de nudité (Picabia), 86
Post-Impressionism, 46
Powell, Michael, 61
Precisionism, 167
Pressburger, Emeric, 61
Pritze, Lotte, 196n25

Prototype Robot Exposition (2005), 154
puppets, 193n36
Pygmalion (Daumier), 11, 13
Pygmalion (film, 1938), 25, 26, 26, 27
Pygmalion (mythical character), 62, 63; in art, 9–14; artificial women and, 9–30; comic/pornographic art and, 11, 12; early images of, 10; idea of simulation coming alive in, 9, 10; in "The Lady Automaton" (Kellett), 18–23; in *Pygmalion and Galatea* (Gilbert), 14–18; retold by Ovid, 5, 9, 10; reversion and reversal, 117–118, 133; revisiting, 128–131; sexual issues implicit in, 90; turned into farce, 128
Pygmalion (Raoux), 11
Pygmalion (Rousseau), 11, 35, 187n5
Pygmalion (Shaw), 3, 23–29, 46, 67, 90, 92, 189n35
Pygmalion (television drama), 26
Pygmalion and Galatea (film, 1898), 63
Pygmalion and Galatea (Gérôme), 3, 11, plate II
Pygmalion and Galatea (Gilbert), 13, 14–18, 92, 93, 188n10; frankness concerning passion in, 17; gender stereotypes in, 15, 16, 17; reflects views on reproductions and simulations of the time, 15; reinforcement of Victorian attitudes about women, 14, 16, 17; view of real wife as superior to sculpture in, 18
Pygmalion and Galatea (Rodin), 11
Pygmalion and the Image: The Soul Attains (Burne-Jones), 11, 187–188n8
The Pygmalion Effect (Stoichita), 187n6

Quay Brothers, 61, 62

Raoux, Jean, 11
Ray, Man, 86, 196n30
Reich, Charles, 107, 198n12
Reilly, Joan, 189n1
Reinhart, Max, 196n29
remote controls, 143, 144
Renou (automaton manufacturer), 41, 42
replicants, in *Blade Runner*, 118–121
Repliee Q1/Q2, 154, 155, 156, plate IX
Respini, Eva, 178
Résurrection des mannequins (Ray), 196n30
Ricci, Sebastiano, 11
"Rip-Off Rosie" (*The Jetsons* episode), 127
Rittau, Günther, 195n11
Riviere, Joan, 112, 195n19, 196n22, 199n17

Robertson, Jennifer, 159, 160
robo-sexism, 159–162, 161
roboticists, female, 159–162; Breazeal, Cynthia, 158, 159; Forlizzi, Jodi, 159; Thomaz, Andrea, 159, 160
roboticists, male, 153–158; findings raise questions of gender, 155, 156; goal to make robots indistinguishable in appearance from humans, 154; interest in robotic sex dolls, 162–165; Ishiguro, Hiroshi, 154, 155, 156, 157; Kosuge, Kazuhiro, 153; MacDorman, Karl, 154, 155, 156, 157; Mori, Masahiro, 155, 157; and remote control, 144; research shaped by attitudes toward women, 153; seeing robots as both nurturing and alluring, 153, 154; seeking to make female robots more realistic looking/acting, 153; use of latest technologies to embody fantasies of perfect female, 153, 154
robots: AF709, 105; ambivalence in portraying emancipation and traditional femininity in, 108; ambivalent views of, 105; animated, 199n23; as collections of parts, 114, 115, 116; as comic kleptomaniacs, 109, 127; compared to fashion show runway models, 155; controlled through computer and voice commands, 125; conversational, 163; critiques of designs, 141, 198n9; Curi, 160; customized to suit individual preferences, 163; as dance partners, 7, 22, 65, 152, 153, 200n2; dangers in creating very human-looking, 155; designed as sexual "pets," 134; designing, 152–165; doubles, 163–165; early examples of, 190n2; experiments, 201n11, 201n13; female doubles for malevolent purposes, 115; "First Robot Supermodel," 161, 161; Geminoid F, 154; gender issues and, 158, 159; glitches in programming of, 155; humanized, 126–128, 158, 159, 160; idealized versions of, 110, 112, 124; interactions with humans, 158, 159; Kismet, 159; knowledgeable, 123; lack of unfettered independence, 105; magical/technical powers of, 104, 105; mechanically adept, 110; mirroring of gender stereotypes, 104; Mobile Dextrous Social Robot (MDS), 158; with moral capabilities, 110, 112, 124, 129; in music videos, 164, 165; "Nathanael Effect" and, 158, 159; Partner Ballroom Dance Robot (PBDR), 153; portrayed as both sexy and smart, 105; presented as technological wonders, 108; realistic appearances of, 108; Repliee Q1/Q2, 154, 155, 156; sex and technology and, 107, 163; as social entity, 158; socially aware, 159; Socially Guided Machine Learning and, 159; softening of tensions between artificial and real in, 124, 125; stereotypical roles for, 160, 161, 162; on television series, 103–114; "True Companions," 163; used in care of sick and elderly, 153, 163; use of speech recognition by, 201n4, 203n31; views on artificial looks to avoid feelings of the uncanny valley, 201n8. *See also* androids; women (artificial)
Roc, Patricia, 137, 138
Rodin, Auguste, 11
Roentgen, David, 35
The Romance of the Rose (*Le Roman de la Rose*) (Lorris and Meun), 10
Rootstein, Adel, 8, 182
"Rosie Come Home" (*The Jetsons* episode), 126
"Rosie's Boyfriend" (*The Jetsons* episode), 104
Rosie the Riveter (cartoon), 95
Ross, Katherine, 141
Roszak, Theodore, 107
Roullet & Decamps (automaton manufacturer), 38, 39, 44, 46, 47, 49, 192n22, 192n27, 192n35
Rounseville, Robert, 62
Rousseau, Jean-Jacques, 11, 35, 187n5
Rowlandson, Thomas, 11
Roxxxy (sex doll), 162, 163, 203n32
Ruby Sparks (film, 2012), 8, 149–151
Ruskin, John, 15
Ryder, Winona, 132

Saint-Simonians, 41
"The Sandman" ("Der Sandmann") (Hoffmann), 6, 7, 22, 56–58, 60, 61, 74, 98, 115, 152, 155, 158, 188n18, 189n1, 194n4; ambiguity in, 56–58; confusion over reality of doll, 6, 7, 56, 57, 58; references to vision and eyes in, 56, 57, 58
Savalas, Telly, 100, 102
Sayer, Robert, 36
Sayonara (Hirata), 153, 154
Schaffer, Talia, 192n25
Schjeldahl, Peter, 178

Science Wonder Stories (magazine), 29
Scott, Ridley, 118, 119, 120, 121, 154, 156
Sellers, Peter, 71
Seltzer, Mark, 155
Sennett, Mack, 68–69
Serling, Rod, 30, 96, 97, 98, 100, 109, 117–118, 122
sex dolls, 162, 163, 203n32
Sex Pictures (Sherman), 179
sexuality: in *The Jetsons*, 127; masked, 14; and *Playboy*, 3; and technology, 73
Shaw, George Bernard, 3, 12, 23–29, 90, 188n20, 189n35
Shawell, Julia, 112
Shearer, Moira, 61, 62
Sheeler, Charles, 167
Shelley, Mary, 8, 72, 73, 133, 166, 167, 169
Sherman, Cindy, 176–180, 177, 184; examines role of artifice in female identity, 8; mannequin photos by, 8; photos of roles women play, 176; on women's constructed masks of identity, 176
Shields, Brooke, 132
Shirow, Masamune, 134
Simians, Cyborgs, and Women (Haraway), 167
Simmons, Laurie, 181, 182
Simone (film, 2002), 7, 132, 133
simulacra (female), 198n14; ambivalence about, 96. *See also* androids; artificial females; dolls; mannequins; robots
Sinatra, Nancy, 131
Siri, 200n29
Small Wonder (television series), 125–126; "The Nerd Crush," 126
social: advances, 23; change, 24, 96; constraints, 138; identity, 8; norms, 141; proprieties, 31; roles, 10; shifting paradigms, 7; status, 14; transformations, 41
Society Portraits (Sherman), 176, 177, 179
The Soul Attains (Burne-Jones), 187n8
Southeil, Ursula, 39
space race, 103, 105, 110
Spigel, Lynn, 103
Stapleton, Maureen, 124
Starbinski, Jean, 37
Star Trek (television series), 113–114; "I, Mudd," 113
Steel Angel Karumi (television series), 133, 134

Steiner, Jules, 52, 99
The Stepford Wives (films, 1975/2004), 141–146, 152, 163, plate VII; application of technology to achieve the perfect wife, 141–146; remote controls in, 143, 144; satirization of 1950s attitudes toward technology, 143
The Stepford Wives (Levin), 3, 115, 140, 141
stereotypes, 7, 8, 14–19, 39, 41, 96, 100, 104, 110, 112, 113, 143, 159, 160, 161, 198n14, 199n15
Stevens, Inger, 97
Strand, Paul, 167
Streep, Meryl, 132
Street of Crocodiles (film, 1986), 61
subRosa (artists' collective), 203n2
"Substitute Woman," 5, 115, 121
Sullivan, Arthur, 14
surgery, cosmetic, 162; culturally defined notions of beauty and, 175; in quest to create perfection, 175, 176
Surrealism, 86, 170, 204n10
Szapocznikow, Alina, 169, 204n10

The Tales of Hoffmann (Offenbach), 60, 61, 146, 196n29
Talking Barbie (doll), 113
Talking Christine (doll), 113
Talky Tina (doll), 99–102
Tanguy, Yves, 86
Tauber-Arp, Sophie, 197n36
Taxi Dolls (film, 1929), 68, 69
technology: benign views of, 124; changing, 30, 117, 125; Cold War paranoia over, 100; complex effects on women's lives, 203n2; contaminated with female messiness, 168; developments in, 7, 14, digital developments, impact of on depiction of robots, 128–129; digital pristineness, 168; electronic, 167, 168; electronic development, impact on 1980s television, 117; electronics and 1970s wonder women, 114–117; fear of malevolent uses of, 100, 101; glitches, 127; infatuation with plastics and electronics, 107, 114; out-of-control, 101; production of second-rate imitations and, 198n12; push-button, 103, 104, 144; "retro-tech," 160; satirical views of, 143; social impact of, 23; sound reproduction, 13, 14; used by men to create

perfect female, 141–146; used for control, 139; use in fashioning simulated women, 4, 31, 107
television: dramatic shift to strong women, 114; introduction of simulated women as characters, 95–113; range of artificial women in postwar programming, 95–102; reversal of abuser/victim roles in programs, 99–102; VCRs and, 117. *See also titles of specific shows*
television (1960s), 103–114; *Bewitched*, 103; *I Dream of Jeannie*, 103, 105; *The Jetsons*, 104–114; *Lost in Space*, 110–113; *My Living Doll*, 103, 104–109; *Star Trek*, 113–114
television (1970s), 114–116; *The Bionic Woman*, 114, 115, 116; *The Mary Tyler Moore Show*, 114; *That Girl*, 114
television (1980s), 117–131; *The Electric Grandmother*, 121–125; *The Jetsons*, 126–128; *Small Wonder*, 125–126; *Twilight Zone*, 117–118
television (2000s): *Battlestar Galactica*, 121, 199n20; *Terminator: The Sarah Connor Chronicles*, 131
Terminator: The Sarah Connor Chronicles (television series), 131
Testart, Robinet, 10
The Texas Chain Saw Massacre (film, 1974), 99–102
That Girl (television series), 114
Thomaz, Andrea, 159, 160, *160*
Tillie, The Telerobotic Doll (Hershman Leeson), 181
Tobiason, Julie, 59
Toyokuni, Utagawa, 46
Trier, Lars von, 64
"True Companions" (sex dolls), 163
Twilight Zone (television series), 3, 96, 117–118; "The After Hours," 30, 96, 97, 117–118; blurred boundaries on, 96, 97; interchangeability of artificial and real on, 96, 97; introduction of simulated women as characters on, 96; "I Sing the Body Electric," 121–125; "Lateness of the Hour," 97; "Living Doll," 99–102, 109; "The Lonely," 98, 99
2001: A Space Odyssey (film, 1967), 101
Twyler, Tom, 65

the uncanny: ambiguity of, 76, 77; anxieties of, 158; as condition of uncertainty and confusion about whether a being is animate/inanimate, 6, 7, 56; descent into, 115; discovering animated being is not alive, 7; implications of, 150; meditation on, 134, 135; moment of revelation of artificial nature of automatons and, 19; pain of, 97; revisited by women filmmakers, 8; slippery boundaries of, 121; theme in television, 96; turned into farce, 68; uneasiness caused by imitation and, 56
uncanny valley, 7, 13, 56, 135, 155, 158, 201n8
"The Uncanny Valley" (Mori), 56, 155
Under the Skin (film, 2013), 199n18
Untitled Film Stills (Sherman), 176

"The Vamp and the Machine" (Huyssen), 73
Van Gogh, Vincent, 46
Vaucanson, Jacques de, 35
Vichy (automaton manufacturer), 38, 39, 44, 46, 49, plate IV
video games. *See individual titles*
Villiers de l'Isle-Adam, Auguste, 19, 28, 139, 156
virtual women in a digital age, 131–136
Vogue (magazine), 76, *76*
virtual women in film, 131–136
von Sternberg, Josef, 77

Wagner, Lindsey, 114
Walken, Christopher, 144
Walker, Robert, 90
Warden, Jack, 98
War of the Worlds (Wells), 18
Warrior (Mori), 180
Watts, Alan, 200n30
Weill, Kurt, 90
Weird Science (film, 1985), 128, 129
Wells, H. G., 18
Whale, James, 5, 8, 11, 71, 73–75, 167, 176
Whitman, Walt, 123
Williams, Carolyn, 14, 17
Wilner, A. M., 64
Winner, Langdon, 101
"The Witness" (*My Living Doll* episode), 109
"Womanliness as Masquerade" (Riviere), 195n19, 196n22, 199n17
"Woman Question," 14
Woman's Home Companion (magazine), 112
The Woman Today (magazine), 112

women: adopting look of dolls, 63–69; ambivalent views of in television, 96, artists as Pygmalion, 166–185; as assemblages of parts in art, 5–6, 73, 121, 166–167; assertion of sense of agency/control by, 7; assigned to domestic "spheres," 14; become self-supporting, 23; bicycling and, 43, 44; boundaries between artificial and real, 55; challenges to gendered portrayals of, 167; changes in notions about technical abilities of, 41–44; changing cultural perceptions of, 5, 39; codes of proper behavior for, 14; complicity in creation of ultrarealistic female robots, 162; control issues, 100–101, 113, 114; in "dangerous female activity," 168; difficulties reconciling emancipation and traditional femininity, 108; doll-like movements due to uncomfortable undergarments, 37, 38, 53; as dolls, 181–185; dual visions of, 65, 67, 70, 100, 113; efforts to improve social status reflected in styles of automatons, 39; empowered/empowering, 104, 125; exaggerated fashions and stiff movements of, 5, 37, 38, 53; expectations of artificiality and genuineness in, 1, 78; expectations of glamour and, 3; filmmakers, 8, 149–151; fulfillment of proper role as devoted wife and mother, 140, 141; ideal, 14, 15, 17; issue of sexuality, 91; lack of fulfillment in conventional domestic roles, 104; leading effort to make robots more humane, 202n21; liberation by machines, 197n2; as "living dolls," 1, 5, 19, 20, 25, 37, 52, 80–81; as machines, 86–89, 197n33; masculinity and assertiveness in, 195n19; masquerading as artificial to achieve own ends, 75–80; metaphorically identified with technological objects, 200n8; new sense of independence and freedom, 23, 24; painted, 178; perceptions of altered during World Wars I and II, 96; power over men, 90; pulling strings of men, 108; representation in media, 87; in robotics design, 152–165; seen as preferable to artificial as worth is recognized by men, 149; simulacra as objects of wonder, 125; social advances for, 23; social construction of, 73, 74, 113; social identity of, 8; stiff undergarments, 37, 38, 53, 116–117; struggling with impossible standards of beauty, 178; "Substitute," 115, 121; suffrage campaigns, 23; transformation to immobile mannequins, 118; turned into artificial beings, 138; users of new machines, 41–44; uses of makeup by, 110, 112; Victorian social attitudes toward, 18, 22; visual objectification of, 75; as witches, 39; work in World War I/II industries, 43, 44

women (artificial): as assemblage of parts in art, 73, 167; bodies fractionalized by male inventors, 52; boundaries between artificial and real, 55, 149–151; clothing rituals, 30; control issues, 20, 100, 101, 108, 113, 114; creation of as goal, 72; as dance partners, 7, 22, 65, 152, 153; as depersonalized objects, 20; developments in plastics and electronics and, 7; digital, 131–136; emergence in television/film, 102; engineering a perfect example, 137–151; exotic, 44–49; as fallible machine prone to mechanical breakdowns, 109; fashioned by women, 7, 8, 137–151; in film and art, 55–89; gender stereotypes and, 7; intelligent, 7, 149–151; mannequins/masks, 173–176; men fooled by appearance of, 98; men's suspicions that they are not real, 118–121, 149–151; mistaking real women for, 137–140; morphing into human-like creatures, 119; narcissistic relationships established with by men, 20, 98; noted for docility rather than brains, 128, 129; passing for real in society, 19; perfect fabrication of, 7; in post-1940 media, 90–136; potential associations of sexual availability and, 65; proof of artifice and destruction of, 122; Pygmalion myth and, 9–30; reflect impact of American and European women's movement and emergence of digital technology, 128, 129; reimagined by female film director, 5, 149–151; as "replicants," 118–121; as safe and unchallenging, 20, 146, 147, 148; seen as superior to real, 9, 10, 137, 156; seen as would-be controllers of men, 108; shaped by changes in science/technology, 7, 127; shaped by men's beliefs about women, 9, 10; shaped by women's movement and impact of personal computers, 128, 129; shifting social paradigms and, 7; Surrealism and, 86; on television, 95–102; unwitting

cause of men's anguish and misery, 69–75; in video games, 131, 180, 200n29

women, artificial (1940s representations): *One Touch of Venus* (film), 90–93, 151; *The Perfect Woman* (film), 137–149

women, artificial (1960s representations): dolls, 99–102; *The Jetsons* (television), 103–104; *Lost in Space* (television), 110–113; *My Fair Lady* (stage/film), 93–94; *My Living Doll* (television), 104–109; *Star Trek* (television), 113–114; *Twilight Zone* (television), 96–102

women, artificial (1970s representations): *The Bionic Woman* (television), 114–116; *The Mary Tyler Moore Show* (television), 114; *That Girl* (television), 114

women, artificial (1980s representations): *Blade Runner* (film), 118–121, 133, 150, 154, 156; *The Electric Grandmother* (film), 121–125; *The Jetsons* (television), 126–128; *Small Wonder* (television), 125–126; *Twilight Zone* (television), 117–118; *Weird Science* (film), 128–129

women, artificial (1990s representations): *Austin Powers: International Man of Mystery* (film), 131; *Eve of Destruction* (film), 163; *Ghost in the Shell* (film), 133; Lara Croft in *Tomb Raider* (video game series), 131; *Playboy* (magazine), 131; *Steel Angel Karumi* (television), 133, 134

women, artificial (2000s representations): *Final Fantasy: The Spirits Within* (film), 131; *Ghost in the Shell 2: Innocence* (film), 133, 134, 135; *Her* (film), 30, 135, 163; *Ruby Sparks* (film), 8, 149–151; *Sımone* (film), 132, 133; *Under the Skin* (film), 199n18

Women and the Machine: Representations from the Spinning Wheel to the Electronic Age (Wosk), 5

women's movement: early, 41; emergence of, 96; in France, 41; in high gear, 114; rebellion against conventional roles and, 141; representations of artificial women and, 7; shaping of female simulacra by, 102; in Victorian era, 14

Women's Social and Political Union, 23

Wood, Gaby, 194n8

Working Girl (film, 1988), 199n22

Wosk, Julie (photographs), 76, plates I and V

Young, Elizabeth, 73, 75, 169, 195n17

Young, Sean, 118, 119

Zenith Space Command Televisions, 143

"Zulma the Snake Charmer" (automaton), 46, 47, 192n35

About the Author

JULIE WOSK is a professor of art history, English, and studio painting at the State University of New York, Maritime College, in New York City. Dr. Wosk has written widely on art, design, and the social impact of technology, and her books include *Women and the Machine: Representations from the Spinning Wheel to the Electronic Age* and *Breaking Frame: Technology and the Visual Arts in the Nineteenth Century*. Her paintings and photographs have been exhibited in American museums and galleries.